American Art

1908-1947 From Winslow Homer to Jackson Pollock

Curators

General Curators: Francis Ribemont, Valérie Lagier, Michel Hilaire
Scientific Curator: Éric de Chassey

ISBN 0-8109-6363-9 (Abrams)

Copyright © Éditions de la Réunion des musées nationaux, Paris 2001
49, rue Étienne-Marcel, 75001 Paris

Distributed in 2002 by Harry N. Abrams, Incorporated, New York
All rights reserved. No part of the contents of this book may be reproduced
without the written permission of the publisher.

Printed and bound in France

Harry N. Abrams, Inc.
100 Fifth Avenue
New York, N.Y. 10011
www.abramsbooks.com

Abrams is a subsidiary of

LA MARTINIÈRE
G R O U P E

Cover:
Raymond Jonson
City Perspectives, 1932
Detail.
The Portland Art Museum

Page 8:
Charles Demuth
Rooftops and Fantasy, 1918
Detail.
The Saint Louis Art Museum

Page 10:
Alexander Hogue
Crane County Dunes, 1937
Detail.
Dallas, The Barrett Collection

Page 18:
Lewis Hine
Opelika, Alabama, c. 1914
Detail.
Estate of Harry Lunn
Paris, courtesy Galerie Baudoin Lebon

Back cover:
Dorothea Lange
Migrant Mother, Nipomo, California, 1936
Detail.
The Mineapolis Institute of Arts

American Art

1908-1947 From Winslow Homer to Jackson Pollock

Edited by Éric de Chassey

Bordeaux,
Musée des Beaux-Arts
October 10
December 31, 2001

Rennes,
Musée des Beaux-Arts
January 18
March 31, 2002

Montpellier
Musée Fabre
April 12
June 23, 2002

Ville de
Montpellier

Translated by Jane McDonald

Réunion
des Musées
Nationaux

distributed by
Harry N. Abrams, Inc., Publishers

This exhibition is the first to be organized under the aegis of

French Regional and American Museums Exchange
www.Frame-madeinusa.com

FRAME is supported by the Foundation for French Museums, The Florence Gould Foundation, the Felix & Elizabeth Rohatyn Foundation, Barbara Walters and by Sophie et Jérôme Seydoux.

The Sara Lee Corporation, Vivendi Universal and Divento.com are the official patrons.

Additional support was provided by Air France, bioMérieux and Cap Gemini Ernst & Young.

Nota bene: the original title of the French exhibition is *Made in USA. L'art américain, 1908-1947.*

Acknowledgements

We take great pleasure in thanking all those without whom this first exhibition organized by FRAME would not have been possible; Alain Juppé, former Prime Minister, Deputy-Mayor of Bordeaux; Edmond Hervé, former Minister, Deputy-Mayor of Rennes, and Georges Fréche, Deputy-Mayor of Montpellier. Our gratitude also goes to everyone who enthusiastically supported this international project: Francine Mariani-Ducray, Director of the Musées de France, Dominique Vieville, Inspector General of the Musées, as well as the regional directors of Cultural Affairs, assisted by their museum advisors, who contributed to the financing of this exhibition in its three locations: Michel Berthod and Jean-Luc Tobie in Aquitaine, Raymond Lachat and Pascal Aumasson in Brittany, François de Banes-Gardonne and Jacqueline Schmitt for the Languedoc-Roussillon Region.

But this project could never have been carried out without the generosity of the Directors and those responsible for the following public and private collections who accepted to deprive their establishments of essential artworks for a considerable time:
Brent Benjamin of the Saint Louis Art Museum; Michael Brand of the Virginia Museum of Fine Arts in Richmond; John E. Buchanan of the Portland Art Museum; Michael Conforti of the Clark Art Institute in Williamstown; James T. Demetrion of the Hirshhorn Museum and Sculpture Garden/Smithsonian Institution in Washington D.C.; Susan Fillin-Yeh, as well as Anne and John Hauberg of Reed College/Douglas F. Cooley Memorial Art Gallery in Portland; Jay Gates of the Phillips Collection in Washington; Lyndel King of the Frederick R. Weisman Art Museum, University of Minnesota in Minneapolis; Dorothy Kosinski, John R. Lane and Bonnie Pitman of the Dallas Museum of Art; Arnold Lehman of the Brooklyn Museum of Art; Evan M. Maurer of the Minneapolis Institute of Arts; Donald Myers of the Hillstrom Museum of Art/Gustavus Adolphus College in Saint Peter, Minnesota, Christina Orr-Cahall of the Norton Museum of Art in West Palm Beach; Harry Parker of the Fine Arts Museums of San Francisco, M. H. de Young Memorial Museum; Terence Pitts of the Cedar Rapids Museum of Art; Katherine Lee Reid of the Cleveland Museum of Art; Jock Reynolds of the Yale University Art Gallery in New Haven and Kate M. Sellers of the Wadsworth Atheneum Museum of Art in Hartford; Christine Riding of the Tate Gallery in London; Tomàs Llorens of the Museo Thyssen-Bornemisza in Madrid; Derrick Cartwright of the Musée d'Art Américain in Giverny; Anne Dopffer of the Musée de la Coopération Franco-Américaine in Blérancourt; Raphaelle Drouhin of the Musée Daniel Vannier/Château Dunois in Beaugency; Josette Galiegue of the Musée Départemental de l'Oise in Beauvais; Serge Lemoine, formely of the Musée de Grenoble; Alfred Pacquement of the Musée National d'Art Moderne/Centre Georges Pompidou in Paris; Jean-Pierre Angremy of the Bibliothèque Nationale de France, Henri Loyrette, formely of the Musée d'Orsay and Andrea Delumeau of the Bibliothèque Américaine in Paris; Halley Harrisburg of the Michael Rosenfeld Gallery; Rose Shoshana and Laura Peterson of the Rose Gallery; Leight Morse of the Salander-O'Reilly Gallery; Baudoin Lebon, Caroline Bouchard, Matthieu Foss of the Galerie Baudoin Lebon; Marion Meyer of the Galerie Marion Meyer and Marcel Fleiss of the Galerie 1900-2000.

Special thanks to Sandra Alvarez de Toledo, Nona and Richard Barrett, John Dixon and Lolita Doppelt, Florence Lunn as well as to Gordon Onslow Ford.

The relatively short time allotted for organizing this exhibition required the prompt assistance of a large number of American and French museum curators, diplomats, art historians and professors, who kindly granted us their advice; their time, their good will and their determination to help us in our efforts were paramount in the success of this project:
Henry Adams, Brian Allen, Timothy Anglin Burgard, Sylvie Aubenas, Quentin Bajac, Béatrice and Wayne Bardin, Sylvain Bellenger, Christian Bernard, Yves-Alain Bois, Karin Breuer, Gilbert Brownstone, Margaret Bullock, Laurence Camous, Richard Campbell, Sue Canterbury, Jean-François Chevrier, Francesca Consagra, Silas B. Cook, Helen Cooper, Nancy Cooper, Daniel Cornell, Valérie

Cueto, Philippe Dagen, Barbara Dayer Gallati, Diane De Grazia, Anny Ellis, Elena Filipovic, Carter Foster, Dominique Fourcade, Pamela Franks, Katia Graisse, Françoise Heilbrun, Fabrice Hergott, Elisabeth Hodermarsky, Kate Hodgson, Cornelia Homburg, Eleanor Jones Harvey, Eik Kahng, Pick Keobandith, Charlotte Laubard, Brigitte Léal, Nathalie Leleu, Sophie Lévy, Olivier Lugon, Karol Lurie, Cara McCarty, Patricia McDonnell, Kathleen McKeever, Guitemie Maldonado, Jacqueline Matisse-Monnier, Ken Moser, Steven A. Nash, Patrick Noon, Caroline Pacquement, Christian Peterson, Léa Perez, Arnauld Pierre, Michel Poivert, Elodie Rahard, Eliza Rathbone, Richard Rand, Phyllis Rosenzweig, Pascal Rousseau, Katleen Schrader, Kevin Sharp, Jackie Starbird, Sam Stourdzé, Erik and Nathalie Umlauf-Williams, Hervé Vanel, Charles Venable, Pierre Wat, Elvan Zabunyan, Judith Zilczer and Deborah Zumwalt as well as the Masters and Doctorate students in Contemporary Art History at the University François Rabelais in Tours.

Within the American and French institutions, numerous individuals worked diligently to facilitate the loaning of artworks:

Lynne Addison, Marián Aparicio, Jennifer Bossman, Marie-Thérèse Cardey, Karen Christenson, Jeanne Lil Chvosta, Margaret Dong, Ann Eichelberg, Joanne Fenn, Mary Herbert-Busick, Joseph Holbach, Brian G. Kavanagh, Diane Mallow, Catherine McFarlane, Tanya Morrison, Angie Morrow, Laura Muessig, Valérie Ozcan, Pamela S. Parry, Maria Reilly, Elizabeth Reynolds, Mireille Sikora, Mary Sullivan, Mary E. Suzor, Leslie Urena, Kris Walton, Katie Welty.

We would also like to express our heartfelt gratitude to the editorial division of the Réunion des Musées Nationaux, Béatrice Foulon and especially Geneviève Rudolf, whose patience and competence enabled us to surmount the difficulties of this publication. Neither could we forget the importance of the work of Robert Fohr, Director of Communications at the Musées de France. We would also like to thank the various individuals in all the establishments who worked on organizing this co-production, as well as on mounting this exhibition in its three locations.

And finally, we would like to express our gratitude to Constance Goodyear, Alice Lobel, Mrs. Lewis T. Preston and John R. Young for their generous participation.

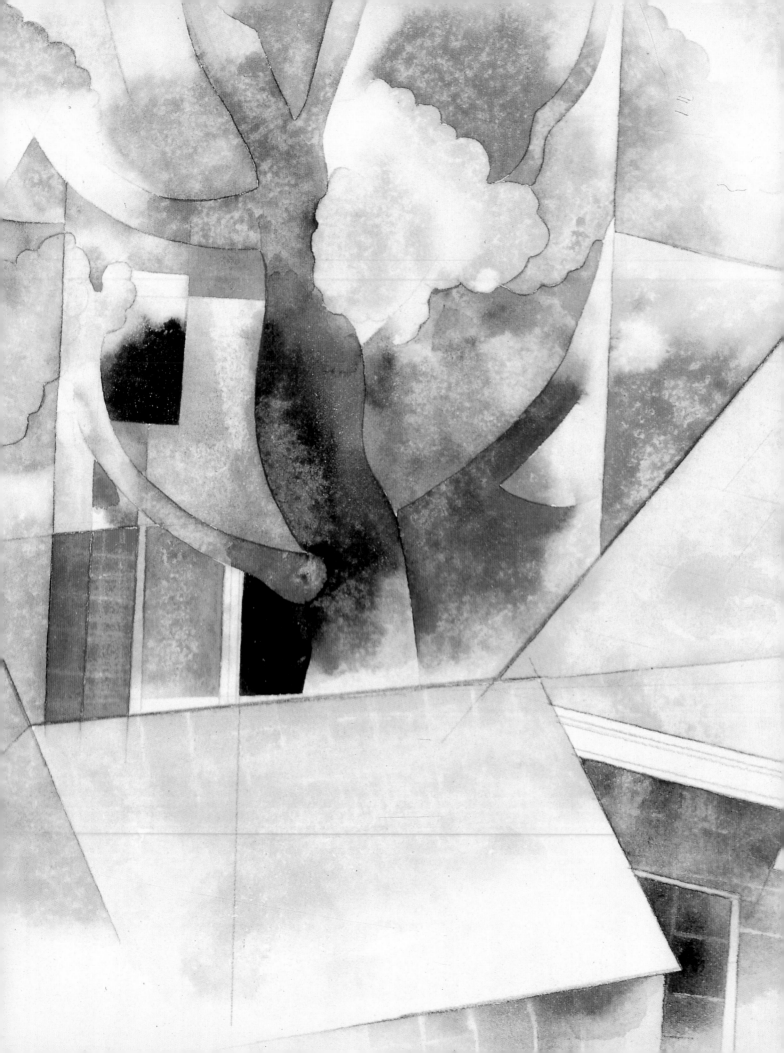

The partnership of nine American museums and nine French museums within FRAME (French Regional & American Museums Exchange) is a unique event in Franco-American relations. FRAME aims to encourage the initiation and the realization of mutual projects, to develop the resources of the partner museums through its network and to reveal the exceptional richness of their collections to a larger public, on both sides of the Atlantic.

A number of major exhibitions have been planned for now and the future under the aegis of FRAME, of which *American Art. 1908-1947 From Winslow Homer to Jackson Pollock*, is the first. It was inaugurated at the Musée des Beaux-Arts of Bordeaux, and then will travel to Rennes and to Montpellier. It will be followed, in 2002-3, by *Sacred Symbols, Four Thousand Years of American Art*, which will gather 100 masterpieces of the art of the Americas, from pre-Colombian civilizations to American Indian art, taken from the museum collections of Minneapolis, Cleveland, Yale, Dallas, San Francisco and Saint Louis, and which will be exhibited at Montpellier, Rouen, Lyon and Rennes.

Also in 2002, a selection of masterpieces of American photography from the Portland Art Museum will be presented at the Musée d'Art Moderne et Contemporain of Strasbourg, and a selection of drawings by Raphael and his contemporaries that comes from the painter Wicar's famous collection—the pride of the Palais des Beaux-Arts of Lille—will travel to Cleveland. 2003 will be no less rich, with new and exceptional projects about the 17th-century French painting, or also about Renoir and Algeria.

American Art. 1908-1947 From Winslow Homer to Jackson Pollock treats a period in American art that is little-known in France. Even though the work of artists such as Edward Hopper or Georgia O'Keeffe is already familiar to the French public, until now few exhibitions in France have shown American art before Pollock. Realized thanks to important loans from collectors and from French and American museums, especially the nine American museums that are partners in FRAME, the exhibition organized by Francis Ribemont in Bordeaux, Valérie Lagier in Rennes and Michel Hilaire in Montpellier, with the scientific curatorial administration of Éric de Chassey, crystallizes an original project that only the collaborative spirit of FRAME could have achieved.

Francoise Cachin, Francine Mariani-Ducray, Elizabeth Rohatyn

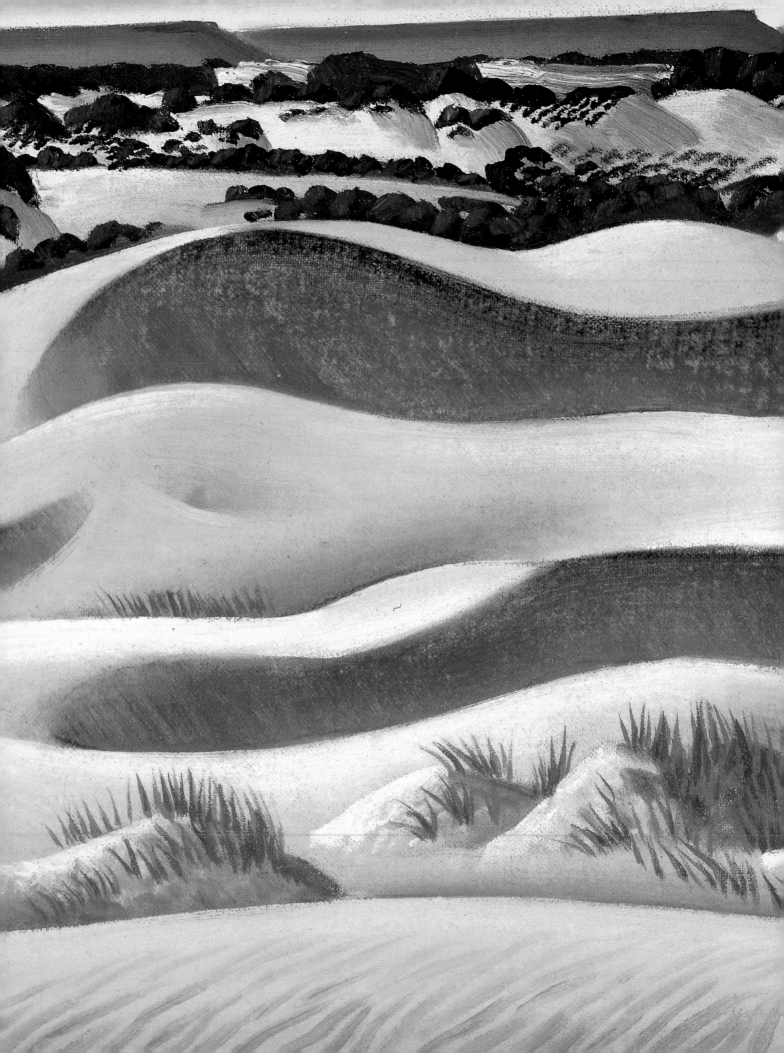

American art of the first half of the 20th century presents us with this surprising case: How could an art that was still under the influence of European canons come, in 40 years, to assert a profound originality and even become the very expression of modernity, to the point where critics could write that the United States had definitively "stolen" the idea of modern art from the Europeans?

One must not overlook the merit due, owing to the fact that the United States paid attention to the most ephemeral trends as well as to the most significant artistic movements. Even more surprising is the assimilation of all these movements, trends and sensibilities in order to invent a radically new art.

Like Picasso, who transformed the most diverse objects into sculptures of goats or monkeys, it is striking to see how American artists seized upon attributes of Impressionism, Cubism, Dadaism or of Surrealism in order to create a thoroughly original and revolutionary artistic expression.

Most exhibitions only show the end of this process, as if American art only began in 1950 with Pollock, De Kooning and Abstract Expressionism. The originality of the current selection lies precisely in leading us into the "laboratory" as of the beginning of the century, describing the process in all its variety and diverse materials, showing how artists of different horizons, with often divergent interests, could develop an art that was both unique and homogenous.

This exhibition offers us a view of a country in evolution, an identity in the process of being forged, with its contradictions, its conflicts, its confusion and its hopes. Here, one discovers an art, which, little by little, freed itself, found its light, its figures, its emblems until it became itself, so perfectly rooted in its country that it became universal—the solitude of Hopper's figures is ours and the severe and unsettling gaze of Grant Wood's hieratic farmers has not stopped haunting us.

This richness in diversity, this commendable crossover and exchanges, this dialogue between cultures and sensibilities lies at the heart of Vivendi Universal's concerns. It is therefore natural that Vivendi Universal should bring its support to this exhibition co-organized by FRAME, the first Franco-American program to form a partnership among eighteen regional art museums in France and in the United States. In my opinion, this half century of modern American art, of heritages reexamined, of creations with multiple roots, provides multiple reasons to have confidence in the extraordinary vitality of cultural diversity.

Jean-Marie Messier
President and Director General of Vivendi Universal

Not many know that we owe to a former President of the United States one of the first classifications of red wines from the Bordeaux region. In fact, during his stay in Bordeaux in 1787, Thomas Jefferson, then a delegate from the United States, wrote a memoir that established the primacy of four quality vineyards: Château Margaux, la Tour de Ségur, Haut-Brion and Château de la Fite. The previous year, in a more belligerent vein, he expedited 3,400 rifles destined for the insurgents of the State of Virginia, by way of Bordeaux's port. Thus, the roots of the historic friendship between Bordeaux and the United States reach back into the 18th century, to their privileged relations at the time when the *Port des Lumières* enthusiastically followed the advent of the young American democracy.

So it is not by chance that Bordeaux welcomed the first representation of the United States in the world. The painting by Pierre Lacour, in the Musée des Beaux-Arts of Bordeaux, shows the residence of the merchant Joseph Fenwick who, in 1790, opened the first official consulate of the United States on the Quai des Chartrons. More recently, during World War I, Bordeaux became one of the seven receiving points for the American troops who were so decisive in the victory of 1918. Bordeaux's outer harbor was then called New Bassens and, in 1916, the Ford Company chose our city for their vehicle assembly plant; it is still here today.

These past choices are still valid and justify the event that constitutes today the first sweeping exhibition devoted to American art of the first half of the twentieth century. Thanks to the persistence of our friend, Felix Rohatyn, former Ambassador of the United States in France, and that of his wife Elizabeth, as well as that of Madame Françoise Cachin, then Director of the Musées de France, FRAME—French Regional & American Museums Exchange—could be born, and thus could provide the starting point and framework for this important exhibition.

I am pleased that the Musée des Beaux-Arts of Bordeaux took the initiative for this exhibition which inaugurates the complete restoration of la Galerie des Beaux-Arts, that has hosted many of the great cultural events of Bordeaux. My warm thanks go to all those who facilitated this adventure, in particular to the partner museums in FRAME, but also to all the museums or American and European collectors who accepted to be part with their prestigious works in order that this first step, that crystallized the very idea of exchange, would live up to the founders' ambitions. Soon, in fact, the museums of Portland, Cleveland, Dallas and Minneapolis in turn will exhibit masterpieces from Bordeaux's collections.

Beyond this new gesture of confidence and of friendship with the United States, the Mayor of Bordeaux is delighted with these particularly promising projects that show once again the international recognition for the cultural activity of our city.

Alain Juppé
Mayor of Bordeaux

Brittany is an artistic region that has attracted numerous foreign artists, who came there seeking a certain exoticism. Between 1864 and 1914, American painters couldn't resist the allure of its rough landscapes and its intense, contrasting light. A veritable artistic colony, mainly from Philadelphia, stayed regularly at Pouldu, Pont-Aven or Concarneau. They found there a certain authenticity of rural life, still intact on the eve of World War I. The Musée des Beaux-Arts of Rennes preserves the trace of one of these artists—Lowell Birge Harrison—and of his stay at Pouldu. His painting, *November*, was shown at the 1882 Salon, and in fact was the first work by an American to be acquired by the French State. In parallel, many Breton artists have found in the United States a receptive audience and a land of exile. Lemordant, the "Fauvist" Breton who went blind, toured the United States triumphantly after World War I. In 1938, Yves Tanguy, the Breton born in Paris, would carry the flame of Surrealism across the Atlantic and would settle there definitively. His oneiric landscapes, inhabited by biological forms, thus spread far and wide the familiar vision of the vast sandy strands characteristic of the Plestin area, on the Côtes d'Armor, where the artist spent part of his youth.

To these artistic friendships are added historical ties woven between the Bretons and the American troops during the two World Wars. From May to October 1918, the "Sammies" disembarked at Brest at the rate of 100,000 men per month, and then stayed at the camp at Pontanézen before leaving for the front. Almost 800,000 men thus came to know the great western port, to the great surprise of the local population, who were amazed by the remarkable organization of this army and by the modernity of its equipment. Slightly more recently, on 4 August 1944, American troops liberated Rennes, before continuing on through all of Brittany, aided by the local underground resistants.

Perpetuating and developing these bonds of friendship is one of the objectives of the City of Rennes. Since 1958, our city has been officially twinned with Rochester, New York. This partnership, at once cultural, educational, economic and athletic, resulted in 1961 in the creation of the Institut Franco-Américain, which, though its diverse activities, diffuses American culture and language. Numerous students have chosen to come to Rennes to complete their university studies. All these elements justified the creation in January 2000 of an American consulate in our city.

The mayor of Rennes can only be delighted to see his Musée des Beaux-Arts included in the vast program of French-American cultural cooperation initiated by FRAME (French Regional & American Museums Exchange), and to host, after Bordeaux, the first exhibition in France of a half century of American art. This exhibition fits perfectly into the tradition of exchanges with American museums already begun by the Musée des Beaux-Arts of Rennes in 1996 and 1997 with the loan of masterpieces from the National Gallery of Art in Washington (*La Ronde des Petites Bretonnes* by Gauguin) and from the Kimbell Art Museum of Fort Worth (*Les Tricheurs* by Caravaggio). *Les Tricheurs* was hung in the space formerly occupied by the famous *Nouveau-Né* by Georges de la Tour. This exhibition also presents an opportunity for continued and fruitful collaboration among the great regional museums, a collaboration that was already highly esteemed during the exhibitions *La Hyre* and *Grand Siècle*.

Edmond Hervé
Mayor of Rennes

The Musée Fabre of Montpellier is pleased to welcome this exhibition devoted to American art of the first half of the 20th century, at this crucial time when our institution will close temporarily, in order to reopen completely renovated in 2006. This emblematic exhibition fits in perfectly with the cultural objectives of the future Musée Fabre, that would like to be more open to modern and contemporary art, and that has been organizing temporary exhibitions in this field for several years. Already, in 1999, the museum's pavilion hosted the exhibition *Abstractions Américaines*, devoted this time to American painting of the second half of the 20th century, with major works by Rothko, De Kooning... More recently, a retrospective of the *"Section d'Or"* that retraced the epic of Cubism in France was held in Montpellier from 15 December 2000 to 18 March 2001, and presented works by Léger, Gleizes, Picasso, Braque, Delaunay, Gris... artists whose repercussions in the United States are well known. Beyond these recent exhibitions, the future Musée Fabre, which will eventually triple its area to 12,000 square meters, will be able to devote more than 1,000 square meters to contemporary art, thus familiarizing the public with the art of our time.

We are grateful for FRAME's collaboration that enabled this exhibition to be organized and to travel from Bordeaux to Rennes and to Montpellier, and that gave us the opportunity to establish numerous contacts with the great American museums: the Dallas Museum of Art, the Fine Arts Museums of San Francisco, the Minneapolis Institute of Arts, the Saint Louis Art Museum... This collaboration will be in evidence again in the summer of 2002, with the first presentation in France of the exhibition *Symboles Sacrés*, that will show exceptional works of Pre-Colombian and American Indian arts, before going to Rouen, Lyon and Rennes. In the future, the French institutions and the Musée Fabre will be able to collaborate on thematic exhibitions organized across the Atlantic, thus showing the masterpieces of French painting to a larger public. During 2003, a retrospective of 17th-century French painting will be shown in Portland and in Cleveland, in which our museum will have the honor of including five major works.

I am convinced that many other projects between our two countries will see the light of day, to even greater pleasure of French and American art-lovers.

Montpellier, city of culture, city of openness and of modernity, is delighted to welcome these artists emblematic of modern art in the United States.

Georges Frêche
Deputy-Mayor of Montpellier

Preface

This exhibition, which enjoyed the joint participation of three large French regional museums, marks a new step in the study and diffusion of American art in France, since it explores a subject that has rarely been treated with such a far-reaching approach.

In fact, interest in American painting is relatively recent. Although the 1950s did indeed constitute a decisive turning point in the recognition of American artists' work, it was primarily because with World War II over, the avant-gardes in New York—with Pollock—and on the West Coast—with Tobey—triumphed in Paris as well as internationally. As of 1951, Pollock presented his works at the Studio Paul Facchetti. In his wake, the avant-garde familiarized the Old Continent with painters of the interwar years. In 1955, the Musée National d'Art Moderne and the Museum of Modern Art organized an exhibition entitled *Salut à la France, 50 Ans d'Art Moderne*. It assembled 108 paintings, 22 sculptures, 82 prints and 100 photographs by Demuth, Prendergast and Russell to Rothko. Curiously, there was no enthusiasm on the part of the French curators to include paintings from the 1930s in their national collections, hence the current scarcity of works from that period.

At the end of the 1960s, the founding of the CNAC and then the preliminaries for the Centre Georges Pompidou were to encourage exchanges between French and American museums until Pontus Hulten took the initiative in 1977 of organizing the important exhibition *Paris-New York*, whose meticulously documented catalogue remains a constant reference for the French public. This remarkable panorama of American painting from 1903 to 1968, while accentuating reciprocal influences, enabled the public to discover a large number of artists other than Hopper and O'Keeffe, who were already known at that time. Almost 20 years later, in its turn, the museum-gallery of the SEITA presented the graphic work of socially committed artists from the 1930s in its exhibition *L'Amérique de la Dépression*, showing a vision of workers and of industry that was hitherto unknown in Europe. Again in 1999, a selection of American abstract works from 1940-60 at the Musée de Montpellier symbolized the emergence and subsequent recognition of the young American artists, who stole the idea of modern art from Europe, according to Serge Guilbaut. In 2000, Strasbourg hosted a large exhibition, co-produced with the Reina Sofia Museum of Madrid, that was devoted to the Surrealists in exile and to the beginnings of the New York School. To celebrate the new millennium in its own way, the Musée d'Art Américain in Giverny, previously devoted solely to Impressionism, like an echo of the Whitney Museum's large retrospective, *L'Art du Siècle*, exhibited around sixty works, primarily from the Foundation Terra's collection, on the theme of modernity. And finally in the Spring of 2001, the Musée Carnavalet showed the rediscovered paintings from the American section of the 1900 World Fair.

As for us, we chose to favor the artistic production of the first half of the 20th century, from 1908 to 1947. While American painting was still being influenced by European Impressionist works, the group of The Eight—Henri, Luks, Glackens, Sloan, Shinn, Lawson, Davies and Prendergast—decided to exhibit at the Macbeth gallery to protest against the New York National Academy of Design refusal to show their works. Breaking with the aesthetic of the artistic institutions and turning their back on high society portraits, they imposed an uncompromising vision of urban life, drawing their subject matter from

the street crowds. John Sloan's work, *Hairdresser's Window*, loaned by Hartford, is particularly eloquent. The members of the Ashcan School forced Americans to look at their country in a different way.

With World War II, while Europe was suffering the iron yoke of the Occupation, American painting underwent another rupture, that of the "passage to abstraction." On May 3, 1943, Adolph Gottlieb and Mark Rothko, assisted by Barnett Newman, published an open letter in the New York Times in which they defined the characteristics and the specific qualities of the new aesthetic in which the nature of the subject matter became crucial: "There are no good paintings about nothing." The new American abstraction, which marked at the same time the end of the traditional artistic representation and of the world conflict, spread throughout Europe, its newfound freedom accompanying the discovery of the "American way of life" with its highways, its supermarkets, its advertisements and its enormous cars.

This exhibition intends to demonstrate how, between these two fundamental breaks, the country progressively acquired an autonomous artistic identity that, until Pollock, drew its subjects from American life. This fundamental questioning of the components of what we conveniently call Americanism expands in a way on the prophecy Matisse made in 1933 upon his return from the United States, which has become the title of a recent book: "When you see America, you will understand that one day they will have painters."

Within this distinctly American perspective, the artistic panorama that begins with the Ashcan School enables the viewer to discover the major aesthetic currents that resulted from the confrontation with European art occasioned by the Armory Show in 1913.

From historical abstraction, which could include American Indian influences, up to the precisionist artists' exceptional fascination with buildings, with New York City or with the power of machinery, from the regionalist painters' quest for identities, and from the emergence of an Afro-American art to the translation of the vast spaces and of the atmospheres so specific to American cities, from the decisive influence of Picasso, of the Dada movement and the Surrealists, on the foreshadowings of pop art, or the personal syntheses of the avant-gardes, this exhibition presents multiple and recomposed visions of the American reality. Photography holds an important place here as much because of the fascinating dialogue that the photographic gaze establishes with the painted works as because of its ability to give us back a lost America that still inhabits our imaginations.

In attempting to convey this diversity of American art during almost a half century, this exhibition could only be ambitious. It gathers 64 paintings, 27 graphic works, 72 photographs and 11 sculptures, but our desire to present particularly important works of each artist occasionally ran up against temporary difficulties which became impossibilities. Several other exhibitions, such as the large Georgia O'Keeffe retrospective in the United States or the Picabia exhibition in France, mobilized a certain number of works that we had originally selected. Other absences are more easily explained, being due to the artist's limited production or to the extreme fragility of the works (Gerald Murphy or Charles Sheeler's photographs). We could also be reproached for not having included more works by an artist as essential as Charles Demuth. However, this ambitious and difficult venture could only succeed because, on each side of the Atlantic, complicity, confidence and competence converged at the same time.

First, complicity was established between our three institutions so that this exhibition could be shown successively in three cities. It was forged with our American colleagues of FRAME during the various trips and encounters that brought us together. We learned to know each other and to understand the differences in our working methods. The respective roles of the coordinators of FRAME in Dallas, Richard Brettell, assisted by Pierrette Lacour, as well as Rodolphe Rapetti and Sybille Heftler in Paris were determinant. It was Richard Brettell who came up with the idea for this exhibition and who proposed it during FRAME's first meeting in Lyon in October 1999. On Rodolphe Rapetti's suggestion, we decided to mount the exhibition in 2001 like adventurers, aware of the risks inherent in being the first to venture forth, but confidence was generously granted to us.

This confidence first came from the founders of FRAME, Elizabeth Rohatyn and Françoise Cachin, then from our elected officials and from our central administration, the Direction des Musées de France, in order to successfully carry out this international operation. We hope we have deserved it. Most importantly, it was also that of the lenders, from American and French public and private collections, who, relying on our professionalism, accepted to loan their masterpieces for such a long period. It is clear that, without the exceptional and prompt collaboration of the intermediaries in the American museum partners in FRAME, this exhibition could never have been mounted in such a short time. We would also like to gratefully acknowledge the contributions of the personal networks of everyone concerned in the great art institutions of New York or Washington.

And finally, to understand this American art of the interwar years, a particular expertise was necessary. In this regard, Éric de Chassey, Professor of Contemporary Art History at the University of Tours and specialist in American art, was our guide; his knowledge and enlightening advice constantly enhanced our purpose and guided our choices. His refreshing vision of American art seduced our partners in American museums as of his first mission for FRAME in September 2000. He met a certain number of our colleagues in record time and established a first selection of works. A few weeks later, during his meeting in Saint Louis, we were already able to propose clear objectives to our colleagues and partners. Over the course of our discussions, our reexaminations, and innumerable electronic messages exchanged, the outline of the exhibition was developed under his amiable and knowledgeable tutelage. Finally, he directed the catalogue, gathering contributions from the best specialists on the subject which make this book into an unprecedented reference work. To everyone, we express our gratitude and hope that our visitors derive as much pleasure in discovering this American art as we did in developing this exhibition for them.

Francis Ribemont,
Director of the Musée
des Beaux-Arts, Bordeaux

Valérie Lagier,
Curator at the Musée
des Beaux-Arts, Rennes

Michel Hilaire,
Director of the Musée Fabre,
Montpellier

Contents

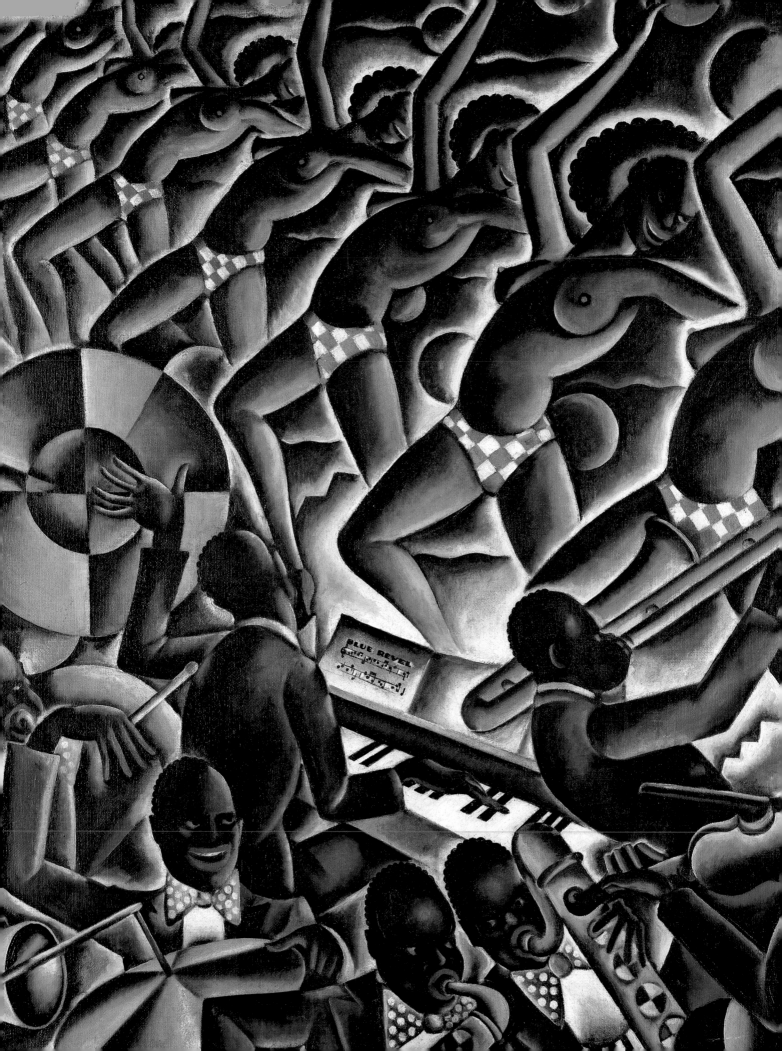

Why Has There Been No Great American Art

(Before the Triumph of Abstract Expressionism)?[1]

Dedicated to Dominique Fourcade and Jean-François Chevrier

Thirty years ago, Irving Sandler published his chronicle of Abstract Expressionism, unambiguously titled: *The Triumph of American Painting.*[2] The same year, Linda Nochlin wrote her article "Why Have There Been No Great Women Artists?"[3] The quasi-concurrence of the publication of these two works, both fundamental for art history and for the way in which American art was viewed in Europe, leads me to formulate a new question which combines both of them: "Why has there been no great American art (before the triumph of Abstract Expressionism)?"

In 1947, the critic Harold Rosenberg had already answered this question in his essay "A Parable of American Painting."[4] According to Rosenberg, the history of American art was marked by the same characteristics as the military and political history of the "young" nation. Just as the victory against the English soldiers had resulted from guerilla operations, the American painters capable of producing convincing works were also all members of a kind of "underground guerilla resistance," that was opposed to an art transposed from Europe. They withdrew into a deeply rooted subjectivity, from which, in the end, they were incapable of freeing themselves, (and, without Rosenberg having to state it outright, they were consequently incapable of convincing non-American art lovers). He concluded, "The Coonskinners [resistants] win, but their method can hardly be considered a contribution to military culture. It has a closer tie to primitive art, which also learns from its subject…." This is another way of saying that the question early 20th century American artists were confronting was that of their attitude vis-à-vis the rest of the world (with Europe and France occupying first place) and vis-à-vis their own native or adopted country. In fact, those artists whom we acknowledge today as having been great—or rather as being great, since the grandeur of an artist lies in his ability to win over our artistic gaze and our mind, here and now—are precisely those who lucidly asked that question. Sometimes the only way they could answer it was by maintaining a lively tension between their various alternatives, as definitively choosing one option as the answer would have meant vetoing the other possibilities, thus losing this vital tension.

The Triumph of the American Cultural Industry

The paradox undoubtedly lies in the fact that, at its birth, the 20th century was indeed characterized by the way in which the entire Western world (and even beyond) had chosen a norm of civilization that the majority of essayists would call "Americanism." The European history of this norm has already been outlined and would take too long to recount here.[5] Its impact on American artists of the interwar years was masterfully studied by Wanda Corn,[6] but I

Opposite:
Viktor Schreckengost
Blue Revel, 1931
Detail

Fig. 1
Piquette plant assembly room, Model N Chassis, 1906. Dearborn, Henry Ford Museum & Greenfield Village.

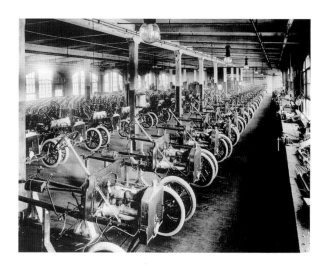

think it is necessary to take a fresh look at it in order to understand what was being played out over a longer period. As of 1934, Gramsci had significantly shown the importance of associating the *Americanist* model of society with the *Fordist* method of rationalizing economic production (fig. 1), without neglecting the resulting "sexual" repercussions ("the rationalization of production and of work cannot be developed until the sexual instinct has been suitably regulated and until it too has been rationalized."[7]). To Gramsci's way of thinking, the goal of this ideal was nothing less than the creation of a "new man,... with unprecedented speed,"[8] thus transforming Americanism into the culmination of the evolution of all of Western society. By extension, one can apply his statements to artistic questions. Where was the desire to create a "new man" greater than on the part of the protagonists of the modernist avant-gardes? Where was the awareness of the importance of sexuality more vividly alive than on the part of those for whom desirous gazes constituted one of the essential tools of their work as well as one of its foremost objectives? These questions definitely deserve more consideration, but for the moment we can be satisfied with merely pointing out that if American artists had such trouble accepting both parts of their engagement—nationalism and internationalism—despite the intellectual and social triumph of an Americanist model which should have allowed them to move from local to global in one fell swoop, it was because the Americanist ideal itself became more complex in its consequences and in its reasons when it was applied to the visual arts.

On the contrary, certain fields in which the artistic dimension only rarely came up against an industrial logic, rapidly saw the birth of internationally renowned American masters. This was also true of architecture, which was subjected first to the laws of production, of controlling construction costs and of managing space, before being expected to address the necessity of creating meaningful or symbolic forms. The architects whose works or ideas had the most far-reaching influence in Europe were, in fact, those who had avoided outside contact and had stayed in areas of the United States identified with the pioneer sub-culture: Louis Henry Sullivan in Buffalo, Saint Louis (fig. 2), or Chicago as of the 1880s, Frank Lloyd Wright in Illinois, Wisconsin, or California principally after 1910... The famous International Style, a concept created by Philip Johnson on the occasion of a New York exhibition in 1932, relied on the synthesis of economic imperatives coupled with political reasons, which would lead its principal European protagonists (with the notable exception of Le Corbusier) to create some of their masterworks in the United States.

The same was true of the American film industry, which had been dominated by commercial logic from its very beginnings up to terms of who was legally considered the creator of the work. In order to create an art which would truly be popular, i.e. of mass appeal, it was necessary to find narrative and cinematic strategies which would transcend the cultural differences between freshly arrived or long-established immigrants. And the films of Charlie Chaplin, Buster Keaton, David Griffith or Walt Disney anchored the disparate groups both within a film lan-

Fig. 2
Louis Henry Sullivan,
Wainwright Building in
Saint-Louis, 1890-91.

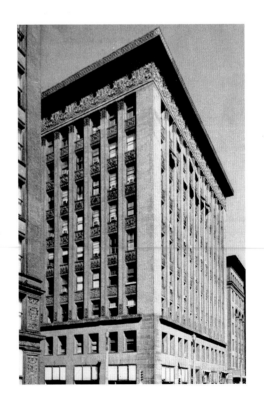

guage that was understandable beyond the barriers of spoken language, class or nationality, and within an expression of the desire to build a new country, with its diverse characteristics. The same again was true of popular music, subjected to the logic of marketing segments and of radio broadcasting, which in several years would develop genres that were fundamentally innovative at the same time as being rooted in specific local traditions. For blues and jazz, the past of slavery and the present of segregation rapidly gave birth to artists who were embraced by an international audience, despite often being neglected locally outside of the African-American population (Scott Joplin, Robert Johnson, Louis Armstrong, Duke Ellington, Charlie Parker). Memories of the Civil War and the contemporary feeling of having been abandoned by federal policies laid the groundwork for the development of country music during the

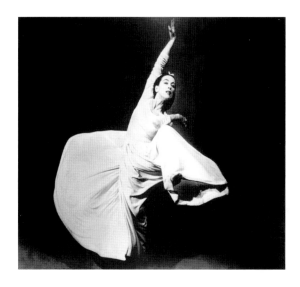

Fig 3
Martha Graham in the ballet *Letter to the World* inspired by Emily Dickinson's work, 1940.

1930s (paradoxically based on a commercial logic envisioned by Ford and his teams of Jewish songwriters from New York).

The same was also true of dance, which, after centuries of artistic inertia in Europe, was ripe for invention and where choreographers would seek very early on—as of the first creations of Isadora Duncan or of Ruth Saint Denis and up until George Balanchine or Martha Graham (fig. 3)—to embody the great Western cultural myths in traits that were distinctive to the American continent (Amerindian dances, the attitudes of bodies fashioned by constant physical exertion, by sports and by sexual liberation).

As for literature, it is not surprising that the first American writers to attain international recognition and a certain influence, other than those who had chosen to profoundly Europeanize themselves such as Henry James, Edith Wharton or T. S. Eliot (in the same way that James Whistler or John Singer Sargent would exemplify in painting at the turn of the century), were the poets, gifted at transforming a language that was shared with other countries in order to individualize it— Walt Whitman, e. e. cummings, Ezra Pound and, especially, Gertrude Stein. As of the 1920s, they were followed by novelists who would invent a way of combining passages of subjective interiority with collective objectivity—John Dos Passos,[9] Ernest Hemingway, John Steinbeck, Henry Miller or William Faulkner.

American Subjects, European Manners

It would take too long to explain precisely why neither American painting nor American sculpture was able to acquire much legitimacy before the mid-1940s. It would be better, I think, to dwell on the way in which the first four decades of the 20th century encouraged or hindered the emergence of individual figures who should not be ignored by today's "globalized" culture. How else can we understand that Bill Gates could spend thirty million dollars for a painting by Winslow Homer,[10] a painter almost unknown outside of the United States? Short of simply seeing it as the nationalistic fantasy of an immensely rich man, one could also consider that it may very well

concern the recognition of a certain quality, which should insert this artist into the global history of art, after he has been integrated into the history of auction market records. If Homer is so important, it is undoubtedly because, towards the middle of the 19th century, he was, along with Thomas Eakins and less so with Albert P. Ryder, the first American artist to have tried to develop a painting style which did not take its subjects and its style from the European academic tradition but rather found them in his surrounding reality. Unlike artists such as George Caleb Bingham or John Kensett who had rhetorically exaggerated these heroic traits several decades earlier, Homer presented his subjects without distorting their actual dimensions (from grandiose landscapes to domestic nature), in the same way as he aroused the spectator's emotions by confronting them with individuals who were still pioneers in the conquest of a new country. At the beginning of the 20th century, Homer, who had been able to integrate the conceptual and formal advances of the European Naturalism into his own artistic preoccupations and into his style, thus appeared as the savior of an American style of painting which would have nothing to blush about next to that of the Europeans.

However, Homer was a man of the 19th century. The new century only really began with the first exhibition of the group of The Eight, in New York in 1908. If Robert Henri, George Bellows or John Sloan remained minor artists in European eyes (because they used a stylistic approach dating from the previous century) their principal merit was to view the conditions of urban life as they truly were, particularly in the big cities on the East Coast, which differed from cities elsewhere because of the mixity of their populations and lifestyles. By attracting attention to the new traits defining the United States, without yet succeeding in finding a language able to describe them because of what must be considered as the real provincialism of American culture at that time,[11] they in fact blazed the trail for an art that was specifically American at the same time as being truly contemporary, (in the sense that in order to attain a global pertinence, it wasn't enough to be merely *modern*—which too often implied a simple imitation of a borrowed style— but rather one needed to be *contemporary,* contemporary with the upheavals of the time). Their principal role was thus that of initiators, which is borne out by the considerable number of Henri's students (notably Stuart Davis and Edward Hopper) who later became major artists. However, if one had to designate one true catalyst in opening up American art to contemporary modernity, it would certainly be Alfred Stieglitz, whose activity preceded the Armory Show (an exhibition which, in New York, Boston, and then Chicago, introduced European modernist painting to an audience of some 300,000 visitors). By placing—also as of 1908—at the disposal of American and European modernist artists the gallery of the Photo-Secession, called "291", that he had founded in 1905 in order to show new photography, Stieglitz in fact encouraged a mixture of attitudes which would produce telling effects in the works of some members of his circle. Even though for these artists, the primary question often still remained that of an anguished confrontation with Europe, as can be seen in their correspondence with their mentor,[12] a few figures who were protected by relative isolation finally came to accept the tensions which arose from this confrontation with Europe and to use them to their artistic advantage.

It was paradoxically the case of Marsden Hartley after his stays in Germany between 1913 and 1915 enabled him to get a little distance on the question; afterwards, he was convinced that "the idea of modernity is but a new attachment to things universal,"[13] and he went on to invent ab-

stract signs to translate his personal preoccupations (the relationship to one's native land, the expression of his love for a Prussian lieutenant) and to give them a shape that profoundly renewed the Cubist or Kandinskyan compositions by substituting to them a two-dimensional piling-up of forms. At the price of claiming a thorough rejection of modernism, he spent the rest of his life trying to find such an alliance again. It was only at the end of his life, in Maine, with his series of "archaic" portraits (1938-39) that his painting finally became the apparently distanced and universalizing topology of the marginal figures to whom he was bound through his own sexuality. In the same way, Arthur Dove, by withdrawing in 1910 to the New England countryside and then to the outskirts of Manhattan, without ever totally breaking contact with the modernist scene, nonetheless recurrently discovered generalizable phenomena to explore, those of cosmology, of transposed popular music or of experiments with various materials (with his assemblages of the 1920s), without ever forgetting to anchor them in a vernacular and personal vocabulary.

The risk of the attitudes favored by Stieglitz was obviously that of falling back onto false qualities, onto what was not Americanism-become-universal, but was rather a pseudo-eternal-America. This risk is indeed confirmed by the names that Stieglitz gave to the galleries he opened in the 1920s—they referred to an America reflecting the impossible return to the land ("An American Place") or to the individual withdrawn into his problems and his "eternal" potentialities ("The Intimate Gallery"), within Thoreau's vein of transcendentalism or within the ideology developed by the artists established around Taos, New Mexico. Only two positions could answer these risks. The first position emphasized the tension inherent in the contradictory attitude maintained by traditional American society towards sexuality, less within the passive affirmation of a pantheistic sexual identity in the manner of Georgia O'Keeffe than in a complex negotiation of a sexual/worldly duality that one finds in the most fully-realized sculptures of Gaston Lachaise. The second position confirmed the supremacy of the individual without separating him/her either from the society that he/she had created and that had in turn created him/her, or from a formal radicality, as one can see in some of Stieglitz's photographic series dating from the years 1920-30 and especially in Paul Strand's work after 1915-16. In fact, Strand's photogravures published in the last two issues of *Camera Work* accommodate both a formal abstraction, with the urban landscape emphasizing the transformations of the American city, and a quasi-topological attention paid to individuals.[14]

The Mechanistic Paradigm

Strand's invention of straight photography ("objectivity is of the very essence of photography"[15]) fits into a process that was both more general and relatively brief—the discovery and the acceptance that Americanism was the machine, an idea that progressively spread from New York between 1915 and 1930. Meanwhile, in order for American artists to become convinced of this, they had to wait for the arrival of the artists who were invested with the authority of their status as well-known members of the French avant-garde: Francis Picabia (with his 1913 abstract water-colors and his mechanistic-portraits for the review *291* in 1915) and especially Marcel Duchamp. Duchamp's founding of the Society of Independents in 1916, then of the Société

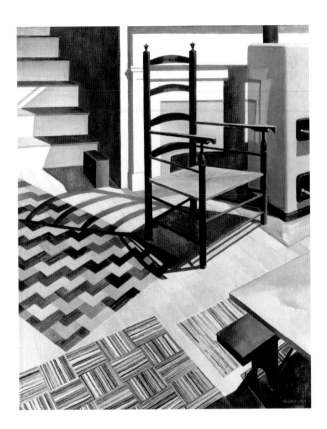

Fig. 4
Charles Sheeler,
Home Sweet Home,
1931. Oil on canvas,
7'7" x 6'1"
(232.2 x 187.2 cm).
The Detroit Institute
of Arts. Gift of Robert
H. Tannahill.

Anonyme (whose name is so suggestive), extended the intellectual and visual impact of his ready-mades that were exhibited in New York in 1916 by structuring the American avant-garde on Tayloristic principles, which would be applied by Morton Schamberg and Elsa von Freytag-Loringhoven in creating their work entitled *God*—an assemblage of a cast-iron plumbing trap and pipes in a wooden miter box—as well as by Man Ray. However, the return or the exile to Paris of the majority of these artists around 1922-23 showed that such a strict interpretation of the mechanistic paradigm was not viable in a country where it ended up in art simply replicating the politico-economic system, and replacing the tension vital to art with a simple positivism (including within the domain of sexual liberation). In the end, those who knew best how to benefit from this paradigm were those who retained that kind of Americanism without forgetting the other kind—Charles Sheeler and Charles Demuth knew both how to approach the machine by making it accessible, and how to present objects and buildings that glorified the national past by mechanizing them. In his painting *Home Sweet Home* (fig. 4)—the title is less ironic that it may seem[16]—Sheeler synthesized these two approaches. He showed the continuity of the American environment by placing next to each other old Shaker furniture, a modern wood stove and a modern, geometric box, and carpets with repetitive motifs which cut out and rendered more complex the surface plane and emphasized its abstract potential.

However, the economic crisis that began in 1929 engendered an extensive re-evaluation of this American model. In fact, the very triumph of Americanism over the world economy became the major reason for a wave of unexpected poverty which spread over the entire planet. The artistic result of the economic and social crisis of the Depression would be the development of a crisis of identities.

Some artists experienced the Depression as a catastrophe, leading to their withdrawal into the comfort of local preoccupations; the supporters of the American Scene, grouped behind Thomas Hart Benton, prided themselves in living in the Midwest rather than in the too-Europeanized New York. Rejecting everything that could grow out of modernism and globalism, they promoted the idea of a thoroughly American art through their choices of subjects (transposing the urban themes of the Ashcan School to the countryside, often with an added dose of lyricism); however, they adapted their formal principles from those of the Italian Renaissance. Under these conditions, their paintings and graphic works could occasionally be brilliant, but this was in spite of their choices and because of their very incongruities, except when they arose from a discreet irony (such as in Grant Wood's work). In the same way, some photographers transformed themselves into plain propagandists; they continued to glorify the triumphs of American industry and

the valiant-but-constructive work of the farmers and of the "little people," as Margaret Bourke-White did in her famous coverage of the dams of Montana and the new cities, which opened the first issue of the hugely popular magazine *Life* in November 1936.

A Redefined Americanism

But the 1929 Depression was also experienced by certain artists as a catalyst which forced them to redefine American qualities in another way, by reinventing an Americanism that would not only embrace Fordism but that would also integrate political and cultural values, at the same time redefining democracy and excellence, individualism and the construction of a new world order, in a way which Franklin D. Roosevelt would explicitly formulate in his inauguration speech after his reelection in 1941: "Democracy is not dying. We know it because we have seen it revive—and grow. ... We know it because democracy alone has constructed [in this country] an unlimited civilization capable of infinite progress in the improvement of human life."[17]

Of course, the Depression also reconfirmed the attitude of those who had largely been left out of the economy's previous course towards prosperity, among whom first of all came the African-Americans. This is why William H. Johnson or Jacob Lawrence could develop works which treated recent historical events or everyday life in Harlem, and why they could invent forms which created a new mythology of black liberation, by combining an international modernist vocabulary with primitivist references to a folkloric culture.

By compelling him to examine more deeply his reasons for painting, the Depression also gave a new impetus to Stuart Davis's work on abstraction, which had been interrupted by a kind of ornamental picturesque style, after the magnificent 1927 series of *Eggbeaters*. In 1936, he explained: "If the artistic process is forcing the artist to relinquish his individualistic isolation and come into the arena of life problems, it may be the abstract artist who is best equipped to give vital artistic expression to such problems—because he has already learned to abandon the ivory tower in his objective approach to his materials."[18] The first movements towards a consistent abstraction among American artists had occurred around 1910-13, and had been made by more or less isolated individuals (such as Manierre Dawson in Chicago, Stanton Macdonald-Wright and Morgan Russell in Paris) whose attempts proved in the end to be sporadic. But the abandonment of the pretension to a universal language,[19] a pretension whose inanity had been demonstrated notably through the globalization of the Depression, enabled a few abstract artists, those who congregated around Burgoyne Diller, to find original solutions to the contradiction between a concentration on formal problems and a commitment to the life of the city. At the end of the 1930s, this would crystallize in certain mural projects of the New York section of the WPA (Works Progress Administration).[20]

Undoubtedly, the Depression also helped Hopper to confront his feelings of desolation which arose from his concentration on typical everyday landscapes. His ability to picture that which only the great masters of *film noir* would know how to suggest visually, by addressing the feelings shared by the majority of the population, never encroached on the quasi-elitist artistic distance of his paintings. It was this same combination of distance and of accessibility, pushed to its limit, that characterized Dorothea Lange's photographic works (especially her series on Asian

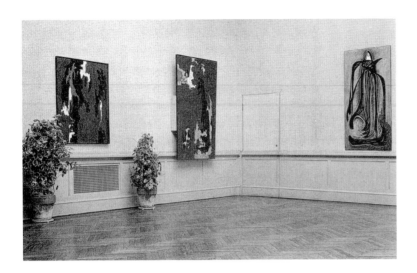

Fig. 5
Exhibition installation,
Clifford Still, 1947.
California Palace
of the Legion of Honor,
San Francisco.

Americans in California from the early 1940s) as well as those of Walker Evans. Evans's work made a significant leap in 1930-31 with his photographic study of the outmoded architecture of New England (a mechanical artistic way of showing the idiosyncratic adaptations of a pseudo-eternal architectural vocabulary). In 1938, Lincoln Kirstein analyzed this position as making use of a tension, and putting it into play. "To implement his own vision, France offered its wonderful analytical method, the classic scalpel of Stendhal and Flaubert, the skimmed eye of Degas and Seurat: so equipped he could turn home to focus on contemporary America the mechanical device of Nicéphore Niepce and Daguerre."[21]

In the series he photographed in the New York subway between 1938 and 1941,[22] Evans pushed the logic of this tension to its limit, connecting anonymity with personalization, specific local traits (corroborated by the writings on the car windows) with universal typology, thus bypassing the question of the choice between nationalism and internationalism.[23] In so doing, he was indeed, with his own means (those of photography), in synch with the artists who were integrating at the same time the dual legacy of Surrealism and of abstraction.

While the offshoots of figurative Surrealism (the Social Surrealists in New York, the Post-Surrealists in Los Angeles) had produced only a handful of non-derivative works, and while the orthodox utilization of primitivism and of visual automatism had begun to allow for paintings and sculptures as convincing as those of Steve Wheeler, Gordon Onslow Ford or David Smith, it would come down to Jackson Pollock and Clyfford Still (fig. 5), to Willem de Kooning and to Barnett Newman, between 1943 and 1947, to fully accept the two terms of the constituent tension of American art, thus becoming not only in their turn great artists, but also the inventors of a great American art, a new tradition that could expand over decades. The paradox here is significant, and Newman would sum it up by observing that, in a war situation, it was necessary to "start from scratch, to paint as if painting never existed before," at the same time as he observed that "in the sense that these pictures try to say something... it was equally inevitable that the abstract form should have Surrealist overtones."[24] This was a way of emphasizing both the extreme individuality of the artistic work, incessantly reexamined and created anew, and the necessity of integrating it into the most contentious currents of the time.

From then on, art *Made in USA,* as a whole, could impose itself outside of its original bases; each artist could find his own place within it and be, at the same time, individual and universal, nationalistic and internationalistic, local and global, intimate and distant, sexual and puritan, subjective and anonymous.

Éric de Chassey

Notes

1. The distinction between "great art" and "great artists" is capital here; the absence of the former does not necessarily imply the absence of the latter, but it certainly does cloud their visibility.

2. Irving Sandler, *The Triumph of American Painting*, New York, Harper & Row, 1970.

3. Linda Nochlin, "Why Have There Been No Great Women Artists?" *Art News*, January 1971.

4. Harold Rosenberg, "A Parable of American Painting" in *The Tradition of the New*, New York, Horizon Press Inc., 1959, p. 18.

5. *Américanisme et Modernité, L'Idéal Américain et l'Achitecture* (Paris, EHESS/Flammarion, 1993), a collection of texts devoted to architecture under the direction of Jean-Louis Cohen and Hubert Damisch, here plays the role-model, of which the extension to other arts was quite limited.

6. Wanda Corn, *The Great American Thing: Modern Art and National Identity 1915-1935*, Berkeley, University of California Press, 1999.

7. Antonio Gramsci, "Americanismo e Fordismo," in *Selections from the Prison Notebooks of Antonio Gramsci*, ed. and trans. by Quentin Moore and Geoffrey Nowell Smith, London, Laurence and Wishart, 1971, p. 297.

8. *Ibid.*, p. 199.

9. Significantly, in his USA trilogy published between 1930 and 1936, Dos Passos divides the narrative into the three distinct categories: "newsreels", biographical "documentaries" and the subjective "camera eye."

10. Concerning this episode, see the letter and photographs that the artist Allan Sekula "addressed" to Bill Gates, under the title *Titanic's Wake*, (exhibition at the CCC in Tours, 2000).

11. In 1910, Max Weber compared, somewhat facetiously, "Le Boul'Mich' and Fifth Avenue. What a contrast! Idealism and materialism—light and dark—culture and ignorance—hope and despair—joy and sorrow—life and death." (Max Weber in Temple Scott, "Fifth Avenue and the Boulevard Saint-Michel," *Forum*, December 1910, cited in Abraham D. Davidson, *Early Modernist Painting: 1910-1935*, New York, Da Capo Press, 1994 [1981], p. 18).

12. See William I. Homer, *Stieglitz and the American Avant-Garde*, Boston, New York Graphic Society, 1977.

13 Marsden Hartley, cited in Gail Scott, *Marsden Hartley*, New York, Abbeville, 1988, p. 49.

14. To this triptych, Strand added the machine in the following years, then a political engagement in his films of the 1930s.

15. Paul Strand, "Photography", Seven Arts, August 1917, p. 524, reprinted in *Photographers on Photography*, Nathan Lyons ed., Englewood Cliffs, Prentice Hall, 1966, p. 136.

16. For a slightly ironic interpretation, see Susan Fillin-Yeh, *Charles Sheeler: American Interiors,* New Haven, Yale University Art Gallery, 1987.

17. Franklin Delano Roosevelt, "Third Inaugural Address, January 20, 1941," website http://odur.let.rug.nl./-usa/P/fr32/speeches/fdr3.html

18. Stuart Davis, "A Medium of 2 Dimensions," *Art Front*, May 1937, p. 7, reprinted in *Stuart Davis*, ed. Diane Kelder, New York, Praeger Publishers, 1971, p. 116.

19. Except in the case of the Transcendental Painting Group led after 1938 by Raymond Jonson.

20. Concerning the development of concepts of abstraction in the United States before the end of the 1950s, I should like to refer to my book *La Peinture Efficace*, Paris, Gallimard, 2001.

21. Lincoln Kirstein, "Photographs of America: Walker Evans," in exhibition cat. *Walker Evans, American Photographs*, New York, MoMA, pp. 193-4.

22. One of the most significant factors influencing the slant of this essay and of the entire exhibition was being able to study attentively a group of photographs from this series in a Parisian collection, which was opened to me with great generosity. This viewing experience was decisive not only because it led me to evaluate Evans's importance in a new way, but also because it drew my attention to certain characteristics he shared with painters and sculptors whom I was more accustomed to admire.

23. "By seeking to push to the extreme, to the absurd, the (blind) confidence in the powers of the machine shown by the first wave of modernism, Evans revealed the dark side of modernism as being the age of the machine." (Jean-François Chevrier, "Double Lecture," in exhibition cat. *Walker Evans & Dan Graham*, Marseille, Musées de Marseille, 1992-93, p. 30).

24. Barnett Newman, in "Jackson Pollock: An Artists' Symposium Part 1," April 1967, and "The Plasmic Image," around 1945, reprinted in *Selected Writings and Interviews*, ed. John O'Neill, New York, Knopf, 1990, pp. 191-2 and p. 155.

The Revival of Naturalism

At the beginning of the 20th century, American art was marked by the intensification of a realist tradition, which through its confrontations with Impressionism and Naturalism, forged the way for a profoundly new outlook, that would cause shocking conflicts and scandals. Since the 1890s, Winslow Homer (who died in 1910) appeared to be the grand master of the national artistic scene, alongside Eakins and Ryder. Homer was the first to use European artistic contributions to create an original vision of the American landscape that exalted both the vast spaces typical of the continent and the individuals there who were still playing the roles of pioneers. This exploration of the landscape would be followed by the adoption of Impressionist techniques and style within local variants that were slightly behind-the-times and rarely convincing. It would only attain its maturity and its autonomy with the Post-Impressionists, particularly with Maurice Prendergast, who assimilated the lessons of Fauvism into his work. Finally though, this trend in painting would prove to be a veritable cul-de-sac, leaving no artistic descendants, except perhaps the pictorialist photographers—such as Clarence White, George Seeley and Alfred Stieglitz—who joined together in 1902 under the banner of Photo-Secession. By adapting photography to the demands of fashion magazines, Edward Steichen and Baron De Meyer would keep this kind of oneiric photography alive up until the 1920s.

As for the individuals who made up the subject-matter, they were more frequently presented as ordinary residents of East-coast cities than as romantic cowboys, and would be the principal subjects of the defenders of the Ashcan School. Coming from the world of press illustration, Robert Henri, William Glackens, and John Sloan, soon to be joined by George Bellows, who prolonged this vision well into the 1920s, caused scandals at their group exhibitions in New York in and after 1908, which grouped them under the name of The Eight. In an atmosphere that was puritanical and incapable of addressing any art outside of the academic models imported from Europe, these artists shocked the status quo by taking their subjects from the everyday life of big American cities and by using unusual colors, as much as by clamoring for independence. If their concerns were shared by the socially-engaged photographers who extolled using their art for political ends—such as Jacob Riis (with his books of photographs about living conditions in the slums of the new cities), and especially Lewis Hine (in his series about child labor)—these latter overtook them rapidly in intensity and in efficiency, pointing out possible directions for the next generations to follow.

Rare were the artists who were attracted to the mythological past of the United States, with the notable exception of the photographer Edward Curtis, who, in his twenty volumes, *The North American Indian*, tried to give an account of surviving American Indian traditions, albeit a slightly embellished one. In painting, Maxfield Parrish was practically alone in upholding the ideal of lyrical symbolism. However, he was working in an environment where mass appeal reigned, and his works acquired a paradoxical illustrative dimension that would be paralleled only in the cinematographic epics of the 1910s and 1920s.

E.C.

Opposite:
Maurice Brazil
Prendergast
Holidays, 1920
Detail

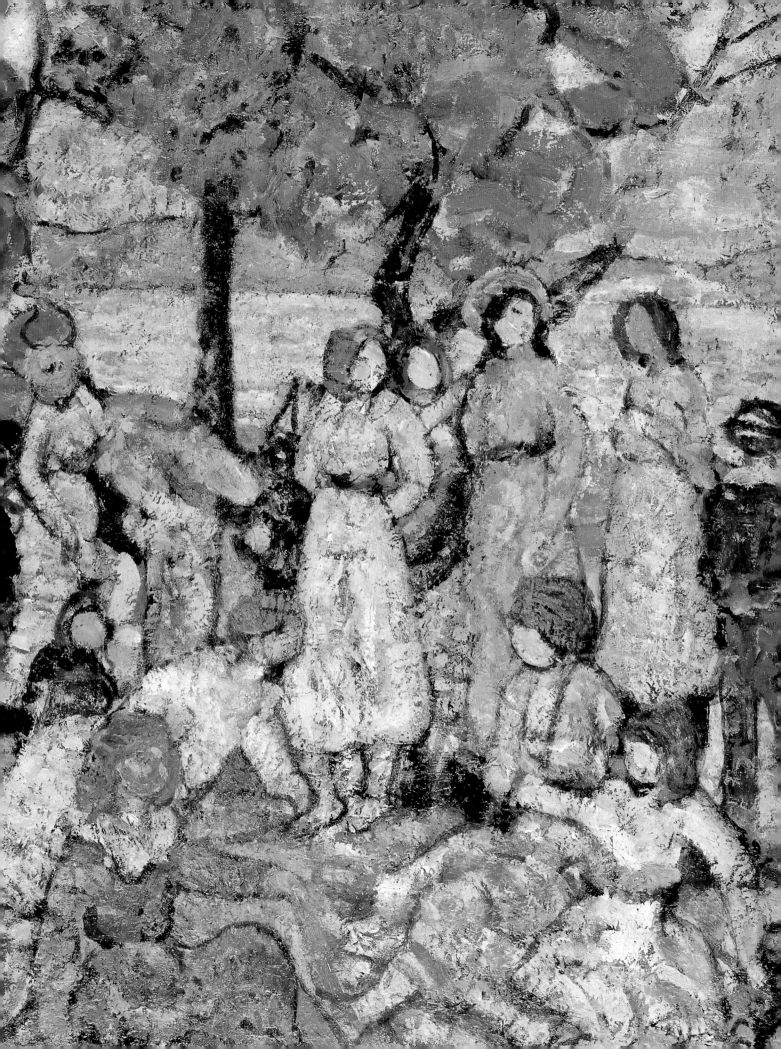

The Great Traditions of Early Modern American Art

At the opening of the 20th century, the United States was very far from becoming the world leader that we know. Indeed, if we list the major innovations in math and physics, we discover that the most remarkable discoveries generally occurred in Northern and Eastern Europe. If we list the major artistic developments, we discover that nearly all of them occurred in France (except the development of purely abstract painting).[1] It is only when we list the major practical innovations of the 20th century that we find the United States playing a major role. Many of them were developed in the United States, including the light bulb, the power plant, the telephone, the record player, the telegraph... The most remarkable inventor of this period, Thomas Edison, who produced over 3,000 inventions and registered over 1,000 patents, was an American. Indeed, even when Americans did not invent a new technology, they showed a remarkable talent for bringing it to practical fruition. (It was George Eastman who made photography a mass culture phenomenon and not its European inventors.)

What all this suggests is that *modern art* and *modern science* developed most vigorously in Europe, but that what might be termed *modern life* developed most rapidly in the United States. As a conse-quence, American art often has a curiously schizophrenic quality, in which modern impulses are often expressed in an outmoded, archaic language—or again, new artistic languages are borrowed from Europe, without establishing a firm connection with the deepest impulses of American life. In part the story of early 20th century American art is that of French painting done badly. This process becomes interesting, however, when we recognize that such mutilation and misunderstanding was part of a larger process of reconfiguring elements to forge a new language of expression.

To the French, American painting tends to look odd—but not because its forms themselves are unfamiliar. What is odd is that in America, French styles carried displaced, even inverted meanings from those that they carried on their home turf. In French painting, for example, Impressionism was the first style that radically broke with past attitudes towards visual appearance, and it was associated with modernism and innovation. In the United States, however, Impressionism had a different connotation. By the time that Impressionism arrived in the United States, in the work of figures such as Childe Hassam and William Merritt Chase, it was no longer a controversial style but had become an accepted touchstone of French culture. Americans saw it not as something radical, but as something that indicated European sophistication. Indeed, the Americans tended to employ an Impressionist approach to portray subject matter that was both genteel and nostalgic: beautiful women in comfortable interiors, colonial houses and churches, and the fashionable street life of the modern city. The tough side of modern life, such as factories, tenement houses, or poor people, only rarely intruded on this idyllic picture. Most of the American Impressionists, in fact, not only favored conservative subject matter, but drew and composed their paintings in a fashion that was essentially academic. Thus, in America, Impressionist styles often carried a mixed message, and were often associated with falseness.

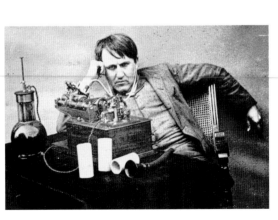

Fig. 1
Thomas Edison,
16 June 1888.
Courtesy Edison National
Historic Site.

Radicalism in America took a different form. The first artistic *succès de scandale* in the United States occurred in 1908, at the Macbeth Gallery in New York, when Robert Henri and seven followers, known as The Eight exhibited paintings that directly confronted the ugliness of modern factories and city life. Quite consciously, they avoided the bright colors of the Impressionists, and worked with a dark palette, which suited the soberness and seriousness of their subject matter. While Henri's group managed to hold the limelight for only a very short period, they introduced a theme that plays a major role in American art through most of the 20th century—the notion that a bright, Impressionist palette indicates a viewpoint that is decorative, and essentially superficial, and that radical, serious innovation is best expressed with black (a color that in Europe often connoted being old-fashioned). The importance of black as a signifier of radicalism and seriousness is an undercurrent that runs through American art for decade after decade, and played a major role in important paintings by figures such as Arthur Dove, Georgia O'Keeffe, Jackson Pollock, Willem De Kooning, Ad Reinhardt, and Frank Stella. As this example suggests, formal devices often had a different significance in America than they did in a European context. Indeed, like any form of art, American painting developed as a reaction to a particular historical and social context. In making sense of early modern American painting, it is useful to draw upon two different schemes. On the one hand, we can view it as an unfolding series of movements or phases, of modernist actions and conservative reactions that ultimately forged a new artistic language. This is the scheme that is found in most surveys of American art. In a general way it reflects a genuine pattern of stimulus and response, which traces the supposed tendency of the leading American artists to move towards increasingly abstract forms of painting. Such a view is obviously reductive in many ways, since it does not bring out the distinctions between one and another modernist

point of view, but alleges that all forms of modernism were narrowly focussed towards a single goal. Indeed, among other limitations, this view tends to present American modernism as something precisely analogous to modernism in Europe.

On the other hand, we can seek to isolate the major innovative impulses, what might be termed the "great traditions" of American modernism, which can be traced continuously through modern American art, decade by decade. While this alternative scheme has not been much used, it is perhaps even more useful for indicating the uniquely American character of many American developments. Focusing on two main examples of such traditions—the social realism of Robert Henri and the spiritual purification of form through design of Arthur Dow—will enable us to come to an understanding of what was innovative and original during the first half century of modern American painting.

Robert Henri

The first of these traditions, that of Robert Henri, promoted a direct connection between art and modern life. Both the strengths and the weaknesses of this tradition were profoundly influenced by the personality and character of its leading spokesman. Born to the name of Robert Henry Cozad, Henri adopted his middle name as his surname, changing its spelling to reflect his French ancestry. While he spent the rest of his life in the East, and never lacked social polish, Henri's underlying character retained the spirit of the Western frontier, and indeed, his approach to art brings to mind Gary Cooper confronting his adversaries on Main Street in *High Noon*. For Henri approached painting as if it were a Western gunfight, fought by the dictates of some simple but intensely personal code of honor. Boldness, quickness, honesty, and a sort of masculine directness are the best features of his work. In formal terms, however, Henri was not a highly original artist, and indeed, viewed simply as a painter,

his achievement is somewhat disappointing. His subject matter—particularly the grinning children—is too repetitive. He falls back too often on the same artistic formulas. But it is as a teacher and proselytizer that Henri had his greatest impact—as an advocate of the individual freedom of the artist against the constraints of academic or traditional thinking, and as a spokesman for the belief that the artist should directly confront and engage the social realities of his time, including such things as poverty and ugliness.

Fig. 2
Robert Henri, 1906.
Private collection.

After his studies, Henri settled in Philadelphia, where he rapidly became the center of a group of radical young upstarts. His principle message was that art should connect with real life, even if that meant tackling subjects that were traditionally considered ugly and ungenteel. Significantly, this message suited the background of his audience. For the young artists who gathered to hear him preach—John Sloan, William Glackens, Everitt Shinn, and George Luks—were all newspaper illustrators, who worked for the Philadelphia Press, recording such events as fires and streetcar accidents. By about 1905, both Henri and the newspaper group had all settled in New York, where they had begun to turn their talents towards boldly painted scenes of urban life. In 1908, when Henri saw the work of every one of his students rejected from the annual exhibition of the National Academy of Design, he arranged to hold a show of his group at the Macbeth Gallery, which was effectively to create the phenomenon known as The Eight or Ashcan School.

The work of the painters he gathered around him was not stylistically consistent, since Henri's thinking about art tended to go in two directions. On the one hand, he believed that art should connect with real life—which in practical terms meant connecting with urban life, including its squalor and unsavory aspects. Consequently, about half the group, and the painters closest to Henri himself, were urban realists—Sloan, Glackens, Shinn and Luks. Henri also believed that art was about free expression, and that artistic styles should be varied. To make this point he enlisted a group of modernists and eccentrics into his group, including Arthur Davies, Ernest Lawson, and Maurice Prendergast.

In the long run, even more important than their program was the fact that The Eight was the first group of American painters to show that one could become successful by creating a scandal. One half of the press vigorously denounced Henri's group as degenerates, apostles of ugliness, and destroyers of culture and art. The other half rushed equally as vigorously to the group's defense. Crowds rushed to the show to investigate what was going on, and while some were truly horrified, others were thrilled by the excitement of the affair. Despite all its bad press, the show was a major financial success, since those who supported the work were proud to purchase paintings.

By modern standards, much of the work of Henri and his followers seems relatively conventional. Stylistically it was hardly more daring than the work

of the American Impressionists. Nonetheless, Henri had hit on a theme which would remain a main issue through much of 20th century American art: the notion that artists should address the tough and the ugly sides of modern life, rather than retreating into a world of sentiment and nostalgia. Significantly, Henri was the teacher not only of the original members of The Eight (that is, Sloan, Glackens, Shinn, and Luks) but taught a younger generation as well, including such figures as George Bellows, Rockwell Kent, Edward Hopper, and Stuart Davis. Through these figures his influence would linger in American painting well into the 1960s.

Perhaps the strongest of Henri's students were Edward Hopper and Stuart Davis, both of whom gained reputations only late in life, and kept Henri's gritty legacy alive and vital well into the 1960s. Stuart Davis, perhaps the most sophisticated American abstractionist of his generation, paid tribute to Henri as his "main and best influence;" while Edward Hopper, the most impressive American realist of the same period, declared of Henri that, "No single figure in recent American art has been so instrumental in setting free the hidden forces that can make the art of this country a living expression of its character and people." Curiously, they both disliked each others work. Davis on Hopper: "I don't know why anyone would want to make dull pictures out of dull subjects." Hopper on Davis: "Am I interested in Davis's work? No."

Edward Hopper responded the most directly to the work of the Ashcan School, to the extent that one can often recognize specific prototypes for his paintings, particularly in the work of George Bellows and John Sloan. In the group of fourteen etchings of the early 1920s, in which he first laid out his signature style, we can trace these influences. His print of *Night Wind*, for example, clearly alludes to Sloan's *Turning Out the Light*, while *The Lonely House* shows a tall, isolated building strikingly similar to the one featured in George Bellows's famous painting, *The Lone Tenement*. One of Hopper's most famous

paintings, *Early Sunday Morning*, seems like a remake of the painting *Pigeons* by Sloan, which shows children scaring pigeons off the roof of a brick building. Nonetheless, Hopper simplified and deepened the feeling of the Ashcan School, to the point where his art became a new form of expression. In some peculiar way, Hopper distilled opposites in his paintings, creating images that are at once ugly and beautiful, abstractly compelling but realistic, banal and yet memorable, anxious and yet soothing. Art historians tend to place Hopper in the modernist camp, linking his work with French existentialism, extolling its treatment of loneliness, and praising its abstract qualities. Hopper, on the other hand, viewed himself as a realist. When his friend Lloyd Goodrich once confessed that he had compared Hopper's work in a lecture with that of the Abstract painter Mondrian, Hopper declared, "You make me sick."

The influence of Henri on Stuart Davis is less obvious, perhaps because Davis grew up so much a part of the Ashcan School that he could take its influence for granted, and devote his conscious attention to other things. In fact, Davis's early work looks very much like that of Henri's other followers, particularly that of his classmate George Bellows, who was certainly the best painter of The Eight, though not technically part of the group. In 1913, however, when Davis visited The Armory Show he was blown away by a new vision of the possibilities of painting. From this point on he became the most formally experimental painter of his generation, changing styles at least once a decade, but generally much more often. Despite his formal experiment, Davis always stopped just short of pure abstraction, and enjoyed working popular imagery into his work, including such brand names as Odol and Champion Spark Plugs. Visitors to his studio were expected to prove their knowledge of the Brooklyn Dodgers before they could talk about art, and his lingering debt to Henri is suggested by his comment that: "I like popular art, topical ideas, and not High Culture or

Fig. 3
Gertrude Kasebier,
Arthur Wesley Dow,
c. 1895-96.
Gelatin silver print,
7 x 5" (17.8 x 12.7 cm).
Private collection,
New Jersey. Courtesy
Spanierman Galleries.

Fig. 4
Cover for *Composition*
by Arthur Wesley Dow.
New York, Doubleday,
Page & Co,
Revised edition, 1916.

Modernist Formalism." His studio contained four radios, a set of Duke Ellington records, and a television set which was usually on, but with the sound off. "I may be watching a prize fight while I have a painting in progress," Davis commented, "and some sort of action in the fight, or some sort of decision in it, may create an emotional attitude which gives me an idea for a painting."

Today Henri's style of painting often looks quaint, but the sort of interaction with real life that he promoted, and that was typified by figures such as Stuart Davis, continues to be an important stimulus for significant modern art.

Arthur Dow, Abstraction, and the Void

Robert Henri certainly is, with Alfred Stieglitz, the best known catalyst of modern American art. One other tradition of modern thinking in America, however, had equal if not greater influence in the shaping of significant modern art: the tradition of formal abstraction that was most skillfully articulated by Arthur Dow. If Dow's place as a progenitor of American modernism is rarely discussed in standard surveys of American art, it is in part because he was not himself a particularly important artist, and in part because his influence as an educator was so diffuse.

Arthur Dow studied art in Paris, where he succeeded in placing some of his paintings at the Salon. But he felt dissatisfied with the mechanical aspects of academic French teaching.[2] His moment of revelation came after his return to the United States, when he encountered a volume of Japanese prints. From that point on, Japanese art served as a principal source of inspiration, providing a new way of thinking about the fundamental principles of art. "One evening with Hokusai," Dow wrote, "gave me more light on composition and decorative effect than years of study of pictures."[3]

While he worked as a painter, photographer and printmaker, Dow's major contribution was made

through a slender book titled *Composition*, with nearly as many pictures as words, which reshaped the thinking of an entire artistic generation. First published in 1899, the book went through twenty subsequent editions, as well as foreign translations, over the course of the next four decades. Moreover, it was widely summarized and paraphrased in other art textbooks of the early 20th century. The power of the book lay both in its originality, and its curious simplicity. Dow argued that painters since the Renaissance had misunderstood the true principles of art by laying stress on the challenges of representation. Such an emphasis ultimately led to a mechanical approach, since it made the artist a mere copyist and stifled his creativity. Instead, the essence of art lay in creative design, which should emanate from an artist's "inner self." Such design depended on the harmonious arrangement of three things, which Dow termed "The Holy Trinity" of art-making—line, color, and *notan*, a Japanese term indicating the relationship of flat patterns of light and dark. If the artist could master these things, things such as representation—if it were necessary at all—would fall into place, almost as an afterthought. Even more stimulating than the text itself were Dow's examples, which stretched widely over the field of art, from Persian rugs and Japanese prints to paintings by Manet and well-known Renaissance masters. Still more provocative, were Dow's wonderfully simple little diagrams, which reduced natural forms to simple arrangements of line and space, or even, in some instances, represented nothing at all, but showed how lines by themselves could be arranged to create pleasing and harmonious abstract patterns. As Dow declared: "In a word, instead of spending most of the effort on drawing, and then adding original work, or Composition, we begin with composition, and find that it will lead to all the rest."[4]

Dow's approach of starting with non-representational elements has an affinity with methods of exploiting accident that can be traced back to such figures as the English watercolorist Alexander Cozens. The difference, however, was that for Dow the relationship of lines was never arbitrary or accidental, but was filled with emotional and spiritual significance even before they represented anything in particular. In other words, in its essence, painting was an essentially abstract form of creation, like music. As he wrote: "We should get from drawn lines, and allusive suggested tones, the same kind of appreciation that music gives."[5] Dow stressed that the artist's most difficult task was that of creating an abstract framework. "The placing of the first few lines on a canvas requires great composing power," Dow wrote. "It is not a power derived from nature, neither is it something to be acquired after learning to draw. It is the foundation on which the artistic work rests."[6]

In certain instances, Dow suggested that the meaning of lines and shapes could be reduced to a kind of mechanics. For example, he proposed that horizontal lines are peaceful, upwardly moving lines are hopeful, and jagged and angular lines are emotionally tense. These principles, however, provide only a very general guide to the emotional significance of a picture, and provide only the crudest hints about how to organize lines into pleasing and significant patterns. Very quickly the artist using Dow's method leaves external guideposts behind and is forced to look inward in a very Protestant fashion into his own conscience and inner soul. "The subject is in you," Dow told his pupils, "nature giving only the suggestions."[7]

Dow's treatise skillfully combined many strands of 19th century thinking about art into a condensed format. The two most powerful inspirations for his book, however, were two traditions that were particularly tied to New England, and to its focus on Transcendentalism and spiritual principles.

The first was a New England passion for disregarding surface appearance to focus on deeper forms of truth, a tradition rooted in the Puritan heritage, which stressed rejecting anything frivolous or fancy,

Fig. 5
Arthur Wesley Dow,
Study of Squares,
reproduced from
Composition,
New York, Doubleday,
Doran and Co.,
1899, p. 39.

and disdaining material pleasures for spiritual ones. In early New England, this attitude resulted not only in simplified forms of religious observance, and in much examination of one's conscience, but in a *plain style* in American architecture and furniture, which valued the simplest, least expensive, most elegantly reductive statement of an idea. In the 19th century this viewpoint found its most powerful American voice in Ralph Waldo Emerson, who extorted Americans to develop their own style, not copied from that of Europe, but based on a fundamental understanding of inner principles.[8]

The second was the notion that Japanese art and thought could be used as a model for purifying Western design. This idea also, while not unique to New England, had unusually strong roots there. Due to its spiritual aspect, and its exoticism, Japanese art was appreciated surprisingly early in New England. The American pioneer in the appreciation of Japanese art was apparently John La Farge, who had begun collecting Japanese prints by 1856, and began making use of Japanese effects in his own work shortly afterwards. In large part through La

Farge's influence, by the early 1860s Japanese effects began to appear in the work of other American artists, such as Winslow Homer. In the last three decades of the 19th century, a surprising number of New Englanders made their way to Japan, the most important being Ernest Fenollosa, who assembled a remarkable collection and wrote the first history of Japanese art by a Westerner. While Dow discovered Japanese art on his own, he soon made contact with Fenollosa, and became first his assistant and then his successor as Curator of Japanese Art at the Boston Museum. Thus, Dow was not a solitary figure, but one who synthesized and popularized a well-established New England tradition.

While most of his ideas were not new, two things about Dow's book were revolutionary. First, he packaged Fenollosa's concepts in a way that reached a vast audience. Dow's new approach to art—which soon came to be known as "The New Method"—was widely distributed all over America, since *Composition* was used as a textbook not only in art schools, but in high school and college classrooms. Second, the principles of *Composition* were curiously open-ended. It was written not as an aesthetic or philosophical treatise, but as a workbook, with exercises intended to stimulate creation of beautiful designs. While it suggested a new way of looking at and creating art, it was agnostic on the issues of subject matter, medium, or whether the result should be realistic or abstract. In other words, Dow's ideas lent themselves to expression in extremely varied guises, in many different art forms.

As a consequence, Dow's book influenced art forms that initially seem very different, or even opposite in nature. He had a major influence on American art pottery as well as on artistic photography, since Gertrude Kasebier and Alvin Langdon Coburn both studied with him, and through them his influence spread to such figures as Paul Strand, Edward Steichen, and Alfred Stieglitz. In painting he influenced styles which are traditionally viewed as opposites, such as the *designed realism* of Grant Wood,

and the *pure abstraction* of figures such as Arthur Dove, and Manierre Dawson. Georgia O'Keeffe, who studied with him, once summarized her art in terms that are lifted directly from Dow: "How to fill a space in a beautiful way—that is what painting means to me."[9]

Since they drew on pervasive currents in 19th century thought, Dow's ideas often ran parallel to the ideas of the European modernists. The American modernist Max Weber, who studied in the atelier of Matisse, recalled that: "When I got to Paris in 1905 I was struck by the fact that Mr. Dow had anticipated some of the aesthetic principles of art the Fauves had striven for only years later."[10] Nonetheless, there are subtle but significant differences of emphasis in the way that Dow looked at Japanese prints and the way that Europeans did so. French artists, from Manet to Toulouse-Lautrec, were interested in the dramatic possibilities of Japanese composition, and tended to stress subjects of an ephemeral nature, often connected with sex, fashion, or modern life. Dow, on the other hand, in keeping with a long tradition of New England Transcendentalism, was interested in the spiritual side of Japanese art. Fundamentally, Dow saw Japanese principles as a way of cleaning out the frivolities of fashion and material things, and touching the spiritual essence of life.

In spatial terms, the void plays a large role in Dow's work. Europeans artists admired Japanese prints for their unusual collisions of color and shape, but their work seldom conveys a feeling of true emptiness. Dow, on the other hand, like the Japanese ink painters, was interested in a world that is neatly balanced between substance and void, the finite and graspable and the infinite and ungraspable. Such a view of the world may well have been prompted in some way by the vastness of the unpopulated American landscape, which seems to place Americans in a closer relation with the sky and the horizon than the landscape of Europe. In any case, after Dow's book we start to see this abrupt juxtaposition of finite and infinite become an increasing-

Fig. 6
Manierre Dawson, 1966. New York, courtesy Hollis-Taggart Galleries. Photo: Grand Rapids Press.

Fig. 7
Manierre Dawson, *Differential Complex,* 1910. Oil on canvas, 16 x 12 ½" (40.65 x 31.75 cm). New York, courtesy Hollis-Taggart Galleries.

ly popular theme in American painting. American painting of the 1930s, for example, often features a single field of wheat or a lonely road which stretches in an unbroken line to the horizon and the vanishing point. In the late 1940s, and the 1950s, this sense of the infinite became one of the major themes, and one of the most striking novelties, of the work of the Abstract Expressionists. To a large degree, in fact, Dow's influence largely accounts for the fact that the work of American painters tends to have an "American look" subtly different from that of European painters.

Conclusion

To view American modernism as a dialogue between "great traditions" allows us to see the ways in which American painting, even when it imitated European forms, often carried different cultural meanings and pointed in a different direction. In addition, it brings out a variety of theoretical issues more complex and more interesting than the simple opposition between realistic and abstract forms of art—a once-pressing theme in the New York art world that in recent years has come to seem less interesting than it once did, if not completely anachronistic. The "great traditions" of early modern American art tended to form around strong-willed or charismatic personalities. But they also drew upon deeper attributes of American culture, and thus even today they remain at least marginally helpful towards elucidating the ever-changing forms of American modern and post-modern expression.

The notion of *tradition* in the United States has always worked slightly differently than in France, and has always had a peculiarly dynamic and even paradoxical character. The paradox of American mod-

ernism was that it created a tradition of revolt before American society had established a clear standard against which such a revolt could be gauged. Aside from the National Academy of Design in New York, an institution which has spent most of its history in a semi-moribund state, and which never enjoyed real cultural authority, the United States completely lacked the sort of academic system established in France, and promoted through lavish government patronage. Indeed, the concept of fixed classical standards seems to be foreign to the American temperament, as is evinced by the contrast between French and American attitudes about what constitutes great literature. Mark Twain's novel, *Huckleberry Finn*, for example, a revered touchstone of excellence in American literature, has a disorganized plot, deals with riff-raff characters, and is written in vernacular dialect, with complete disdain towards the rules of grammar established by school teachers. The most admired "classics" of American painting and literature have always been distinctly unclassical.

Yet one of the most striking things about American modernism is that it did create real traditions—something which American art had seldom done successfully before. Before the 20th century, taste in American art shifted with each artistic generation, generally in response to new developments in Europe. Throughout the 19th century, each new generation of American artists looked towards Europe, and turned its back on what had been done earlier in the United States. Somewhat paradoxically, the traditions of the avant-garde were the first long-lasting traditions in the history of American art—the first that can be traced with some continuity through several artistic generations.

Henry Adams

Notes

1. Only in one art form did the United States play a major role: that of architecture. But to a large degree, the achievement of Sullivan and Wright was to devise a formal language that gave expression to new structural developments, such as the use of two-by-fours and a balloon frame for residential construction, and of the steel frame with terra cotta sheathing for high-rise office buildings.

2. Nancy Green, *et al.*, *Arthur Wesley Dow (1857-1922): His Art and His Influence*, Spanierman Gallery, New York, 1999, p. 14.

3. Johnson, *Arthur Wesley Dow: Historian, Artist, Teacher*, Ipswich, Mass., Ipswich Historical Society, 1934, p. 54.

4. Joseph Masheck, "Dow's 'Way' To Modernity for Everybody," introduction to Arthur Wesley Dow's *Composition*, University of California Press, Berkeley, 1997, p. 19.

5. Arthur Dow, Trowbridge lecture delivered at Yale University, 17 February 1917, Archives of American Art.

6. Mascheck, *op. cit.*, p. 21.

7. Arthur Dow, "A Note on Japanese Art and What the American Artist Can Learn Therefrom," *Knight Errant*, vol. 1, January 1893, p. 115.

8. Dow's ties with Emerson are suggested by the fact that he purchased Emerson's former home in Ipswich.

9. Mary Lynn Kotz, "A Day with Georgia O'Keeffe," *Art News*, December 1977.

10. Max Weber, letter to Ethelwyn Putnam, Archives of American Art, Washington D.C., cited in Nancy Green, *Arthur Wesley Dow and His Influence*, Herbert F. Johnson Museum of Art, Cornell University, Ithaca, New York, 1991, p. 17.

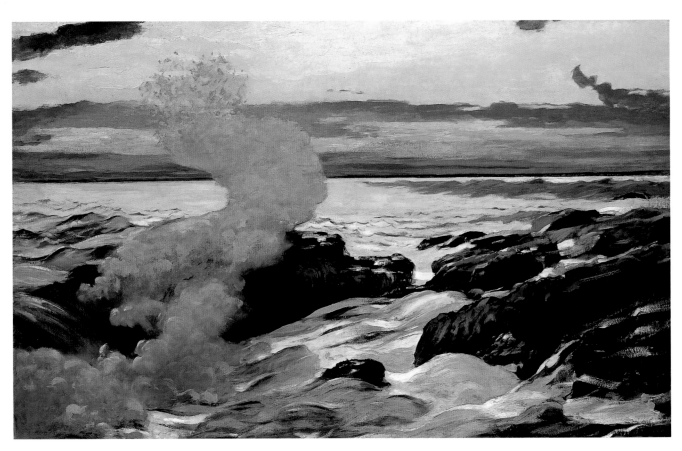

Winslow Homer
West Point, Prout's Neck, 1900
Oil on canvas, 30 $^1/_{16}$ x 48 $^1/_8$" (76.4 x 122.2 cm)
Sterling and Francine Clark Art Institute, Williamstown

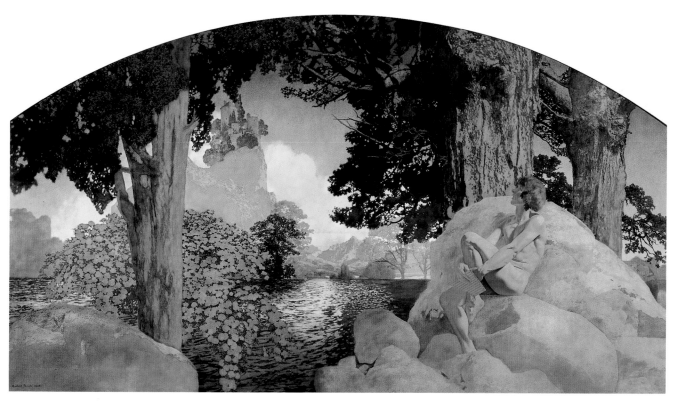

Maxfield Parrish
Dream Castle in the Sky, 1908
Oil on canvas, 5'9" x 10'8" (175.3 x 325.1 cm)
The Minneapolis Institute of Arts
The Putnam Dana McMillan Fund

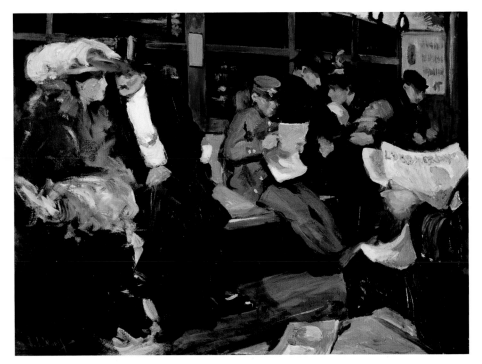

Samuel J. Woolf
The Underworld, c. 1909-10
Oil on canvas, 22 1/2 x 30 1/2" (57.1 x 77.5 cm)
Richmond., Virginia Museum of Fine Arts,
Museum Purchase, with funds form a private
Richmond foundation

John Sloan
Hairdresser's Window, 1907
Oil on canvas, 31 7/8 x 26" (80.96 x 66.04 cm)
Hartford, Wadsworth Atheneum Museum of Art,
The Ella Gallup Sumner and Mary Catlin Sumner
Collection Fund

William James Glackens
The Drive, Central Park, c. 1905
Oil on canvas, 25 3/8 x 31 7/8" (64.5 x 81 cm)
The Cleveland Museum of Art
Purchase from the J. H. Wade Fund

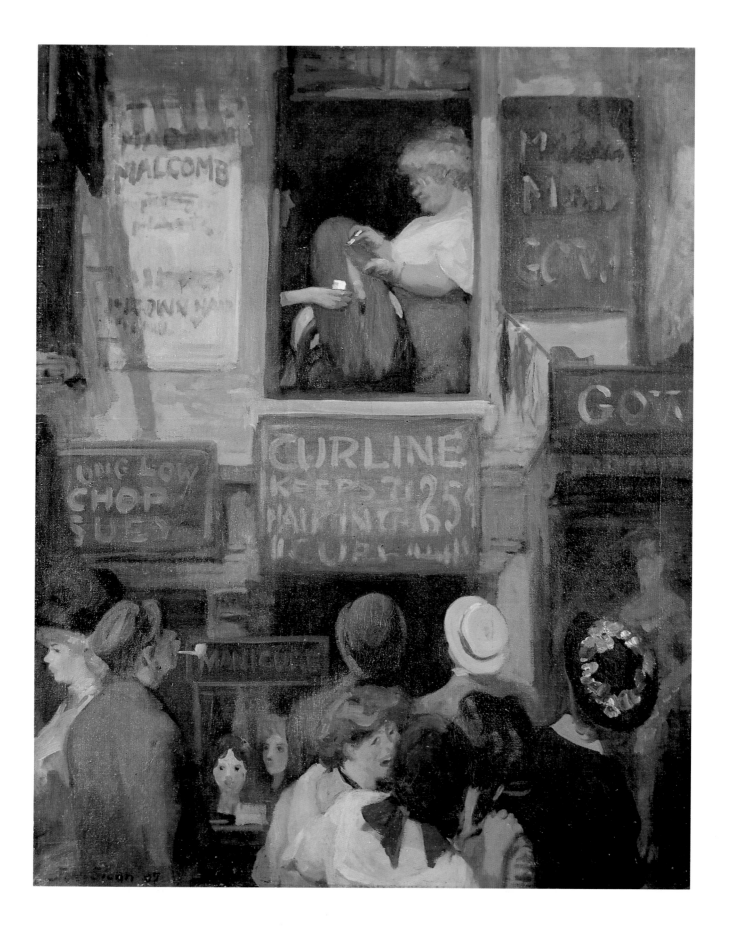

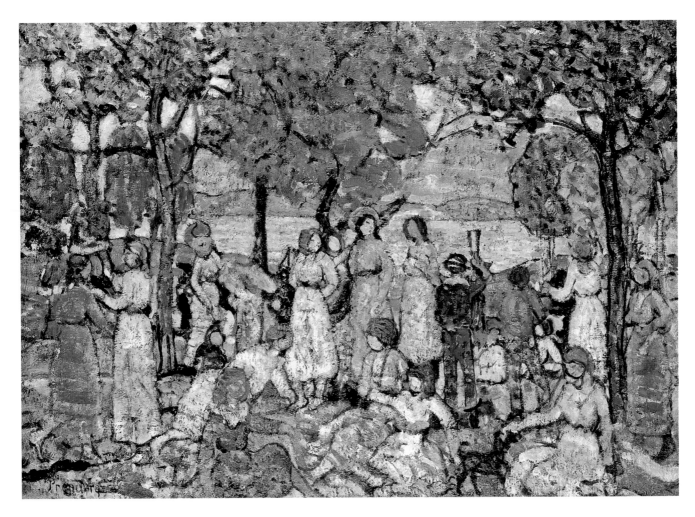

Maurice Brazil Prendergast
Holidays, 1920
Oil on canvas, 29 $^5/_8$ x 42 $^5/_8$″
(75.2 x 108.3 cm)
The Minneapolis Institute of Arts
The Julia B. Bigelow Fund

Maurice Brazil Prendergast
Rocky Coast Scene, 1912-13
Oil on canvas on panel, 13 $^3/_4$ x 19 $^1/_2$″
(34.9 x 49.5 cm)
M. H. de Young Memorial Museum,
Fine Arts Museums of San Francisco
Gift of Mrs. Charles Prendergast to the
California Palace of the Legion of Honor

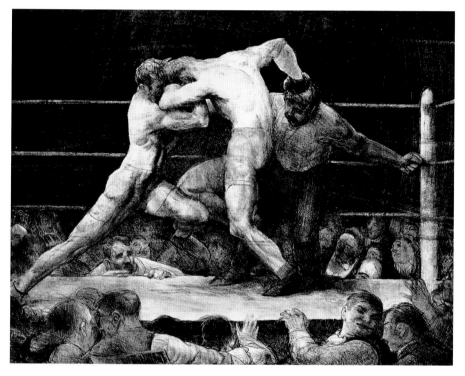

George Bellows
Stag at Sharkey's, 1917
Lithograph, 18 ¹/₂ x 23 ⁷/₈" (47 x 60.5 cm)
The Saint Louis Art Museum
Purchase

George Bellows
Billy Sunday, 1923
Lithograph on vellum paper, 9 x 16 ¹/₈"
(22.86 x 40.96 cm)
St. Peter, Minnesota, Hillstrom Museum of Art
Gustavus Adolphus College

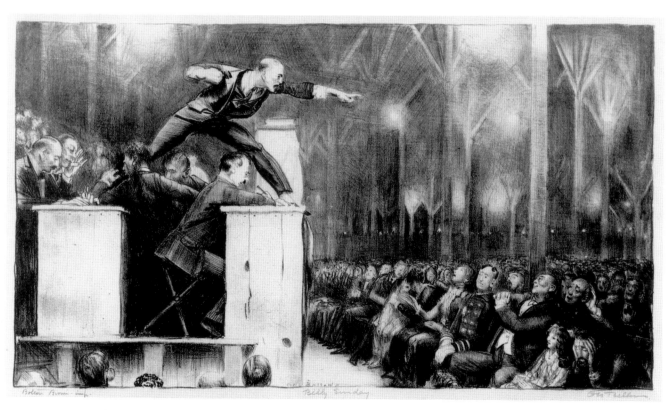

George Bellows
In the Park, Dark, 1916
Lithograph, 16 7/8 x 21 1/8" (42.87 x 53.67 cm)
Dallas Museum of Art
Junior League Print Fund

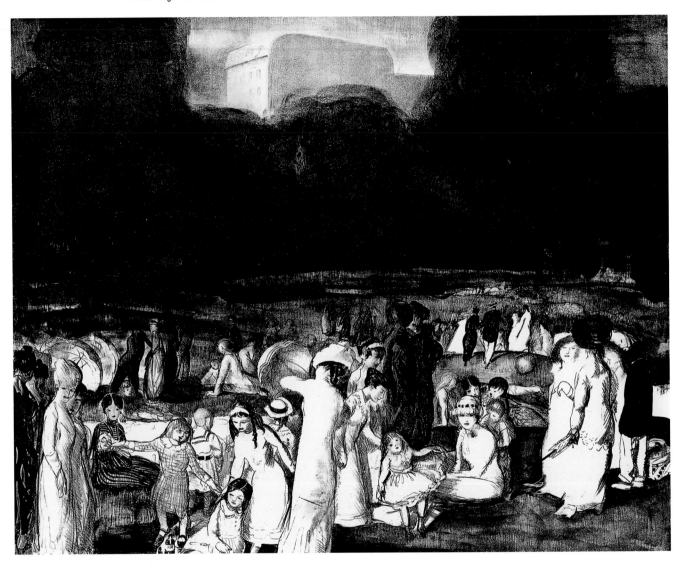

Alfred Stieglitz
City of Ambition, New York,
published in *Camera Work,* October 1911
Heliogravure on Japanese vellum, 13 1/4 x 10 1/4"
(33.7 x 25.9 cm)
Paris, Musée d'Orsay

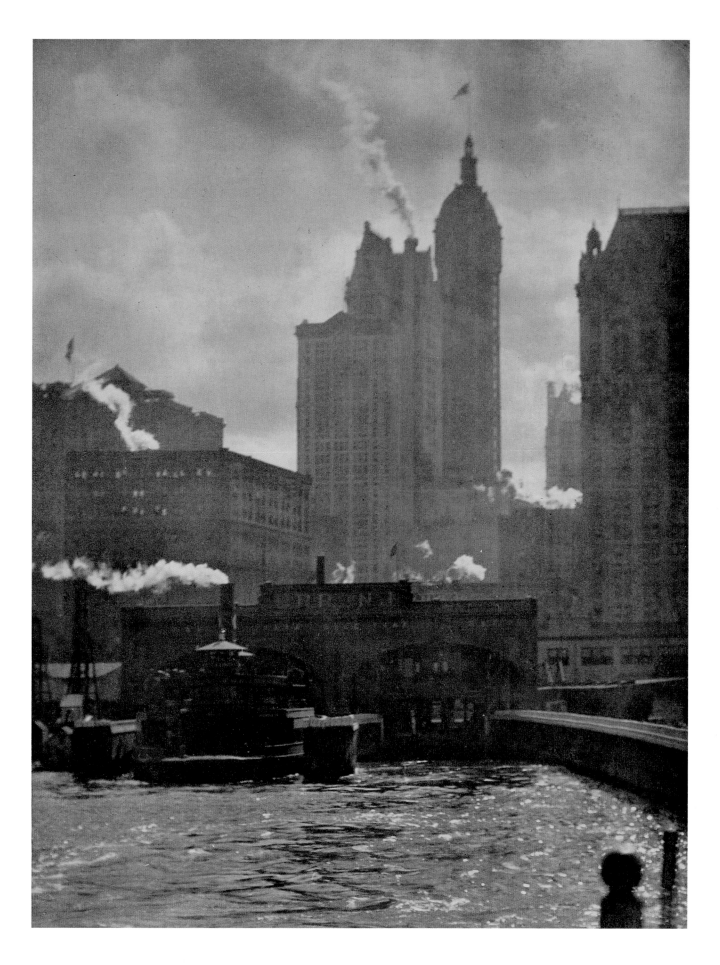

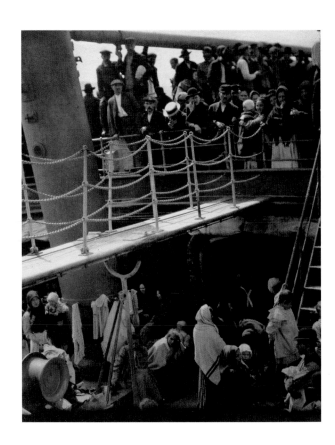

Alfred Stieglitz
The Steerage, published in *291*,
September-October 1915
Heliogravure on Japanese vellum, 13 ¹/₈ x 10 ¹/₂"
(33.4 x 26.6 cm)
Paris, Musée d'Orsay

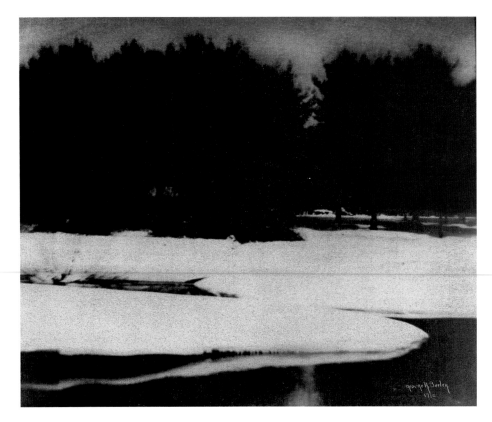

George Henry Seeley
Winter Scene, 1912
Gum bichromate print, 17 ³/₈ x 2 ¹/₄"
(44 x 54 cm)
Paris, Musée d'Orsay

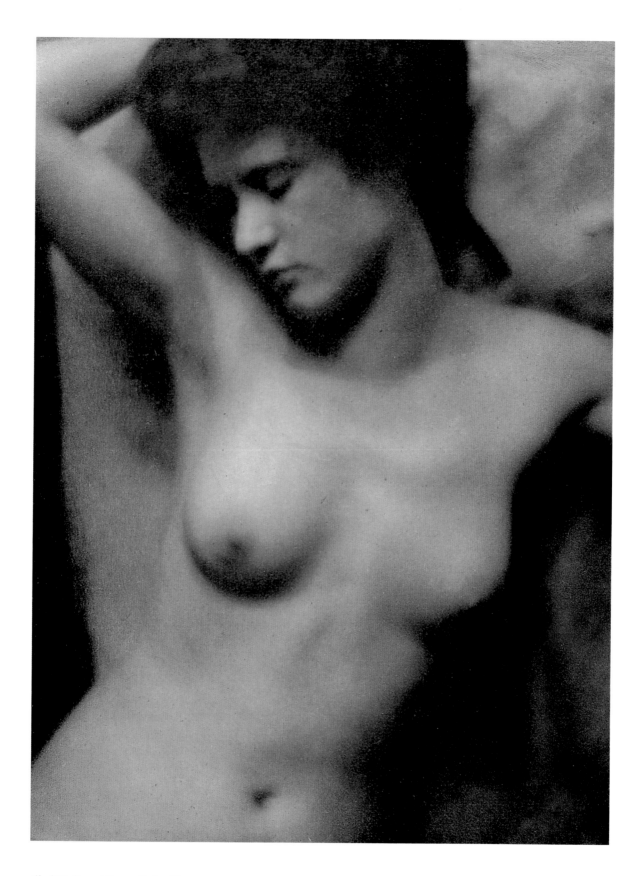

Alfred Stieglitz and Clarence Hudson White
Torso, published in *Camera Work*, July 1909
Heliogravure, 8 ⁵/₈ x 6 ¹/₄" (22 x 16 cm)
Paris, Musée d'Orsay

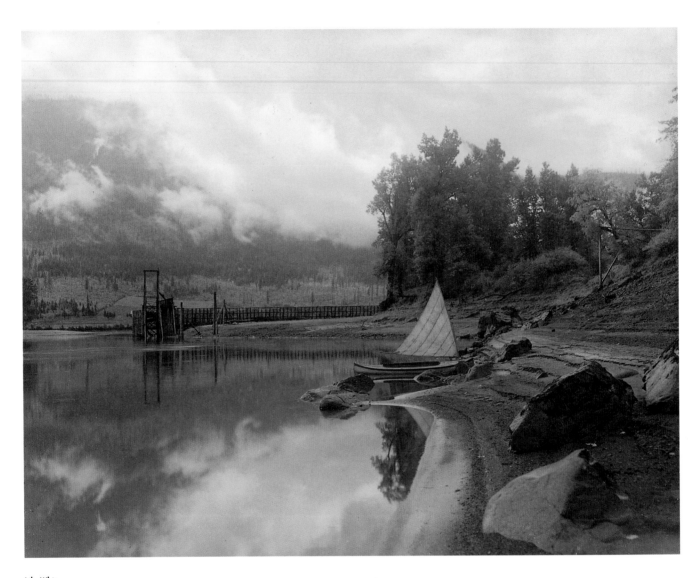

Lily White
Moonlight on the Columbia, c. 1902
Platinum palladium print, 10 $1/4$ x 13 $1/4$ "
(26.1 x 33.7 cm)
Portland Art Museum
Caroline Ladd Pratt Fund

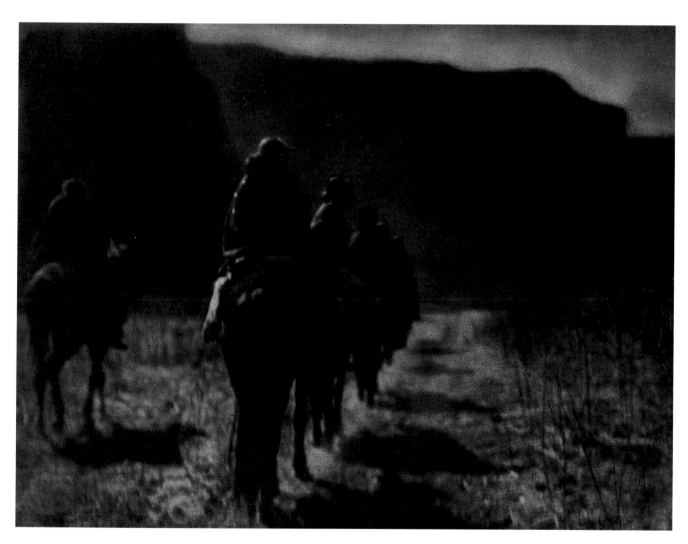

Edward S. Curtis
The Vanishing Race — Navaho, 1904
Photogravure, 11 3/4 x 15 3/4″ (29.85 x 40 cm)
Portland Art Museum

Adolf de Meyer
Marilyn Miller, 1921
Gelatin silver print, 9 ¹/₂ x 7 ¹/₂" (24.3 x 19.1 cm)
Paris, courtesy Galerie Baudoin Lebon

Lewis Hine
Small Girl in Hosiery Mill, Cherokee,
10 April 1913
Gelatin silver print on salt paper, 4 $^3/_8$ x 4 $^7/_8$"
(11 x 12.5 cm)
Estate of Harry Lunn
Paris, courtesy Galerie Baudoin Lebon

Lewis Hine
Newspaper Boys, Hartford, c. 1909
Gelatin silver print on salt paper, 11 $^1/_4$ x 14"
(28 x 35.5 cm)
Estate of Harry Lunn
Paris, courtesy Galerie Baudoin Lebon

Lewis Hine
Opelika, Alabama, c. 1914
Gelatin print on salt paper, 4 3/4 x 4 7/8"
(11 x 12.5 cm)
Estate of Harry Lunn
Paris, courtesy Galerie Baudoin Lebon

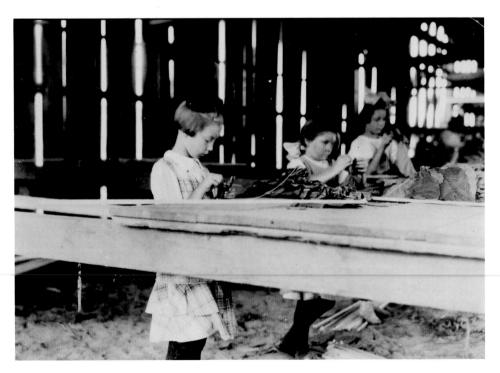

Lewis Hine
Interior of Tobacco Shed, Hazardville, 1917
Gelatin silver print, 5 x 7"
(12.7 x 17.78 cm)
Estate of Harry Lunn
Paris, courtesy Galerie Baudoin Lebon

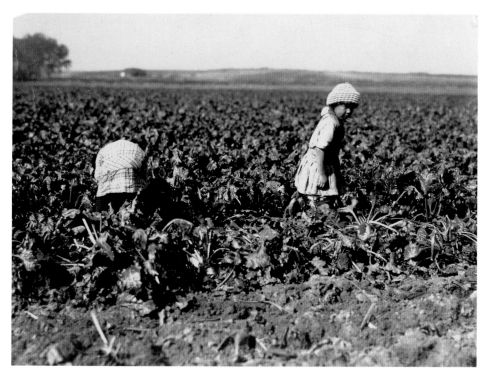

Lewis Hine
Two girls in field, Near Sterling, Colorado, c. 1915
Gelatin silver print on salt paper, 4 ³/₄ x 6 ¹/₈"
(12 x 15.5 cm)
Estate of Harry Lunn
Paris, courtesy Galerie Baudoin Lebon

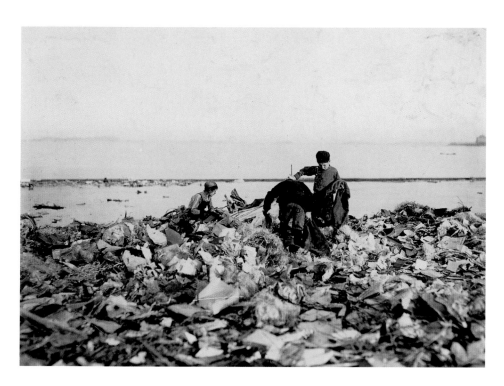

Lewis Hine
Boys of the Dump, South Boston, c. 1909
Gelatin silver print on salt paper, 4 ³/₄ x 6 ³/₄"
(12 x 17 cm)
Estate of Harry Lunn
Paris, courtesy Galerie Baudoin Lebon

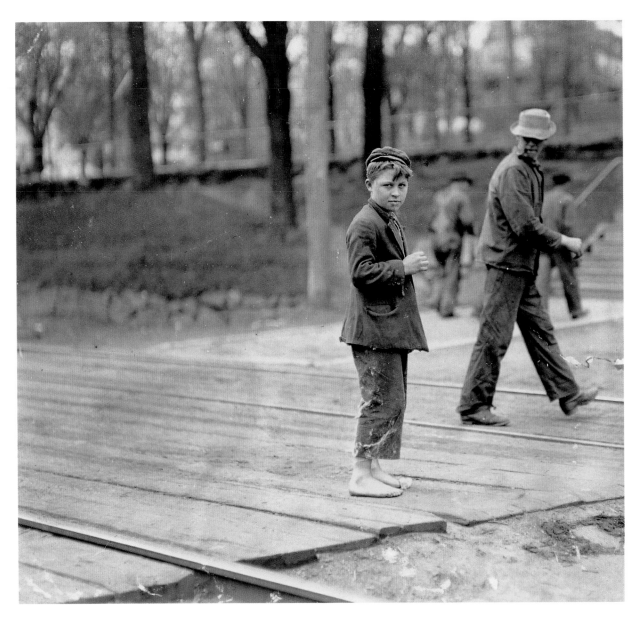

Lewis Hine
Small Boy Barefoot, New Hampshire, c. 1909
Gelatin silver print on salt paper, 4 ¹/₂ x 4 ⁷/₈"
(11.5 x 12.5 cm)
Estate of Harry Lunn
Paris, courtesy Galerie Baudoin Lebon

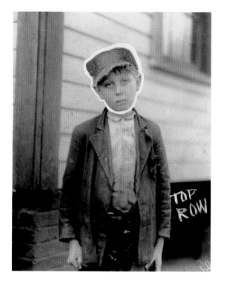

Lewis Hine
Boy with Hat, c. 1913
Gelatin silver print on salt paper, 4 $^7/_8$ x 3 $^7/_8$"
(12.5 x 10 cm)
Estate of Harry Lunn
Paris, courtesy Galerie Baudoin Lebon

Lewis Hine
Newspaper Boys, Hartford, c. 1909
Gelatin silver print on salt paper, 11 $^1/_4$ x 14"
(28 x 35.5 cm)
Estate of Harry Lunn
Paris, courtesy Galerie Baudoin Lebon

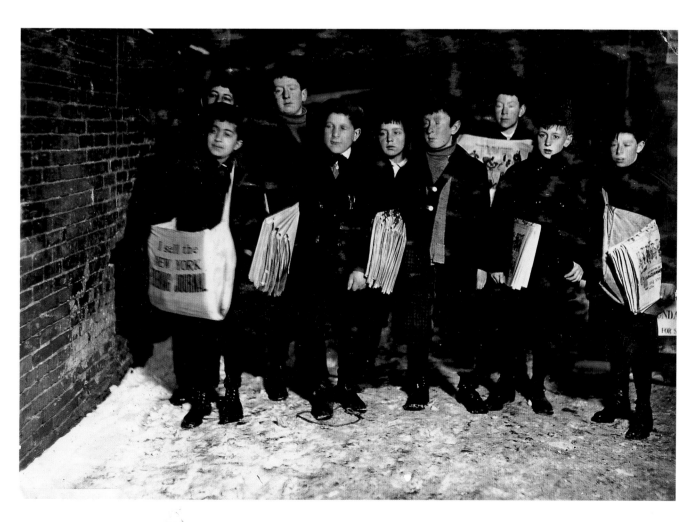

The Pioneers of Modernism

Modernism was born in the United States in an artistic environment where photography played a major role. In fact, it was principally around Alfred Stieglitz and his gallery—founded in 1905, it became known under the name "291" when, after 1908, it broadened its scope to encompass the European avant-gardes—that the painters and photographers who laid the foundations of a truly American modernism gathered, even before the shocking public upheaval caused by the gigantic overview exhibition of the Armory Show in 1913.

After 1909, some artists were re-addressing urban themes that they generally interpreted in a metaphorical and generalized way, without any intent at objective documentary. For this, they incorporated influences they had discovered during their stays in Europe. John Marin and Abraham Walkowitz used Cézanne's shapes to convey what they considered to be the dynamism inherent to New York or to the landscapes of New England. In order to describe the visual and mental excitement of New York and of its new gathering spots, Joseph Stella drew inspiration from Italian Futurism and Max Weber from Parisian Cubism and Primitivism.

Closer to the methods of abstraction (in particular to those of Kandinsky), Marsden Hartley stood out by moving from Post-Impressionist rural landscapes to paintings in which he combined signs (numbers, flags, simple geometric shapes) with no mimetic intent, in order to render in a cryptic way his love for a Prussian lieutenant he had met in Berlin and who had disappeared early in World War I. He also used this method to treat more general subjects, such as cosmic phenomena and American Indian symbolism. Unaware of European parallels, Arthur Dove painted his first Abstract Expressionist works in 1910, based on a subjective transformation of nature, or, during the 1920s, based on popular music. In 1916 and after, he would be followed on this path—readily abstract—by Georgia O'Keeffe.

Independently of Stieglitz, abstraction was also the path chosen around 1910-13 by isolated but surprising figures such as Manierre Dawson in Chicago (based on spirituality) or by several painters temporarily exiled in Paris: the "Synchromists" Morgan Russell and Stanton Macdonald-Wright (who exhibited under this name as of 1912), as well as the independent Patrick Henry Bruce (a friend of Sonia and Robert Delaunay), who all based their works on a scientific approach to the autonomous properties of color, in works where the figure remained at most a secondary element.

With his photographs from 1916-17, published in the last two issues of the review *Camera Work*, (edited by Stieglitz), Paul Strand synthesized these Modernist trends. Doing away with the idea that only Pictorialism could make photography into a true art form, he showed how this means, used objectively and without transforming the image after the shot ("straight photography"), enabled one to reconcile observation of the individuals who peopled the city with that of the new characteristics of urbanism and of a more formal—more abstract—perception of the world. In fact, he was the only one to inspire a line of important artistic heirs, whereas the 1916 Forum Exhibition, which intended to prove the vitality of the American avant-garde by exhibiting together the artists championed by Stieglitz, the Synchromists and a few independent figures, ended up simply playing the role of taking an inventory before closing time.

E.C.

Opposite:
Joseph Stella
Battle of Lights, Coney Island, Mardi Gras,
1913-14
Detail

The 1913 Armory Show

Stakes, Strategies and Reception of a Media Event

The exhibition presented in 1913 on the premises of the 69th Regiment Armory in New York—known as the Armory Show—which then traveled to Boston and Chicago (fig. 1), constitutes one of the most famous episodes in the history of modern art in America. With the 1938 publication of *The Story of the Armory Show*, by Walt Kuhn, one of the exhibition's organizers, the Armory Show acquired an aura of myth that would complement an abundant body of literature on the subject. Everything or almost everything has already been said concerning the historical account of this exhibition. The fascination arises from the miraculous aspect of its arrival and subsequent impact—how could 1,600 works of a modern and revolutionary art that had never been seen before create the biggest scandal of the year in the United States and, after the arrival of the war, could mark the end of the epoch of the no less mythic "American innocence?" So, we remember it for its shock value, its innovative impact, its contribution to a history of the avant-garde, expressed as a succession of aesthetic ruptures.

Our intention is not to retrace the history of this event one more time.[1] The exhibition's unusual aspect and the extraordinary effect it had on its 300,000 visitors deserves to be analyzed in light of the singularity of the American cultural context. Beyond the myth-making it has inspired over the years, the strategies that led to the conception of the Armory Show, as well as the immediate reactions to it, follow a uniquely American logic.

In December 1911, fifteen artists decided to create the Association of American Painters and Sculptors (AAPS), "an association of live and progressive men and women who shall lead the public taste in art rather than follow it. The National Academy of design is not expected to lead the public taste. It never did and never will, and no such organization as the one contemplated exists in this country today...."[2] This declaration of intent illuminated the profound antagonism that ran through American artistic creation at that time. On the one hand, the Academy still controlled the diffusion of art and imposed its moribund aesthetic dictates. On the other hand, the visual arts were met with an almost total cultural indifference that was rooted in the puritan tradition. Beyond simply opposing the Academy and creating an alternative system of representation—as was the case in France at the end of the 19th centu-

Fig. 1
View of the Armory Show, presented in Chicago, 24 March-15 April 1913.

ry—it was about establishing the role of the artist in society and stimulating the art market which included a mere ten or so galleries at that time. The Association envied the privileged status of the modern European artist, and so came up with the idea for a commercial, unjudged exhibition modeled on the independent Parisian Salons, in order to show a far-reaching overview of the evolution of American art since the 1876 World's Fair in Philadelphia, integrating the modest rebellions of The Ten (1898) and of the Ashcan School (1908, which included the majority of the AAPS members).

As for the original concept, the organizers chose to include a few works by European artists in the exhibition in order to better represent the most recent innovations. This decision that would result in "flinging wide open the doors of their internal "art market" for competition from the most unleashed European artists"[3] can be explained by their ignorance of the latest aesthetic revolutions in Europe. During their art-gathering trip in Europe, principally in Paris, Arthur B. Davies, the president, and Walt Kuhn quickly realized how out of step, indeed behind, American artists were, compared to their European counterparts. Fascinated by the extreme aesthetic freedom of artists such as Brancusi, Matisse and all the Cubists, Davies and Kuhn modified their strategy and borrowed the maximum possible number of works (around 350). From then on, it was about using the formidable scandal potential of the European avant-garde to their own particular ends. This choice of strategy might appear surprising. It appears less so in terms of the American cultural history. Thus, the art critic Christian Brinton confirmed the pertinence of this decision by arguing that "the awakening of the American public to the appreciation of things artistic has, in brief, been accomplished by a series of shocks from the outside rather than through intensive effort, observation or participation." He reminds us that this began with the presentation of antique marble sculptures at the World's Fair in Philadelphia, then with the Barbizon School, etc.[4] The resulting aesthetic shock was thus predictable in the sense that it disturbed deeply-rooted iconoclast puritan qualities in American culture. It was not surprising that the Armory Show organizers had considered this shock to be necessary in order to revolutionize the stagnant situation of the art-world in the United States.

The members of the AAPS were aware of their aesthetic backwardness and were convinced that American art would, in the end, be strengthened by this confrontation. The inaugural speech of John Quinn, a patron of the arts and the lawyer for the Association, abundantly displays this opinion: "The members of this Association have shown you that American artists—I mean young American artists—do not fear and should not fear European ideas. They think that in the domain of art, only the best should prevail."[5] Nevertheless, the Association's artists were aware that they were staking their future on this crazy adventure; as the catalogue's epigraph, borrowed for the occasion from Greek tragedy, showed, "To die well is better than live poorly."[6]

The exhibition's organization resembled a political campaign, indeed a war for independence that had to be won. The symbols and the syntax used were revealing on this point. Walt Kuhn saw himself as a "Minister of War,"[7] organizing an event that would be "like a bomb."[8] The Association's emblem became the old pine tree with three flags that the Association published not only on the cover of the catalogue and also on thousands of buttons.

These latter were not the only publicity devices to be distributed by the thousands. The funds raised, principally by the Association's president Arthur B. Davies from a few patrons of the arts, enabled them to finance the printing of more than 100,000 post cards and posters, which were distributed all over the country, as much to local art leagues as to public institutions and schools. To that should be added the publication of 50,000 exhibition catalogues and four pamphlets, each printed in 5,000 copies. In fact, as of its first meetings during the winter of

1912, the AAPS regularly informed the press of the progress of its activities. Walt Kuhn, along with the public relations agent hired for the occasion, Frederic James Gregg, devoted the two months preceding the exhibition's opening to contacting all the newspaper and magazine editors in the country, attaching documents and photos. This publicity campaign, ahead of its time, was impressive. In a letter to the painter Prendergast, Kuhn noted: "As you notice, we are taking hold of this thing in a rather modern way"[9] It is difficult to imagine the artists themselves using these new methods. Another of Kuhn's letters was also enlightening: "John Quinn, our lawyer and biggest booster, is strong for plenty of publicity."[10] To his friend Edward Gewey of the *Kansas City Post*, he wrote: "We are doing this according to American methods and have spent a good deal of money on advertising."[11] Thus the event's considerable media impact, immediately and later, can be explained by the extraordinary dimension of its publicity campaign.

The organizers found themselves in a paradoxical position: how to convert a public to this revolutionary art that it would initially reject? Pedagogical concerns of the AAPS members led them to "document" the development of independent art by publishing monographs (on Cézanne, Gauguin, Redon, Duchamp-Villon) and by including in the exhibition the "ancestors" of modern art, from Ingres up to Cézanne. Their efforts led them to describe a history of avant-garde art, such as is shown in Davies's diagram published in the special issue of *Art & Decoration* devoted to the Armory Show.[12] Positioning avant-garde art within an historical perspective enabled them to draw attention to the public's incomprehension in the face of the innovators. Walter Pach wrote: "... we have one of the greatest centuries of painting, a succession of glorious creators, every one of whom has been misunderstood and attacked, until appreciated and canonized."[13] The accent was placed on the logical evolution of art, freeing itself from the sterile yoke of imitation in order to become progressively autonomous and subjective. The synesthesic metaphor that compared the evolution of modern art to that of music recurred in lectures. Francis Picabia, the only European who made the trip to New York for the exhibition, contributed quite a bit to popularizing this interpretation in the interviews he gave to the press.

Many other arguments put forth by the defenders of modern art shared this perspective of bypassing the usual categories of aesthetic distinctions and appealing to the progressive themes in vogue since the 19th century. The first frequently advanced argument was that of viewing change as a vital phenomenon, a vector of progress—a popular concept during that time of liberal optimism. In the catalogue's second edition, a paragraph was added describing the fact that "art is a sign of life. There can be no life without change, as there can be no development without change."[14] To legitimize the modern works, some critics advocated that they comprised the epistemological metaphor of the modernism of the time. Arthur Jerome Eddy, an art collector and author of *Cubism and Post-Impressionism*, viewed it in this way: "The recent exhibition was not an isolated movement. There are no isolated movements in life.... The world is filled with ferment—ferment of new ideas, of originality and individuality, of assertion of independence. This is true in religion, science, politics as well as in art. It is true in business. New thought is everywhere."[15] Superficially, some of the aspirations of Art Nouveau could be reconciled with the progressive ideas, reinterpreted by William James's and John Dewey's pragmatic philosophies which opposed materialism. The declaration of the artist's subjectivity, of his formal freedom, shares some tenants of pragmatic individualism: humankind must affirm its independence in order to deserve its freedom. The other, more commonplace argument advanced interpreted the artists' financial success as proof of the respectability of their artistic approaches. In American culture, individual success was measured in monetary terms,

and as a shrewd businessman, Eddy spoke in financial terms, as did John Quinn, in his article "Modern Art from a Layman's Point of View." A patron of the arts and a collector, Quinn described the advantages of collecting modern art: "When a man sets out to mark a collection of works of living artists he undertakes to anticipate the verdict of the future. It is an exciting adventure [16] Gambling on the future and the inherent risk constituted a very powerful motivation in the United States. Furthermore, collecting modern art rather than academic art presented other, new advantages as well. This art's new aesthetic gave the impression that it no longer demanded a sound foundation in traditional art history in order to appreciate it. It thus left the field open to experimental and innovative interpretations, in accordance with the pragmatic way of thinking, with no preconceived prejudices or theoretical dogmas. In this way, it also enabled one to bypass an eventual cultural inferiority complex, inherent to the youthfulness of the American civilization. The Armory Show therefore set the American public to the challenge and gave it a new role to play, that of adopting and fighting for a cause.

More than 300,000 visitors went to see the AAPS's exhibition during the three months it was shown in New York, Chicago (at the Art Institute) and in Boston (at the Copley Society). At first, the organizers congratulated themselves; they had attained their goal—reaching the public. Then however, the mushrooming public reactions transformed the exhibition into a sort of democratic cultural demonstration…indeed into a Barnum and Bailey circus. The fact that the public, from all social classes and origins, was attracted to the exhibition mainly because of its mediatization quickly disconcerted its organizers. Kuhn described his dismay to his wife, "Today was the first day of free admission. We had 15,000 visitors. The masses are disgusting; just riffraff. I spent 20 minutes today in the Cubist room and I had to admonish six people for touching the paintings."[17] Because of its mediatization and its so-

Fig. 2
"The Original Cubist" in the *Evening Sun*, 1 April 1913.

Fig. 3
"Art at the Armory by Powers, Futurist" in the *New York American*, 22 February 1913.

New Art By Maurice Ketten

Fig. 4
Maurice Ketten,
"The New Art"
in *World Daily Magazine,*
February 1913.

ciological repercussions, the Armory Show constituted one of the first major instances of cultural tourism in the United States. The latent idea of cultural consumerism was already emerging. You pay one dollar to see a show, you experience the thrills of the scandal and, as this conservative critic invited to the Association's press dinner concluded: "Men, it was a bully shot, but don't do it again!"[18]

However, the hostile reactions were overwhelming. They revealed the profoundly violent response aroused by the subversive nature of the European works. Contrary to what had happened in Europe, the United States had not followed the increasingly radical development of independent art. Since the arrival of Impressionism in the 1880s, almost nothing had been exhibited, except in the few exhibitions at Alfred Stieglitz's gallery 291. But this artistic lag cannot alone account for the extent of the public's rejection. The way in which the Armory Show was presented and hung sustained the confusion and hardly illuminated the aims of modern art. Cubists, Fauves, Post-Impressionists, Symbolists, practitioners of classicism or of *art naïf* were all exhibited there side by side. The fact that the organizers were recent initiates to modernism in part explained such chaos. Some of the major reasons for the rejection were the inconceivable distortion or disappearance of form and the unbearable intensity of the colors—all factors that flew in the face of acquired traditional knowledge. The numerous caricatures (figs. 2 to 4) and the many pamphlets testified to this incomprehension which found an outlet in laughter. More generally, the majority of the public was convinced that the European artists were either insane or traitors to tradition. A plethora of expressions, such as "the freaks," "the charlatans," or "the lunatic asylum," were found on the front pages of the daily newspapers. For many, such as the virulent critic Kenyon Cox, "This is not amusing; it is heart rending and sickening."[19] The investigation by an Illinois Senatorial commission into a possible indecency offense, like the mock trial of effigies of

Matisse and of Brancusi by the students of the Art Institute of Chicago, speak worlds about the extent of the scandal created by this exhibition.

Some innovations were rejected as unacceptable because of the specific context of American culture. For example, the distortion of the nude was seen as a serious attack on puritan beliefs, according to which the human body is essentially divine, having been created in God's image. With this in mind, we can better understand how truly shocking Duchamp's *Nu Descendant l'Escalier* must have been. The infantile and archaic side of other artists—Matisse in particular—was decried just as much. An article in *Art and Progress* shed light on the reasons for this rejection: "distort the human form divine until it becomes a nauseating monstruosity."[20] This step backwards was incomprehensible for a country overly concerned with "advancing" its civilization, and confirmed the general assumption about the decadence of Old Europe.[21] For modern art's supporters, the total freedom expressed in the modern works represented a kind of culmination of the American dream, whereas its detractors saw it rather as a dangerous extremism of democracy. The critic Kenyon Cox made it into his battle cry: "Art has a social function. In all great periods of art it has spoken to the people in a language that they understood.... The men who would make art merely expressive of their personal whim, make it speak in a special language only understood by themselves, are as truly anarchists as those who would overthrow all social laws."[22] By presenting independent art in a progressive light, its supporters paradoxically hid its subversiveness. The idea of individualism set forth by the European art aesthetic went beyond that professed by progressivism. More profoundly, it constituted the metaphor of human freedom to break free of the yokes of the social system. The distortion or effacement of the figure in modern painting suggested the disappearance of human values in the industrial and capitalistic society. This criticism of Western civilization's lifestyles and production

methods went against American values and, for this reason, was unacceptable to public opinion.

Among the 300,000 visitors, only a few hundred individuals were won over. Nevertheless, it was enough to assure the future of artistic modernity in the United States. René Brimo, in his 1938 pioneering study, *L'Evolution du Goût aux Etats-Unis d'après l'Histoire des Collections*, emphasized the importance of the idealism that inspired the American genius.[23] This idealism characterized the minority of individuals who, after the Armory Show, believed strongly in modernism. Without really grasping the profound antagonism that existed between the aims of modern art and American cultural values, artists and art-lovers believed in this experimental and innovative art that reflected the profound changes of their time. On the contrary, others thought it reflected a search for the absolute which corresponded to their more mystical ideals. Everyone—collectors, patrons of the arts, artists, critics—turned it into a religion, a battle cry that led them to make New York the artistic center of the world. "America in spite of its newness is determined to be the coming center," confided Kuhn.[24] American idealism was easily transformed into Messianism.

It is helpful to remember that the Armory Show arose from an economic imperative—that of finding a market for American artists. However, the undeniable aesthetic advantage of the Europeans over their American counterparts soon turned the situation around in their favor. The Europeans' success proved to be press-worthy and economic: three-quarters of the 200 works sold were by European artists. Still disdained on the Old Continent, the avant-garde made a spectacular breakthrough towards the New World, at the expense of the Americans. Modern art's influence on progressive American artists cannot be underestimated. After seeing the exhibition, many artists tried to integrate—more or less readily—the new aesthetic into their work. In the conclusion of his *Story of the Armory Show*, writ-

ten 25 years after the event, Walt Kuhn gave it a mixed review; it was not so much the artists who benefited from the modern aesthetic and created innovative art, but rather it was the designers. While the Armory Show marked the decreasing influence of American art over the next two decades, it enabled the European avant-garde to gain active support on American soil in its strategic struggle to impose itself as the dominant aesthetic of the 20th century.

Charlotte Laubard

Notes

1. For a precise historical account of the exhibition, see Milton Brown, *The Story of the Armory Show*, Washington D.C., Hirshhorn Foundation, 1963.

2. Excerpted from the minutes of the meeting held on December 14, 1911, *Walt Kuhn Papers and Armory Show Records*, Washington D.C., Archives of American Art, Smithsonian Institute, reels D72-D73.

3. Robert Lebel, "Paris-New York et retour avec Duchamp, Dada et le Surréalisme," *Paris-New York, 1908-1968*, Paris, Musée National d'Art Moderne, Centre Georges Pompidou, 1977, p. 102.

4. Christian Brinton, "Evolution, not Revolution in Art," *The International Studio*, April 1913, p. 27; reissued in *The Armory Show, International Exhibition of Modern Art*, New York, Arno Press, 1972, vol. III.

5. Milton Brown, *op. cit.*, p. 26.

6. Excerpt from *Iphigenia in Aulis* by Euripides. The exhibition catalogue was entitled *International Exhibition of Modern Art* (1913, n.p.); reissued in *The Armory Show, op. cit.*, vol. I.

7 Walt Kuhn, *The Story of the Armory Show*, New York, 1938, p. 25; reissued in *The Armory Show, op. cit.*, vol. III.

8. 12 December 1912 letter from Walt Kuhn to Arthur B. Davies, in *Walt Kuhn Papers, op. cit.*, reels D72-D73.

9. Milton Brown, *op. cit.*, p. 57, no source indicated.

10. 12 December 1912 letter from Walt Kuhn to Walter Pach, in *Walt Kuhn Papers, op. cit.*, reels D72-D73.

11. *Ibid.*

12. *Art & Decoration*, special issue on the Armory Show, February 1913, p. 150; reissued in *The Armory Show, op. cit.*, vol. III.

13. Walter Pach, "Hindsight and Foresight," in *For and Against*, p. 27.

14. Frederic James Gregg, "Preface," *International Exhibition of Modern Art, op. cit.*

15. Arthur Jerome Eddy, *Cubism and Post-Impressionism*, Chicago, A. C. McCleng, 1914, p. 4.

16. John Quinn, "Modern Art from a Layman's Point of View," *Art & Decoration, op. cit.*, p. 158.

17. *Walt Kuhn Papers, op. cit.*, reels D240-D242.

18. Walt Kuhn, *The Story of the Armory Show, op. cit.*, p. 25.

19. Milton Brown, *op. cit.*, p. 130, no source indicated.

20. Adeline Adams, "The Secret of Life," *Art and Progress*, April 1913; in *Walt Kuhn Papers, op. cit.*, reel 1191.

21. Even on the part of Art Nouveau's defenders, there was frequent opposition between the feminine and artificial Parisian culture and the virility of the young American culture. See Arthur Jerome Eddy's chapter on "L'Impressionisme Viril" of American artists, in *Cubism and Post-Impressionism, op. cit.*, p. 196 and *passim*.

22. "The New Art: Kenyon Cox on 'Futurism' and 'Cubism'," *For and Against, op. cit.*, p. 37.

23. René Brimo, *L'Evolution du Goût aux Etats-Unis d'après l'Histoire des Collections*, Paris, 1938, pp. 77-78: "This time of scientific minds...which deeply believed in Taylorism and in progress, find also people of the elite...who, on the New Continent, provided important examples of global art."

24. Letter to his wife Véra, October 28 1912, in *Walt Kuhn Papers, op. cit.*, reels D240-D242.

25. Milton Brown, *op. cit.*, p. 194. He quotes Jerome Myers, one of the AAPS members: "Our land of opportunity was thrown wide open to foreign art, unrestricted and triumphant, more than even before, our great country had become an art colony ; more than ever before we had become provincials." (No source indicated.)

26. Walt Kuhn, *The Story of the Armory Show, op. cit.*, pp. 25-26 : "Industry certainly took notice. The decorative elements of Matisse and of the Cubists were immediately taken as models for the creation of a more colorful and more lively America."

The Art of Light

Colors, Sounds, and Technologies of Light in the Art of the Synchromists

In 1909, the American painter Morgan Russell settled in Paris. Two years later, he met another American artist Stanton Macdonald-Wright in the studio of the painter Percyval Tudor-Hart. Two years after that, in 1913, these two Americans presented their chromatic works to the French public under the name "Synchromism."[1] At the 1913 Salon des Independents, Russell exhibited his painting *Synchromy in Green*. The work itself has been lost, but a surviving photograph captures Russell's characteristic figurative elements (a piano, some fruit, a composer). Guillaume Apollinaire called it "a vaguely Orphic painting."[2] Three months later, Russell and Macdonald-Wright, who wanted to make a clean break from Delaunay Orphism, exhibited a series of interiors and still-lifes at the Neue Kunstsalon in Munich (fig. 1). Although the autonomy of color was not always fully realized, they addressed the question in a manifesto that marked their entry into the debate about pure painting. It was in the exhibition *Les Synchromistes*, which opened on October 27, 1913 at the Parisian gallery Berheim-Jeune, that Russell presented his first abstract work, *Synchromie en Bleu-Violet* [*Synchromy in Blue-Violet*]. The text he wrote for the exhibition catalogue defended the introduction of a temporal factor into the inert field of painting as an alternative to its potential depletion in the face of the fast-paced technological advances of the modern era: "In order to resolve the problem of a new construction of painting, we have viewed light as interconnected chromatic waves, and we have studied very thoroughly the harmonic relations between colors. In a sense, these color rhythms incorporate the idea of time into painting: they give the illusion that the painting evolves, like a musical

Fig. 1
Morgan Russell,
Poster for "Der Neue Kunstsalon", 1913.
Gouache and ink on paper,
41 1/2 x 26 1/2"
(105.41 x 67.3 cm).
The Montclair Art Museum. Gift of Mr. and Mrs. Henry M. Reed.

score, over time, while the old painting style spread out strictly in space—with just one glance, the spectator could simultaneously grasp all its levels."[3] Relying on what had been called color music[4] since the end of the 19th century, the Synchromists wanted to replace the classic medium of oil on canvas with light bulbs or projectors. Indeed, in a more hybrid way, they wanted to bring paintings on translucent paper to life by back-lighting them in varying intensities, so that they could eventually create enchanting chromoluminous works on a large screen. In so doing, Russell and Macdonald-Wright defended a cinematic modernism that, beyond the formal specificity of the medium, acknowledged the impact of recent lighting technologies on the resurgence of pictorial grammar, while still reflecting the fluidity of contemporary modes of perception.

Color Music: The Musical Analogies of Pure Painting

Discussed early on in esthetic treatises[5] and very prevalent in Romantic and Symbolist circles, the theory of an analogy between painting and music haunted the turn of the century and provided one of the keys for interpreting abstraction's beginnings.[6] Painters such as Kandinsky, Picabia or Kupka affirmed the semantic autonomy of color by modeling it on the anti-descriptive purity of music, as Russell did in 1912: "The subject being merely an excuse for the making of a work beautiful in itself by its relations of forms, movement, colors such as a musical symphony."[7] Russell's own training as a musician favored this analogical reflex. In his notes, he left numerous scores that confirm the importance of musical vocabulary to his painterly research. In the United States, he had studied with the painter Robert Henri, who had advised him to read attentively the musical model in Signac's treatise. Henri

also had taught a pictorial formalism in his studio, in which "the orchestration of color" was clearly presented as an alternative to a kind of painting that merely copied nature.[8] In Paris, Russell and Macdonald-Wright rediscovered this analysis in the studio of Percyval Tudor-Hart, who at that time was circulating his work on the relationships between sounds and colors at the Institut Général Psychologique.[9]

Following in Tudor-Hart's footsteps, Russell and Macdonald-Wright were interested in the synesthesic phenomenon of "correspondences." Preserved in Russell's archives was a 1911 article that treated the question of hearing colors. The author, Emile Gautier, in a rather Darwinian lecture, announced the arrival of a new art of sensory concordances: "Not only will we hear the voice of colors: we will also perceive their odor, their taste, their shapes, their movement, their intimate life. We will learn to combine them, so as to bring about states of consciousness and moods, to inspire feelings, to

plant ideas, to manipulate crowds. The painter, succeeding the orator, will be king of the world."[10] In this way, music was invoked not only for its abstract qualities—founded on its own language and "divorced from the real world"—but also because its hypnotic hold on the spectator seemed much more powerful than that of visual language. That is what the entire trend of psychological esthetics was affirming at the time. It turned its attention to the precise connections between musical language and the layers of the unconscious—a theory that Russell encountered in September 1912 in a book by Jules Combarieu.[11] Purity in painting thus draws a double—usually contradictory—paradigm from the musical model: abstraction versus empathy. Stanton's brother, the art critic Willard Huntington Wright, discussed this very subject in his book, *Modern Painting. Its Tendency and Meaning*. In one introduction, written in Paris before the war, he emphasized the "emotional ecstasy" of "color-rhythm:" "Painting should be as pure an art as music, and the struggles of all the great painters have been toward that goal. Its medium—colour, is as elemental as sound, and when properly presented…it is fully as capable of engendering æsthetic emotion in music. Our delight in music, no matter how primitive, is not dependent on an imitation of natural sounds. Music's pleasurable significance is primarily intellectual. So can painting, by its power to create emotion and not mere sensation, provoke deep æsthetic feeling of a far greater intensity than the delight derived from transcription and drama. Modern painting strives toward the heightening of emotional ecstasy; and my *esthétique* is intended to pave the way for an appreciation of art which will make possible the reception of that ecstasy."[12]

The painter, therefore, should intensify color so that "its power…equals that of music,"[13] without sacrificing, in the process, his visual integrity to a too-psychological use of chromatism. It is by emphasizing the physiological quality of the language of colors that the Synchromists wanted to separate

themselves from the European tendency of pure painting; for this reason, they reproached the Goethean heritage of Kandinsky's work. According to Wright, the European painters, under the influence of the German psychological esthetic (notably Worringer's), had favored the emotional code of chromatism at the expense of its physical qualities. To the feminine and decadent approach of the Continental "Expressionists," which was founded on the principle of psychological resonance, he contrasted the more rational, physiological, and "masculine" approach of the Americans: "Their insight extended only to the emotional and associative characteristics of the colours ; the physical side was was overlooked. Had the painters been more scientifically minded they would have known that these characteristics, which were the feminine traits, could not have existed in isolation; and they would have searched for the colours' dominating and durecting properties which represented the masculine traits. Such a search would have led them to the meaning of colours, in relation to volumes, that is, to colours' formal vibrations which alone are capable of expressing plastic fullness."[14]

The genre question was not entirely new in American criticism, which sought to distinguish art on the other side of the Atlantic from the dominant pole of the Parisian scene, notably based on the cliché of an America invested, under the aegis of pragmatism, in the cult of action.[15] In fact, it was not solely the "feminine" nature of psychologism that was attacked here, but also the "musical transcendentalism"[16] of Kandinsky's manifesto, *The Spiritual in Art*, to which Wright contrasts his "biological" interpretation of color word for word (fig. 4 and 5). Readdressing the question of the stigmatization of Post-Romanticism spread throughout Europe by Max Nordau, he called Kandinsky "decadent" for having favored the esoteric interpretation over the "visual meaning of color."[17] Just as in Robert Delaunay's work,[18] it was about defending the physical density of chromatism, the very physical underlayer of the

Fig. 4
Morgan Russell behind sculpture in his studio, Paris, c. 1910.
The Montclair Art Museum.

Fig. 5
Morgan Russell,
Study for Synchromy in Orange: To Form,
1913-14. Lead pencil on paper (verso),
6 1/4 x 8"
(15.9 x 20.3 cm).
Private collection.

mobility of colors: "Art, in all of its manifestations, is, in its final analysis, an interpretation of the laws of bodily rhythm and movement."[19]

In fact, the synesthesic theory that Wright defended relied on a motile, even muscular, interpretation of artistic understanding, like that advanced by Dalcroze at this time. By the notes he left, we know that Russell had studied the method of Emile Jaques-Dalcroze.[20] In it, he found an entire system of movement and of "gesture" for the construction of an individual consciousness when the interior music imposes, through rhythm, the "driving images" that propel one towards action (ideodynamism). One of the major proponents of the Dalcrozian method in France was Albert Cozanet, alias Jean d'Udine, who was closely linked to the review *Montjoie!*, on which Russell collaborated. They probably met during the evening gatherings called the "Grenier de *Montjoie!*" In 1910, D'Udine published *L'Art et le Geste*, in which he developed a theory of sensations based on the rhythmic perception of touch.[21] Like Russell, Wright embraced this monistic logic. Between music and dance, the rhythm endowed the perception of colors with a temporal dimension that inscribed the contemplation of the work into a more concrete perceptive reality. Wright believed that one had to appeal to all the senses in order to capture the spectator's attention. Each sense corresponded to a level of consciousness necessary to understand events;

taking away one of the densities of sensory experience (volume, color, sound…) was like amputating the degree of tangibility of the esthetic challenge. Wright rejected the pure and disincarnate visual orientation of modernism, and based the acuity of esthetic perception on a total coordination of the senses: "The process of perceiving a work consists in associating the different sensations produced by its various individual factors. Such a process requires active mental participation."[22] He thus established a distinction between "sensational art" and "perceptive art." The first implied an immediate, rather passive, experience, in which Wright, following the sexual interpretation, heard a feminine resonance (emphasizing, like many others at that time, a link among oculocentrism, modernism and masculinity).[23] The second, a more cerebral and contemplative experience, demanded a more elaborate degree of attention, which separated the passivity of the brain from the ephemeral basis of optical stimulus: "In Defense of Complex Art."[24]

This kind of analysis sheds light on the stylistic evolution of the Synchromists toward more elaborate chromatic arrangements, like Kandinsky's passage from "Impressions" to "Improvisations" and then to "Compositions." The numerous sketches left by Russell and Macdonald-Wright testify to their growing sophistication in exploiting the colors of the prism; they displayed a broad range of relational balances between areas of warm colors (yellow, orange) and cold colors (blue-violet, green) (fig. 6). Color was unveiled within a play of binary contrasts that became more and more geometric and whose arrangement demanded closer attention from the spectator: "The more conscious our process of perception, the keener our ecstasy. Awareness is the vitaly of aesthetic comprehension: the intellectual emotion transcends the physical…. In order for forms to be appreciated to their full, the spectator must consciously perform the operation of perception."[25] Here Wright formalized what Jonathan Crary identifies today as one of the driving forces

behind the revolution of the gaze that resulted from modernism: the ability to manage attention which allows the spectator to maintain a coherent but not exclusively optical sense of the world by means of a productive and controllable subjectivity.[26]

The Kinetic Light Machine: Modernism and the Technology of Light

Thus, the Synchromists sought to develop the motile potential of painting; in their view, it was a necessary adaptation to counter the ephemerality of contemporary cognitive modes[27]—what Russell

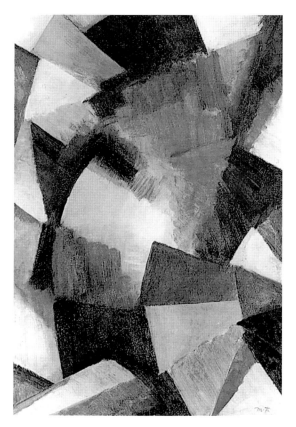

Fig. 6
Morgan Russell, *Synchromy in Blue-Violet*, 1913.
Oil on canvas, 10'4" x 7'6" (314.9 x 228.6 cm).
Minneapolis, The Regis Corporation.

called the "intensive cerebrality of today."[28] In 1912, they tried to perfect a mechanism for animating color through luminous projection: "The medium of this new art will be light, namely: color in its purest, most intense form.... The color-organ, in fact, is the logical development of all the modern researches in the art of color. It is the only means whereby pure color-forms may be significantly projected.... The Synchromists were the first 'school of painting' to foresee this future of the color-art."[29] This developmental theory was spread in the United States by many critics, ranging from Arthur Jerome Eddy[30] to Sheldon Sheney,[31] who predicted that pure painting would slide toward an art of light. Among these critics, Matthew Luckiesh stood out for a series of works he published between 1915 and 1918. A physician, director of a research laboratory at the General Electric Company, and author of a treatise on *The Language of Color* and various articles on "mobile color,"[32] Lukiesh published a text in 1917 whose title, *The Lighting Art*,[33] acquired the statute of a manifesto. Although he had doubts about the analogical methods of color music,[34] which to his mind were too indebted to Symbolist principles, Luckiesh presented the artistic use of electric light as a decisive way to overcome the inertia of the pictorial field, by endowing colors with real mobility. Lighting art was presented as the natural development of the first qualitative leap of abstract art ("formless paintings"): "man's most abstract achievement in art."[35]

This was precisely the evolutionist discourse Wright adopted when he established the direct causality between the medium's technological nature and the work's empathetic efficacy: "The modern artist has come to realize that the media of art have never been fully sounded, and that only by perfecting the purely mechanical side of his art can he achieve that new intensity which to-day is so needed.... It is for this reason that the prescient modern artists are experimenting, some with new instruments and methods of archestation, some with the functionings of

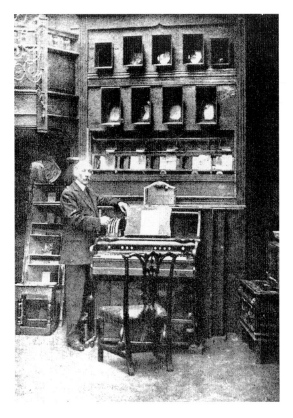

Fig. 7
Professor Alexander
Wallace Rimington and
his color-organ.

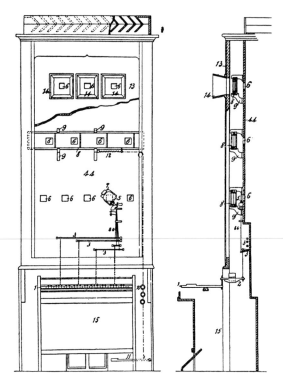

Fig. 8
Diagram of Alexander
Wallace Rimington's
color-organ in *Colour
Music. The Art of Mobile
Colour*, London,
Hutchinson, 1912.

pure color."[36] To the Baudelairian figure of "the painter of modern life," who was satisfied with illustrating the world's changes using unchanged means, Wright contrasted an authentic modernism that found in the new lightings an artistic support both flexible and malleable, fluid and in synch with the world: "Methods and not the content determine the degree of modernism of an artist."[37] To the European "old modernists" (Futurist and Orphist painters together) Wright contrasted Russell and Macdonald-Wright's electric projects.

The idea of calling upon a system of luminous projection appeared very early on in the Synchromists' work, in September 1912. Far from being an isolated incident, this artistic research into the cinematic development of painting coincided with other contemporary developments that Wright was eager to suppress, either from ignorance or from partisanship. Between 1911 and 1912 in Italy, the brothers Arnaldo and Bruno Ginanni-Corradini developed the rudiments of abstract cinema. Bruno wrote an essay on chromatic music in which he discussed the mechanism of a keyboard of colors and certain experiences from the first color films. The same year, Leopold Survage began his series of "Rythmes colorés [Colored Rhythms]," which he wanted to develop into a series of cinematographic sequences; and Vladimir Baranoff-Rossiné invented and perfected his "optophonic piano." Each of these experiments involved the shattering of the academic distinction between arts of space and arts of time, favoring that which then appeared as the most successful form of pure painting: an enchanting realm of mobile chromatic forms. The idea was not new. It had already existed in the 18th century with the Jesuit Louis-Bertrand Castel's "ocular harpsichord." Interest in the idea was renewed however, at the turn of the century, when artists were searching for ways to build new instruments able to capture and to dazzle the spectator's eye with colors in motion.[38] At the forefront of this movement was a professor at Queen's College in London, Alexander Wallace Rim-

ington, (fig. 7) who in 1895, disseminated theories of color music.[39] His performances received a good deal of attention in the United States.[40] They benefited from the renewal of interest in his work generated by the 1912 reedition of his book, *The Art of Mobile Colour*[41] (fig. 8), though it was only later, in France, that Russell discovered Rimington's work. This is confirmed by the presence in Russell's archives of an article by Lucien Chassaigne devoted to Rimington's performances of "luminous music" published in August 1913 in the Journal: "M. Rimington's apparatus looks exactly like a church organ, a series of keys ending in electrical contacts that project various beams of light. The intensity of the lighting is 13,000 candle-power, its intensity is modifiable through a pedal that acts on the rheostats in such a way as to create what in music is called piano and forte effects.... So equipped, the author truly plays his luminous symphony. Slowly or rapidly, following his inspiration, he projects various colored chords; it is said that the resulting sensations are exactly the same as those experienced when listening to an orchestra."[42]

Although Russell and Macdonald-Wright had imagined such a light machine very early on, they lacked the resources necessary to finance its construction: "Now all we're waiting for...is the money we need to build the machines.... We are waiting for a sublime 'madman,' such as King Ludwig II, in order to give birth to this ultimate art: The Art of Light."[43] In the autumn of 1913—a date that seemed to confirm the emulation aroused by Lucien Chassaigne's article—Russell envisioned building an apparatus he hoped to present in Europe and the United States, in performances that would give "birth to a new art."[44] The ultimate objective was a cinematographic animation of painting,[45] possible only with considerable financial and logistical support. Such support was not to be forthcoming. Russell, however, was already preparing a first "apparatus that, by simply reducing the luminosity of the screen, or of the lamps...would reduce the intensity of the col-

ors." This project, more rudimentary than the filmed sequences, led him to produce a first series of translucent paintings on paper which, when positioned within a luminous box and lit by lamps equipped with dimmers, produced a play of pulsating chromatics.

Today the sketches for this machine are preserved in the Morgan Russell archives (fig. 9 and 10) at the Montclair Art Museum. Both the design and the handwritten notes indicate how it would work: numerous mobile lightbulbs, activated by a "photographer's pear switch," in front of which painted rolls would move, turned by a handcrank: "Behind are the two 'pear switches' and one of the lamps, which is moved manually backward or forward.... A more perfected apparatus would have a keyboard of six keys or light switches—one for each lamp and one for each roll, activated by the switches. One hand would suffice to work the keyboard; the other would remain free for the mobile lightbulb [sic]."[46] The basic mechanism, then, was that of cinematographic animation, according to a principle closely related to the archaic workings of magical lanterns, to which Russell explicitly refers in his handwritten notes of 1914.[47] One small sketch shows an example of a roll with a rhythmic succession of light and dark bands, painted directly on translucent screens.[48] Morgan Russell called his invention the light organ, which he modified slightly several times. In his 1924 notes, he once again took up the idea of a machine equipped with six mobile lamps and modulated by a rheostat that projected colors on to a movable screen.[49] In this way, Russell defined two "classes" of Synchromies: the "Eidos," composed of colors alone, and the "Synchromies," composed of lines and graduated color that generated a greater "sensation of space-light" by using "two superimposed reels, turning in opposite directions at the same speed." The notes also inform us that the rolls were made of wax paper and painted in oil, by brush, and even by palette-knife. The rotational speed of the rolls was adjusted by a pedal-

controlled electric motor, like that of a sewing machine. In order to play on the chromatic variations of the "Synchromies," Russell superimposed the films by crisscrossing the rolls—one going from left to right, the other from bottom to top, or one roll laid directly against another, rotating at the same speed.[50] He wondered about the possibility of "camera angles, shooting a film" for a cinematographic adaptation.[51]

His correspondence with Macdonald-Wright, who had returned to the United States in 1916, certainly pushed him in this direction. In fact, after returning to California, Macdonald-Wright had begun to produce a voluminous body of work in pastel (almost 5,000 drawings, the artist estimated), intended to be the sequences of an abstract film. Although camera shots were taken, nothing remains of the film today, the negatives having been destroyed in the early 1920s in the explosion of the Blum Laboratories in Hollywood. Macdonald-Wright's technical collaborator, Walter Wight, an engineer, helped him resolve technical problems; together they created the Synchrome Corporation, which held the patent for a system of adding color to images. Russell, who had no such similar logistical support, was still limited to colored screens. Because he was unsuccessful at transferring the images to film, he decided to accompany the rhythm of the chromoluminous variations with a foundation of sound that could hold the spectator's attention, without diminishing or distracting from the scenographic orientation of the experience. An intermediate step opened up with the "Eidos" series, abstract Synchromies that Russell envisioned projecting on to screens with musical accompaniments. Five of these "Eidos (synchromatic themes) for a sight Synchromy" were presented in Paris in 1923, at the Galerie La Licorne. But the kinetic light machine project rapidly grew to embrace a more spectacular concept in terms of the surrounding space. According to Russell, the projections of colors should ultimately take the form of "pyrotechnical" events, which Elie Faure, in a text

published in July 1921, called "spatial Synchromies:" "This spiritual appropriation of space, emptied of any animated forms but thoroughly reverberating with melodic waves, that invite the mind to wander and which gently rock it—no longer through the sense of hearing but through that of sight—led him to look at material space itself as a giant keyboard, where, with the aid of electric light that is captured, colored, directed, spread, intersected by rays and dust and beams in the atmosphere, he would compose spatial Synchromies whose continuously perfected complexity and splendor would be limited solely by the available technical means. Morgan Russell was a poor American waiting for the rich American to come along who could lift his heart up to the level of these festive spectacles and of these aerial dramas."[53]

"Entertainment Art Form:" the Orphic Drama of the "Luminous Synchromies"

This dramatic conception of light as spectacle—a theatrical cornerstone of the World's Fairs at the end of the 19th century and the very basis of the Wagnerian esthetic[54]—found an ardent admirer on the Parisian avant-garde stages of the early 20th century in the person of Ricciotto Canudo, the mentor of the revue *Montjoie!*, on which Russell collaborated.[55] His encounter with the Italian was apparently decisive for Russell, both in the development of his cinematic painting project[56] and in his evolution toward a system of spectacle that used light to recount the great mythic epiphany of forms. Canudo—who defended the direction of Synchromism toward the art of mobile color[57]—was in fact the great advocate of total spectacle in the Orphist circles. A music critic and pionneer in the artistic recognition of the cinema, he defended in his writings the synesthesic ideal of a fusion of the arts: "We know today that all the rhythms, mute or sounded, visual or musical, if they touch our sensibility… are strengthened by their re-

ciprocal virtues; any painting, looked at while hearing isochrone and isochrome music, communicates an emotion 10 times more intense than it would have been capable of communicating to us separately."[58]

The passage from "sight Synchromies" to "Luminous Synchromies" illustrated this cumulative process by responding to the musical influence on sight. Canudo had analyzed this in his 1911 "Essai sur la Musique comme Religion de l'Avenir,"[59] in which he endowed musical emotion with the indeterminate and volatile status of an abstract form in constant evolution. This was exactly the artistic position presented in the abstract series the "Eidos"— the eye devours luminous embryonic forms, the hypnotic impact of which gives access to what Canudo called, with a hint of mysticism, "the obliteration of the vision of the world through sensation."[60] The spectator was plunged into the rhythmic sputterings of pure colors in order to better melt into the inchoate reality of his unconscious. The colors in action gave rise to a kind of optical vertigo, a troubling feeling in the spectator, who, in a daze, relives simultaneously the origin of the world and his own birth as the musical unconscious forces the individual to commune with his own biological evolution.[61]

This embryological interpretation reappeared in numerous analyses devoted to the first perfomances of color music. The poet Blaise Cendrars described in this way the model of the "*paturition*" to discuss the "Rhythmes coiorés" of Survage,[62] just as the American Mary Hallock Greenewalt (fig. 11) did in her first texts on the art of light, which compared the rhythmic scansion of the colors enveloping the spectator to the primitive sensations of the fetus floating in amniotic fluid.[63] In so doing, Greenewalt employed an analogy in common use widespread at the time in treatises on musical esthetics. Denton Snider, another American, re-addressed it in his 1913 study of the relationships between music and the fine arts, in which he discussed "the genetic unity of music" and

Fig. 11
Mary Hallock Greenwalt
at the console of
her Sarabet, 1919.

its ability to reproduce the "primordial process of individuation."[64] The Synchromists were susceptible to this biological paradigm. Willard Huntington Wright drew out the cellular metaphor to discuss Russell's "Synchromies" by comparing the centrifugal movement of the colors to the principle of auto-generation of a "melodic composition."[65] This accounts for the presence of the term "genesis" in the titles of the first "Synchromies." Indeed, Macdonald-Wright adopted it many times, and Russell employed it in direct reference to the first chapters of the Bible, when the Word, transported by color, was embodied in a glimmer of light.

For Canudo, the artistic work that best exemplified this autogenetic luminous creation was not a painting but a musical composition, Beethoven's Ninth Symphony, "the profoundly metaphysical vision in sound of the creation of our universe, the great book of Genesis."[66] The Ninth Symphony evolves from chaos in the beginning to an undefined form, in a maelstrom of sounds dominated in the end by the Orphic cry of light; this original cry coincided with the avant-gardist fantasy of a pure and intuitive language that rejected any conventional formalism. As Macdonald-Wright reminded us in retrospect, it was while listening to the music of Beethoven that the two American painters created their first Synchromies in Paris,[67] and Russell again referred to Beethoven later, when he discussed the musical accompaniment of the "Eidos."[68] The coincidence deserves to be noticed. Now, in retrospect, it seems to illuminate the source of Russell's unprecedented 1922 project of the first great "Synchromie Lumineuse," the *Grande Synchromia à la Vue en 4 Parties et en 13 Thèmes.*

Canudo divided Beethoven's symphonic narrative into four movements. In the first, Humankind emerged from the great luminous chaos: "Le Brouillard cosmique (La Formation des Mondes) [The Cosmic Fog (The Formation of the Worlds)]." Then came "La Marche des Mondes (La Naissance de la Terre) [The March of the Worlds (The Birth of the Earth)]," followed by "La Nuit Religieuse (La Naissance de l'Homme) [The Religious Night (The Birth of Mankind)]." It ended with "Le Triomphe de l'Homme [The Triumph of Humankind],"which formed a cosmic epilogue in which color—more and more vivid and contrasted—triumphed over the original molten elements. For his first great project of "Synchromie Lumineuse," Russell used the same composition. Relying on the biblical story of Genesis to provide the structure,[69] he divided his Grande Synchromia into four "parts," and gave each one a chromatic dominant: orange for the first, white for the second, turquoise for the third and purple for the fourth:

" 1re partie : L'Homme, la lumière, le feu

Thème A : Et Dieu créa l'Homme à son image

B : L'œil s'ouvre à la lumière

C : Et Dieu sépara la lumière d'avec les ténèbres

D : Foyer

E : Flamme

2e partie : La Féerie florale

F : Kaléidoscope aux roses

G : Kaléidoscope à toutes les fleurs

3e partie : Nocturnes

H : Nox (nuit)

I : Aurora

J : Nocturne saturnienne

4e partie : La Merveille sidérale

K : Au seuil de ces mondes par cent couleurs de cent soleils éclairés

L : Le jour sans fin d'une terre de ces mondes

M : Kaléidoscope à la lumière

Nous t'adorons

Lumière

Aux sept couleurs

Sœur éthérée du son."[70]

The colors evolved in a discontinuous rhythm, with potentiometers varying their tints and intensities. The show's finale, the "Kaleidoscope of Light," was a phantasmagoria in which the passage of the colors through the spectrum was accelerated—a final bouquet wherein Russell literally translated Beethoven's symphonic poem into colors. Neither the musical score that was supposed to accompany this spectacle of light nor the technical details of the "pyrotechnics" have survived, but Russell's scenario was largely indebted to Canudo, whose scenographic principle was exemplified by his reinterpretation of Scriabin's famous synesthesic spectacle, *Prometheus* or the *Poem of Fire, Opus 60*, which premiered at New York's Carnegie Hall on 20 March 1915.[71] The stage, lit by a chromatic keyboard baptized Chromola, progressively changed color from yellow to purple, re-enacting the "creative principle of light,"[72] exactly as in Rimington's pioneering light shows at St. James Hall in London (6 June 1895) and in Loie Fuller's first *Danses Serpentines* in 1892.[73] In each case, by acting out the original drama of burgeoning nature, through the precariousness of imponderable forms sought to hypnotise the spectator with the enchantment of colors in movement:[74] "The pyrotechnics already amazed the spectator, and raised it to the power of a sublime art—then an art of more modest means through the luminous screen—arts of an unheard-of power, dormant at first, then illuminating the mind through the divine intoxicaation of the senses—the real goal of all superior art—that is what it is about."[75]

Although none of these monumental Synchromies ever saw the light of day, they nevertheless highlighted the sublime ascendancy of modernism as defended by Russell and Macdonald-Wright. The change of scale referred less to this feeling of dimensional rupture, which was proper to the Romantic conception of the sublime than it suggested, within a revival of the Wagnerian project, a clear participative orientation of the artistic experience, couched in a trenchant criticism of the domesticity

of art. There again, Canadu's influence was obvious, measured against a thoroughly American modernity in which the culture of entertainment secularized the experience of the sublime. For Macdonald-Wright, the obsolescence of the pictorial medium was not only linked to his technical archaism, but also to his particular domestic destiny.[76] He believed that, because art was contemplated collectively and experienced as a fusional event, the art of mobile color would, by its very nature, be more democratic than painting.[77] It would be the only art in symbiosis with the era of a productive sharing of emotions. Russell, having returned to a much more traditional painting, would fail to seduce the "great American art patrons." His "Synchromies Lumineuses" cut to the very heart of the democratization of art. In postwar capitalism and American popular culture however, the art of color music found a field ripe for development. That was what triumphed during the rendezvous with modernity, in the great World's Fairs of arts and engineering, and the luminous spectacles of Thomas Wilfred (fig. 12), Mary Hallock Greenewalt or Adrian Klein. The spectacular aspect of lighting art melded with the "electrical sublime"[78] of technology.

Pascal Rousseau

Fig. 12
Thomas Wilfred
preparing a composition,
no date.

Notes

I would like to thank Francis Ribemont whose help made the research for this essay much easier.

1. As William C. Agee remembers it, the term was not unheard of in the Parisian avant-garde circles, contrary to what Russell may have said about having invented the expression. Three of the works presented by the Nabi painter Paul Sérusier at the 1910 Salon des Indépendants carry this title. One year later, at the 1911 Salon, two of Sérusier's works were also so entitled (William C. Agee, "Morgan Russell, Then and Now: Notes on an American Modernist," in Marilyn S. Kushner, *Morgan Russell*, New York, Hudson Hills Press, 1990, p. 18). Stanton Macdonald-Wright, who frequented the Julian Academy, could have been in contact with Sérusier.

2. Guillaume Apollinaire, "A Travers le Salon des Indépendants," *Montjoie!*, 18 March, 1913.

3. Morgan Russell, in exhibition cat. *Les Synchromistes. Morgan Russell et S. Macdonald-Wright*, Paris, Galerie Bernheim-Jeune, 27 October-8 November 1913, n.p.

4. Concerning the genealogy of these projects, see Adrian Bernard Klein, *Colour-Music: The Art of Light*, London, Technical Press, 1926.

5. Herbert M. Schueller, "Correspondence between Music and the Sister Arts According to the Eighteenth-Century Aesthetics and Art Criticism," *Journal of Aesthetics and Art Criticism*, XI, June 1953, pp. 324-33.

6. See namely Howard Risatti, "Music and the Development of Abstraction in America: The Decade Surrounding the Armory Show," *Art Journal*, no. 39, 1979, pp. 8-13; Judith Zilczer, "Color Music: Synaesthesia and Nineteenth-Century Sources for Abstract Art," *Artibus et Historiae*, vol. 16, 1987, pp. 101-26.

7. Morgan Russell, hand-written notes, around 1912, Fonds Russell, Montclair Art Museum, microfilm copy at the Smithsonian Institution, Archives of American Art, New York, roll 4534.

8. "When art becomes more principled, more fundamental, when it concerns itself with reproduction of material objects with all their technical insignificance, but with the underlying constitution of nature, the public will find art easy and beautiful, and as satisfying as music." (Robert Henri, quoted in Hutchins Hapgood, "Insurgents in Art," *The Globe and Commercial Advertiser*, 24 October 1911, p. 6, reprinted in Howard Risatti, art. cit., p. 10.) See also Robert Henri, *The Art Spirit* [1923], Philadelphia, Lippincott Company, 1930.

9. Concerning Tudor-Hart's chromatic theories, see notably Percyval Tudor-Hart, "Exposition et Critique des Ouvrages de M. de Lescluze," *Bulletin de l'Institut Général Psychologique*, no. 5-6, 1910, pp. 505-31; "A New View of Colour," *Cambridge Magazine*, 23 February 1918, pp. 452-6; "The Analogy of Sound and Colour," *Cambridge Magazine*, 2 March 1918, pp. 480-6.

10. Emile Gautier, "La Couleur des Sons et le Son des Couleurs," *Le Journal*, 3 July 1911.

11. Jules Combarieu, *La Musique: Ses Lois, Son Evolution*, Paris, Flammarion, 1907, p. 288. We find a reference to this work consulted by Russell at the Saint-Geneviève library in his hand-written notes from September 1912 (Fonds Russell, *op. cit.*, roll 4535).

12. Willard Huntington Wright, *Modern Painting. Its Tendency and Meaning*, New York, John Lane, 1915, p. 10. Concerning criticism of the musical analogy adopted by the Synchromistes, see notable George Soule, "The Musical Analogy in Painting," *New Republic*, VI, 8 April 1916, pp. 258-60; Charles Caffin, "Last Week: Forum Exhibit of Modern American Painters," *New York American*, 29 March 1916, Alan Burroughs, "New Books," *The Arts*, May 1923, pp. 368-9.

13. Morgan Russell, hand-written notes, October 1912, Fonds Russell, *op. cit.*, roll 4535.

14. Willard Huntington Wright, *Modern Painting*, *op. cit.*, p. 293.

15. Wanda M. Corn, *The Great American Thing. Modern Art and National Identity, 1915-1935*, Berkeley, University of California Press, 1999.

16. Willard Huntington Wright, *Modern Painting*, *op. cit.*, p. 302.

17. *Ibid.*

18. Other than Apollinaire, numerous critics in France have noted the formal proximity of Synchromism with Delaunay Orphism. See notably Gustave Kahn, "Les Synchromistes," *Mercure de France*, 1 November 1913, pp. 426-8; V. de Vaugironne, "Une Nouvelle Ecole: le Synchromisme," *Revue Moderne*, 25 November 1913, pp. 12-4; Gustave Coquiot, *Cubistes, Futuristes et Passéistes*, Paris, Ollendorf, 1914, pp. 177-87.

19. Willard Huntington Wright, *The Creative Will. Studies in the Philosophy and the Syntax of Aesthetics*, New York, John Lane, 1916, p. 11.

20. In Russell's hand-written notes, we find a reference to *Gammes et Tonalités*, one of the volumes of the Jaques-Dalcroze method which Russell had consulted at the Sainte-Geneviève Library (Emile Jaques-Dalcroze, *Méthode Jaques-Dalcroze pour le Développement de l'Instinct Rythmique, du Sens Auditif et du Sentiment Tonal*, Neuchâtel, Sandoz, 1906).

21. Jean d'Udine, *L'Art et le Geste*, Paris, Alcan, 1910. About Udine's influence on Orphist circles, see our article "Confusion des Sens. Le Débat Evolutionniste sur la Synesthésie dans les Débuts de l'Abstraction en France," *Cahiers du Musée National d'Art Moderne*, no. 74, 2000, pp. 3-33, and Arnauld Pierre's excellent article, "Picabia, Danse, Musique: une Clé pour Udine," *Cahiers du Musée National d'Art Moderne*, no. 75, 2001, pp. 58-81.

22. Willard Huntington Wright, *The Creative Will*, *op. cit.*, p. 240.

23. See notably R. Felski, *The Gender of Modernity*, Cambridge, Cambridge University Press,

1995; L. Tickner, "Men's Work? Masculinity and Modernism," *Differences*, no. 4-5, 1992, pp. 1-37.

24. Willard Huntington Wright, *The Creative Will*, *op. cit.*, p. 263.

25. *Ibid.*, pp. 283-4.

26. Jonathan Crary, *Suspensions of Perception. Attention, Spectacle and Modern Culture*, Cambridge, MIT Press, 1999.

27. We note the link that Wright established between the technological modality of art and capturing attention: "There is no escaping the effects of this art, once contact with it has been established. *It is distracting and absorbing.*" (Willard Huntington Wright, *The Future of Painting*, New York, B. W. Huebsch, 1923, p. 30). This link precisely corroborates Crary's analysis of the recomposition of a "productive" subjectivity at the time of Taylorism (Jonathan Crary, *Suspensions of Perceptions, op. cit.*, p. 2).

28. Morgan Russell, hand-written notes, April 1913, Fonds Russell, *op. cit.*, roll 4535.

29. Willard Huntington Wright, *The Future of Painting, op. cit.*, p. 47.

30. Arthur Jerome Eddy, "Color Music," *Cubists and Post-Impressionism*, Chicago, A. C. McClurg, 1914, pp. 140-6.

31. Sheldon Cheney, *A Primer of Modern Art*, New York, Horace Liveright, 1924.

32. Matthew Luckiesh, "The Art of Mobile Color," *Scientific American Supplement*, vol. 79, 26 June 1915, pp. 408-9; *The Language of Color*, New York, Dodd, Mead and Company, 1918.

33. Matthew Luckiesh, *The Lighting Art*, New York, McGraw-Hill, 1917.

34. Matthew Luckiesh, "Lighting: A Fine Art?" *Artificial Light. Its Influence upon Civilization*, London, University of London Press, 1920, p. 344.

35. *Ibid.*, p. 356.

36. Willard Huntington Wright, *The Creative Will, op. cit.*, pp. 26-7.

37. *Ibid.*, p. 232.

38. Kenneth Peacock, "Instruments to Perform Color-Music. Two Centuries of Technological Experimentation," *Leonardo*, vol. 21, no. 4, 1988, pp. 397-406.

39. Alexander Wallace Rimington, *A New Art. Color Music*, London, Spottiswoode & Co., 1895.

40. A photograph of Rimington's chromatic piano was reproduced in *The Musical Courier* of 14 August 1895 (p. 29), following an article on color music which appeared several days earlier. These analyses of the performances of St. James Hall opened a debate in the United States, that culminated with the article that Joseph Goddard devoted to what he called at that time "a new art in abstract color" (Joseph Goddard, "Color Compared with Music and Painting," *The Musical Courier*, 13 November 1895, pp. 52-3).

41. Alexander Wallace Rimington, *Colour-Music, The Art of Mobile Colour*, London, Hutchinson,

1912.

42. Lucien Chassaigne, "Feuilleton de Journal," *Le Journal*, 22 August 1913. In *The Creative Will* (*op. cit.*, p. 81), Willard Huntington Wright discussed Rimington's color organ, and reproached it for its too decorative use of color.

43. Morgan Russell, in exhibition cat. *Exposition de Tableaux et Synchromies par Morgan Russell*, Paris, Galerie La Licorne, May 1923, p. 4.

44. Morgan Russell, cited in Gail Levin, *Synchromism and American Color Abstraction, 1910-25*, New York, Brazilier, 1978, p. 44.

45. "One can paint on the film, and the cinema or the magic lantern will do the rest." (Morgan Russell, hand-written notes, around 1914, Fonds Russell, *op. cit.*, roll 4536).

46. Morgan Russell, *Etude pour la Kinetic Light Machine*, about 1922-3, ink on paper, Morgan Russell Papers, The Montclair Art Museum.

47. The principle of mobile lamps was developed in Matthew Luckiesh's works ("The Portable Lighting-Unit," *Lighting Art, op. cit.*, p. 122-31). In a chapter devoted to "spectacular lighting," Luckiesh discussed small easily transported machines, that functioned with three lamps—blue, red and green—whose respective intensities were controlled by a rheostat.

48. Morgan Russell, hand-written notes, around 1914, Fonds Russell, *op. cit.*, roll 4536.

49. Morgan Russell Collection, New York, The Museum of Modern Art Archives, series 1.3a, around 1924.

50. Morgan Russell Collection, New York, The Museum of Modern Art Archives, series 1.3b.

51. "If shooting film in color did not exist, one would have to work with film rolls whose lines and graduated colors would give the sensation of something that was formed in space." (Morgan Russell, "Synchromies Lumineuses, Paris 1924," hand-written notes, Morgan Russell Collection, The Museum of Modern Art Archives, series 1.3a). Later, in 1933, this time calling it a "Synchromie instrument," Russell again took up the idea of an appliance with many portable lamps that could be moved around in front of screens which were also mobile (Morgan Russell, "Synchromie Instrument," hand-written notes, Summer 1943, Fonds Russell, *op. cit.*, roll 4536).

52. These experiences would later result in Stanton Macdonald-Wright's creation of a *synchrome kineidoscope*, that supported the luminous projection of colors onto musical accompaniment. About the workings of this machine, see notably the typed retranscriptions of an interview between Betty Lochrie Hoag and Stanton Macdonald-Wright (April 1964, New York, Archives of American Art, Smithsonian Institution).

53. Elie Faure, "Morgan Russell," *La Revue de l'Epoque*, July 1921, reprinted in exhibition cat. *Exposition de Tableaux et Synchromies par Morgan Russell, op. cit.*, (preface).

54. In hand-written notes from 1915, Russell evoked the "trilogy of the three arts" defended by Wagner, which he defined as "a Dionysical orgy of sounds, colors, forms and words." Morgan Russell, hand-written notes, around 1915, Fonds Russell, *op. cit.*, roll 4536).

55. Morgan Russell gave Canudo a drawing that illustrated, in January-February 1914, the issue of *Montjoie!* devoted to the renewal of dance.

56. "The new expression of Art should be, in reality, a kind of Painting and Sculpture that is developed over time, in the manner of Music or Poetry." (Ricciotto Canudo, "La Naissance d'un Sixième Art, Essai sur le Cinématographie," *Entretiens Idéalistes*, 25 October 1911, pp. 169-79.)

57. "I declare that, not long from now, a new art will put into movement no longer simply the line, but color itself, creating through the plays of intensities plays of emotions which the spectator will be unable to escape. A man, a young and talented American painter, is working on this: Morgan Russell." (Ricciotto Canudo, "La Leçon du Cinéma, *L'Information*, 23 October 1919, p. 2).

58. Ricciotto Canudo, *Le Livre de l'Evolution – L'Homme*, Paris, Sansot, 1907, pp. 303-4.

59. Ricciotto Canudo, "Essai sur la Musique comme Religion de l'Avenir. Lettre aux Fidèles de Musique," *La Renaissance Contemporaine,* 24 November 1910-10 February 1912; reprinted in October 1913, in English, in Ricciotto Canudo, *Music as a Religion of the Future. Translated from the French of M. Ricciotto Canudo with a "Praise of Music,"* by Barnett D. Conlan, London, Foulis, 1913.

60. *Ibid.*, 10 February 1912, p. 167.

61. Russell had encountered this idea in Jules Cambarieu's analyses, for whom "the essential laws of organized matter are apparent in...the musical body of work [that] evolves and perpetuates itself like a living being" (Jules Cambarieu, *La Musique, op. cit.*, p. 328).

62. Blaise Cendrars, "La Parturition des Couleurs," *La Rose Rouge*, 17 July 1919, reprinted in Blaise Cendrars, *Aujourd'hui*, Paris Denoël, 1987, pp. 73-4.

63. Mary Hallock Greenewalt, *Light: The Sixth Fine Art. A Running Nomenclature to Underly the Use of Light as a Fine Art*, Philadelphia, Greenewalt, 1918, p. 4.

64. Denton J. Snider, *Music and the Fine Arts. A Psychology of Aesthetic*, Saint Louis, Sigma Publishing, 1913, p. XIII.

65. Willard Huntington Wright, *Modern Painting, op. cit.*, p. 300.

66. Ricciotto Canudo, *Le Livre de la Genèse, la IXème Symphonie de Beethoven*, Paris, Editions de la Plume, 1905, p. XVII.

67. That is what Stanton Macdonald-Wright said in retrospect to the collector Henry Reed (discussed by Marylin S. Kushner in *Morgan Russell*, New York, Hudson Hills Press 1990, p. 135 and p. 182).

68. Letter from Morgan Russell to Stanton Macdonald-Wright, 19 October 1922, New York, Smithsonian Institution, Archives of American Art; cited in Marilyn S. Kushner, *Morgan Russell, op. cit.*, p. 135.

69. Morgan Russell, "Dieu Créa, au Commencement, les Cieux et la Terre," hand-written notes, May-June 1913, Fonds Russell, *op. cit.*, roll 4535.

70. "Grande Synchromia à la Vue en 4 Parties et en 13 Thèmes, le 24, 25, 26 Décembre 1922 (Noël)," hand-written notes, Morgan Russell Collection, New York, The Museum of Modern Art Archives, series 1.3a.

71. On this subject, see notably Bulat Galayev, "The Fire of Prometheus: Music-Kinetic Art Experiments in the USSR," *Leonardo*, 1988, vol. 221, no. 4, pp. 384-5.

72. Harry Chapin Plummer, "Color Music. A New Art Created with the Aid of Science," *Scientific American*, 10 April 1915, p. 343.

73. In Russell's hand-written notes a reference to Loie Fuller's serpentine dance (Morgan Russell, hand-written notes, Fonds Russell, *op. cit.*, roll 4536).

74. In her memoirs, Loie Fuller remembers that her very first performance in New York began with a "scene of hypnotism," (Loie Fuller, *Quinze Ans de Ma Vie*, Paris, Félix Juven, 1908, pp. 26-7).

75. Morgan Russell, exhibition cat. *Exposition de Tableaux et Synchromies par Morgan Russell, op. cit.*, p. 4.

76. According to Wright, who redefined the economy of aesthetic pleasure in terms of a division between the private or public contemplation of art, painting became even more obsolete (an official art of museums) that even the new individual spaces, arising from the new functionalist trends, were not able to supply the partitions necessary for hanging the paintings (Willard Huntington Wright, *The Future of Painting, op. cit.*, p. 38).

77. Willard Huntington Wright, "Art and Popularity," *The Creative Will, op. cit.*, pp. 61-2.

78. David Nye, "The Electrical Sublime: The Double of Technology," *American Technological Sublime*, Cambridge, MIT Press, 1994, p. 151.

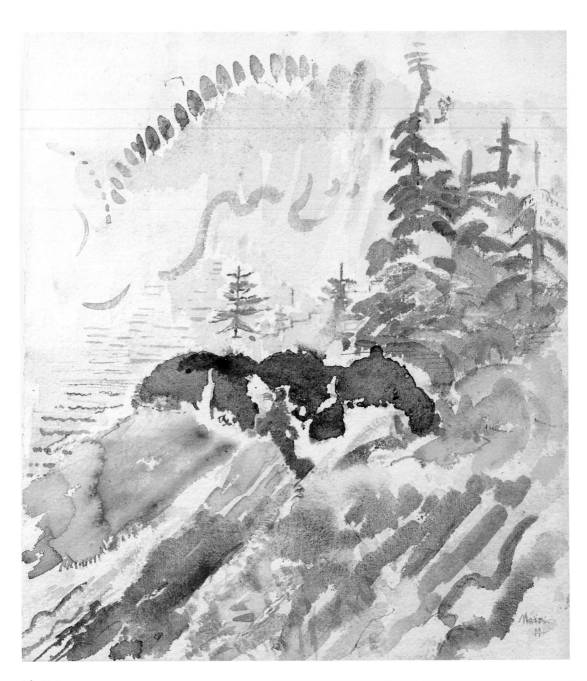

John Marin
Marin Island, 1914
Watercolor on paper, 6 3/8 x 14 1/2" (41.5 x 36.6 cm)
The Cleveland Museum of Art
Norman O. Stone and Ella A. Stone Memorial Fund

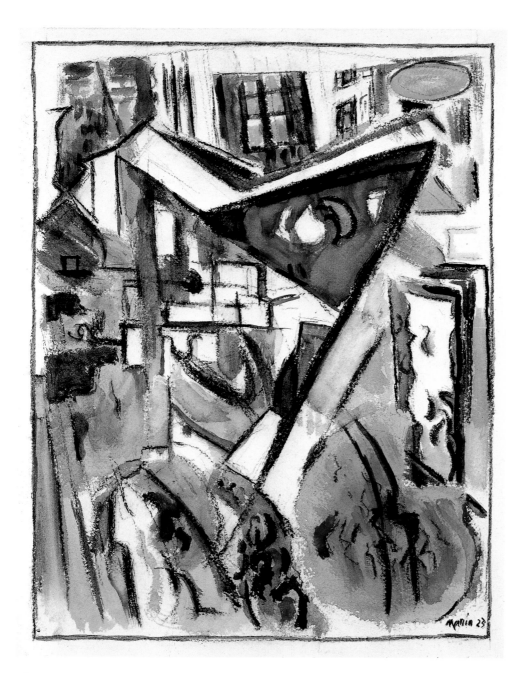

John Marin
Lower Manhattan, 1923
Watercolor on paper, 26 ¹/₂ x 21 ³/₈"
(67.3 x 54.3 cm)
Madrid, Museo Thyssen Bornemisza

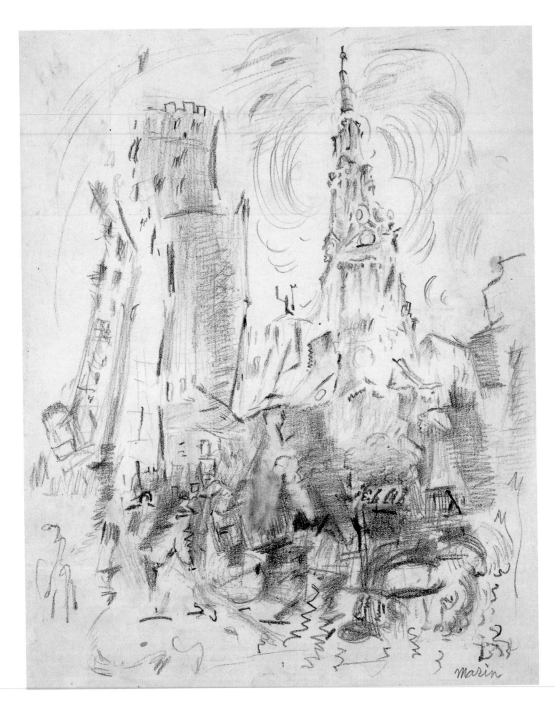

John Marin
Saint Paul's, New York Downtown, c. 1914
Black lead pencil, 10 x 7 $^{15}/_{16}$" (25.3 x 20.2 cm)
The Saint Louis Art Museum
Felicia Meyer Marsh, by exchange, and Eliza McMillan Fund

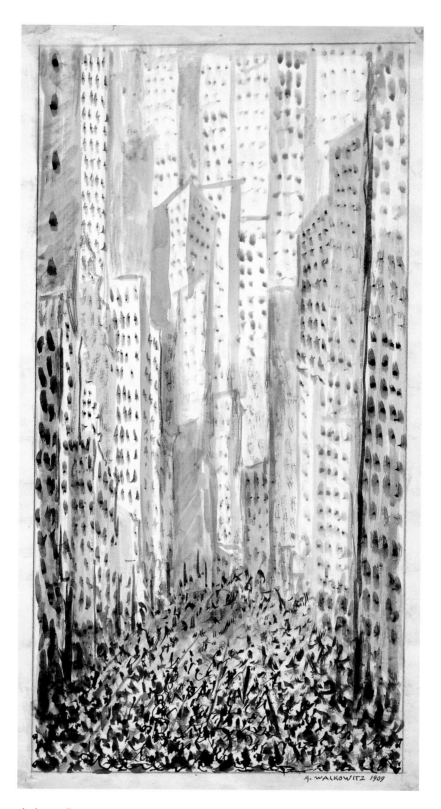

Abraham Walkowitz
Cityscape, New York Improvisation, 1909
Watercolor on paper, 13 $^1/_2$ x 7 $^1/_4$" (34.29 x 18.42 cm)
Saint Peter, Minnesota, Hillstrom Museum of Art, Gustavus Adolphus College

Abraham Walkowitz
Brooklyn Bridge, c. 1912
Watercolor, 22 x 17 ¹/₂" (55.88 x 44.45 cm)
New Haven, Yale University Art Gallery
Gift of George Hopper Fitch, B.A.

Abraham Walkowitz
City of the Future, c. 1926
Lithograph, 22 ¹/₈ x 16" (56.2 x 40.6 cm)
The Saint Louis Art Museum
Purchase, Funds given by Lyle S. and Aileen E. Woodcock

Joseph Stella
Battle of Lights, Coney Island, Mardi Gras, 1913-14
Oil on canvas, 64 x 71" (162.6 x 180.3 cm)
New Haven, Yale University Art Gallery
Gift of Collection Société Anonyme

Abraham Walkowitz
Abstraction, c. 1914
Black lead pencil, 17 $^1/_2$ x 11" (44.4 x 27.9 cm)
The Minneapolis Institute of Arts
Gift of Rev. Richard Lewis Hillstrom

John Marin
Abstraction, 1917
Watercolor on paper, 16 x 19" (40.6 x 48.3 cm)
Madrid, Museo Thyssen Bornemisza

Manierre Dawson
Abstraction. Passed Correlations, 1913
Oil on canvas, 30 x 36" (76.2 x 91.4 cm)
Private collection

Marsden Hartley
Movement N° 10, 1917
Oil on cardboard, 15 1/4 x 19 1/2″
(38.8 x 49.5 cm)
The Art Institute of Chicago
Alfred Stieglitz Collection

Marsden Hartley
Military, 1914-15
Oil on canvas, 23 $^3/_4$ x 19 $^1/_2$"
(60.3 x 49.4 cm)
The Cleveland Museum of Art
Gift of Professor Nelson Goodman

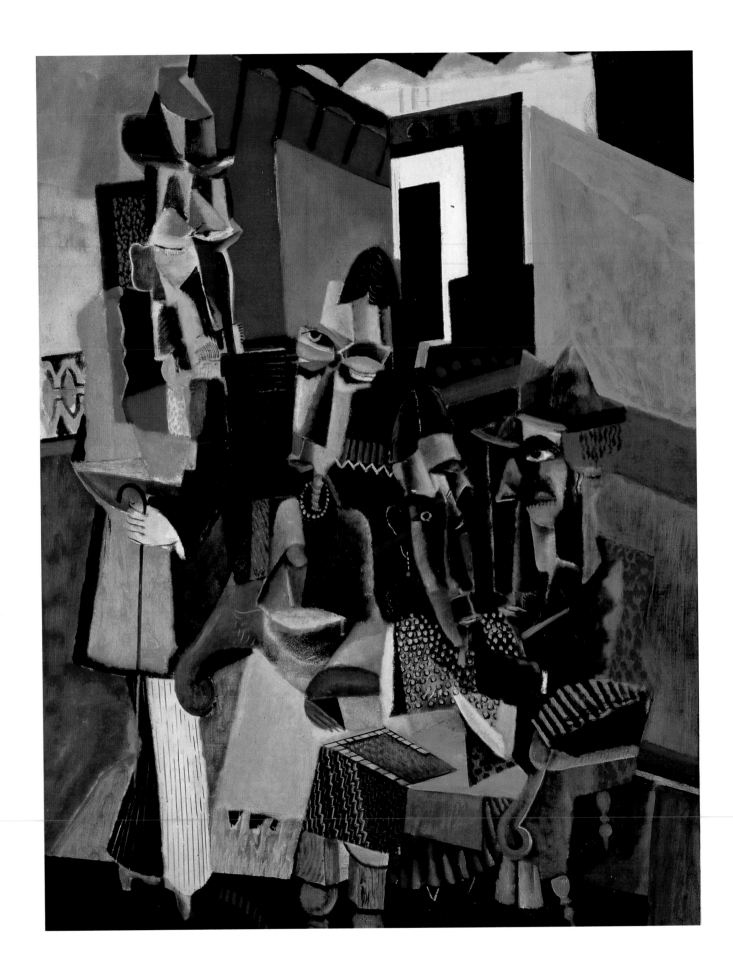

Arthur Dove
Orange Grove in California – Irving Berlin, 1927
Oil on cardboard, 20 1/16 x 15" (50.8 x 38.1 cm)
Madrid, Museo Thyssen Bornemisza

Max Weber
The Visit, 1919
Oil on canvas, 40 x 30" (101.6 x 76.2 cm)
Brooklyn Museum of Art
Bequest of Edith and Milton Lowenthal

John Storrs
Action, Destruction, Reaction, c. 1918
Front and back views
Granite and paint, H: 41 $^7/_8$" (106.3 cm)
Beaugency, Musée Daniel Vannier

Paul Strand
Abstraction, Porch Shadows, Connecticut, 1915,
published in *Camera Work*, June 1917
Gelatin silver print, 1976, 9 $^9/_{16}$ x 6 $^5/_8$"
(25.2 x 16.8 cm)
Dallas Museum of Art
The William Hood Dunwoody Fund

Paul Strand
Wall Street, 1915
Platinum print, 9 $^5/_8$ x 12 $^5/_8$" (24.4 x 32.1 cm)
M. H. de Young Memorial Museum,
Fine Arts Museums of San Francisco,
Achenbach Foundation for Graphic Arts
Gift of Michael E. Hoffman, New York,
in honor of Mr. Joseph Folberg

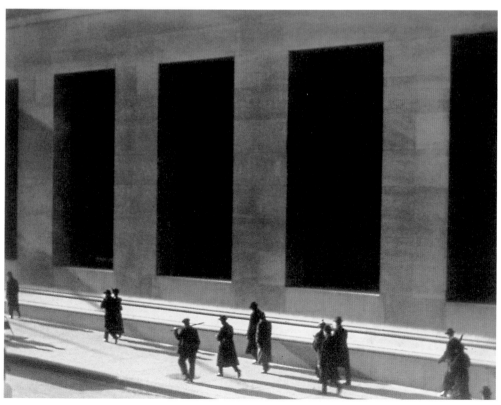

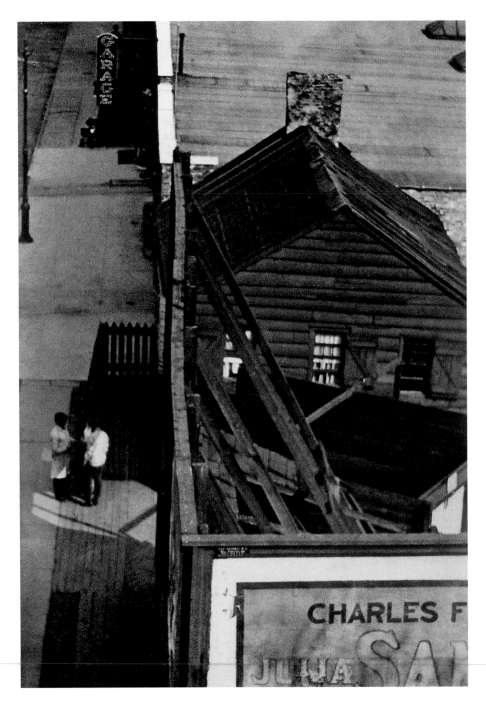

Paul Strand
New York, published in *Camera Work*, June 1917
Photogravure, 9 1/2 x 6 11/16" (24.2 x 17 cm)
The Minneapolis Institute of Arts
The William Hood Dunwoody Fund

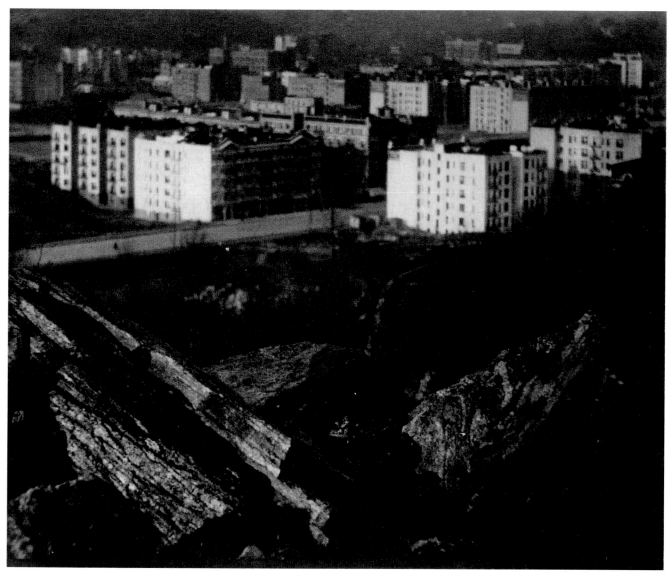

Paul Strand
New York, published in *Camera Work*, October 1916
Photogravure, 5⁷/₁₆ x 6⁹/₁₆" (13.8 x 16.7 cm)
The Minneapolis Institute of Arts
Gift of Julia Marshall

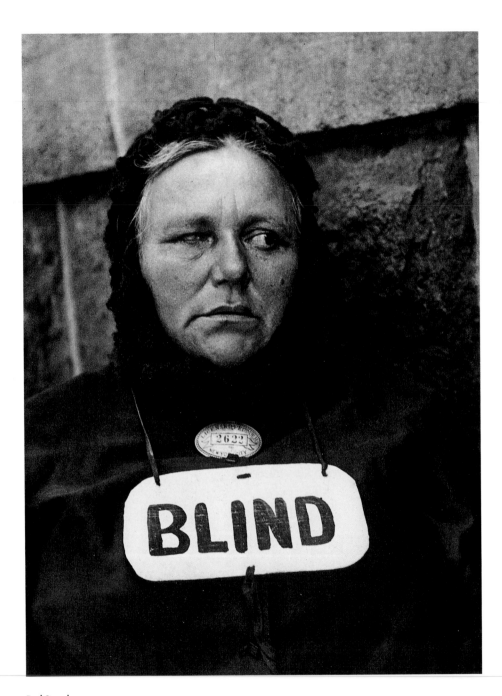

Paul Strand
New York, published in *Camera Work*, June 1917
Photogravure, 8 7/8 x 6 9/16" (22.5 x 16.7 cm)
The Minneapolis Institute of Arts
The William Hood Dunwoody Fund

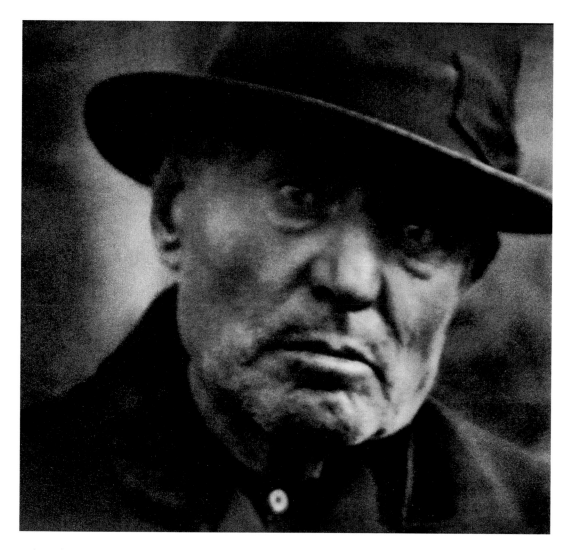

Paul Strand
New York, published in *Camera Work*, June 1917
Photogravure, 6 $^{11}/_{16}$ x 7 $^{7}/_{16}$" (17 x 18.9 cm)
The Minneapolis Institute of Arts
The William Hood Dunwoody Fund

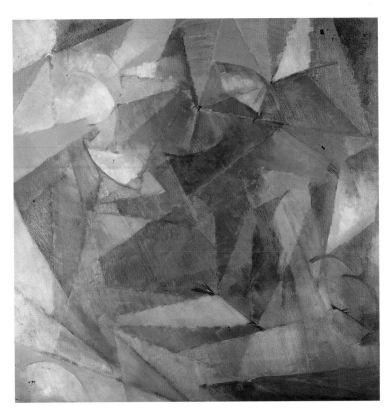

Stanton Macdonald-Wright
Synchromy 3, c. 1915-16
Oil on canvas, 28 1/8 x 28 1/8 " (71.44 x 71.44 cm)
Minneapolis, Frederick R. Weisman Art Museum,
University of Minnesota,
Bequest of Hudson Walker from the Ione
and Hudson Walker Collection

Morgan Russell
À la Vie de la Matière, 1925
Oil on cardboard, 24 1/4 x 19 7/8" (61.5 x 50.5 cm)
Paris, Musée National d'Art Moderne,
Centre Georges Pompidou
Gift of M. et Mme Michel Seuphor, 1978

Morgan Russell
Untitled Study in Transparency, c. 1913-23
Oil on tissue paper, 10 1/4 x 14 3/4"
(26.04 x 37.47 cm)
Dallas Museum of Art
Foundation for the Arts Collection
Gift of Suzanne Morgan Russell

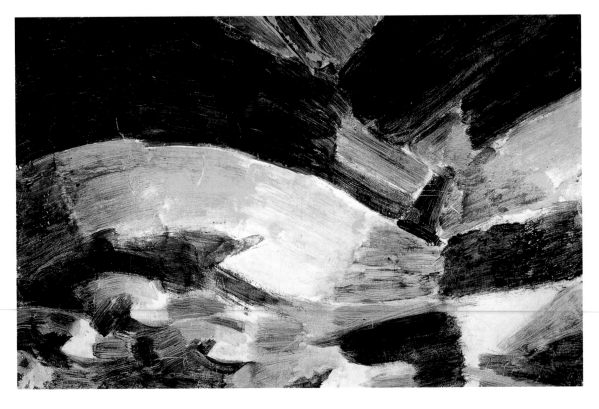

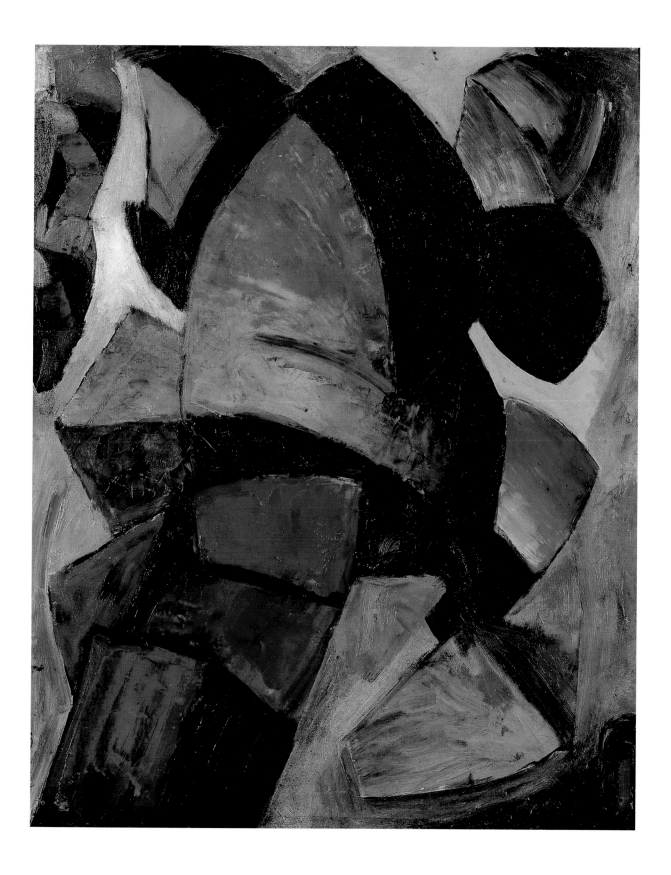

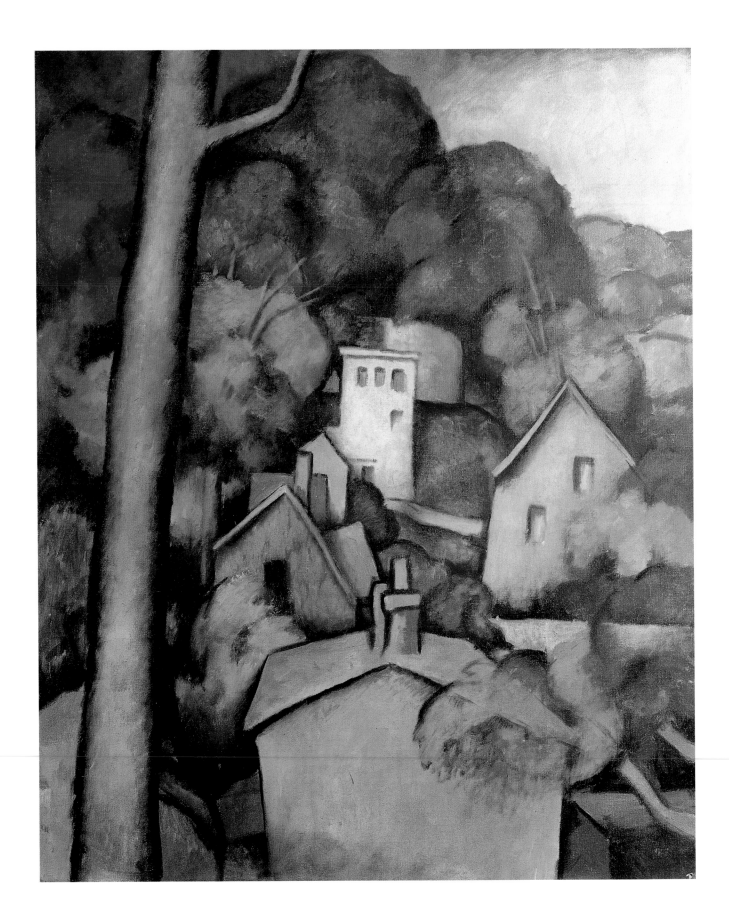

Patrick Henry Bruce
Composition, c. 1923-26
Oil and pencil on canvas, 25 1/2 x 31 3/4"
(64.7 x 80.5 cm)
Paris, Musée National d'Art Moderne, Centre Georges Pompidou
Gift of M. and Mme Michel Seuphor, 1978

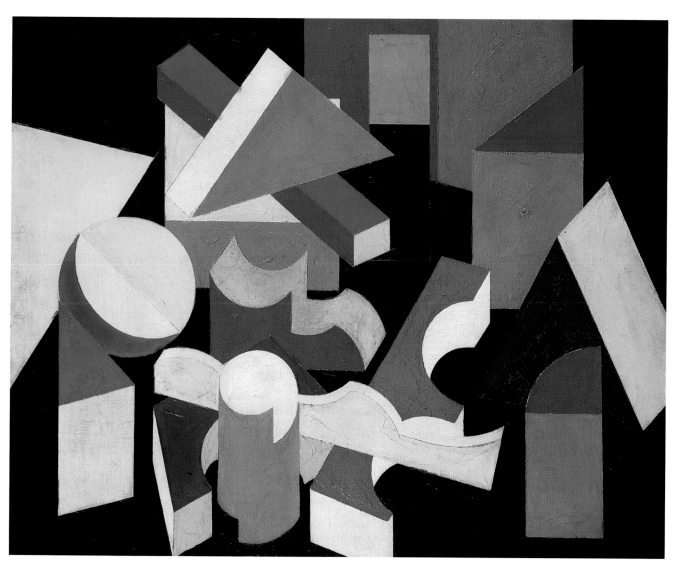

Thomas Hart Benton
Upper Manhattan, 1917
Oil on canvas, 28 1/8 x 34"
(71.5 x 86.3 cm)
The Cleveland Museum of Art
Anonymous Gift

The Machine Age

As of 1915 in New York, the reexamination of traditional conceptions of art had reached such proportions that it gave rise to the equivalent of what the Europeans would call Dada, especially among the artists who frequented the Arensbergs' salon. The first strong signals in this direction came from the French artists who had moved to New York because the war was raging in Europe. Francis Picabia, who had already painted several abstract versions of the city during his first stay there in 1913, returned in 1915, and refined his mechanical works, declaring that the "genius of the modern world is machinery." He published these works in the review *291*, founded by Marius de Zayas.

Not long afterwards, Marcel Duchamp thoroughly perfected the idea of the ready-made, exhibiting unadulterated manufactured objects in 1916. After organizing the Society of Independent Artists, whose first exhibition would give rise to "The R. Mutt Case" (from the signature on the urinal entitled *Fountain*), Duchamp became the ringleader of a group of *artistes-provocateurs*. Conspicuous among them were Man Ray, whose experiments involved a broad diversity of materials, John Covert, who was fascinated by cryptography, and Florine Stettheimer, whose caustic, acid-drop-colored paintings utterly sabotaged established artistic values. One of the recurrent themes of these artists, and especially one of their methods, consisted in replacing man as the subject and the artist as the author with a generalized model of mechanization.

During the 1920s, even though the majority of its founders had left the United States, this model gained acceptance, resulting in a sometimes ambiguous valorization of mechanization, based on the fact that the machine was indeed what best characterized the new civilization developing in the United States, as the 1927 Machine Age Exhibition in New York would confirm. By adopting a style the precision of which verged on anonymity, the painters Gerald Murphy (exiled in Paris), Charles Demuth and Charles Sheeler, joined by such artists as Louis Lozowick, George Ault or later Ralston Crawford, brought the same concern for detail and for visual construction to bear on subjects ranging from the machine and the urban environment (subjects which Joseph Stella was treating at the same time, producing some of the most accomplished works in this vein) to still lifes (a domain in which Georgia O'Keeffe joined them by creating her series of flowers in close-up). By adapting the medium of watercolor to modernist procedures and goals, Demuth, in particular, would renew a singularly American tradition.

It is not surprising that this pictorial and graphic *Precisionism* would, in parallel, nourish and help develop the diversified practice of mechanical art *par excellence* that is photography. Some photographers, such as Sheeler and Paul Strand, in fact, chose the machine as their principal subject, magnifying and studying its details and complexities. In California, Edward Weston and Imogen Cunningham led a group, founded in 1932 and tellingly called "f/64" (after the camera's shutter speed that allowed for the highest definition and the most depth of field). They applied a similar principle of "absolute and impersonal recognition" of the world to objects seen in close-up (plants and machines, as well as human bodies or natural spaces). They thus progressed from mechanization as a subject to a true mechanography of the American environment—a principle which would find a decorative application in the large color photographs of Paul Outerbridge.

E.C.

Opposite:
Charles Sheeler
Suspended Power, 1939
Detail

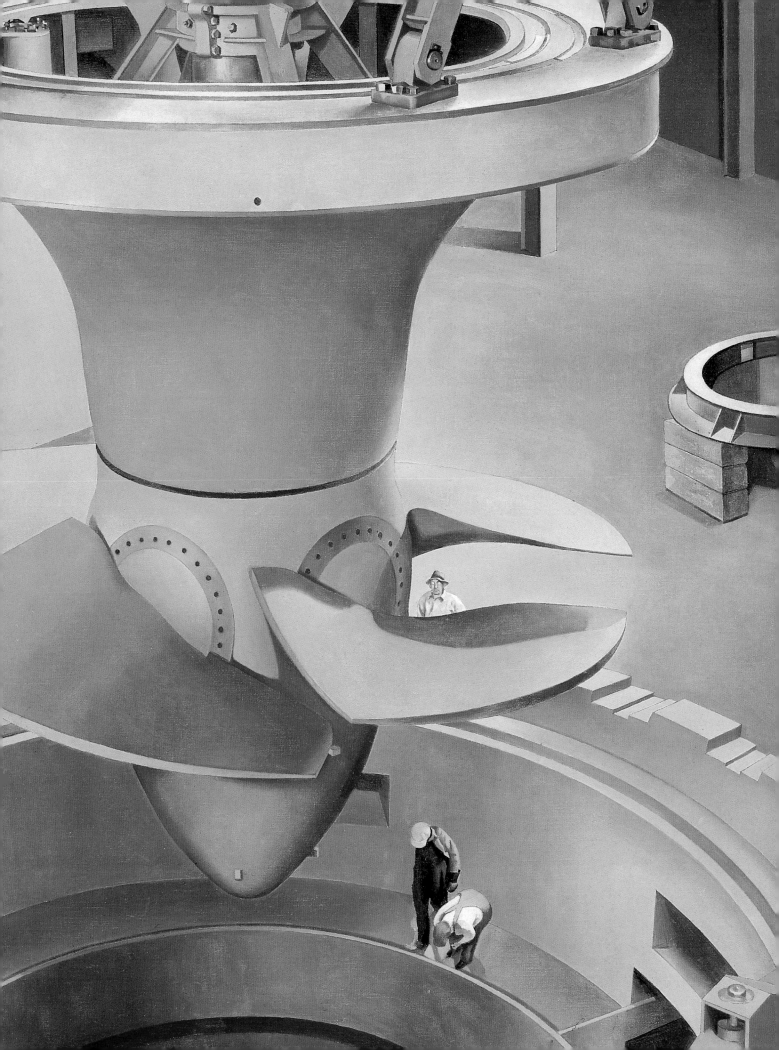

The Machine Between Cult Object and Merchandise

Photography and the Industrial Aesthetic in the United States during the Interwar Years

In 1929, when trying to pinpoint the founding event of Modern photography, a German publication chose the precise date of November 1922. That month, Paul Strand's article entitled "Photography and the New God" appeared in the American art journal *Broom*, illustrated with five of his images, all dealing with industry.[1] Among these images were three early examples of a photographic style which, like photograms and tilted angle views, became one of the major symbols of avant-garde photography over the next decade: the close-up of a machine. On both sides of the Atlantic, this genre spread throughout exhibits and picture books, art or architecture journals, advertising, and after Strand, helped to establish the reputation of many other photographers—namely, Albert Renger-Patzsch, Germaine Krull or Margaret Bourke-White. Although it ensured the same modernity for everyone, and elicited forms that often appeared similar at first sight, the functions it fulfilled and the meanings it took on proved to be quite diverse as the years went by.

The Machine as Idol

The new God heralded by Strand in his title was precisely the machine, to which the nascent 20th century would dedicate a real cult, and which seemed to have found its "supreme altar"[2] in the United States. This fact was acknowledged by a majority of American literary and artistic figures who, fueled by the Europeans' enthusiasm for the New Continent's industrial production—the craze of the French expatriates of the 1910s, in particular Francis Picabia and Marcel Duchamp—started seeing in it the essence of a specifically American modernity. This fervor for the machine, which *Broom* ardently defended in the early 1920s, grew steadily throughout the decade, spreading progressively through all of American culture and leaving a deep mark on the art of the interwar years in all its forms—from the Precisionist painting of Charles Sheeler or Charles Demuth to Louis Lozowick's inquiries into an American Constructivism, from architecture to music, from design to dance, everyone sought to adapt their artistic practice to the reign of industry and to the demands of a civilization that proclaimed itself as embodying "the age of the machine."[3]

More than any other art form, however, photography benefited from this infatuation, which not only did legitimize specific themes and forms, but the medium itself, turning its old inherent flaw—its mechanical nature—into a major advantage. After decades of trying to free itself from this specificity by imitating painting, photographers suddenly appeared very eager to emphasize anything that connected their art to the technical world. The very stamp of modern works—with their displayed objectivity, extreme precision in rendition, glossy surfaces—was there to remind us of and to glorify its mechanical origin. This affirmation of basic equivalence with the industrial world culminated in the close-up of a machine, where the mechanical device was celebrated both as an object and as a medium; revealing the aesthetic richness of the former also validated the latter. This mirror play, where the machine that was photographed was like a magnified reflection of the machine that was used to photograph it, was particularly apparent in Strand's 1922 images in the months preceding the publication of his *Broom* article. The device that fired his short-lived passion for mechanical motifs, and which he photographed frantically during that summer, was actually a device for taking images, an Akeley

movie camera that he originally acquired to shoot sports news and commercial assignments, but that he first used as a motif for his still camera—the emblematic staging of the confrontation between two recording machines (see p. 132). In the following months, not content with exhausting the rich visual possibilities of his new device, Strand went so far as to visit Akeley's New York workshops in order to admire first-hand the machines that produced it, and to celebrate their beauty in a series of close-ups of drilling machines, milling machines and lathes.

However, for Strand, acknowledging the aesthetic potential of the machine was not at all synonymous with giving his unreserved approval to the reign of industry. Upon closer inspection, his position in this regard proved to be much more ambivalent than it seemed, and his appeal in *Broom* for a grand mechanical art was quite paradoxical. Wary of any blind submission to the power of industry and the "somewhat hysterical attitude of the Futurists toward the machine,"[4] he explained that the machine and the economic system that supported it had so far mostly displayed their destructive force, and that precisely as a reaction to this oppressive power the machine should be addressed in a more spiritual, creative and detached way. For him, that would be the fundamental cultural role of art photographers, to be the ideal mediators between technology and creation: "Not only the new God but the whole Holy Trinity [God the Machine, Materialist Empiricism the Son, and Science the Holy Ghost] must be humanized lest it in turn dehumanize us."[5] In the end, the art of the machine would be a means of subduing it before it crushed us, a means of regaining *"control"* over a threatening force (the word comes back almost obsessively in the article)—an action directed paradoxically "against" the all-powerful nature of the object it glorified. For Strand, "humanizing the machine" meant first freeing it from the business and materialism

with which it was associated by drawing it into the sphere of true art. He insisted on this strongly in his text—the image of the photographer he defended was that of a noble artist detached from business and profit, "heretic to existing values,"[6] and developing his art in a totally independent and detached way. Though he had previously tried his hand at advertising and had taken a few close-ups of industrial products for commercial ends (one of them, an image of ball bearings, was reproduced in *Broom*), it was precisely at the time when he freed himself from these assignments to return to a more personal practice of photography that he began to take close-up after close-up of machines (from then on he earned his living with the film). In this utter refusal to compromise with industry, he mirrored the inflexible attitude of his mentor Alfred Stieglitz, who was flattered at great length in the article, and who was preoccupied with freeing the art of photography from its growing commercial uses as he had earlier emancipated it from the yoke of painting.

Faced with alleged commercial corruption and the beginnings of advertising's industrialization of photography, both men defended using the machine in a way that, paradoxically, tended to divest it of its mechanical specificity, its potential for rationalization and automation. For Strand, therein lay the other aspect of its "humanization," of the "creative control" of the mechanical world he hoped for—to reaffirm "the eternal value of the concept of craftsmanship."[7] Above all, it was this—individual know-how, the taste for careful work—that he claimed to admire in his precious movie camera and to which he obviously sought to pay tribute in his photographs of the Akeley workshops. Cogwheels, adjusting levers, the precision of sliding encasements—everything called attention to the mechanic's highly meticulous work and to his personal involvement, which evidently had little to do with the mechanical

motions and automated processes Ford intro-
duced on his assembly lines some ten years earli-
er. This nostalgia for quality craftsmanship in me-
chanical manufacturing also applied to the work
of the photographer. From lavish time exposures
(up to thirty minutes to enhance the texture of
materials) to the refinement of platinum prints,
Strand's works clearly rejected any "standardiza-
tion" of photography, a term he used in 1923
when arguing with his old friend Sheeler about
this subject.[8]

In fact, more than being a tribute to the machine,
Strand's images celebrated a twofold skill: that
of the mechanic/engineer and that of the pho-
tographer. His virtuoso split-framings emphasize
this. By arbitrarily fragmenting their mechanics,
he only added to their complexity; the novice
viewer had a hard time understanding how it
functioned, or in imagining using it himself, and
readily acknowledged it as being within the pri-
vate preserve of specialists. Above all, these
close-ups testified to the active role of the pho-
tographer—through his skillful compositions, he
alone took credit for bringing to light a latent or-
der, rhythm, and dynamism, for revealing the
beauty of the machine that would have remained
invisible without him. Ultimately, the reconcilia-
tion of art and technique that Strand advocated
through his motifs and through his work was like
an attempt to rescue quality craftsmanship in the
industrial era.

Not surprisingly, his confrontation with technical
imagery was short-lived. As early as 1924, he
gave up photographing machines or any urban
theme, preferring to concentrate on natural or
rural subjects. This decision probably arose from
the fact that, during these years, the formulas he
had developed in the hope of creating a great
independent photographic art were being taken
over by the very things he wanted to oppose—
industry and trade.

The Machine as Advertisement

At that time, advertising photography was ex-
panding considerably. In fact, it attracted a dissi-
dent faction of Stieglitz's circle—Edward Steichen
as early as 1923 and Charles Sheeler a year later,
as well as an entire generation of students of his
old friend Clarence White. They transformed the
canons of straight photography as embodied by
Strand—above all extreme sharpness and close-
ups— into privileged instruments for the promo-
tion of goods[9]; likewise, the imagery of the ma-
chine was progressively recycled by advertisers
and big business, who rapidly understood the
profit they could glean from such an aesthetiza-
tion of industry.

The most famous example of such a conciliation
between avant-garde photography and big busi-
ness was undoubtedly the major public relations
campaign assignment the Ford advertising agen-
cy gave to Sheeler for launching the new Model
A in great pomp at the close of 1927. Rather
than describing the product, the artist was invit-
ed to glorify the mammoth manufacturing ma-
chinery set up on the new site of River Rouge,
near Detroit (fig. 1), which he did with great en-
thusiasm. In a series of monumental views of
conveyor belts, piping, blast furnaces, metal-
works and power presses, he endowed a city of
machines, that was almost devoid of human pres-
ence, with a truly classical majesty, a quasi reli-
gious aura, that was used profusely in the firm's
advertising rhetoric. For a long time, this earned
the artist the cumbersome reputation of "the
Raphael of the Fords."

But it was mostly the slightly younger generation
out of Clarence White's School—namely, Anton
Bruehl or Ralph Steiner, or other less famous pro-
fessionals such as Arthur Gerlach or William
Rittase—who added the close-up of the machine
to the common repertory of commercial photog-
raphy. Around 1930, fragments of engines, tur-

Fig. 1
Charles Sheeler,
Industry, 1932.
Gelatin silver print,
triptych: 7 7/8 x 2 3/4"
(20 x 7 cm),
7 7/8 x 6 3/8"
(20.1 x 16.2 cm),
7 7/8 x 2 3/4"
(20 x 7 cm).
The Art Institute
of Chicago. Gift of Jean
and Julien Levy.

bines or dynamos, views of gears or ball bearings became the true clichés of advertising imagery. They reached beyond industrial ads, and were used as broader symbols of efficiency and modernity, to illustrate numerous services in magazine spreads or economic journals. Bourke-White established herself as the great specialist in this field, imposing a more dramatic dimension onto the formulas developed by Strand or Sheeler. She emphasized highlights and shadows, the brilliance of surfaces, the play on repetitions, the dynamism of diagonal framings, and the power of mechanics *at work*. Her heroic vision of the machine graced the pages of *Fortune,* a luxurious industrial monthly magazine that was launched in 1930 for business managers, and that copied the format and illustrative quality of an art magazine. Like Strand, these photographers claimed to be striving for the reconciliation of art and industry, however they took the exact opposite path.

According to them, art should be made available to industry in order to introduce quality, taste and a certain aesthetic modernity into the very heart of trade and mass production, rather than shunning these in an attitude of haughty withdrawal. This position was not foreign to certain Constructivist ideals expressed, for instance, in the *Machine-Age Exhibition* held in 1927 in the gallery of the *Little Review* in New York. But what had previously remained a theoretical principle of essentially utopian values was rapidly taken over, much more pragmatically, by art directors and advertisers, who were primarily concerned with consolidating their own power within the economic system, and who managed to convince industrialists of the importance of aesthetics in selling their products. Confronted with growing competition, automobile manufacturers, in particular, were quick to acknowledge that the technical quality alone of their models was no longer

enough to attract customers; they applied themselves increasingly to offering a meticulous presentation of their machines, to endowing them, through images, with a sheen of elegance, with an additional touch of art and of aesthetic modernity.

The Machine as Merchandise

With the stock market crash in 1929 and the Depression in the early 1930s, the idea of a necessary aesthetization of industrial production gained further ground as an essential instrument for economic recovery. Making products more desirable seemed to many to be the ready-made solution to a crisis perceived as a mere problem of under-consumption. This idea became so widespread that industrialists readily accepted to go a step further: no longer content with embellishing their finished products with a seductive image, they endowed the production of the object itself with beauty. In this way, a new profession was born that deeply marked the American imagination of the 1930s—that of industrial designer. Its heroes were Norman Bell Geddes, Raymond Loewy, Walter Dorwin Teague or Henry Dreyfuss. Most of them came from advertising circles and, in the beginning, their mission consisted mainly of expanding the graphic designer's work to a three-dimensional presentation of the merchandise, from packaging to window display. However, they rapidly laid claim to remodeling the very objects they were responsible for selling, in particular by redesigning the numerous mechanical devices that were beginning to flood the market. The consecration of the industrial designer cannot be dissociated from this other new event: the triumph of the machine as a consumer product. The machine celebrated in the 1920s for its pure power of production transformed itself into a commercial object; the machine, previously only photographed in power plants and assembly shops, now entered the home. Refrigerators, washing machines, vacuum cleaners, radios or automobiles were as many mechanical objects which, despite the Depression, rapidly conquered American middle-class households, and the designer was in charge of boosting their commercial appeal by making them attractive, with a luster of elegance and modern efficiency. He applied himself, first, to refining the complex and angular forms of these mechanical objects, to fusing them into a compact and unitary whole, into a play of smooth surfaces, soft lines and rounded angles—streamlined forms that embodied the ideals of fluidity and homogeneity that dominated the new industrial aesthetic.

Indeed, it was the designer who was in charge, from now on, of giving an *image* to the machine through his streamlined bodies. It was he who embellished it and endowed it with an additional touch of art. Above all, it was the designer who integrated into the object its commercial appeal, who endowed the product with its own sales pitch—the product had to be made to sell itself, as *Fortune* explained in 1934.[10] Under these conditions, the role of the photographer became highly subordinate. What could one add to an object that ostentatiously asserted its own beauty. Why and how could one transfigure a body designed from the outset as an image of perfection? From then on, industrial design products of the 1930s elicited far fewer artistic photographs than had the complex machinery glorified in former years. Unlike these, the images Geddes or Loewy used to promote their creations refer to the most traditional form of commercial representation, a slightly elevated three-quarter view showing the entire object standing out against a plain background (fig. 2). Beyond its traditional assets (to simultaneously suggest the object's silhouette, size and volumetric proportions by presenting three of its facades at the same time), this formula offered several advantages to the *stream-*

line designers. The angle view created a natural play on diagonals and asymmetry, even for an object with perfectly symmetrical facades, and thus enhanced its dynamism. Moreover, it emphasized this very angle, or more precisely its elision, the fluidity of the articulations and the homogeneity of the body; the full frame further enhanced this indivisible coherence of the form, which, according to the designers, constituted the essence of mechanical beauty.

The studied streamlined continuity of these devices made them particularly difficult to crop, and the modernist photographer was hard put to leave his imprint. Where Strand's or Bourke-White's split compositions always celebrated the unique know-how of the technician and the photographer, from then on, it was the industrial designer himself who fulfilled the dual roles of engineer and artist, and who, to a certain extent, replaced them. Through the immaculate appearance of their creations, the designers had to ensure that nothing betrayed the true complexity of the machine, that nothing intimated that they required the slightest specific skill to operate. Above all, it had to appear to be formally complete and not require any ulterior embellishment. Numerous examples illustrated this kind of unspoken competition between designer and photographer in the aesthetization of the machine. Thus, in one of the contemporary books published glorifying designers, *Art and the Machine* by Sheldon and Martha Cheney (1936), the image of a mechanical object will credit the designer *or* the photographer, rarely both. When a shot strayed freely from the object displayed, using the frame to fragment the volume, the credit went to the photographer and the designer was forgotten; when, on the other hand, the illustration used the conventional full frame approach, the designer was mentioned and the photographer was relegated to anonymity.[11] The way in which Sheeler chose to treat one of the symbols

Fig. 2
Norman Bel Geddes,
Gas stove "Oriole"
for the Standard Gas
Equipment Corporation,
c. 1930. Austin,
Norman Bel Geddes
Collection, Harry Ransom
Humanities
Research Center,
University of Texas.

of industrial design—the J3 locomotive of the famous 20th Century Limited train of Dreyfuss—was equally significant. On assignment for *Fortune*, in 1939, he both photographed it and painted it (fig. 3). However, in both cases, he chose to represent the only section that was independent of the designer's streamlined body, the only section of mechanical complexity, that of the train wheels and rods. *He* succeeded in glorifying the machine's beauty by playing down the previous work of the designer.

A brief chronology of the exhibits dedicated to the relationships between art and industry around 1930 also illustrated this phenomenon—how the machine in a way progressively absorbed images and made them superfluous. The pioneering event in this field was the *Machine-Age Exhibition* in 1927 that Jane Heap organized in the gallery of the *Little Review* in New York. In order to celebrate the machine as the foundation of modern aestheticism and to help bring together art and industry, she deliberately confronted the fine arts—painting, sculpture, architecture, photography—with real machines, as if the viewer's gaze required the presence of the former to ac-

knowledge the latter as objects of contemplation. Three years later, based on a similar program, the exhibition *Man and Machines* at the Museum of the Peaceful Arts in New York already did without the traditional fine arts entirely—photographs alone (including those of Bourke-White) now sufficed, to encourage this new aesthetic perspective, to point out the beauty of the machines on display. Finally, in 1934, the exhibition *Machine Art* organized by Philip Johnson at the Museum of Modern Art dispensed with images entirely—the viewer was invited to admire in the temple of contemporary art, springs, propellers, precision instruments, and household implements as works of art in their own right, formally installed on pedestals or hung on walls as paintings would be (fig. 4). Apparently, artists and photographers were so successful in awakening public enthusiasm for and awareness of the machine (the Cheneys explicitly credit photographers for blazing the trail for designers by "educating the eye" to appreciate the beauty of industry)[12] that the celebration of the machine could do without them entirely from then on. That same year, another exhibition, *Dynamic Design,* at the Art Alliance of Philadelphia, relaunched the 1927

principle and again confronted industrial objects with works of art, however, its approach was very different. This time, the industrial devices exhibited were *signed*, just like works of art; the visitor contemplated "a Geddes"—a gas stove—just as he would a Mondrian, and "a Dreyfuss"—a refrigerator—next to a Hélion. From then on, the idea of an *aesthetic* of the machine seemed to be unanimously accepted and no longer required the slightest additional glorification.

However, more than this validation by museums, it was probably the simultaneous trivialization of these mechanical devices, their propagation in the daily environment of the kitchen and the garage, that primarily accounted for the decline of the close-up of the machine in the photographic art of the 1930s. As Sheldon and Martha Cheney pointed out in 1936, did the modern poet describe "the fixtures of the artist's new twentieth-century world as including tools and dynamos, bridges, towers…tractors and cranes, he need only add the potato masher, electric juicer and automatically timed stove to complete his picture and make it inclusive of the whole mechanized realm."[13] It was by entering the world of ordinary consumption that the machine

Fig. 3
Charles Sheeler,
Rolling Power, 1939.
Oil on canvas, 15 x 30"
(38.1 x 76.2 cm).
Northampton, Smith
College Museum of Art.
Drayton Hillyer Fund.

was finally consecrated—what even the very distinguished MoMA indirectly acknowledged in its Platonic apology for mechanical forms, when it listed the prices of the objects exhibited in its catalogue of the *Machine Art* show. Under these conditions it was difficult to still evoke any sacred aura, difficult to project eternal values, those of religion or those of classical art, onto an object now subjected to programmed obsolescence, by the vagaries of fashion and by an increasingly limited lifetime.[14] This disillusionment with an industrial myth eroded by the law of rapid consumption and constant renewal was incisively addressed by Walker Evans in his book *American Photographs* in 1938, where objects of mass industry were mainly shown in states of scrap or loss: cars as wrecks, and factories near cemeteries.

The Machine as Monument

Other photographers, however, sought to regain a certain majesty of the machine elsewhere. This renewed conquest of greatness occurred in a very literal way, by namely transforming the works to a monumental scale, that of the *photomural*." It was briefly in fashion in the United States in the 1930s, in particular following the 1932 exhibit *Murals by American Painters and Photographers* at the MoMA, that promoted it as a modernized version of the monumental image, adapted to the age of the machine and of technical reproduction (Walter Benjamin, when referring to photography, employed the term "mechanical reproduction*.") Mechanical and industrial subjects in fact dominated the contributions of the guest artists, that of Sheeler for instance, who recycled his views of River Rouge to render them even more sacred, or that of Edward Steichen. The same year, the latter was asked to create a vast mural montage, on the theme of aviation, for the smoking room of the Roxy Theater in the Rockefeller Center. Some months later, in the

same complex, Bourke-White decorated the NBC studios with a similar photographic frieze—thought at the time to be the longest in the world—dedicated to radio technology and consisting of colossal close-ups of microphones, receiver, and antennas. After these, this model seduced a large number of industrialists who happily adorned lobbies and exhibition halls with such giant images, conferring onto their activities both the guarantee of technical modernity and the authority of monumental art.

But it was also through the subjects treated that photographers sought to give a new stature on the machine. One theme in particular—that of civil engineering work—that was oddly discreet in the 1920s, and was even absent from the *Machine-Age Exhibition* in 1927, acquired major significance over the following decade. Dams, bridges, traffic and power supply infrastructures were among the major projects of the Roosevelt administration and occupied a prime place in the iconography of the New Deal. Dams—these machineries designed from the outset as national monuments—inspired Sheeler's majestic photographs in his series "Power" done for *Fortune* in

Fig. 4
Wurts Brothers, *Machine Art*, Exhibition installation, New York, Museum of Modern Art, 6 March-30 April 1934.

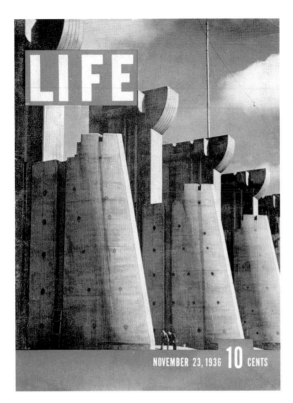

Fig. 5
Margaret Bourke-White,
*Dam. Fort Peck,
Montana*, 1936.
Cover of the first issue
of *Life*, 23 November
1936. Time Warner, Inc.

1939, as well as Bourke-White, whose imposing photograph of the Fort Peck dam (Montana) adorned the cover of the first issue of *Life* magazine in 1936 (fig. 5). With these themes, the technique not only took on the dimensions of a monument, but also those of the scenery. Far from the confinement of plants and workshops, the engineers' projects now encompassed geographical space and acquired an almost geological quality through their combinations with rocks, rivers and sky. Industry and nature seemed to be reconciled here. By spreading throughout the land, the machine blended with it so intimately that, to photographers, celebrating the machine seemed to go hand-in-hand with glorifying the nation. Hence, this new visual representation unquestionably expressed the emergence of a certain patriotism in the face of growing international tensions, the radicalization

of ideologies and the approaching war. The rooting of industrial power on vast lands, the merging of technique and natural resources, the demonstration of the country's inexhaustible irrigation power could be perceived as so many reassuring manifestations of national strength. However, this patriotic sub-text was nothing new in the history of American industrial iconography. Though the cult of technique spread throughout the Western countries during the interwar years, and though America could by no means claim exclusive rights to it, she alone succeeded in turning it into a national attribute; she alone claimed to found a specific tradition freed from foreign influences on the machine (which made it very difficult for American art of this period to establish a clear boundary between pro-industrial and urban trends, internationalist by nature, and other more rural ones which would alone encapsulate the temptation to national withdrawal). This type of American naturalization of the machine was more specifically noticeable in photography. Like many others, Strand used it profusely, in *Broom* or elsewhere, mostly in an attempt to annex the mechanical medium he claimed to champion: as if by natural law, America "the supreme altar of the new God", became the chosen land of photographic art. After Strand, this idea continued to influence the specialized literature in the United States for a long time. In 1935, the magazine *US Camera* even took the liberty of elevating the medium to the rank of "A Real American *Native Art*," the only one not to imitate Europe, but to be imitated by it.[15] However, on these grounds too, photographers very soon ran into rife competition with industrial designers also intent on claiming unequalled affinity with the machine and on embodying thus the first specifically great American art.

Olivier Lugon

Notes

* translator's note.

1. Paul Strand, "Photography and the New God," *Broom,* vol. 3, no. 4, November 1922, reprinted in *Photographers on Photography*, Nathan Lyon ed., Englewood Cliffs, Prentice Hall, 1966, p. 138-144.

2. *Ibid.*, p. 255 and p. 257.

3. For a good overview of the subject, see Richard Guy Wilson, Dianne H. Pilgrim, Dickran Tashjian, *The Machine Age in America 1918-41*, New York, The Brooklyn Museum/Abrams, 1986.

4. Paul Strand, *op. cit.*, p. 143.

5. Idem.

6. *Ibid.*, p. 139.

7. *Ibid.*, p. 143.

8. Paul Strand, letter to *The Arts*, 1 June 1923, cited in *Paul Strand, Sixty Years of Photography*, London, Gordon Fraser, 1976, p. 150. In a review of Stieglitz's exhibition, Sheeler had the misfortune of alluding to the "preciousness" of the master's prints, immediately provoking the ire of Stieglitz and of Strand, who answered him in this letter.

9. In an ironic coincidence, the date of November 1922 cited earlier as a turning point in the history of art photography with the *Broom* article was also the month in which *Vanity Fair* published the famous advertisement by Paul Outerbridge for Ide collars, one of the first "masterpieces" of purely commercial *straight photography*.

10. "Both Fish and Fowl," *Fortune*, vol. 9, no. 2, February 1934, p. 43. Like so many other articles singing the praises of the new profession, that of *Fortune* cited numerous examples of appliances whose sales rose up to 900% after designers had worked on them.

11. Sheldon and Martha Cheney, *Art and the Machine, An Account of Industrial Design in 20th-Century America*, New York, Whittlesey House, 1936 [reprint New York, Acanthus Press, 1992]. Page 37 was particularly revealing; it showed the difference in treatment and in credits for two views of objects with almost identical forms.

12. *Ibid.*, p 286.

13. *Ibid.*, p. 232.

14. Concerning the fundamental tension of industrial design between the search for perfection and the logic of planned obsolescence, see the exciting book by Jeffrey L. Meikle, *Twentieth Century Limited. Industrial Design in America, 1925-39*, Philadelphia, Temple University Press, 1979.

15. M. F. Agha, "Preface," *US Camera 1935*, 1935, p. 3.

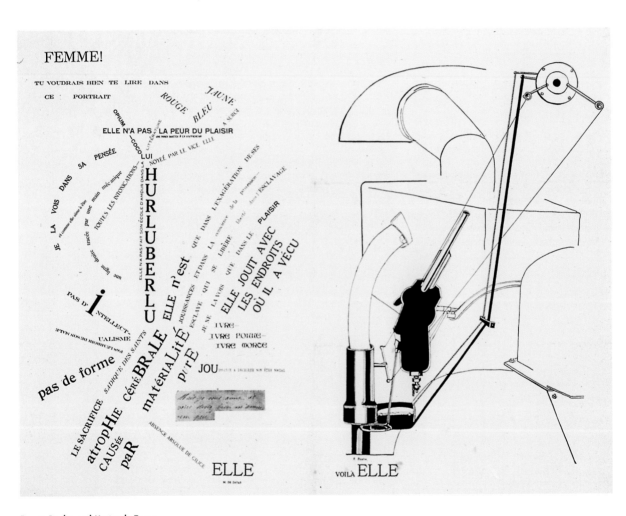

Francis Picabia and Marius de Zayas
Femme !, published in *291*, November 1915
Half-tone engraving, 17 $\frac{3}{8}$ x 22 $\frac{5}{8}$" (44 x 57.5) (double page)
Paris, Musée d'Orsay

Francis Picabia
Ici, c'est ici Stieglitz, cover of *291*, July-August 1915
Half-tone engraving, 17 3/8 x 11 3/8" (44 x 28.75 cm) (the page)
Paris, Musée d'Orsay

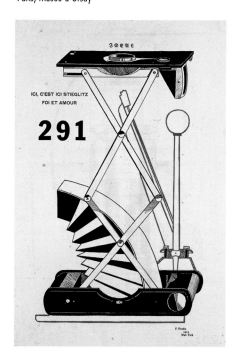

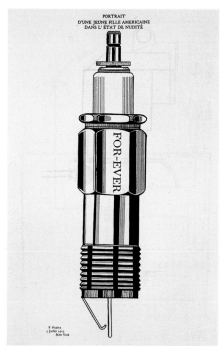

Francis Picabia
Portrait d'une Jeune Fille Américaine dans l'Etat de Nudité,
published in *291*, July-August 1915
Half-tone engraving, 17 3/8 x 11 3/8" (44 x 28.75 cm) (la page)
Paris, Musée d'Orsay

Beatrice Wood
The Blindman's Ball, poster, 1917
Serigraph, 27 1/2 x 9 11/16" (69.9 x 24.6 cm)
New Haven, Yale University Art Gallery
Gift of Francis M. Naumann

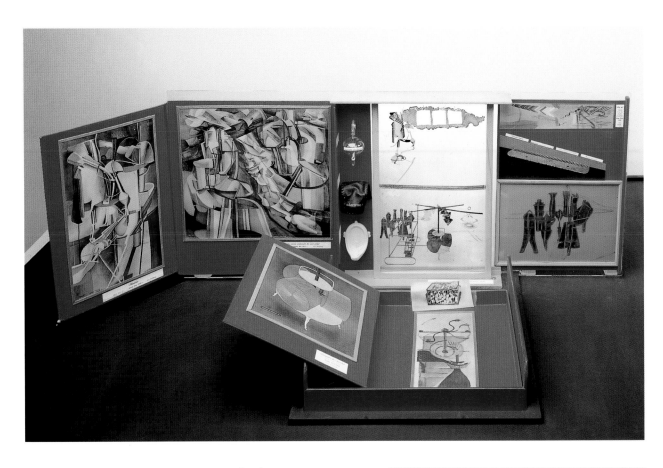

Marcel Duchamp
La Boîte-en-Valise, 1936-68
Red leather, cardboard, red canvas, paper,
Rhodoïd (or mica), 16 1/$_4$ x 15 x 4 1/$_8$"
(40.7 x 38.1 x 10.2 cm)
Paris, Musée National d'Art Moderne,
Centre Georges Pompidou

Marcel Duchamp
La Belle Haleine – Eau de Voilette,
detail, cover of *New York Dada,* 1921
Heliogravure, 14 1/$_2$ x 10"
(36.8 x 25.5 cm)
Paris, courtesy Galerie Marion Meyer

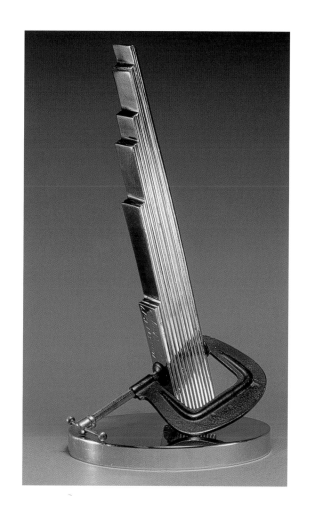

Man Ray
New York, 1917
Clamp and silver, H: 17 1/4";
D: 9 1/2" (H: 45 cm; D: 24 cm)
Paris, courtesy Galerie Marion Meyer

Man Ray
Obstruction, 1920-61
63 wooden hangers, each hanger H: 4"
(10.2 cm); total H: 29 1/2" (74,9 cm)
Paris, courtesy Galerie Marion Meyer

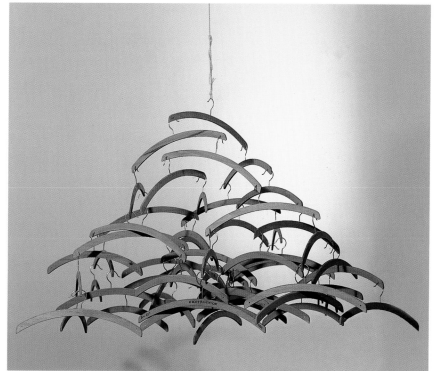

John Covert
Time, 1919
Oil, thumbtacks and tempera on a scrap of wood covered
with cardboard, 24 1/8 x 24 1/8" (61 x 61 cm)
New Haven, Yale University Art Gallery
Gift of Collection Société Anonyme

John Covert
Will, Intellect, Sensation, Emotion, 1920-23
Oil on a scrap of wood covered with cardboard,
23 5/8 x 25 1/2" (60 x 65 cm)
New Haven, Yale University Art Gallery
Gift of Collection Société Anonyme

Man Ray
Return to Reason, 1921
Oil on panel, 14 ⁵/₈ x 9 ⁷/₈" (37.1 x 25.1 cm)
The Minneapolis Institute of Arts
The Margaret G. Deal Fund in honor of Gertrude C. Deal,
Harrison H. Deal and Mary Deal Selcer

Florine Stettheimer
Portrait of Our Nurse, Margaret Burgess, 1929
Oil on canvas, 37 $\frac{1}{2}$ x 19 $\frac{1}{2}$"
(95.3 x 49.8 cm)
The Minneapolis Institute of Arts
Gift of the Ettie Stettheimer Estate

Alfred Stieglitz
Equivalent, c. 1927-29
Gelatin silver print, 4 $\frac{1}{2}$ x 3 $\frac{5}{8}$
(11.7 x 9.2 cm)
The Cleveland Museum of Art
John L. Severance Fund

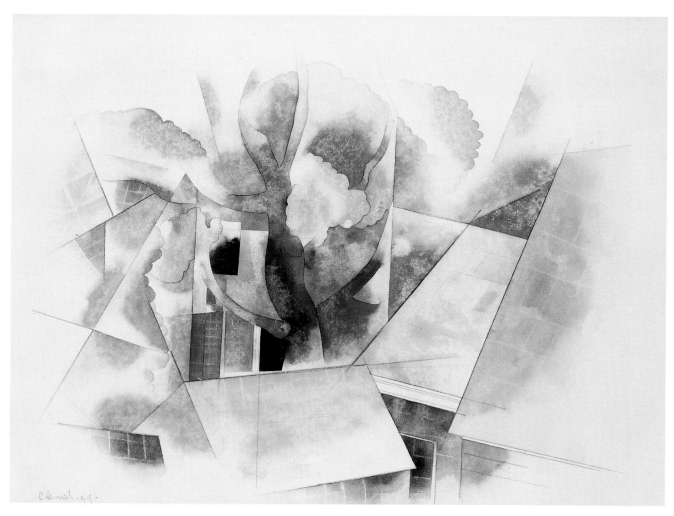

Charles Demuth
Rooftops and Fantasy, 1918
Watercolor and pencil on paper, 10 x 14 ¹/₈"
(25.4 x 35.8 cm)
The Saint Louis Art Museum
Gift of Mr. and Mrs. G. Gordon Hertslet

Charles Sheeler
Church Street El, 1920
Oil on canvas, 16 x 19 $\frac{1}{8}$"
(40.6 x 48.5 cm)
The Cleveland Museum of Art
Mr. and Mrs. William H. Marlatt Fund

Charles Demuth
Rue du Singe Qui Pêche, 1921
Tempera on panel, 20 $\frac{9}{16}$ x 16 $\frac{1}{8}$"
(52.2 x 41 cm)
Chicago, Terra Foundation for the Arts
Daniel J. Terra Collection

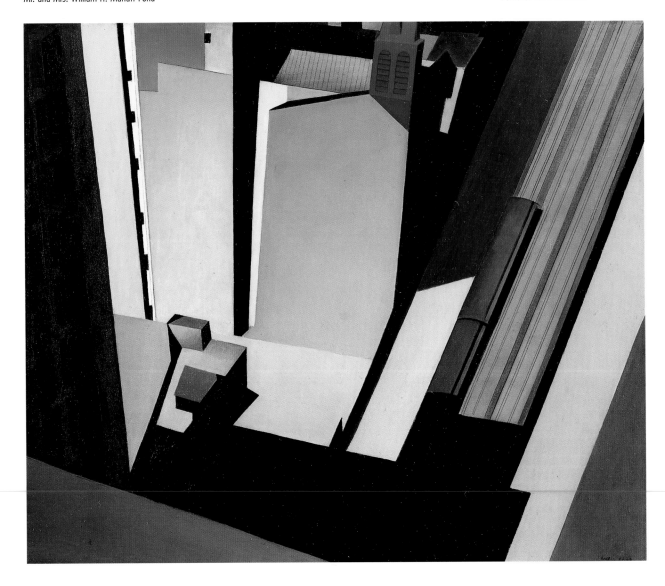

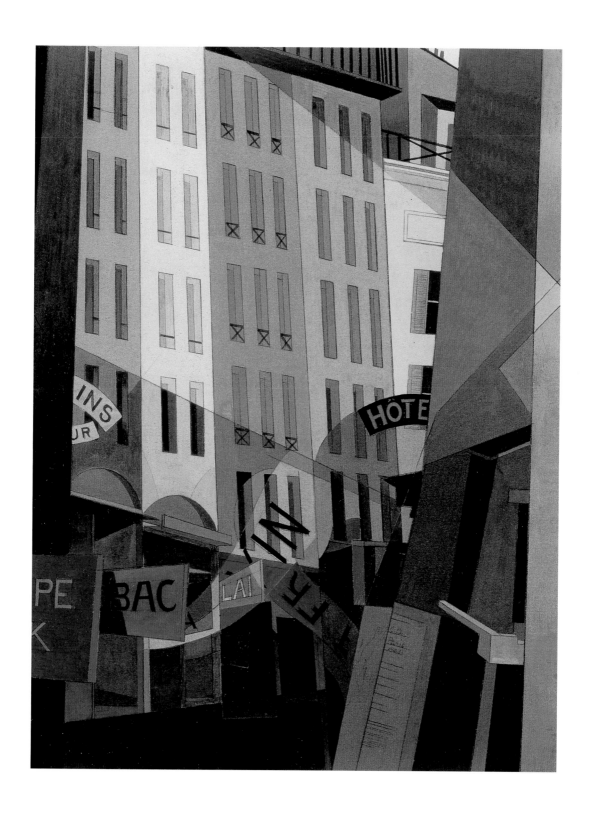

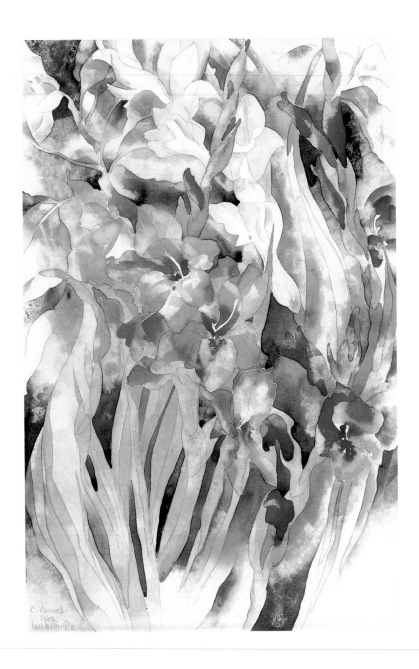

Charles Demuth
Gladiolus, 1920
Watercolor on paper, 18 ⅛ x 12 ⅛" (46 x 30.7 cm)
The Cleveland Museum of Art
Bequest of Lucia McCurdy McBride

Joseph Stella
Flowers (Fuchsia), c. 1930
Silverpoint and colored pencil on paper, 13 ¼ x 10"
(33.8 x 25.5 cm)
M. H. de Young Memorial Museum,
Fine Arts Museums of San Francisco
Gift of Dr. Robert A. and Minna Johnson

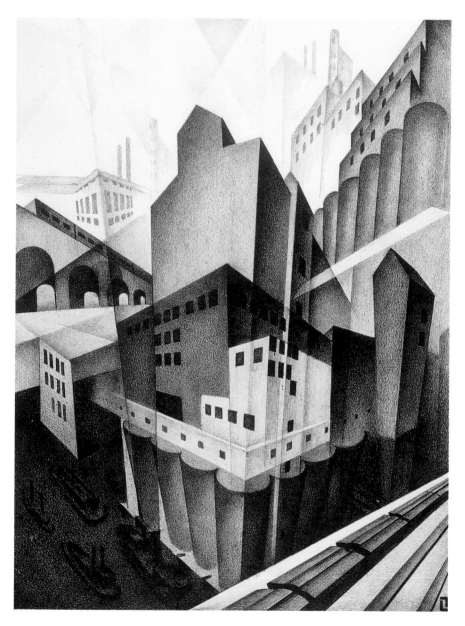

Louis Lozowick
Minneapolis, 1925
Lithograph, 11 $^5/_8$ x 8 $^7/_8$" (29.7 x 22.7 cm)
The Minneapolis Institute of Arts
The John R. Van Derlip Fund

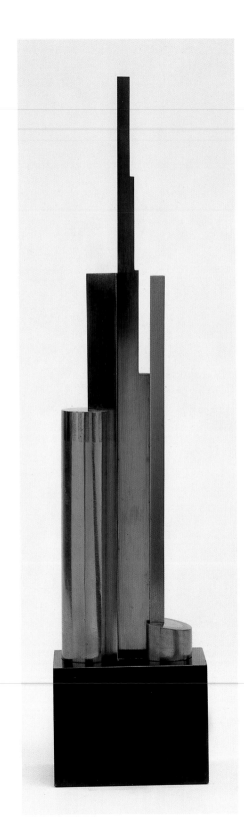

John Storrs
Study in Pure Form (Forms in Space N° 4), 1924
Steel, copper, and brass on marble base,
12 1/4 x 3 x 1 1/2" (31.1 x 7.6 x 3.8 cm)
Private collection

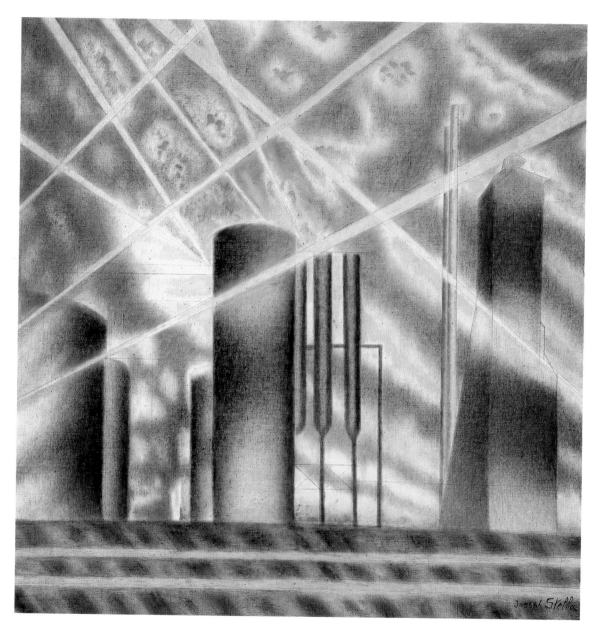

Joseph Stella
Factories at Night, no date
Oil on canvas, 36 x 36" (91.44 x 91.44 cm)
Portland Art Museum
Lent by Public Buildings Service, General Services Administration

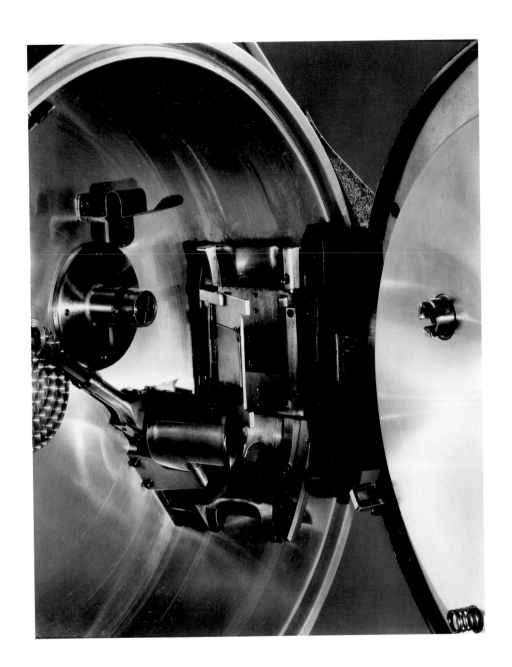

Paul Strand
Akeley Motion Picture Camera,
New York City, 1923
Gelatin silver print, 1976, 9 1/2 x 7 5/8"
(24.13 x 19.37 cm)
Dallas Museum of Art
Gift of Joseph W. Gray, M.D.

Georgia O'Keeffe
Morning Glory with Black, 1926
Oil on canvas, 35 7/8 x 29 3/4" (91 x 75.5 cm)
The Cleveland Museum of Art
Bequest of Leonard C. Hanna, Jr.

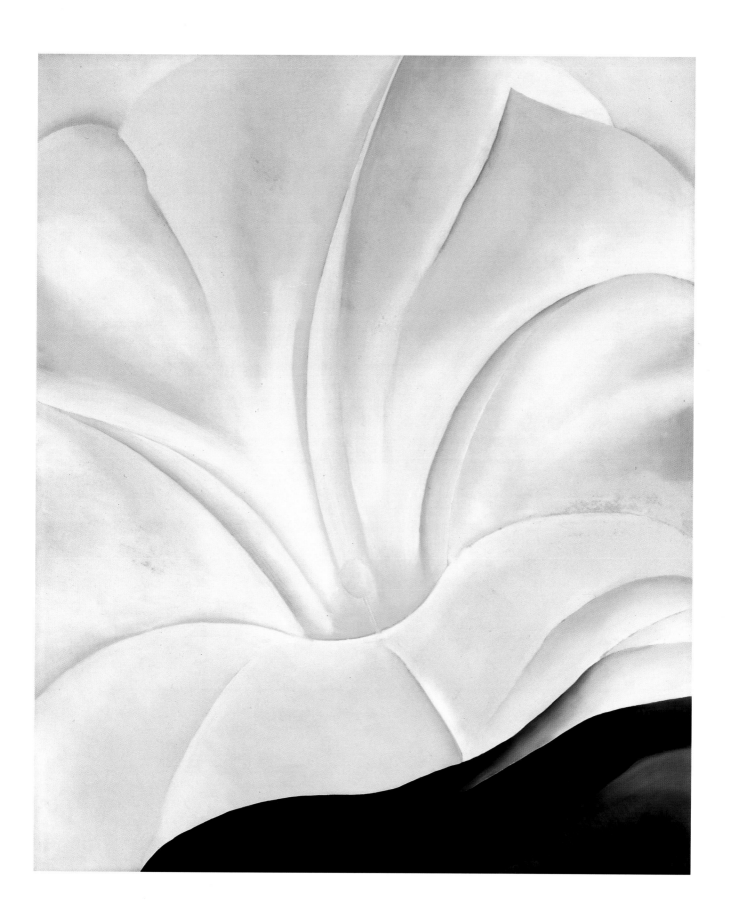

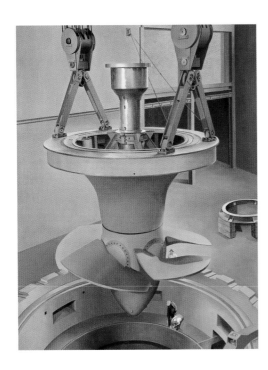

Charles Sheeler
Suspended Power, 1939
Oil on canvas, 33 x 26" (83.82 x 66.04 cm)
Dallas Museum of Art
Gift of Mr. Edmund J. Kahn

Georges Lee Ault
The Mill Room, 1923
Oil on canvas, 22 x 16" (55.88 x 40.64 cm)
M. H. de Young Memorial Museum, Fine Arts Museums of San Francisco
Gift of Max L. Rosenberg to the California Palace of the Legion of Honor

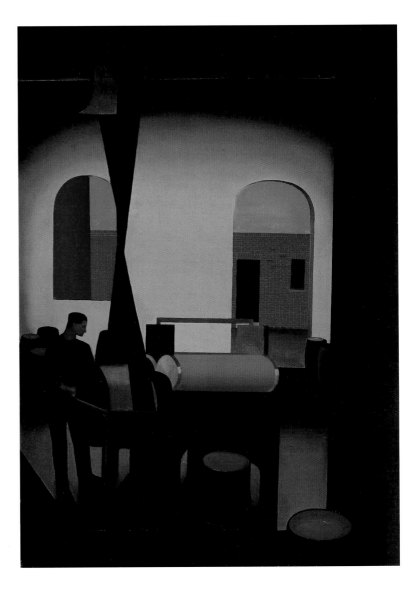

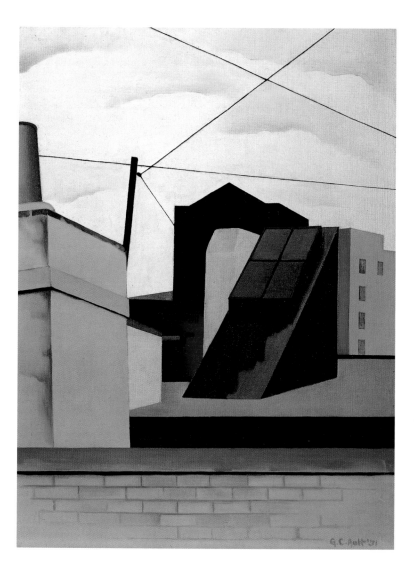

Georges Lee Ault
Jane Street Roofs, 1931
Oil on canvas on panel, 15⁷/₈ x 12" (40.3 x 30.5 cm)
Washington D.C., Hirshhorn Museum and Sculpture Garden,
Smithsonian Institution
Gift of Joseph H. Hirshhorn, 1966

Ralston Crawford
Electrification, 1936
Oil on canvas, 32¹/₈ x 40³/₈" (81.6 x 102.6 cm)
Washington D.C., Hirshhorn Museum and Sculpture Garden,
Smithsonian Institution
Gift of Joseph H. Hirshhorn, 1972

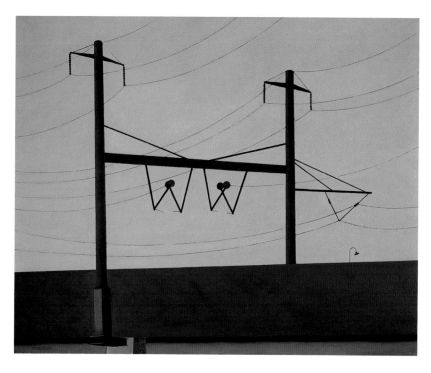

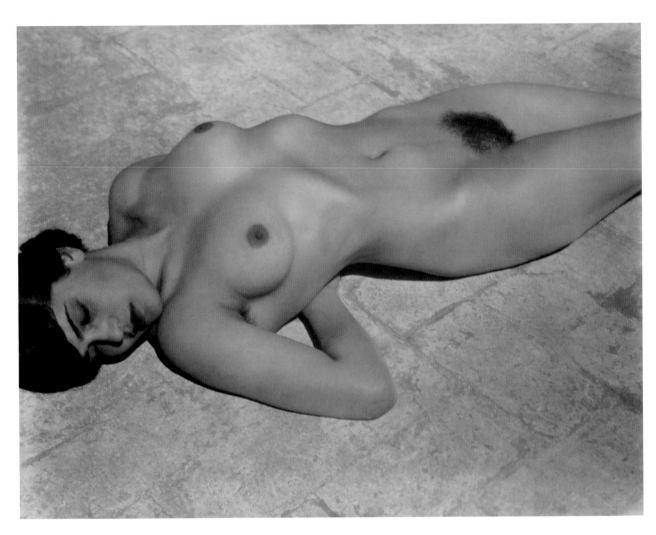

Edward Weston
Nude, 1923
Gelatin silver print, 7 1/4x 9 3/8" (18.4 x 23.8 cm)
New Haven, Yale University Art Gallery
Gift of William A. Turnage, B.A.

Edward Weston
Cabbage Leaf, 1931
Gelatin silver print, 7 $^{9}/_{16}$ x 9 $^{7}/_{16}$" (19.2 x 24 cm)
The Minneapolis Institute of Arts
John R. Van Derlip Fund

Ansel Adams
Barn, Cape Cod, Massachusetts, 1937
Gelatin silver print, 9 1/2 x 13 5/8" (24.3 x 34.6 cm)
The Cleveland Museum of Art
Andreux R. and Martha Holden Jennings Fund

Imogen Cunningham
Two Callas, c. 1929
Gelatin silver print, 13 1/4 x 10 1/4" (33.66 x 26 cm)
Portland Art Museum
Bequest of Fae Heath Batten

Paul Outerbridge
Sandwiches on Tray, c. 1935
Carbon print, 16 1/8 x 13 3/8" (41 x 34 cm)
Paris, courtesy Galerie Baudoin Lebon

Paul Outerbridge
The Kitchen Table, 1935
Color print, 11 7/8 x 16 3/4" (30.1 x 42.5 cm)
The Cleveland Museum of Art
Gift of Mrs. Ralph S. Allen

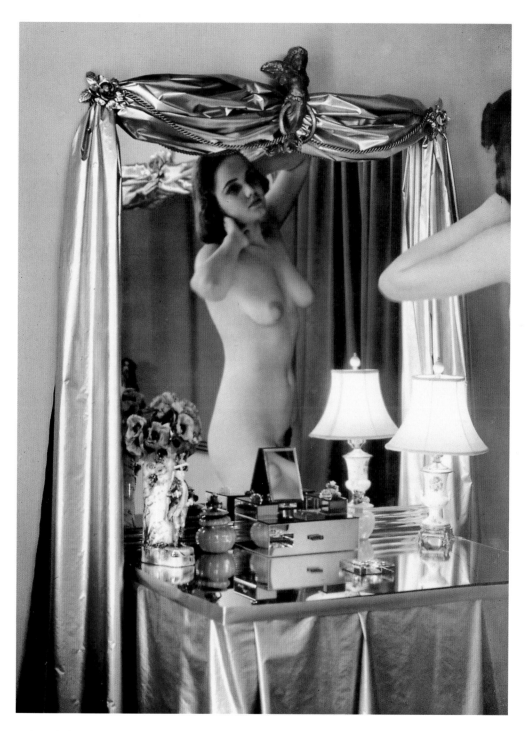

Paul Outerbridge
Nude Standing at a Dressing Table, c. 1936
Carbon print, 15 3/4 x 11 3/4" (40 x 30 cm)
Paris, courtesy Galerie Baudoin Lebon

The Search for Identities

The upheavals of the economic crisis of 1929 aroused a desire for social commitment on the part of many artists. Whereas most photographers found their work readily integrated into the international artistic scene, for numerous painters, it was an entirely different story. In fact, the early 1930s saw the advent of the American Scene, a regionalist trend which found in Thomas Hart Benton its leader and its most vehement spokesperson against the supposed damage done by European art, favoring instead the virtues of rural life. In Grant Wood's work, this return to typically American values was coupled with a sense of irony and of conspicuous precision. Some locally established artists, such as Alexander Hogue in Texas, Raphael Gleitsman in Ohio, John Atherton in California, Luigi Lucioni in Minnesota, practiced a realism which sometimes verged on the fantastic because of the precision of the details. The vast programs of public commissions initiated by the New Deal Works Progress Administration/Federal Arts Project (or WPA/FAP) would exploit this trend, spreading it throughout the entire country.

Without claiming to break with Europe in the same way, some realist painters demonstrated a pronounced desire to explore the specificities of the American life and landscape: this was the case with Charles Burchfield, and in a very specific and fully realized way with Edward Hopper. After decisive stays in Paris in the early 1900s, where he painted several surprising landscapes, after the 1920s, Hopper devoted himself to a painting imbued with solitude and desolation, in his landscapes as well as in his urban scenes, peopled by impassive figures. The members of Alfred Stieglitz's circle, such as John Marin, Marsden Hartley and Arthur Dove, showed a marked tendency to use painting for an utterly personal expression, and produced singular works offering unique visions of the American landscape, ranging from the desert to more domestic environments. Milton Avery, soon to be followed by his disciples Mark Rothko and Adolph Gottlieb, developed a color-based and affective expressionism in his portraits and genre scenes.

In the work of African-American artists, which began to acquire its own voice with the Harlem Renaissance or with those artists exiled in Europe, modernism and narrative engagement were mixed together with aspects that were either folkloric (Horace Pippin), primitivist (Jacob Lawrence, William H. Johnson), or political (Romare Bearden). Despite the racism dominating the country, some artists from other ethnic backgrounds, such as Robert Gwathmey or Viktor Schreckengost drew inspiration from what they saw as the beauty specific to the African-American minority. In this way, they connected with the tenants of a Social Realism which would find its most fully realized expression with Philip Guston and Ben Shahn.

Between 1935 and 1943, many photographers were briefly affiliated with the federal program FSA (Farm Security Administration). Inside and outside this program, they documented the United States in its regional, social, and indeed ethnic, diversity. After several years of free-lance practice in Cleveland, Margaret Bourke-White bent to the demands of a mass audience by becoming the appointed photographer for the magazines *Fortune* and *Life* (which was created in 1936). Dorothea Lange focussed on the San Francisco area and delivered images that were poignant without being sentimental. Walker Evans especially distinguished himself with a combination of distance and of commitment. All his photographs testified to his desire to transform the identity crisis which imbued all of American art at that time into an engine for creativity instead of a brake. **E.C.**

Opposite:
Edward Hopper
House at Dusk, 1935
Detail

142

Harlem Renaissance

The Making of a Black Identity

Given the utter absence of 20th century African-American visual arts within standart versions of American Art History, one can easily wonder how they ever managed to exist at all. The analysis attempted here concentrates on the importance of one period, after 1920, when progressively although with difficulty, African-American artists broke free from the dire consequences of slavery, and tried to construct a new black identity. At a time when racial discrimination, segregation in many states, social and economic injustices, political pressures, material difficulties of day-to-day life relegated the African-American population to the fringes of white society, the sheer power of an unprecedented desire fueled the emergence of an artistic and intellectual movement, which for the first time, compensated for its long absence. This founding movement was concentrated symbolically in the black ghetto of New York whose population increased after the 1910s with the rural exodus to the North. The community that settled in Harlem finally had the opportunity to express itself freely. What we have since then called the Harlem Renaissance concentrated all the intellectual and creative effervescence of African-American writers, musicians and intellectuals. Yet, compared to the respected place occupied by jazz or literature—essential references in American cultural history of the 1920s—the visual arts remained peripheral. Very few theoretical indications, indeed bibliographical references, allowed one to identify the formal transitions in African-American visual arts of these decades, when on the contrary, Western art was carrying out a penetrating reflection about the question of modernity. Ostracized to invisibility, the works of painters and sculptors tended to employ a creative process that sought to render this invisibili-

ty visual. As early as 1902, the African-American historian W. E. B. Dubois, in his work, *The Souls of Black Folk,*[1] defined the idea of dual awareness as resembling the antagonistic relationship between Africa and America. However, one had to wait until the 1910s to see such a dichotomy assimilated in a concrete way. Before then, the members of the African diaspora had experienced this dual awareness as an often painful duality. The making of this new black identity was markedly influenced by the personalities of intellectuals such as Alain Locke—an historian, philosopher and Harvard graduate—who contributed to the creation of the New Negro movement with the 1925 publication of his book, *The New Negro.*[2] Hoping to unify the black artistic movement, Locke recommended that black painters and sculptors draw inspiration from original African sources, and advised those who worked in Harlem to take advantage of the important collections of African objects there. If he encouraged them to look at African arts, which had often been previously considered simply as ethnological curiosities, it was also to try to endow the works with an impact that they did not have, compared to other art forms such as dance, music or poetry, in which historically, the black dimension seemed more obvious. The New Negro movement allowed painters and sculptors to join poets, novelists, playwrights, and musicians in a sphere that established Harlem as the capital of black culture. This situation caused a rupture in black art, such as it had existed until then. Black artists refused to submit to the too-heavy-handed canons of Western art, and appropriated the African forms that comprised their heritage, and in so doing, they overturned the representation of the black figure by defining a vocabulary that was entirely their own.[3]

At the same time, the Jamaican nationalist movement led by Marcus Garvey called the Universal Negro Improvement Association (UNIA) motivat-

ed America's black population and preached their return to Africa; however, it was thanks to the help of white patrons of the arts that a majority of African-American artists could work at all. The William E. Harmon Foundation, created in 1922 to "contribute to developing greater economic security for the black race," was, after 1926, the major source of prizes and grants for black artists and writers. It organized an annual traveling exhibition that gave unprecedented visibility to African-American artistic practices. The first exhibition was held in 1927 at the Harlem Branch of the New York Public Library, at the intersection of 135th Street and Lenox Avenue. When the Foundation ended its program in 1933, it was also the end of any private subsidies for African-American artists. Thus, paradoxically situated between the two extremes of Marcus Garvey's militant Pan-African activity and the black community's dependence on a white institution, African-American visual arts evolved within an environment still marked by racial segregation. The Harmon Foundation had a notably ambiguous attitude. Certainly it organized exhibitions of black artists, but it also insisted that their art works contain certain characteristics such as "natural rhythm," "optimism," "humor," and "simplicity," that is to say the most stereotypical aspects of blacks, like an emancipated slave expressing his gratitude to whites. These clichés were often embodied in the famous character of Uncle Tom, who, in a certain way, represented the Old Negro instead of the New Negro.

Despite the remarkable success of musical, theatrical or literary performances and the fashionable "interracial" evenings held in Harlem nightclubs, visual artists were far from satisfied in this context. The climate of apparent frivolity did not allow them to firmly anchor their artistic concerns. The subordination they felt prompted them to fully affirm their creative status by refusing the patronage of black organizations such as the National Association for the Advancement of Colored People (NAACP, founded in 1909 to protect the civic and political rights of American blacks) and of the National Urban League (founded in 1910 to help new arrivals get settled in cities), at the risk of incurring the wrath of their powerful protectors. They reproached them notably for wanting to dictate their artistic choices and for not allowing them sufficient creative freedom, under the pretext of assigning them an exclusively sociological role—that of identifying a racial difference and diffusing it through their works—instead of acknowledging their work as authentic art. It was in this context that Langston Hughes published his famous essay in *The Nation* in 1926, "The Negro Artist and the Racial Mountain," in which he advocated artistic independence by claiming that the literary, musical, and pictorial works would have, in the long run, more influence on ignorance in the face of racial questions in the world than all the combined efforts of black cultural institutions. "We, creators of a new generation, we want to examine our black personality, without shame or fear. If it pleases the whites, we are very happy. If it does not please them, it does no matter. We know that we are beautiful and ugly too" This new position of black artists caused a tipping of the scales that was important for the recognition of African-American culture, where race was affirmed by its difference, and not exclusively by its attempt at integration *into* and acceptance *by* white culture. A new generation began to explain that it was no longer necessary to camouflage one's origins, to strive for an assimilation that was in fact false. These artists showed in and through their work that their difference could never be ignored, that there would always be a tense relationship between Western culture and a culture that physically carried the signs of racial distinction. Langston Hughes, for example, was the first poet to pronounce himself clearly as be-

ing black in the sense of Negro: "I am a Negro/Black as the night is black/Black like the depths of my Africa," he claimed in 1922 in the first and last lines of his poem "Negro."[4] This transition from Negro to black was particularly important in acquiring cultural autonomy. It was the New Negro who decided to explicitly draw attention to his difference by emphasizing the color of his skin. When one accepts oneself as black, a new perspective on one's past and one's culture opens up. One is no longer prisoner of a *Negro* (a term created by whites) culture, and it was this perspective that enabled an artistic form of protest to be created—visually—in the face of the imposed condition.

Aaron Douglas (1899-1979), one of the most famous artists of the Harlem Renaissance, belonged to this contentious fringe. Celebrated and respected, his illustrations were published in *The Crisis* and *Opportunity*, and his mural paintings adorned official buildings. Douglas left his home town of Topeka, Kansas, and settled in Harlem in 1924. Not long after his arrival, he met Albert Barnes, a white collector from Philadelphia, who had also contributed to Locke's book, *The New Negro*, and was a fervent supporter of black art. Barnes showed him his immense collection, essentially composed of objects from Western Africa and of modern European paintings. Thus, at a time when white institutions were still ultimately ambivalent toward the influence of "Primativism" on Modernism, Douglas had access to the best examples of African art and could judge its influence on such painters as Gauguin, Picasso or Matisse. At the same time, he was also trained by the German artist Winold Reis who, after arriving in the United States in 1913, quickly opened his own school and drawing studio in New York. Although his art was located midway between commercial graphics and interior design, Reis was also interested in the visible manifestations of racial identity, and initiated Douglas into the notion of *blackness*.

Douglas's art encompassed several forms of representation: illustrations in published works, mural paintings and canvases. Whether they were drawings destined to be printed, or grand mural frescoes, his works essentially relied on an historical narrative. This was the case with his 1931 mural painting dedicated to Harriet Tubman, the 19th century anti-slavery activist. Faithful to Alain Locke's intellectual perspective, Douglas chose to observe different aspects of African rituals as they were expressed in the dance of day-to-day life, using stylized forms reminiscent of African motifs. The designs, the masks, the frank juxtapositions of colors on large mural surfaces were decorative, however these decorations also incorporated the constituent elements of African-American history. It was by immersing himself in the Harlem nightclub crowds, by observing bodies moving to the musical rhythms, that Douglas picked out the movements he wanted to give his painted fig-

Fig. 1
Aaron Douglas,
Play De Blues, 1926.
Lithograph for *Misery*
by Langston Hughes,
11 x 16"
(27.9 x 40.6 cm).
Schomburg Center for
Research in Black Culture,
Art & Artifacts Division.
The New York Public
Library, Astor, Lenox and
Tilden Foundations.

ures. He used diagonal lines and concentric bands of color to accentuate the geometry of the shapes, and applied his colors in flat expanses, with composite shadings that created successive depths of field, while still avoiding a three-dimensional perspective. The painted figures were almost always shown in silhouette, and gave the spectator a mere glimpse of a schematic mass, in frozen motion. The super-imposed layers of paint also depicted the evolution of African-American history. In this way, *Building More Stately Museums*, an oil on canvas dating from 1944, is like a visual "resume" of African-American history, a narrative marked by the symbols of work and of architectural construction. Douglas's metaphysical and metaphorical visions of African heritage, as well as his style imprinted with epic lyricism marked the image of the Harlem Renaissance. His 1934 mural painting on the Harlem Library, *Aspects of Negro Life*, a history of black Americans in several stages concluding with contemporary jazz, influenced painters of the following generations.

Palmer Hayden, another of the first American painters to integrate African elements and subjects into his paintings, was formally opposed to Douglas, but was also closer, in his figuration, to African-American day-to-day life. In representing their "slices of life," he imbued their lives with folkloric elements borrowed from his own life in his hometown of Wide Water, Virginia, or from his stint building the railroad not far away. Despite making a parallel between African motifs and the urban and rural reality of American blacks, Hayden remained impossible to categorize. James A. Porter, the art historian and author of *Modern Negro Art*, considered him to be a "naive painter" who created stereotypical images.[5] On the contrary, Alain Locke saw him as an interpreter of black themes *par excellence*, whose work was characterized by a narrative pictorial representation that endowed his painted figures with

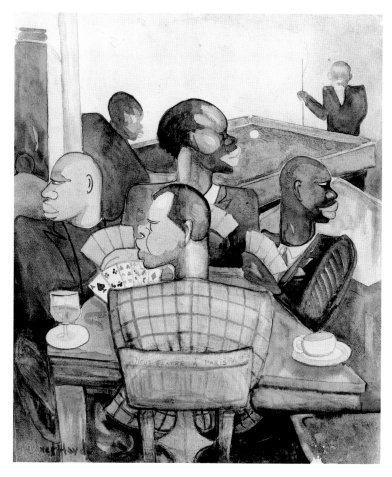

traits proper to their time period. Hayden's career was full of contradictions.[6] For example, he was considered a self-taught man, but we know that when he arrived in New York in 1919, he took art classes at Cooper Union. He was criticized for his grotesque representations of blacks who embodied the caricatured traits generally attributed to African-Americans by whites, but he was also celebrated after 1926 by the Harmon Foundation, which awarded him first prize and the first golden medal of the Foundation's inaugural exhibition. He received a grant which allowed him to go to France, where he stayed for five years. That was where he developed his studies of African-American figures: he was the first black painter to present "Negro subjects" to the European public. In 1933, one year after return-

Fig. 2
Palmer Hayden,
"Nous Quatre à Paris,"
c. 1930. Watercolor
on paper, 21 ¹/₈ x 18"
(53.6 x 45.7 cm).
New York,
The Metropolitan
Museum of Art.
Joseph H. Hazen
Foundation Gift Fund.

ing to New York, his 1926 painting *Fetish and Flowers* was honored with a new prize from the Harmon Foundation. Hayden's treatment of this still life, which shows a fang mask from Gabon and yellow and red fleurs de lys overflowing a vase placed on a cloth with a raffia Bakuba African motif, does not explicitly question the forms of modern artistic representations. If Picasso—one of the most famous examples of modern art—was directly inspired in 1907, for his *Demoiselles d'Avignon*, by so-called "primitive" sculpture, it should be emphasized that he broke away from the Western pictorial tradition by radically transforming the representational process. The confrontation between the works of European artists who borrowed from so-called "primitive" forms and the works of African-American artists raised a fundamental question. These latter, conscious of referring to their origins, directly alluded visually to Africa and reproduced figurative schemas that had existed in Western art since the 19th century. Although they did affirm their cultural heritage, their pictorial representations did not display any formal changes. These were difficult to interpret in this context that was particularly decisive for the history of modern art.

Hayden, one of the first black artists to inscribe an African shape in an American painting, opened a debate about the history of the represented object, but in the end, he did not cause a formal revolution. It was precisely during this period that the majority of African-American artists felt themselves imprisoned within a social and intellectual structure that also confined the majority of the analyses of their works. How to treat the discrepancy between form and content in a field where blacks had always been marginalized? What needed to be done was to fill in the gaps first by integrating the elements of a culture proper to their identity, and then by reexamining established forms and values. As for the African-American works of the Harlem Renaissance, it

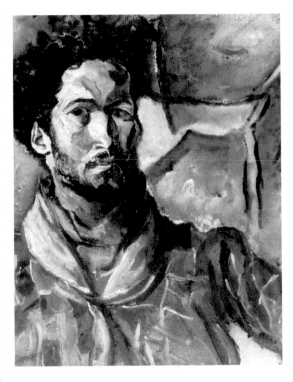

seems particularly difficult to part from this approach. One concentrated more specifically on what was represented—the black themes—rather than on the way in which these representations questioned a pictorial or sculptural tradition. The debate revolved around a precise idea: The supremacy of Western art restrained the cultures that sought to found their identities on their difference. For black artists, the consequence was the impossibility of reversing this hegemony.[7] Many analyses by African-American theoreticians underlined the difficulty of drawing a parallel between modern art and black art in the sense that the latter was never considered to be "equal or on the same level" as modern art in the minds of Western theoreticians and artists. This necessarily accentuated the distance separating the mainstream (the majority) from the periphery (the minority). For this reason, the title of Porter's 1943 book, *Modern Negro Art*, was indeed shocking, because it seemed improbable that a non-Western intellectual could associate the term

"modern" with black art. How to write a history of African-American art when this art was always considered *on the sidelines, apart, other*? It was by asking this question in this perspective that we can analyze the negative criticism directed at Hayden's work for representing blacks as being too black. When reproached for painting stereotypes, Hayden insisted that he was painting and representing a time-period, and that his works "symbolically made reference to the comedy, tragedy and pleasures of a black life-style."[8] The fundamental question, concerning the stereotypical representations, was whether the artist participated in denouncing the image of blacks in white society, or whether on the contrary, he developed in his own right a negative image that only reinforced the racist imagination. In African-American consciousness, self-mockery is often rejected as being disrespectful of black dignity.[9] If we look at the photographic works of the Harlem Renaissance, in particular those by James VanDerZee, we can sense the strong desire to produce "positive" images of blacks as opposed to the previously stereotypical portraits. Photographing the residents of Harlem was one way of writing the visual history of a people who had been, until then, deprived of one, as well as a way of preserving a memory in one of the most popular means of reproduction.

VanDerZee took portraits of people—both well-known or unknown—and treated all of them with the same degree of importance. By photographing African-Americans of all social classes, appareling the most deprived in the most expensive Sunday clothes, staging them in elegant poses and decors, correcting their complexions and their teeth, erasing their wrinkles, their blemishes and the circles under their eyes, adding beauty marks to women's cheeks, hair onto bald heads, retouching and reworking the negatives, VanDerZee created a fabricated representation, that, by bolstering black self-confidence, gave

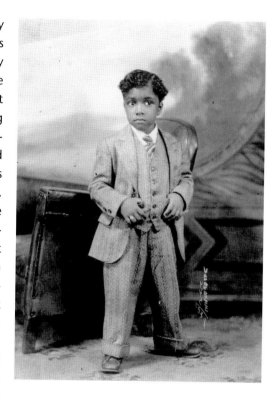

Fig. 4
James VanDerZee,
Boy in Three-piece Suit,
1931. Gelatin silver
print, 10 x 8"
(25.4 x 20.2 cm).
© Donna M. VanDerZee

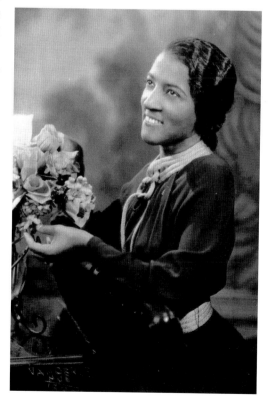

Fig. 5
James VanDerZee,
*Portrait of Woman
with Flowers*, 1935.
Gelatin silver print,
10 x 8"
(25.4 x 20.2 cm).
© Donna M. VanDerZee

pride to bodies which had long been invisible because of racial segregation. Despite the glorification of the image and its distortion of reality, VanDerZee nonetheless maintained a specificity proper to each individual photographed. Paradoxically, by erasing the imperfections, he endowed his subjects with specific personal traits and lifted them out of their anonymity: they thus became the actors of Harlem.

It is surely not by chance that the controversial exhibition, *Harlem on my Mind*, held at the Metropolitan Museum in 1969, used almost exclusively VanDerZee's photographs to illustrate this important historical period.[10] The fact that the African-American population had to go to a museum institution run by whites in order to see the first exhibition ever devoted to black culture magnified the sense of injustice. The justified polemic that preceded and accompanied *Harlem on my Mind* was based on the omission of any pictorial or sculptural work by contemporary African-American artists who rebelled against an idealized presentation of this recent historical context, and who expressed their deep-seated disagreement with this new form of segregation. Let's cite among them Romare Bearden who, as early as during the Depression, expressed his reservations about the artistic impact of the black renaissance. Although Bearden may have contributed to making a black identity and to creating a new culture that claimed to be autonomous, he was also reproached for not being sufficiently involved in the political and social realities of his time and for not having developed, in the end, an original art form. In his 1934 essay entitled "The Negro Artist and Modern Art," published in *Opportunity*, Bearden lashed out: "Their work is at best hackneyed and uninspired and is only a rehashing of the work of any artist who may have influenced them. They have looked at nothing with their own eyes—seemingly content to use borrowed forms. They have evolved nothing original or mature like spirituals or jazz music." This commentary was deadly and also addressed the absence of more ideological questions. Nevertheless, it must be emphasized that the struggles in which black artists were engaged after the 1920s tended, above all, to compensate for the centuries of "nonexistence" by affirming an individual and collective identity. Yet, the Harlem Renaissance did help clarify the statute of the African-American artist. The artist could now address head-on artistic, social or political issues, thus fully assuming responsibility for his role in forging the historical memoir of his community. It is not by chance that the African-American oral narrative tradition finds its extension in visual narration. To quote Walter Benjamin, "Preserve one's inner forces and one will be able to explain oneself clearly for a long time."[11]

Elvan Zabunyan

Notes

1. W. E. B. Dubois, *The Souls of Black Folk*, New York, Penguin Books, 1969 (1st edition 1903).

2. Alain Locke, *The New Negro*, New York, Albert and Charles Boni, Inc., 1925; republished New York, Atheneum, 1968.

3. To avoid simply listing the artists who were working during the Harlem Renaissance, we opted to present more precisely two painters—Aaron Douglas and Palmer Hayden—whose artistic practices in fact emphasized an unprecedented pictorial vocabulary in black art. It is important, nonetheless, to specify that other important artists were producing sculpture, for example, by investing themselves in a figuration that asserted its African-American identity; among the most well-known, let us cite Selma Burke, Meta Warrick Fuller, Augusta Savage or Richmond Barthe. In one way or another, all of them took African sculpture as the starting point for a stylistic study and for an homage to an ancestral heritage.

4. "Negro," in *The Collected Poems of Langston Hughes*, ed., Arnord Rampersad, New York, Vintage Books, 1994, p. 24. The poem was published for the first time in January 1922 in *The Crisis* under the title "The Negro," then was reprinted in *Current Opinion* in March of the same year.

5. James A. Porter, *Modern Negro Art*, New York, Dryden Press, 1943; reprinted New York, Arno Press and the New York Times, 1969.

6. Questions already abounded concerning his date of birth: in Richard J. Powell's work (*Black Art and Culture in the 20th Century*, London, Thames and Hudson, 1977) and in that of Samella Lewis (*African-American Art and Artists*, Berkeley, University of California Press, 1990), we find 1893, while in the catalogue, *Harlem Renaissance, Art of Black America* (New York, The Studio Museum in Harlem), 1994, as well as in *250 Years of Afro-American Art, an Annotated Bibliography* (New York/London, R. R. Bowker Company, 1981), it is indicated as 1890. Hayden died in 1973.

7. Thus, in a significant way, the importance of a painter such as William H. Johnson (1901-70), who was considered very early on by historians of African-American art as a prominent personality in Modern Art, especially after his stay in France where he discovered the work of Cézanne and Van Gogh, was always overlooked within the general history of American art of the 20th century.

8. David Driskell, "The Flowering of the Harlem Renaissance: The Art of Aaron Douglas, Meta Warrick Fuller, Palmer Hayden, and William H. Johnson," exhibition cat., *Harlem Renaissance, Art of Black America, op. cit.*, p. 132. It is also within this perspective that one could consider the pictorial work of a painter such as Archibald Motley, Jr., who, at about the same time, presented war scenes in which he especially emphasized the effervescence of the everyday life of American blacks. His figurative choices relied on airy shapes and vibrant colors that replaced any pathos with the "joie de vivre" of the Harlem Renaissance.

9. In this regard, it is important to note that an author of the stature of Zora Neale Hurston, who early on distinguished herself in anthropological studies of African-American folklore, and who, boldly but with considerable critical distance, painted verbal portraits of the Southern United States that often bordered on caricature, was often decried by her contemporaries.

10. *Harlem on My Mind, Cultural Capital of Black America, 1900-1968*, reprinting of the exhibition catalogue with a new introduction by Allon Schoener and a preface by Henry Luis Gates, Jr., New York, The New Press, 1995.

11. Walter Benjamin, french trans. in "Le Narrateur," *Poésie et Révolution*, Paris, Denoël, 1971, p. 147.

Georgia O'Keeffe
Pelvis with Moon, 1943
Oil on canvas, 30 x 24" (76.2 x 61 cm)
West Palm Beach, Norton Museum of Art
Purchased through the R. H. Norton Fund

Arthur Dove
Sea Gull Motive (Sea Thunder or The Waves), 1928
Oil on mahogany panel, 26 1/4 x 20 1/2" (66.7 x 52.1 cm)
M. H. de Young Memorial Museum,
Fine Arts Museums of San Francisco
Museum Purchase, Richard B. Gump Trust Fund,
Museum Society Auxiliary, Museum Acquisition

Arthur Dove
Pine Tree, 1931
Oil on canvas, 30 1/8 x 40" (76.4 x 101.6 cm)
The Cleveland Museum of Art
Leonard C. Hanna, Jr., Fund

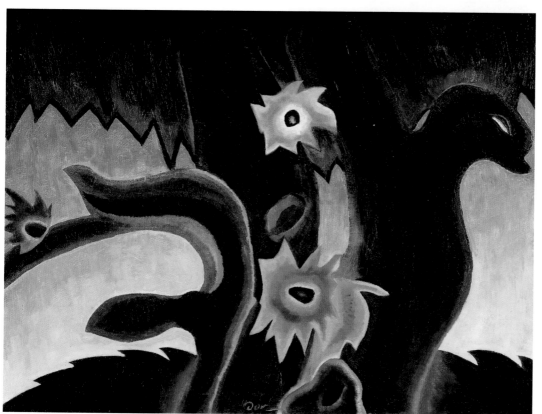

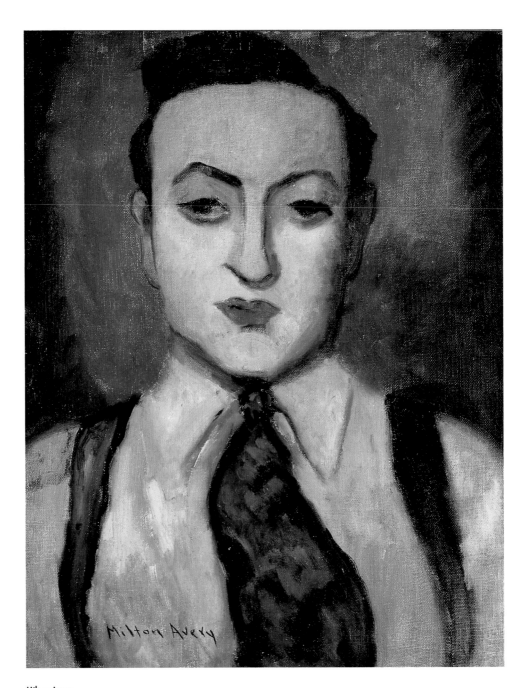

Milton Avery
Portrait of Louis Kaufman, 1927
Oil on canvas on masonite, 20 x 16" (50.8 x 40.64 cm)
Portland Art Museum
Gift of Dr. Annette Kaufman in Memory of Dr. Louis Kaufman

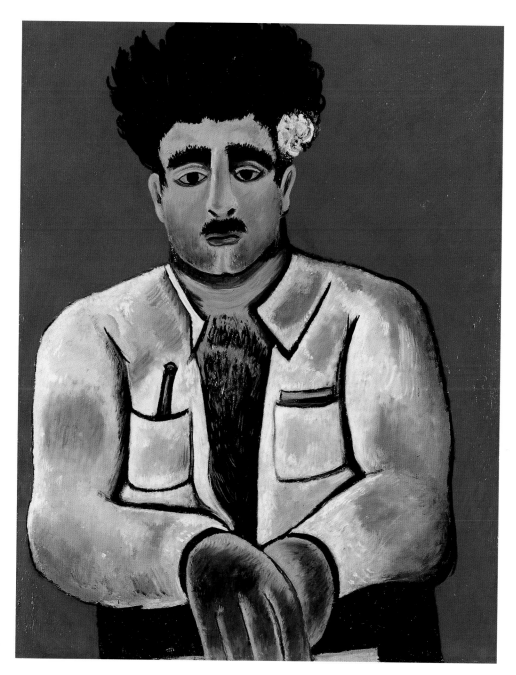

Marsden Hartley
Adelard the Drowned, Master of the "Phantom," c. 1938-39
Oil on panel, 28 x 22" (71.12 x 55.88 cm)
Minneapolis, Frederick R. Weisman Art Museum
Bequest of Hudson Walker from the Ione and Hudson Walker Collection

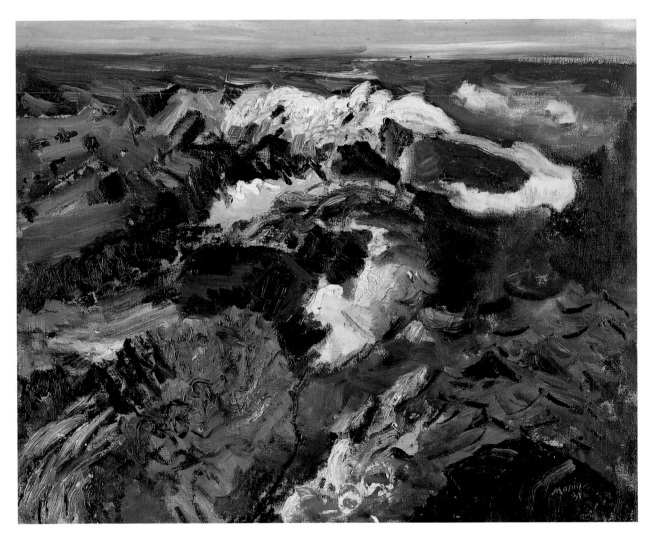

John Marin
Maine Rocks and Sea: Small Point, Maine, 1931
Oil on canvas, 22 1/8 x 28" (56.2 x 71 cm)
The Cleveland Museum of Art
Norman O. Stone and Ella A. Stone Memorial Fund

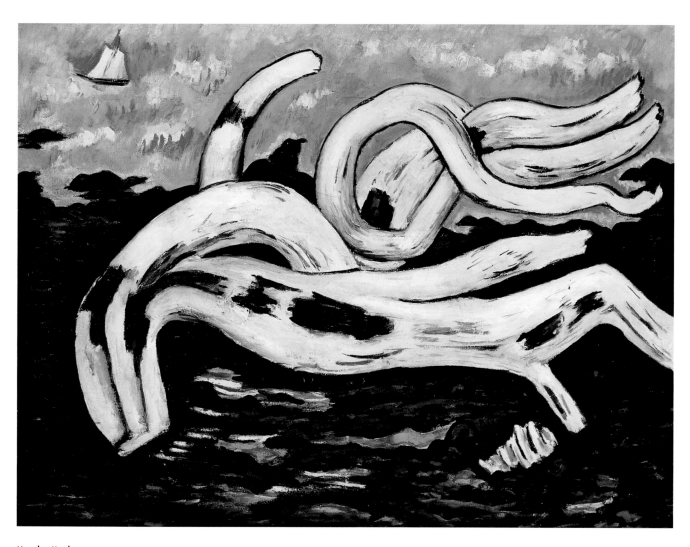

Marsden Hartley
Driftwood on the Bagaduce, 1939-40
Oil on canvas, 30 $\frac{1}{8}$ x 40 $\frac{1}{8}$" (76.5 x 102 cm)
The Saint Louis Art Museum
Gift of Morton D. May

Gaston Lachaise
Breasts, Small 1930
Bronze, 6 x 6 $^1/_2$ x 4 $^1/_2$"
(15.2 x 16.5 x 11.4 cm)
New York, courtesy Salander-O'Reilly Galleries

Gaston Lachaise
Torso with Arms Raised, 1935
Bronze, 37 x 33 ¹/₂ x 16 ¹/₂"
(94 x 85.1 x 41.9 cm)
New York, Courtesy Salander-O'Reilly Galleries

Gaston Lachaise
Dynamo Mother, 1933
Front and rear views
Bronze, 11 ¹/₈ x 17 ³/₄ x 7 ¹/₄" (28.3 x 45 x 18.4 cm)
New York, courtesy Salander-O'Reilly Galleries

Walker Evans
Untitled,
Architectural Study, c. 1932
Gelatin silver print, 4 3/4 x 2 7/8"
(12 x 7.2 cm)
Paris, private collection

Walker Evans
Architectural Study, New York State, 1931-32
Gelatin silver print, 5 3/8 x 4 1/2" (13.5 x 11.6)
Paris, Sandra Alvarez de Toledo

Walker Evans
Ginger Bread Houses, Cambridge, 1932
Gelatin silver print, 4 3/4 x 6 3/4" (12 x 17 cm)
Paris, Sandra Alvarez de Toledo

Walker Evans
Ruin of Tabby Shell Construction, St Mary's, Georgia, 1936
Gelatin silver print, 10 x 12 7/8" (25.4 x 32.7 cm)
Richmond, Virginia Museum of Fine Arts
The Sherritt Art Purchase Fund

Frame Houses in Virginia, 1936
Gelatin silver print, 6 1/4 x 7 3/4"
(15.9 x 19.7 cm)
The Minneapolis Institute of Arts
The William Hood Dunwoody Fund

Walker Evans
View of Easton, Pennsylvania, 1935
Gelatin silver print, 7 ¹/₂ x 9 ¹/₂" (19 x 24.1 cm)
The Minneapolis Institute of Arts
Gift of D. Thomas Bergen

Charles Burchfield
Old House and Elm Trees, 1933-40
Watercolor on paper, 26 ¹/₂ x 40" (67.1 x 101.6 cm)
Richmond, Virginia Museum of Fine Arts
The John Barton Payne Fund

Charles Burchfield
Study N° 1 for "Church Bells Ringing, Rainy Winter Night", 1917
Pen and black ink, black and gray wash, black and colored pastel on paper
14 ¹/₂ x 8 38" (36.7 x 21.2 cm)
The Cleveland Museum of Art
Norman O. Stone and Ella A. Stone Memorial Fund

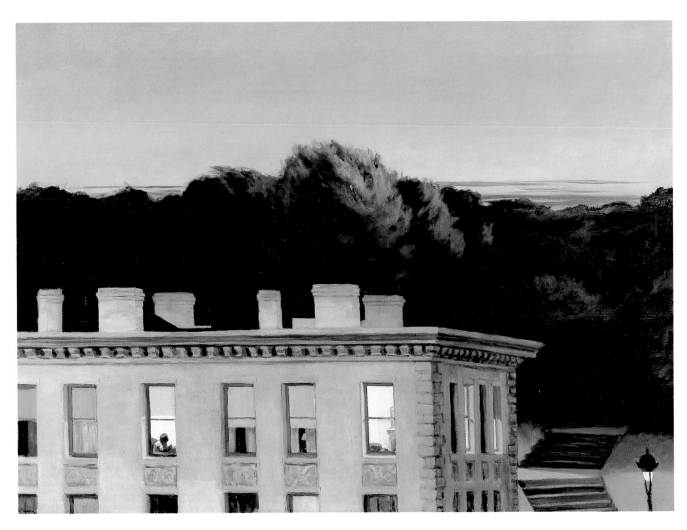

Edward Hopper
House at Dusk, 1935
Oil on canvas, 36 1/4 x 50" (92.1 x 127 cm)
Richmond, Virginia Museum of Fine Arts
The John Barton Payne Fund

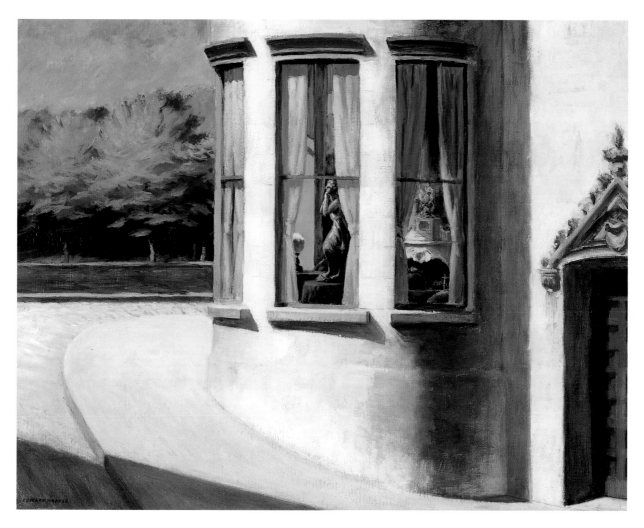

Edward Hopper
August in the City, 1945
Oil on canvas, 23 x 30" (58.4 x 76.2 cm)
West Palm Beach, Norton Museum of Art
Bequest of R. H. Norton

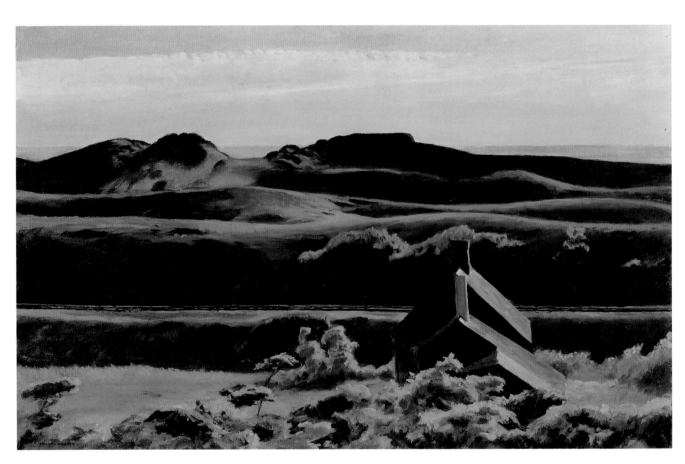

Edward Hopper
Hills, South Truro, 1930
Oil on canvas, 27 3/8 x 43 1/8" (69.5 x 109.5 cm)
The Cleveland Museum of Art
Hinman B. Hurlbut Collection

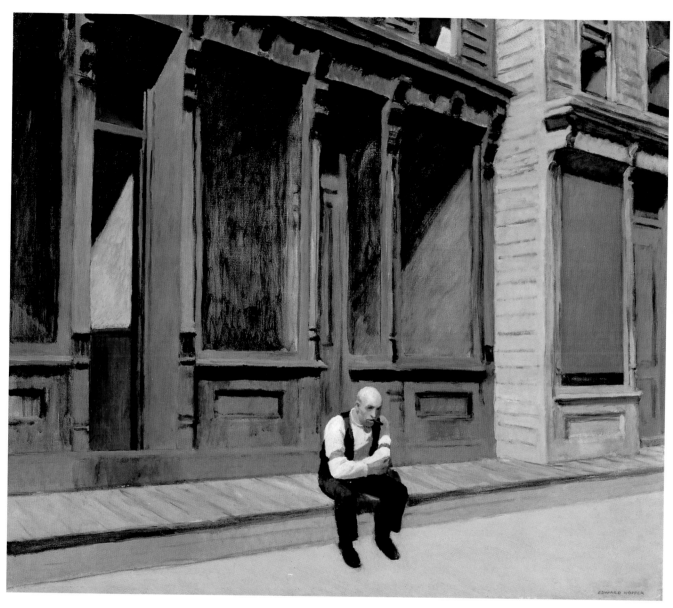

Edward Hopper
Sunday, 1926
Oil on canvas, 29 x 34" (73.7 x 86.4 cm)
Washington D.C., The Phillips Collection

Grant Wood
Spring in the Country, 1941
Oil on masonite, 24 x 22 1/8" (61 x 56.2 cm)
Cedar Rapids Museum of Art
Art Association Purchase

Grant Wood
Shrine Quartet, 1938
Lithograph, 7 7/8 x 11 7/8" (20.1 x 30.1 cm)
M. H. de Young Memorial Museum, Fine Arts Museums of San Francisco
Gift of George Hopper Fitch

Grant Wood
Fertility, 1939
Lithograph, 7 7/8 x 11 7/8" (22.7 x 30.2 cm)
M. H. de Young Memorial Museum, Fine Arts Museums of San Francisco
Gift Of George Hopper Fitch

Grant Wood
July Fifteenth, 1938
Lithograph, 9 x 11 7/8" (22.8 x 30.1 cm)
M. H. de Young Memorial Museum, Fine Arts Museums of San Francisco
Achenbach Foundation for Graphic Arts

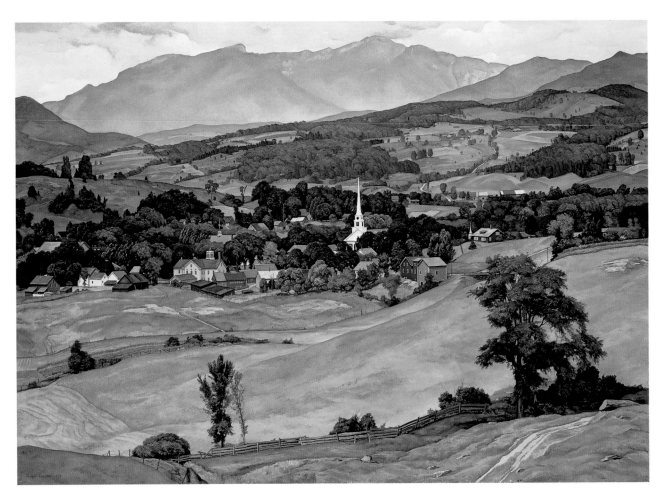

Luigi Lucioni
Village of Stowe, Vermont, 1931
Oil on canvas, 23 1/2 x 33 1/2" (59.7 x 85.1 cm)
The Minneapolis Institute of Arts
Gift of the Estate of Mrs. George P. Douglas

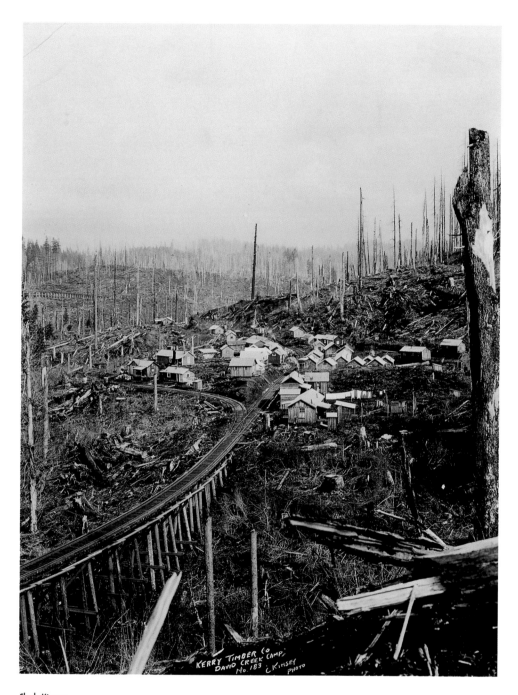

Clark Kinsey
Kerry Timber Co., David Creek Camp, N° 183, c. 1920
Gelatin silver print, 13 ¹/₈ x 10 ¹/₄" (33.3 x 26 cm)
Portland Art Museum
Gift of Ed Cauduro

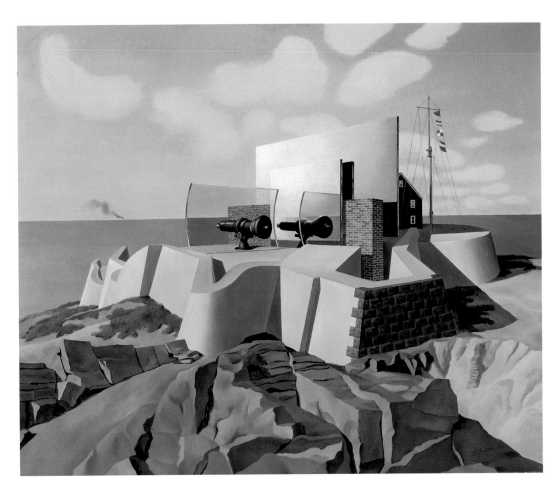

John C. Atherton
Coast Fortification, 1940
Oil on canvas, 20 ¹/₈ x 24 ¹/₈" (51.1 x 61.3 cm)
M. H. de Young Memorial Museum, Fine Arts Museums of San Francisco
Gift of the Mason B. Wells Foundation, Inc.

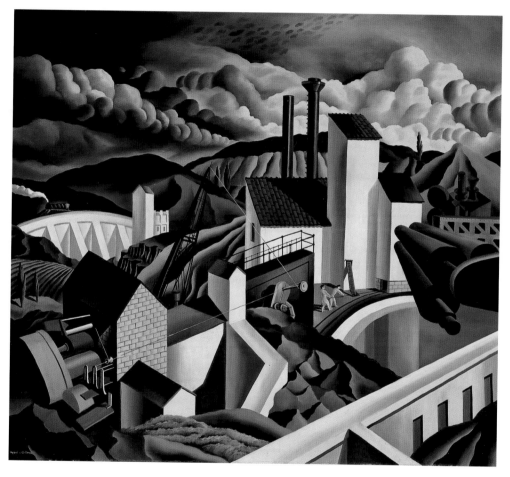

Raphael Gleitsman
The White Dam, 1939
Oil on canvas, 38 $\frac{1}{2}$ x 44 $\frac{3}{8}$" (97.8 x 112.7 cm)
The Cleveland Museum of Art
Leonard C. Hanna, Jr. Fund

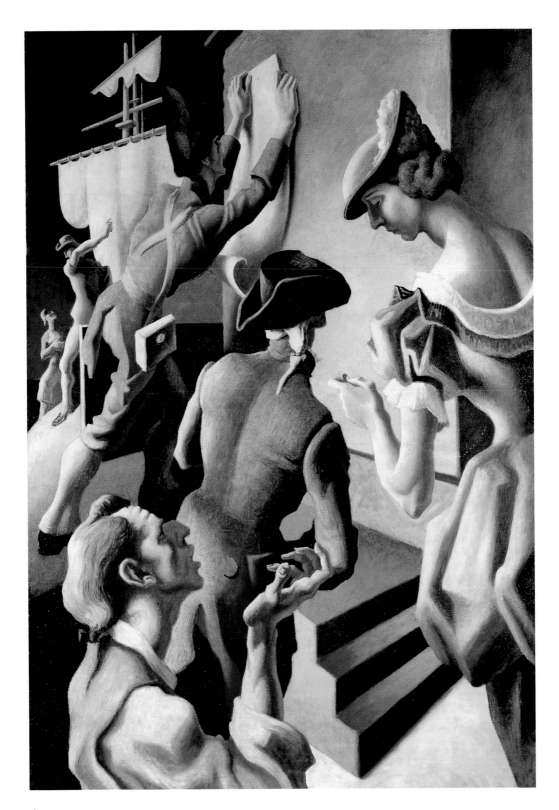

Thomas Hart Benton
Brideship (Colonial Brides), 1927-28
Oil and tempera on panel, 60 $^3/_{16}$ x 42 $^1/_8$" (153.2 x 107 cm)
Richmond, Virginia Museum of Fine Arts
Gift of Crosby Kemper, The J. Harwood and Louise B. Cochrane
Fund for American Art and Museum Purchase

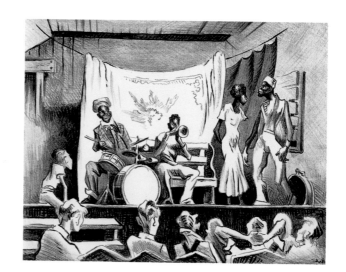

Thomas Hart Benton
Minstrel Show, 1934
Lithograph, 8 ⁷/₈ x 11 ⁵/₈"
(22.56 x 29.54 cm)
Dallas Museum of Art
Gift of Mrs. Arthur Kramer, Sr.

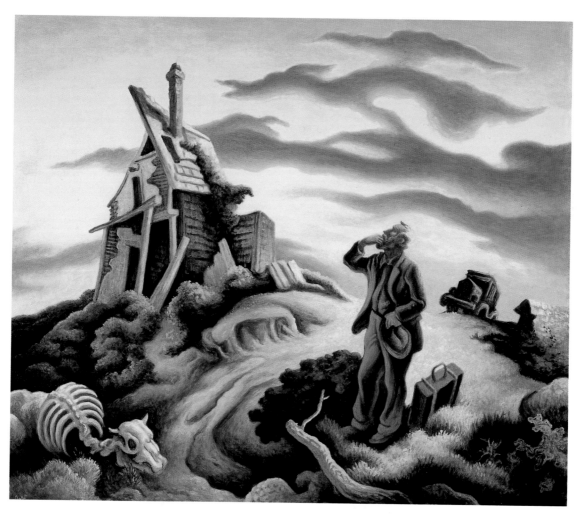

Thomas Hart Benton
Prodigal Son, c. 1939-41
Oil and tempera on panel, 26 ¹/₈ x 30 ¹/₂"
(66.36 x 77.47 cm)
Dallas Museum of Art
Dallas Art Association Purchase

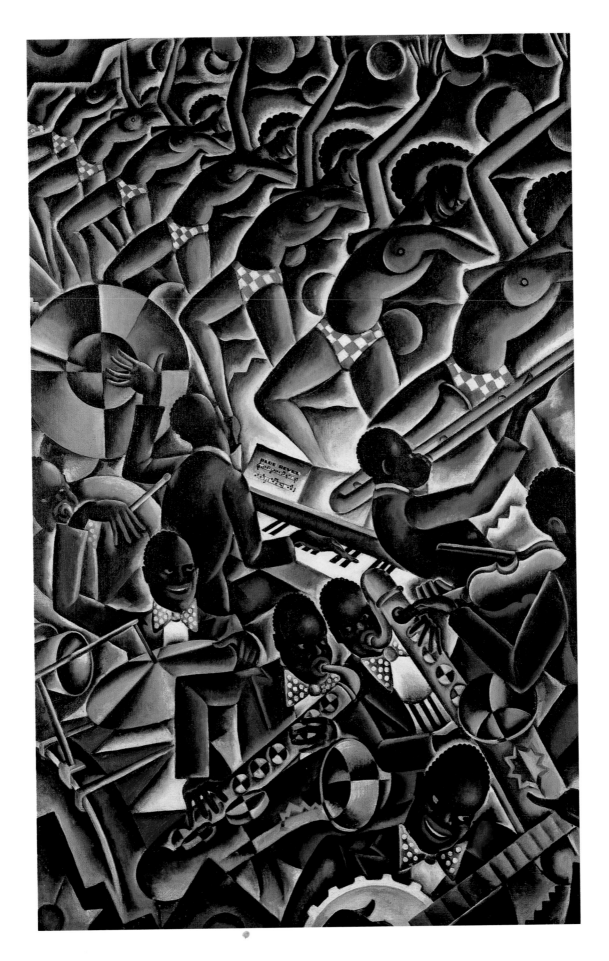

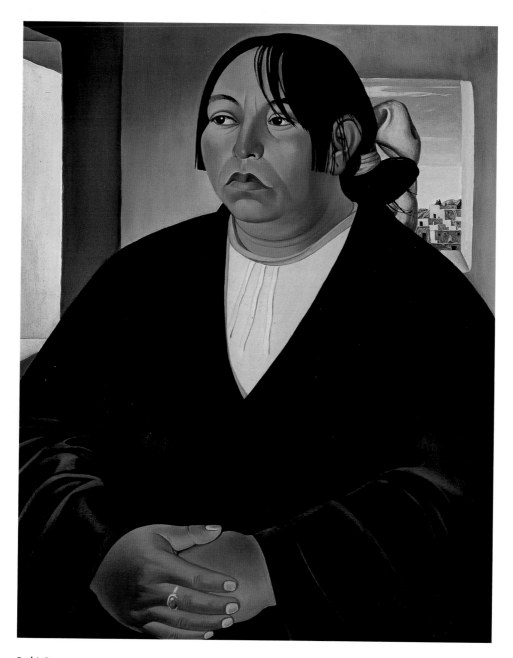

Emil J. Bisttram
Pueblo Woman, 1932
Tempera and oil glaze on panel, 30 x 24"
(76.20 x 60.96 cm)
Dallas Museum of Art
Gift of Mr. and Mrs. Royal C. Miller

Viktor Schreckengost
Blue Revel, 1931
Oil on canvas, 54 $^3/_4$ x 36 $^5/_8$"
(139.1 x 93.1 cm)
The Cleveland Museum of Art
Gift of Vik Schreckengost

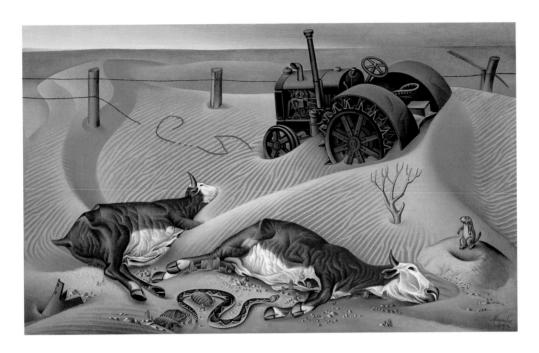

Alexander Hogue
Drought Survivors, 1936
Oil on canvas, 30 1/8 x 48"
(76.5 x 122 cm)
Blérancourt, Musée de la Coopération
Franco-Américaine

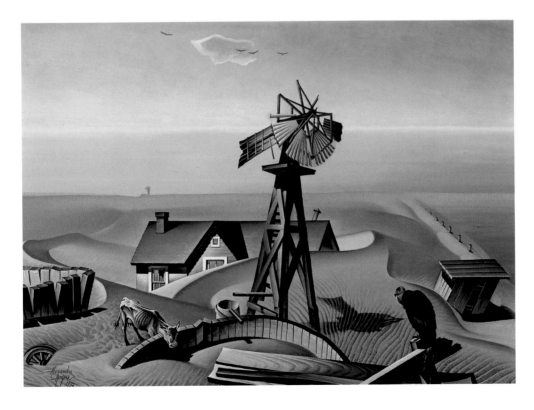

Alexander Hogue
Drought Stricken Area, 1934
Oil on canvas, 30 x 42 1/4"
(76.2 x 107.32 cm)
Dallas Museum of Art
Dallas Art Association Purchase
Estate of Alexander Hogue,
courtesy Cline Fine Art, New Mexico

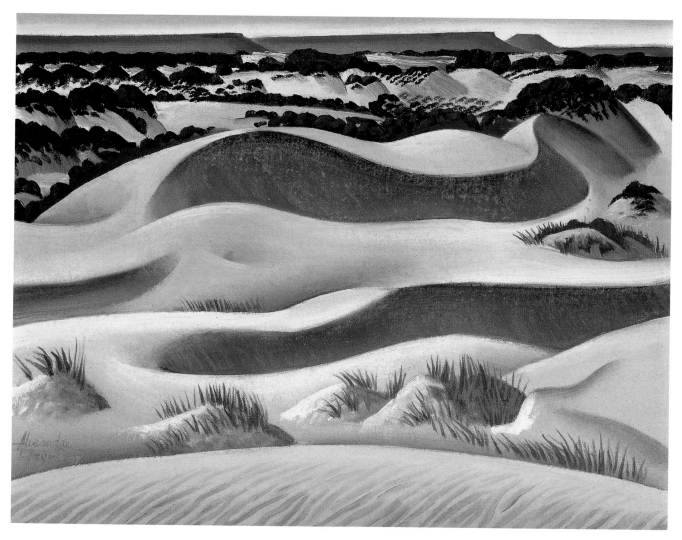

Alexander Hogue
Crane County Dunes, 1937
Oil on panel, 12 x 16"
(30.48 x 40.64 cm)
Dallas, The Barrett Collection

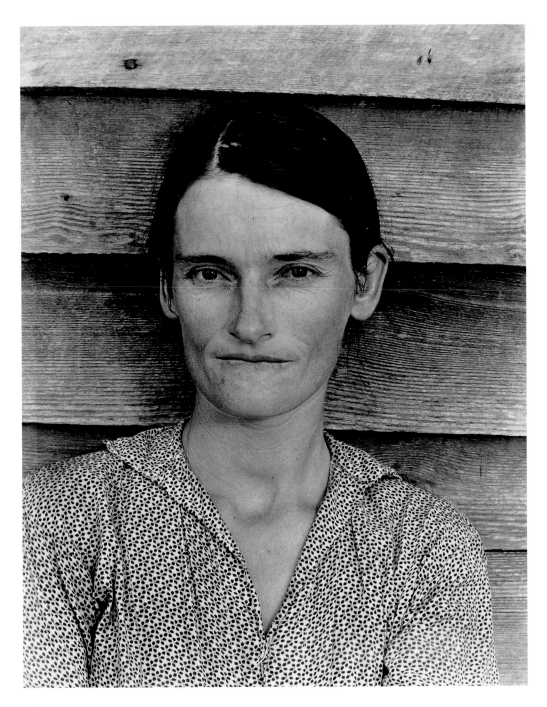

Walker Evans
Allie Mae Burroughs, Wife of a Cotton Sharecropper, Hale County, Alabama, 1936
Gelatin silver print, 9 3/$_8$ x 7 1/$_2$" (23.65 x 19.05 cm)
The Saint Louis Art Museum
Purchase, Bequest of Jean F. Harris and Funds given by Mr. and Mrs. Robert Rosenheim

Dorothea Lange
Migrant Mother, Nipomo, California, 1936
Gelatin silver print, 13 1/$_4$ x 10 1/$_4$" (33.8 x 26.19 cm)
The Minneapolis Institute of Arts
The Alfred and Ingrid Lenz Harrison Fund

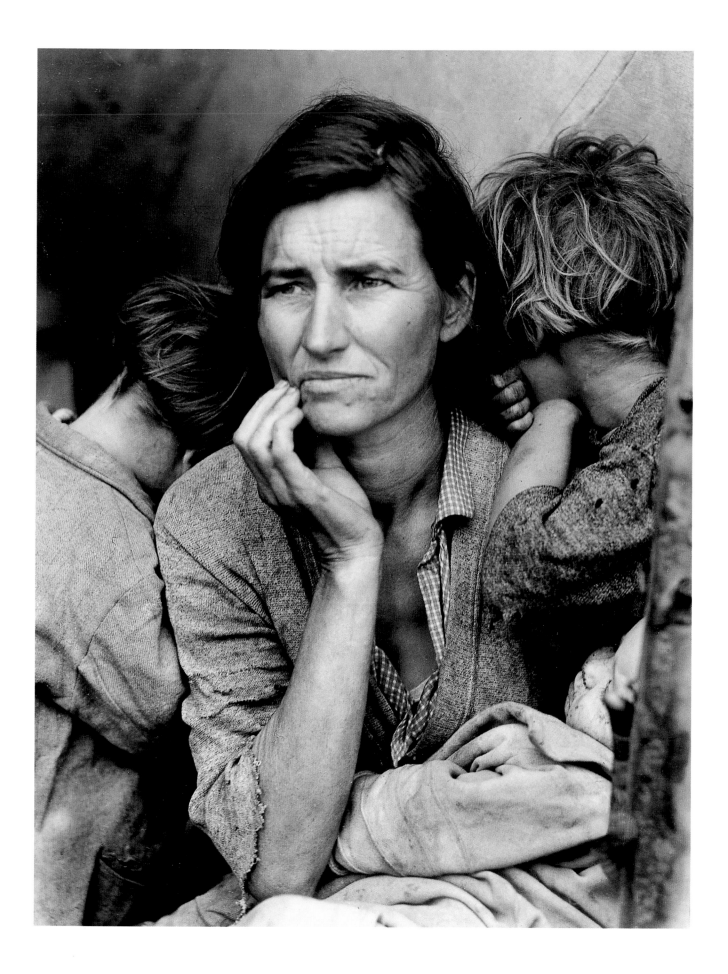

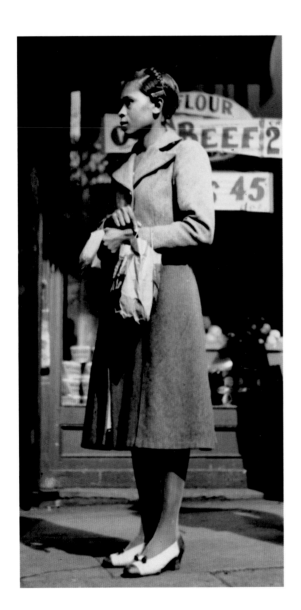

Walker Evans
Negro Girl at Tallahassee, 1934
Gelatin silver print, 8 3/8 x 3 7/8" (20.4 x 10 cm)
Paris, Sandra Alvarez de Toledo

Walker Evans
Independence Day, Terra Alta, West Virginia, 1935
Gelatin silver print, 6 1/4 x 8 5/8" (16 x 22 cm)
Paris, Sandra Alvarez de Toledo

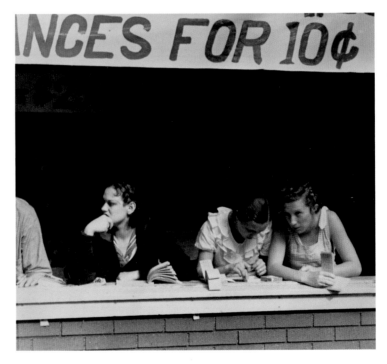

Walker Evans
Independence Day, Terra Alta,
West Virginia, 1935
Gelatin silver print, 6 1/4 x 8 5/8"
(16 x 22 cm)
Paris, Sandra Alvarez de Toledo

Walker Evans
Sidewalk in Vicksburg, Mississippi, 1936
Gelatin silver print, 7 5/8 x 8 5/8"
(19.5 x 24.5 cm)
Paris, Sandra Alvarez de Toledo

Margaret Bourke-White
Ludlum Steel Company, 1928-1931
Gelatin silver print, 13 1/8 x 9 1/2" (33.3 x 24.10 cm)
The Cleveland Museum of Art
John L. Severance Fund

Reginald Marsh
Locomotives Watering, 1932
Oil and tempera on panel, 24 x 36" (61 x 91.4 cm)
The Cleveland Museum of Art
Bequest of Felicia Meyer Marsh

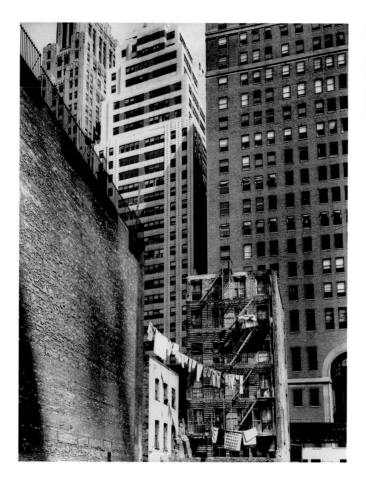

Berenice Abbott
Untitled, New York, 1935
Gelatin silver print, 13 ³/₈ x 10 ¹/₂"
(34 x 26.7 cm)
Estate of Harry Lunn
Paris, courtesy Galerie Baudoin Lebon

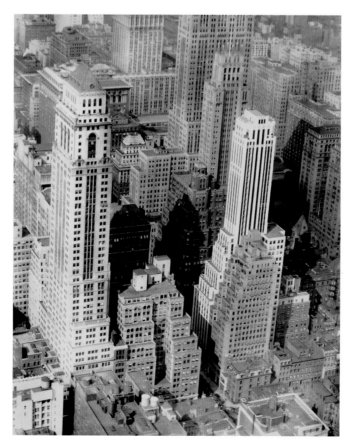

Berenice Abbott
Untitled (Skyscrapers, New York), 1935
Gelatin silver print, 9 ⁷/₈ x 8" (25.2 x 20.2 cm)
Estate of Harry Lunn
Paris, courtesy Galerie Baudoin Lebon

Philip Guston
Martial Memory, 1941
Oil on canvas, 40 1/8 x 32 1/4"
(101.9 x 82.6 cm)
The Saint Louis Art Museum
Eliza McMillan Fund

Romare Bearden
Factory Workers, 1942
Gouache and casein on brown wrapping paper mounted on panel,
39 ³/₄ x 31 ¹/₄" (100.97 x 79.38 cm)
The Minneapolis Institute of Arts
The John R. Van Derlip Fund

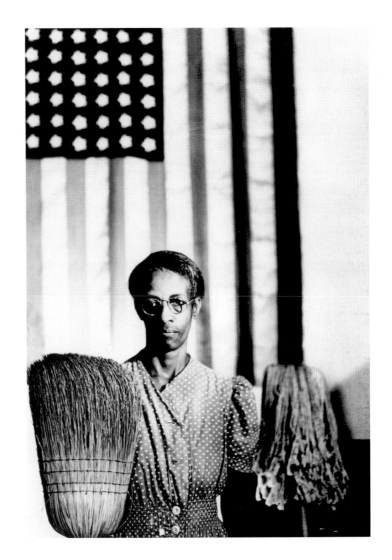

Gordon Parks
American Gothic, 1942
Gelatin silver print, 13 1/4 x 9 5/8" (33.7 x 24.4 cm)
West Palm Beach, Norton Museum of Art
Purchased through the R. H. Norton Fund

Ben Shahn
We Fight for a Free World !, c. 1942
Gouache on panel, 13 x 30" (33.02 x 76.20 cm)
New York, courtesy Michael Rosenfeld Gallery

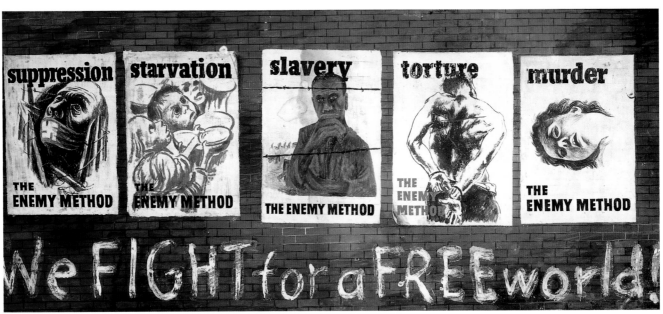

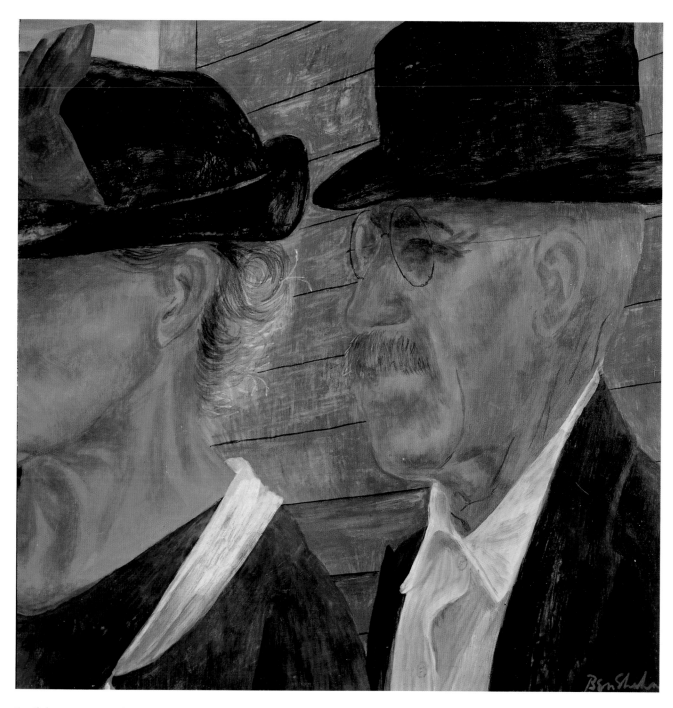

Ben Shahn
American Couple, c. 1938
Tempera on paper, on panel, 23 x 23" (58.42 x 58.42 cm)
New York, courtesy Michael Rosenfeld Gallery

Dorothea Lange
Shipyard Worker, 1944
Gelatin silver print, 9 $^1/_2$ x 7 $^5/_8$"
(24.4 x 19.5 cm)
Dixon Family Collection

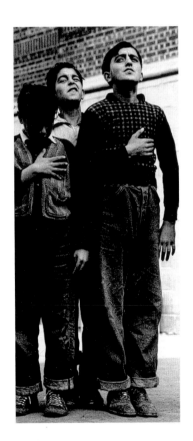

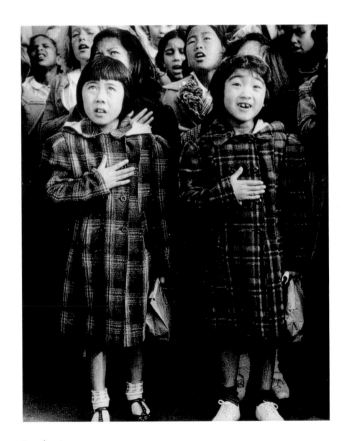

Dorothea Lange
Pledge to the Flag, 1942
Gelatin silver print, 12 $^1/_2$ x 5 $^1/_2$ "
(31.6 x 14 cm)
Dixon Family Collection

Dorothea Lange
Pledge of Allegiance, San Francisco, 1942
Gelatin silver print, 11 x 8 $^7/_8$"
(28.1 x 22.4 cm)
Dixon Family Collection

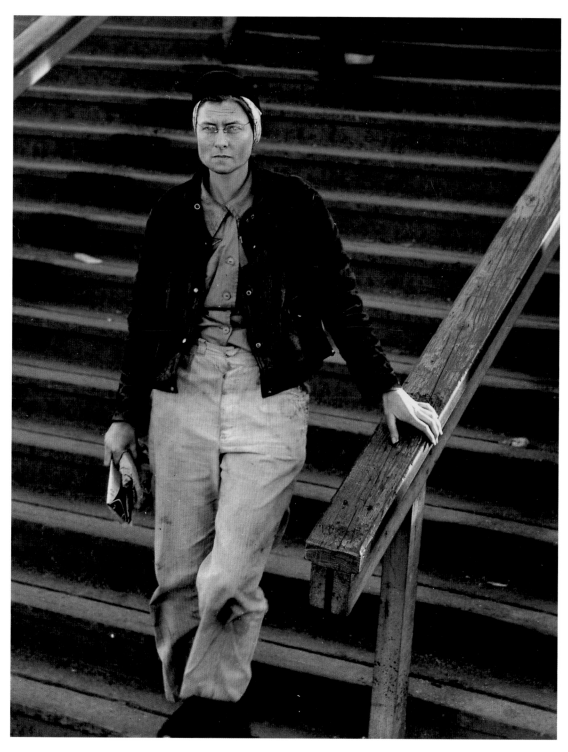

Dorothea Lange
Shipyard Worker on Stairs, 1942
Gelatin silver print, 9 $^1/_2$ x 7 $^1/_2$"
(24 x 19 cm)
Paris, Sandra Alvarez de Toledo

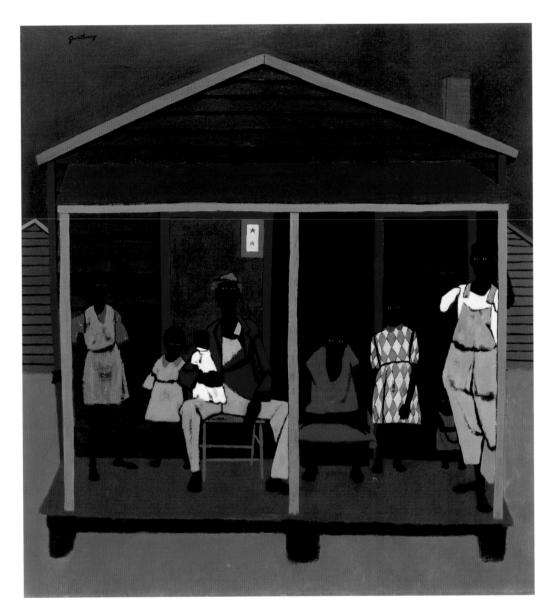

Robert Gwathmey
Family Portrait, c. 1945
Oil on canvas, 30 x 28" (76.2 x 71.1 cm)
Richmond, Virginia Museum of Fine Arts
The Katherine Rhoads Memorial Fund

Jacob Lawrence
Harlem Society, from the *"Harlem"* series, 1943
Gouache on paper, 15 x 21 ³/₄" (38.10 x 55.25 cm)
Portland Art Museum
Helen Thurston Ayer Fund

Jacob Lawrence
Bootleg Whiskey, from the *"Harlem"* series, 1943
Gouache on paper, 15 ¹/₂ x 22 ¹/₂" (39.37 x 57.15 cm)
Portland Art Museum
Helen Thurston Ayer Fund

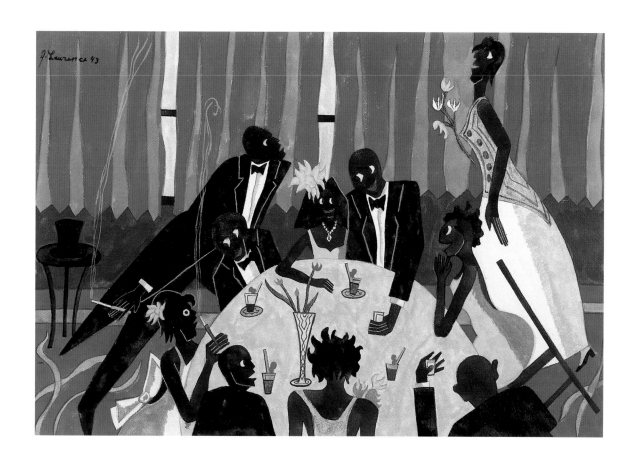

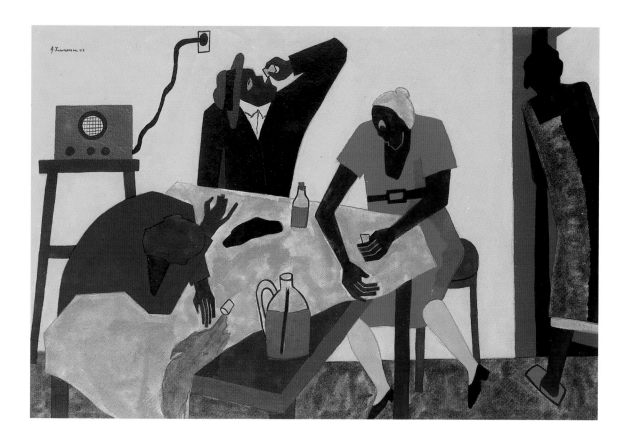

The Search for Community:

Abstractions and Automatisms

During the 1920s, some artists still based their work on Cubism. In this, they were accompanied and supported by the creation of institutions that accorded a great deal of importance to abstraction—the Société Anonyme founded in 1920 by Marcel Duchamp and Katherine Dreier, the Gallery of Living Art exhibiting the collection that Eugene Gallatin assembled between 1927 and 1943, and the Museum of Modern Art of New York presided over by Alfred Barr as of its creation in 1929. The best-known and the most remarkable of these artists was Stuart Davis. Depending on the period, he considered himself either an abstract or a figurative painter. As of 1926-27, he had already created his method of experimenting freely with flat expanses of color in order to recompose non-mimetic images of everyday reality. His engagement with the unionists of the Art Front after 1935 testified to his belief that modernism should participate in constructing a renewed American democracy.

After 1935, more and more artists opted for a non-figurative geometric abstraction. This was the case with Alexander Calder in his semi-exile in France where he literally put into motion the shapes of Mondrian and Miró. It was also the case with the New York artists who banded together after 1937 within the framework of the American Abstract Artists (AAA): notably Burgoyne Diller, Ilya Bolotowski, George L. K. Morris, Ad Reinhardt, Arshile Gorky and Charles Biederman, with whom Jean Hélion actively associated after settling in Virginia. The stylistic diversity of their works in no way betrays the radicality of their choices, founded on a strict opposition to what they perceived as the provincialism of the American scene. If most of these artists were excluded from the two major exhibitions organized by Barr in 1936—*Cubism and Abstract Art*, and *Fantastic Art, Dada and Surrealism*—they nonetheless would find the occasion to show their work to the public by creating several of the monumental murals with which the New Deal decorated public buildings in New York.

Simultaneously but more discreetly, several painters who had settled in New Mexico, such as Agnès Pelton, gathered around Raymond Jonson. In 1938, they created the Transcendental Painting Group. They were committed to a spiritualistic and futuristic abstraction, that was entirely original and surprisingly close to the popular modes of expression such as movies or science fiction comic books.

Up until the European countries entered the war, the world of American art had been characterized by the irreconcilable tensions between modernist internationalism and descriptive regionalism. A this time several artists on the East Coast—Jackson Pollock, Barnett Newman, David Smith, Steve Wheeler, Isamu Noguchi, Willem De Kooning—and on the West Coast—Clyfford Still, Mark Tobey, Gordon Onslow Ford—reconciled and incorporated into their paintings and sculptures the contributions of Abstraction and of Surrealism (which had penetrated into the United States as of 1931, giving birth to forms that proved too derivative). Freely using the principles of surrealist automatism, radical abstraction would progressively take the lead, evolving into what critics would call Abstract Expressionism after 1947. In 1943, with Pollock's first *all-over pourings* (paintings made by pouring the paint and letting it flow over the canvas with no centered composition), this abstraction appeared to be the best means for reconciling the expression of subjectivity and the universal impact of form. It was no coincidence that Walker Evans was pursuing the same artistic goal at the same time, with means proper to photography, in his *Subway Portraits*.

E.C.

Opposite:
Charles Howard
The Progenitors, 1947
Detail

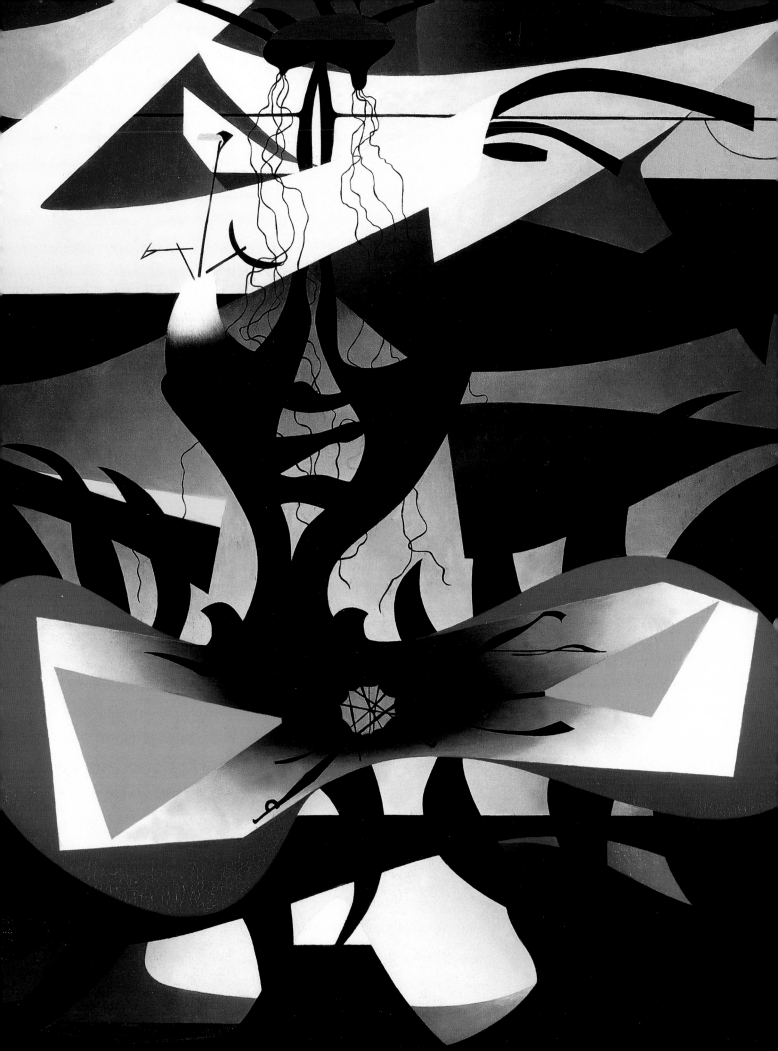

Jean Hélion and Albert E. Gallatin

One Aspect of the Exchanges Between Europe and the United States[1]

In keeping with what could be called a typically American philanthropic and pedagogical viewpoint, the collector, essayist and painter Albert E. Gallatin (1881-1954) wanted to make his private collection—comprised mostly of painters of the School of Paris (Chagall, De Chirico, Kikoïne, Pascin...) with a few Cubist examples (Picasso, Braque and Gris)—accessible to the largest possible number of people, so he gave it as a permanent loan to New York University.[2] This is how a small museum was opened in December 1927 in one of the University's ground-floor reading rooms on Washington Square. The museum was tellingly called the Gallery of Living Art, " founded in order that the public might have an opportunity of studying the work of some of the progressive twentieth century painters." Gallatin added, "It is certainly a matter of considerable surprise that hitherto no such public collection existed in the United States, in most respects one of the most modern of countries, for that there was an urgent need for a museum of this character, and had been for years, was generally recognized."[3]

During the Gallery of Living Art's early years, a French painter, Jacques Mauny, was already playing the role of advisor to Gallatin. Under his influence, the collection grew between 1928 and 1929 by numerous works by artists ranging from Modigliani to Marie Laurencin, Utrillo, Rouault, Soutine, Gromaire, reinforcing the gallery's slant in favor of the School of Paris, but counterbalanced by a few Cubist acquisitions. Later, Gallatin acknowledged that "at the inauguration of the museum...about the only indications of the future evolution of the collection were to be found in the Cubist canvases by Braque, a Gris, a Léger, five Picassos, a Roux and a Man Ray which hung upon the walls."[4] However, on the occasion of a first rehanging of the presentation of his collec-

tion, Gallatin announced that he wanted to concentrate on works representative of "the most recent developments."[5] In 1930 and 1931 however, he slowed down the pace of his acquisitions, that still favored Cubism and added no new names to the collection. Gallatin's desire for innovation and a sentient modernization wasn't to be satisfied until he had encountered the constructive abstract art circle in Paris that gathered around the Abstraction-Creation group, after the stalemates of Cercle et Carré and of Art Concret. His friendship at that time with Jean Hélion, whom he had met in 1932, was decisive. Because of their collaboration, the Gallery of Living Art became a museum that offered an increasingly larger place to abstract tendencies throughout the 1930s. Hélion's influence supplanted Mauny's; his advice was also preferred over Robert Delaunay's, whom Gallatin was quite close to during his stay in Paris in 1932. In fact, it was a letter from Delaunay to Gallatin that gives us a good idea of the insistence that the collector was faced with when he was urged to adopt a policy favorable to the abstract trend. In the letter, Delaunay urged: "Your museum must be the startup for an abstract museum showing the entire evolution of this art with its origins.... We must have a museum or rather an active and living center of our present times.... It is a fact that we need help internationally. I guide you *often*, in fact very *often*, in your choice, in your selection and in your directives by way of ideas."[6] When he returned to New York in the autumn of 1932, Gallatin set up a new hanging with a recent painting by Hélion, two pre-1912 Delaunays, and two Torrès-Garcias. This still slim group filled out the next year with the addition of another *Construction* (1933) by Hélion, new Delaunays, *Fenêtres* (*Windows*, 1912) and *Tour Eiffel* (*Eiffel Tower*, 1910-11), two Arps of 1930, and its first Mondrian, a *Composition* from 1932.[7]

The evolution of Gallatin's collection was illustrated in press releases issued by the Gallery of Living Art and by New York University, which documented the

majority of the acquisitions until the space closed in early 1943. This documentation provides a useful source that complements the correspondence between Hélion and Gallatin,[8] and more generally, it also highlighted the various initiatives taken to create closer ties between European and American artistic communities, Gallatin's collection being only one of the ways to achieve these ends. Others included editorial projects, for example. In 1933, Hélion collaborated both as author of a text[9] and as graphic consultant on a new edition of the Gallery of Living Art's catalogue, a sign of its new direction. However, he declined Gallatin's offer to sign the book as the graphic designer, not judging his work to be fully accomplished.[10] More ambitious and more modern in appearance than the previous simple booklets, the work nonetheless marked an epoch in the United States at a time when literature on abstract art was scarce—but no more so than in Europe where the book had also been distributed, thanks to Hélion's efforts.

Soon thereafter, another editorial project, that of an international avant-garde review, preoccupied the two men. Hélion alluded to it for the first time in a letter on 23 May 1934. Slightly later, the title of the review in question, *Plastic*, appeared in their correspondence. Hélion sent a detailed outline of the contents of four issues, defining for each one the subjects to be addressed, the best authors to treat them, the number and layout of the reproductions. Through the choice of artists and critics, New York

Fig. 1
Jean Hélion in his studio, no date.

and Paris were by far the best represented in this project in which a very clear bipolarity was apparent.[11] Hélion sought to reinforce the American influence by interesting the historian James J. Sweeney and George L. K. Morris in *Plastic*. Morris, like Gallatin combined the roles of painter, critic and collector. Also like Gallatin, he came from a wealthy milieu and was associated very early on with the Gallery of Living Art and had just purchased, on Gallatin's advice, Hélion's first painting done in the United States, *Équilibre entre deux jaunes* (*Balance between Two Yellows*), during a stay at the Rockbridge

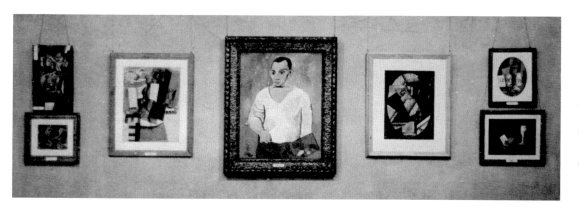

Fig. 2
A wall of the Gallery of Living Art, c. 1932: works by Picasso, Gris, Braque, Masson.
Cat. *Gallery of Living Art Collection*, New York, 1933.

Fig. 3
View of the *César Domela* exhibition, Gallery of Living Art, New York, 30 March-6 April 1936: the *Construction* or *Relief Néoplastique n°7,* 1929, purchased by Gallatin is in the center. Paris, Archives Domela.

Baths in Virginia, from June 1933 to February 1934. Detailing the review's objectives, Hélion wrote him, "The outline of the subjects should be organized in such a way as to reveal to the public, in a reasonable order, the different attitudes which taken together, in one way or another make up the visual efforts of today. And I think it is important to try to distinguish, among these, those that are accomplished, that have attained their apogee and conclusion (Mondrian for example, or the Surrealism of Miró, or Braque, etc.) and those that seem capable of ultimately developing the art of painting. It is also important to investigate the emerging movements in different countries and to give them some contemporary coverage.[12] Hélion gathered the necessary material for the first issues, organized mailing the photographs, and procured the necessary documentation from the artists and the authors of articles—notably soliciting a contribution from his friend Anatole Jakovski.[13] Léger promised him a drawing for the cover of the inaugural issue and confirmed to Gallatin that he could assure a very wide distribution for the review in Paris as well as throughout all Europe.[14]

However, while everything seemed ready on Hélion's side, Gallatin, apparently had not received the same support from Sweeney and from Morris, and, alarmed by the potential financial difficulties, had already decided not to bring out *Plastic.* " I cannot understand how everybody was not immensely pleased with your offer to create a magazine that the States and the world miss so badly," lamented Hélion, who kept insisting, " I hope that you did not give up the idea for always and that when you meet better conditions, you will give America what it needs so badly, a periodical seriously and intelligently devoted to the manifestations of modern art."[15] We know how Cesar Domela, Jean Arp and Sophie Taeuber-Arp resurrected the project two years later, under a less ambitious form, since *Plastique,* in spite of its sub-title "Paris-New York," in fact appeared only in France, eliciting new regrets from Hélion, staying in Virginia, far from the actual birthplace of the review.[16]

In Hélion's mind, the Gallery of Living Art and *Plastic* were naturally associated in defense of the same artistic ideas. He thus wanted to accompany the review's launching with a large exhibition "showing as much as possible a group of works that would interest *Plastic,* from Picasso to Léger, from Morris to Calder, from Nicholson to Mondrian and from Arp to Hélion."[17] The connection between the review and the collection that this project was based on was far from existing in reality in 1934, if one believed the straightforward way he spoke to Morris about "excluding the undesirables that still exist on Washington Square."[18] Gallatin was subjected to the same incitement in words hardly less direct: "I think the idea of an abstract show is excellent. All your pictures properly gathered for two or three months will look splendid. Am I wrong if I guess that, this show being over, it will be very hard to hang again the non-abstract pictures? I also hope that, following the project you had last winter, you will discard a few items that were necessary for the foundation of a Living Art gallery, but now that they have proved that they were not anymore alive, can disappear without pain. Their absence will mean greater clarity and greater expression."[19] These recommendations were soon put into practice. A press release on 5 January 1935 announced, at the same time as the acquisition of works by Braque, Léger, Picasso, Hélion, Arp and Torrès-Garcia, the installa-

tion of the collection in an enlarged and modernized space. In February, Gallatin published a bulletin from the Gallery of Living Art, presented as a supplement to the 1933 catalogue, in which he specified: "A new room was added, all cornices and mouldings removed and all walls from floor to ceiling painted a light gray. In very carefully re-hanging the collection in this fresh and more modern interior about three-quarters of the walls was given over to the exponents of Cubism, Constructivism, Neoplasticism and other artists whose paintings are characterized by little or no reference to the appearance of objects in nature."[20] The article was illustrated by a photograph showing a wall where were hung in interesting proximity three works by Arp, of which two were reliefs, and Mondrian's *Composition with Blue and Yellow* (1932).[21] During 1935 Gallatin again declared that "abstract art is the most expressive form of all contemporary art"[22] and he continued to rearrange the paintings in the space. Satisfied allusions to this are to be found in letters from Hélion: "I am glad to know that you are well and busy with cleaning the Gallery and weeding out. Thank you for all the details. I do not regret what is going out more than you do. Their absence will help a lot the understanding of the rest."[23] The collector nonetheless liked to repeat that he favored no "clique" in particular and although a guiding line did become more and more apparent at the heart of the collection, some acquisitions—such as Duchamp and Ernst for example at the end of 1935—stood out from it. Hélion then suggested that Gallatin hang them in the same room as Schwitters, Klee, De Chirico and Miró—among whose works Gallatin had owned since 1929 the famous *Chien aboyant à la Lune (Dog Barking at the Moon, 1926)*.[24]

In 1936 Gallatin continued his investigations into European geometric abstraction by exhibiting and buying reliefs by Domela. " It was very fine of you to give Domela a show, when he could not exhibit in a gallery. I am glad also you and George bought one of his things each, thus defining well an angle

of the field of painting embraced by your museum."[25] The same year, a new painting by Hélion and a drawing by Pevsner entered the collection.[26] In the autumn of 1937, at the same time as a few reliefs, Gallatin exhibited a group of Arp's recent *papiers collés*, bought that very summer during one of his annual trips to Paris.[27]

In 1938, he acquired a *Composition* by Théo Van Doesburg from 1929, along with a sculpture by Vantongerloo from 1917, *Construction*.[28] Previously, still in the field of sculpture, Hélion had advocated the purchase of a 1932 relief by Calder,[29] which preceded the purchase of one of Gabo's *Constructions in Space* (1928). More unexpected in this context, a gouache by Magnelli and a painting by Hartung that appeared at Washington Square,[30] directly reflect Hélion's advice: "Among the new things to see in Paris I think that Hartung's drawings and small pictures and Magnelli's collages (some on iron) are things you would care to investigate."[31] A letter written early in 1936 by Sophie Taeuber-Arp, whose painting *Point sur Point (Dot by Dot)* was added to the collection at that time, revealed that Gallatin had taken advantage of a visit with the Arps in Germany in order to ask them to find a work by El Lissitzky.[32] Since the chance hadn't come up, it was only in 1939 that a 1920 *Proun* was bought, along with Mondrian's *Composition in Blue* (1926), at the sale of so-called "degenerate" art organized by the Nazis in Lausanne. These works were exhibited at the end of the year, at the same time as a larger

Fig. 4
View of the César Domela exhibition, Gallery of Living Art, New York, 30 March-6 April 1936. Paris, Archives Domela.

201

group of Mondrians, made up of another acquisition, *Opposition of Lines, Red and Yellow* (1937), and of loans from private collections (Russell, Warren, Morris).[33] As a result of some contacts Hélion had made with the British artists gravitating around the review *Axis*, Ben Nicholson's *Painting* (1936), a first work representative of Constructive Abstraction in England, was added during the same period to the Gallery of Living Art.[34]

But the preceding list should not overshadow the fact that those most favored by Gallatin's acquisition policy remained, throughout all these years, Picasso, Léger, Gris and Braque. If the importance of these artists was not particularly pronounced when the gallery opened, their presence grew from year to

Fig. 5
View of the Hans Arp exhibition, Museum of Living Art, New York, 25 October-20 November 1937. *Partisan Review*, vol. IV, January 1938.

year; above all, their preeminence arose not so much because they "best expressed the spirit of our time," according to Gallatin,[35] but because they were considered as representative, in modern times, of a pictorial tradition that was already several centuries old, and that had been founded on the qualities of balance and structure. Gallatin wrote in 1938: "The cornerstone of the collection is the group of paintings by Picasso, Gris, Léger and Braque. Already they are nearly Old Masters. These artists have endeavored to revive the great traditions of design and form as exemplified by Giotto, Piero della Francesca, Uccello, El Greco."[36]

In 1936 five new Picassos entered the collection, among which was the large painting of the *Trois Musiciens* (1921), bought with Morris's financial help. The work was triumphantly presented "as one of the most important paintings of modern

times."[37] Hélion approved unreservedly this kind of acquisition: "I am indeed very happy to learn that you have augmented your museum with such an important item as the *Trois musiciens* (*Three Musiciens*) of Picasso. You probably remember that, in as much as you kindly ask my advice about your plans concerning the M.L.A. I always suggested it would be better to concentrate on important and rare-in-quality works by the artists you were interested in, now that the general visage of contemporary painting was about expressed by your list of names."[38] One day Hélion pointed out at the gallery Pierre "a little picture by Picasso, a true Cubist one, made of very abstract lines on a grey and brown texture, one of the very best I ever saw, a marvel.... I advised Pierre to send you a photo of it.... It is a piece that would look splendidly [sic.] in your collection."[39] Although this transaction never transpired, we know on the other hand that it was Hélion who pushed Gallatin to buy, shortly after the *Trois Musiciens*, Léger's masterpiece, *La Ville* (*The City*, 1919).[40] With these two major works as keynotes, the collection exemplified what modern heirs to an immemorial pictorial tradition could produce in the 20th century.

Gallatin believed, in accordance with the official recognition bestowed on Cubism in France as early as even before 1914, that the first radical reformer of this tradition in modern times was Cézanne. The two Cézanne watercolors that he owned never left the presentation of the Gallery of Living Art. Already in 1929, it was affirmed that "Cézanne, although belonging to an earlier period, is here because he was the father of the present movement."[41] Later, Gallatin confirmed that "Cézanne...is included for historical reasons: the vast majority of the significant painters of today owe much to him. Cézanne is universally recognized as being the chief source of what is known as modern art, and his profound investigations into the architecture of great painting, largely learned from the Old Masters...paved the way for the Cubists and later groups of searchers."[42] From

then on it was clear that it was this putting into historical perspective of Abstraction, and of its direct antecedent in the tradition of structure—Cubism, that assured the coherence of the collection.

This approach directly affected Hélion at a time when he was beginning to feel the need to compare his art to the art in museums. Twice he spoke of this feeling concerning an article he was preparing for *Plastic:* "It could be something rather short about my understanding of the great tradition and how it can work today.... I said also I should try to perfect a series of notes on the connections of my efforts in the abstract field, with the traditions of painting carried out by Cimabue, Mantegna, Uccello, Fouquet and Nicholas [sic] Poussin."[43] He mentioned about the same time his visits to the Louvre and wrote: "Following what we said in London, I consider the actual forms of art, in the light of the peaks of the past; blamed in this by the painters, very numerous, who affect not to go to the museums or to care just for the very primitive forms of sculpture."[44] The essay he alluded to was to become known because, in the end, it appeared in *Cahiers d'Art* under the title "La Réalité dans la Peinture" (Reality in Painting). By examining paintings by Le Nain—revealed in 1935 by the exhibition *Les Maîtres de la Réalité au XVIIe Siècle (Masters of Reality in the 17th Century),* by Poussin and by Cézanne, Hélion wanted to show that the reality of the work resided in the well thought out and reflective ordering of its components and in the relationships that the painter consciously established between them. According to Hélion, this reality of the painting, that the Impressionists had neglected, reappeared forcefully thanks to Cézanne, was strengthened by the Cubists and had developed in "Constructivist work."[45] Subsequently, Hélion was led to reexamine Cézanne's role by studying Seurat's work, which he found more accomplished in the construction of a superior visual order. He declared that "the way to abstraction is much clearer through Seurat." He went on to say that, in fact, "Cézanne looks at the motif. Seurat looks at his canvas. Thus Cézanne deforms, while Seurat forms. Seurat builds, engineers his pictures."[46] These reflections, which Morris's writings also echoed,[47] took form in 1939 when Gallatin decided to include a drawing by Seurat, *L'Artiste dans son Atelier,* in his collection. As he had done with Cézanne, Gallatin used an historical argument to justify this twisting of the rule he had made to buy only from living artists: "*The Artist in His Studio* supplements the Cézanne watercolors already on display and with them will demonstrate the developments of modern art from its nineteenth century origins.... It is work such as this, wherein a strong aesthetic emotion has been projected through the simplest means, that cleared the way for future traditions in twentieth century painting."[48] Changing the gallery's name from the Gallery of Living Art at the end of 1936 to the Museum of Living Art, was also a sign of the increasing importance given to the comprehensive and historical function of the collection.[49]

Defining such a framework had heavy consequences, since it was in these terms that Gallatin wondered on what bases an American pictorial school that was truly alive and modern should be founded and developed. In 1927, at the opening of the Gallery of Living Art, the catalogue still grouped the American painters under a separate category, entitled in the former style "The American School." This category included the figurative works of Charles Demuth, Charles Sheeler, Marsden Hartley, John Marin....[50] In 1929 Gallatin announced his desire to pursue his "policy of gradually building up its section of works by the younger progressive American painters."[51] Despite these good intentions, American art before 1935 was represented solely by artists such as Joseph Stella, Arthur Dove, Gaston Lachaise, Yasuo Kuniyoshi....

However, contrary to some collectors and American museum authorities at that time, Gallatin was aware relatively early on of the existence of young American artists whose works, after the early 1930s,

reacted to what they could glean from European abstract tendencies. Thus, it was through Hélion that Gallatin met one of the most important figures of the future Mondrianesque American circle—Harry Holtzman.[52] Having arrived in Paris in order to meet Mondrian, whose paintings in Gallatin's collection had deeply impressed him, Holtzman also met Hélion there who took him to Lucerne to see the exhibition *Thèse-Antithèse-Synthèse (Thesis-Antithesis-Synthesis)*. He sang Holtzman's praises to Gallatin: "He is intelligent and gifted; his early work, going through all the important influences of the century shows class. He is now dealing with abstract compositions far more advanced already than any other I saw by American artists, Calder excepted. But Holtzman is only 23 or so. He is here for one or two months, seeing very much Mondrian and me. He is somebody to watch carefully and to encourage I believe…. He says he owes a good deal to your shows in Washington Square where he went often.."[53] Hélion sized up the emerging American abstract movement when he lived in a New York studio from autumn of 1936 to spring of 1937. Consequently, he was in New York when the association of American Abstract Artists was formed; although he was not a member, he still played the role of mentor to many of its members.[54] For his part, Gallatin, who had taken up pictorial abstraction again in his work, was invited to the group's first meetings and entered it in 1937 with Morris. Through his acquisitions for the Museum of Living Art, he rapidly gave his approval to the rise of American Constructive Abstract Art—between 1936 and 1942 he bought works by Charles Biederman, Gertrude Greene, Jean Xceron, Ilya Bolotowsky, Fritz Glarner, Suzy Frelinghuysen, Alice T. Mason, Esphyr Slobodkina.[55] He seemed to be pleased to be able to announce that "a selection from the now large group of American abstract painters, several of them concerned largely with problems of construction, has been made for the museum and it is pleasant to be able to state that a number of them are gifted and

apparently on the point of producing mature work."[56] Among them, Gallatin favored three artists who belonged to the same milieu of enlightened art lovers as he—George L. K. Morris, John Ferren and Charles Shaw.[57] He exhibited them in 1936 and added Biederman and Calder to the show, in a small group that he called *Five Contemporary American Concretionists*, a name obviously derived from the term *art concret* invented by Van Doesburg and Arp. The way Gallatin presented the Five Concretionists—by recapitulating his historicist vision of Abstraction—showed clearly where the collector situated the current of American abstract art: "When Cézanne and Seurat…revived the classical and architectonic traditions of great painting they broke the ground for Picasso, Gris, Braque, Léger and the other innovating and creative painters of their epoch. In turn these artists have assisted in making possible the investigations of those who today have been labeled Abstract, a name with even less meaning than Impressionist or Cubist. As the works of this present group are essentially examples of concrete plasticity and simplification, the term 'concretion' seems vastly preferable."[58] In this way, Gallatin became the promoter of American art, to the degree that his visual preoccupations reconnected him to an artistic tradition of which he had already collected European examples.

Meanwhile, in July 1936 Hélion had begun his longest stay in the United States, with the confirmed intention of settling there definitively. That year began auspiciously for him. In April, the dealer Valentine Dudensing devoted an exhibition to him that was a success. Hélion had admitted to Gallatin that his staying in the United States depended on the results of this exhibition, and Gallatin either bought himself or was responsible for the sale of four paintings.[59] Among other things, Dudensing had proposed a future exhibition in the form of a small group along with Arp and Mondrian. Hélion had apparently succeeded in convincing them to come to New York to work for at least one year, and

left without yet knowing that Dudensing would not pursue this project.[60] And finally, he was also pleased that two of his works were included in the exhibition *Cubism and Abstract Art* at the Museum of Modern Art. He owed his presence there in part to Dudensing's and Gallatin's recommendations, since at the time Alfred Barr was slightly reticent towards his work.[61] Hélion interpreted in this an encouraging sign for the art he defended: "It seems that after the example given by the Gallery of Living Art, the 53rd Street one [i.e., the Museum of Modern Art] is considering abstract art more seriously. It is very moving for us to see how an interest is developing in the States when it so stagnates over here. We certainly owe a good deal of that to you for having started it on Washington Square."[62] It was thus in an excellent state of mind that Hélion embarked for America—definitively, he thought. He evaluated lucidly but not bitterly an artist's living conditions in Paris, and then declared his confidence in the future for art in the United States: "I hope there will be a young generation in N.Y. large enough to give the efforts of George Morris and his friends the strength of a current, and, by waves, create in the public a tolerance and an understanding."[63] Letters such as this one show how blind Hélion could be in his judgments—he who wasn't worried for a minute about the tensions that traversed as well American society, and who overestimated its ability to accept innovation. Soon mentions of material difficulties and of disappointments of all kinds reappeared in his correspondence. He especially deplored the fact that not one of his exhibitions had renewed the success of 1936.[64] In 1938 Hélion was officially hired by Moholy-Nagy to teach at the New Bauhaus in Chicago; then he seemed to have rediscovered a certain zest for life, sending a study outline that was "accepted with enthusiasm." He was preparing to go to Chicago when he was informed of the school's financial difficulties and warned not to make the trip; legal complications accompanied the school's closing and ended up discouraging him.[65] In any

case, at that time, Hélion was about to take the first step that would enable him to readdress figuration; he devoted the following year to living isolated in Virginia and preparing for this decisive step. After one year of silence, Hélion wrote to Gallatin to announce his imminent mobilization.[66]

The rest is known—it was told by the artist himself in *They Shall Not Have Me*. Captured, prisoner-of-war camp, escaped, passage into the free zone, new exile to the United States, [67] Hélion returned to New York just at the moment (1943) when an exhibition organized by Gallatin associated him with Léger, Mondrian and Ozenfant alongside twenty-one of the AAA, as one of the tutelary figures of the new abstract movement. However, it was a swan song. The next year the Museum of Living Art closed, and

Fig. 6
Museum of Living Art, New York: *La Ville* (*The City*, 1919) by Fernand Léger is at the rear. *Life*, May 1938.

its collection (around 170 works at that time) was for the most part obtained by the Philadelphia Museum of Art. 1943 was also the year that Jackson Pollock made his entrance onto the artistic scene— a page was being turned.

Arnauld Pierre

Notes

1. This is the abridged version of a study first published under the title "Les Echanges Entre l'Europe et les Etats-Unis dans les Années Trente: Hélion et Gallatin," in *Akten des XXVIII. Internationalen Kongresses für Kunstgeschichte*, Berlin, Akademie Verlag, 1993, pp. 333-48.

2. On Gallatin and his collection, see *Albert Eugene Gallatin and His Circle*, New York, Grey Art Gallery and Study Center, New York University, 1986; Gail Stavitsky, *The Development, Institutionalization, and Impact of the A. E. Gallatin Collection of Modern Art (1927-43)*, New York, Institute of Fine Arts, New York University, 1990 (unpublished Thesis). For a bibliography of texts by Gallatin, including essays on Beardsley, Whistler, Braque..., see Alexander D. Wainwright, "A Check List of the Writings of Albert Eugene Gallatin," *Princeton University Library Chronicle*, vol. XIV, no. 3, Spring 1953, pp. 141-51.

3. Albert E. Gallatin, "The Gallery of Living Art, New York University," *Creative Art*, vol. IV, no. 3, March 1929, p. xi. Gallatin was the descendent of one of the founders of New York University, Albert Gallatin, who was also Secretary of the Treasury under Thomas Jefferson.

4. Albert E. Gallatin, "Abstract Painting and the Museum of Living Art," *Plastique*, no. 3, Spring 1938, pp. 6-7.

5. Exhibition cat. *Gallery of Living Art, New York University*, Paris, Editions Horizons de France, 1930, n.p.

6. Letter from Robert Delaunay to Albert E. Gallatin, Paris, September 19, 1932, in *A. E. Gallatin Papers, Correspondence of Prominent People, Arp-Whitney*, Archives of American Art, Smithsonian Institution, roll 57.

7. Press release from the Gallery of Living Art, 25 October 1932 and December 9 1933, in *A. E. Gallatin Papers, Scrapbooks*, Archives of American Art, Smithsonian Institution, roll 1293.

8. Press releases from 31 October 1927 to 14 December 1942, in *Ibid.* roll 1293; *A. E. Gallatin Papers, Correspondence of Prominent People, Arp-Whitney, op. cit.*, roll 507. The correspondence from Hélion to Gallatin comprises 37 letters, almost all written in English, dated from 10 July 1932 to 4 January 1943 and represents almost 100 mostly typewritten pages.

9. Jean Hélion, "The Evolution of Abstract Art as Shown in the Gallery of Living Art," *Gallery of Living Art, A. E. Gallatin Collection*, New York, December 1933, n.p

10. Letters from Jean Hélion to Albert E. Gallatin, Rockbridge Baths, 21 September and 20 November 1933.

11. Letter from Jean Hélion to Albert E. Gallatin, Paris, 23 July 1934.

12. Letter from Jean Hélion to George Morris, Paris, 23-25 August 1934, in *George L. K. Morris Papers*, Archives of American Art, Smithsonian Institution, roll D 337.

13. About this unusual figure of French criticism, see F. de Lachèze and A. Pierre, "A Propos de 24 Essais par Anatole Jakovski," *Le Moule à Gaufres*, no. 4, solstice d'été, Paris, 1992, pp. 15-23.

14. The entirety of Jean Hélion's work for *Plastic* can be retraced through his letters to Albert E. Gallatin from 29-30 August, 13 September and 30 September 1934.

15. Letters from Jean Hélion to Albert E. Gallatin, Paris, 4 October and 21 November 1934.

16. For the history of *Plastique* after 1937, see Gabrièle Mahn, "On demande: pourquoi Plastique? Qu'est-ce que Plastique?," exhib. cat. *Sophie Taeuber*, Paris, Musée d'Art Moderne de la Ville de Paris, 1989, pp. 104-12.

17. Letter from Jean Hélion to George Morris, cited in note 12.

18. *Ibid.*

19. Letter from Jean Hélion to Albert E. Gallatin, Paris, 21 November 1934.

20. Albert E. Gallatin, [Untitled], *Gallery of Living Art, Bulletin*, New York, February 1935, n.p.

21. The exhibition *Produktion Paris 1930* (Kunstsalon Wolfsberg, Zurich, 8 October-15 November 1930), had already ventured such a daring arrangement. In a 1931 letter to Alfred Roth, Mondrian had declared: "For my part, I find Arp's work (the flat reliefs) very close to my work.... I like Arp's things very much: I find that he is the only 'true purist' after neoplasticism." (Piet Mondrian and Alfred Roth, *Correspondance*, ed. Serge Lemoine and Arnauld Pierre, Paris, Gallimard, 1994, p. 58 [repr.] and p. 66).

22. Press release of 26 October 1935.

23. Letter from Jean Hélion to Albert E. Gallatin, Paris, 6 November 1935.

24. *Ibid.*

25. Letter from Jean Hélion to Albert E. Gallatin, Paris, 24 April 1936.

26. Press releases of 22 April and 27 October 1936.

27. Press release of 23 October 1937.

28. Press release of 19 November 1938.

29. As can be surmised from the Calder's correspondence to Gallatin, in *A. E. Gallatin Papers, Correspondence of Prominent People, Arp-Whitney, op. cit.* roll 507.

30. Press release of 19 November 1938.

31. Letter from Jean Hélion to Albert E. Gallatin, Paris, 10 June 1938.

32. Letter from Sophie Taeuber-Arp to Albert E. Gallatin, Meudon, 15 January 1936, in *A. E. Gallatin Papers, Correspondence of Prominent People, Arp-Whitney, op. cit.* roll 507.

33. Press release of 28 October 1939.

34. *Ibid.*

35. Albert E. Gallatin, "Les expositions à New York," *Cahiers d'Art*, vol. VI, no. 2, 1931, p. 112.

36. Albert E. Gallatin, "Abstract Painting and the Museum of Living Art," art. cit.

37. Press release of 27 October 1936.

38. Letter from Jean Hélion to Albert E. Gallatin, Rockbridge Baths, 15 September 1936.

39. Letter from Jean Hélion to Albert E. Gallatin, Paris, December 1934.

40. Merle S. Schipper, "Jean Hélion: the Abstract Decade," *Art in America*, September-October 1976, p. 88.

41. Albert E. Gallatin, "The Gallery of Living Art, New York University," art. cit.

42. Albert E. Gallatin, "The Plan of the Gallery of Living Art," *Gallery of Living Art, op. cit.*, n.p.

43. Letters from Jean Hélion to Albert E. Gallatin, Paris, 30 September and 4 October 1934.

44. Letter from Jean Hélion to Albert E. Gallatin, Paris, 15 April 1935.

45. Jean Hélion, "La Réalité dans la Peinture," *Cahiers d'Art*, no. 9-10, 1934, pp. 253-60.

46. Jean Hélion, "Seurat as a Predecessor," *Burlington Magazine*, July 1936 (reprinted in *The League*, New York, April 1937); "Poussin, Seurat and Double Rhythm," *Axis*, no. 6, Summer 1936.

47. George Morris, "On America and a Living Art," *Museum of Living Art, A. E. Gallatin Collection*, New York, George Grady Press, December 1936, n.p.; "On the Abstract Tradition," *Plastique*, no. 1, Spring 1937, pp. 13-14.

48. Press release of 11-12 March 1939.

49. Press release of 27 October 1936.

50. *New York University, Gallery of Living Art (Catalogue of Opening Exhibition)*, New York, 13 December 1927-25 January 1928.

51. Press release of 27 February 1929.

52. Jack Burnham, "Mondrian's American Circle," *Arts Magazine*, vol. 48, September-October 1973, pp. 36-9.

53. Letters from Jean Hélion to Albert E. Gallatin, Paris, 22 February and 15 April 1935. Holtzmann had gone to see the Mondrians in the Gallery of Living Art on Burgoyne Diller's advice. See Susan C. Larsen, "Albert Gallatin: The 'Park Avenue Cubist' who went downtown," *Artnews*, vol. 77, no. 10, December 1978, pp. 80-2.

54. Merle S. Schipper, "Jean Hélion: the Abstract Decade," art. cit., p. 90.

55. Ilya Bolotowsky gives a good account of the circumstances of these events in an interview with Susan C. Larsen, "Going Abstract in the '30s," *Art in America*, September-October 1976, p. 71-9.

56. Albert E. Gallatin, "Abstract Painting and the Museum of Living Art," art. cit.

57. The "Park Avenue Cubists," as they are sometimes called. See Susan C. Larsen, "Albert Gallatin: The 'Park Avenue Cubist' who went downtown," art cit.

58. Albert E. Gallatin, [Untitled], *Five Contemporary American Concretionists*, New York, The Gallery of Living Art/The Paul Reinhardt Galleries, 9-31 March 1936, n.p.

59. Letters from Jean Hélion to Albert E. Gallatin, Paris, 21 March and 24 April 1936.

60. Jean Hélion-Valentine Dudensing correspondence, Archives Hélion, Paris, IMEC.

61. Letter from Valentine Dudensing to Jean Hélion, New York, 29 January 1936; Letter from Jean Hélion to Albert E. Gallatin, Paris, 21 March 1936.

62. Letter from Jean Hélion to Albert E. Gallatin, Paris, 24 April 1936.

63. Letter from Jean Hélion to Albert E. Gallatin, Rockbridge Baths, 17 October 1936.

64. Letters from Jean Hélion to Albert E. Gallatin, Rockbridge Baths, 26 January and 27 February 1938.

65. Letter from Jean Hélion to Albert E. Gallatin, Rockbridge Baths, 24 September 1938. The copy of a letter from Moholy-Nagy to Mondrian (26 May 1938, Archives Hélion, Paris, IMEC) reveals that Mondrian showed his interest, through Hélion, in a position at the New Bauhaus in Chicago: " I was so happy to hear from Hélion that you are willing to join us at the New Bauhaus. You know how I admire you and your work, perhaps most among all living artists, so it is not necessary to assure you what it would mean to me if we could have you as collaborator. But, unfortunately when the Hélion letter arrived all dispositions were made for next year's faculty so I can only ask you to keep your willingness to work with us for the future."

66. Letter from Jean Hélion to Albert E. Gallatin, Rockbridge Baths, 3 September 1929.

67. Jean Hélion, *They Shall Not Have Me*, New York, E. P. Dutton, 1943.

Transferal and Synthesis

American Biomorphism of the 1930s

"It is very easy to get stuck in the narrow and precise universe of Mondrian, or to go off into the Capernaum of Surrealism; but to both believe in order and not to like enclosing walls at the same time seems difficult to conceive of."[1]

Arshile Gorky's work was known for his successive borrowings from Cézanne, Picasso, Miró, Kandinsky or Matta. Embracing one in order to escape the influence of another, he assimilated, alternately, the components of their formal vocabulary and their modes of pictorial organization. Based on these experiments, he came to define his own original style. It was a style characterized by amorphous interconnected shapes that spread over the surface and structured the space while imparting dynamism to it, a style commonly called biomorphic[2] due to its evocations of vital rhythms.

In fact, far from concerning only Gorky, such a statement could apply even more to an entire generation of lesser known American artists, who were born at the very end of the 19th century or in the first decade of the 20th century and who were active in New York after the 1920s. This generation was undoubtedly the last one to have looked openly and assiduously towards European artistic developments, with the paradoxical aim of freeing the American artistic scene from the regionalism that was triumphant at the time, while at the same time founding a national abstract tradition able to rival Europe's, in this way buttressing their nationalist ambitions with internationalist arguments. These same artists reacted against the European prejudice of the exhibition *Cubism and Abstract Art* (MoMA, New York, 1936), and some helped found the association American Abstract Artists (AAA) at the end of 1936, while others took part in annual exhibitions that the AAA organized after 1937. They gravitated around Eugene Gallatin[3] and the Gallery of Living Art, whose collection of modern European art was opened to the public after 1927, and was subsequently enriched by their works; over a relatively long period, all these artists developed an abstract vocabulary that was dominated by the curve and that aimed to combine the influences of Mondrian and Miró. This vocabulary was to become the hallmark of the AAA. Almost all of them spent time in Paris where they came into direct contact with European artists; and although they never stopped admiring them, it didn't take them long to foresee the collapse of the Parisian scene, weighed down by its too heavy heritage and to see in the relative youth of American art its major asset.[4] These artists were among the first to form a group and to advocate a specifically American Abstract art; they included, among others, Charles Biederman, Ilya Bolotowsky, Byron Browne, John Ferren, Gertrude Greene, Balcomb Greene, Carl Holty, Ibram Lassaw, Alice Trumbull Mason, George L. K. Morris, Ad Reinhardt, Esphyr Slobodkina, and Albert Swinden.

The Time of Revivals

The similarities are often striking between Gorky's works, in particular his drawings, and Picasso's, such as his *Carnets de Dinard* (*Dinard Sketchbooks,* 1928) or his studio scenes from the late 1920s. Picasso's *Le Peintre et son modèle* (*The Painter and his Model,* 1928) constituted one of the highlights of the exhibition *Cubism and Abstract Art*; the work was given a full page reproduction in the catalogue. It was enlivened by a strong tension between a network of lines and right angles and, in the center, in the painting in-progress, undulating curves of a simplified profile and palette. Gorky's paintings, such as *Composition* of 1936-39 (cf. p. 229) or *Enigmatic Combat* of 1936-38, also used this central zone, reframed and enlarged, to accentuate an amorphous form painted flatly. Biederman's works offered a particularly fertile ground for this little game of references. Standing in front of some of his works (fig. 1), how could one not be reminded of Léger's com-

positions in which he isolates, enlarges and simplifies the elements—such as knots of rope, ladders or flowers—on a background that is uniformly colored and contained within an undulating frame (for example *Composition with Ropes*, 1935, Galerie Gmurzynska, Cologne)? Miró's influence on Carl Holty's works[5] (fig. 2) or Hélion's on Ferren was undeniable. If one adds to these examples the names of Kandinsky, Arp and Tanguy, a kind of bulimia of appropriation appears in these American artists' works, reinforced by a strong dose of audacity, indeed effrontery—the limit between re-utilization and plagiarism being quite tenuous.

Beyond an apparent heterogeneity, the choice of models appeared to be supported by a strong logic—in fact these artists oscillated between poles that were very clearly set apart in the Parisian context of the times, between Abstraction and Figuration, between geometric simplification and reference to natural forms, between Abstract Art and Surrealism. Picasso of 1928 was the one who, after the invention of Cubism and a neo-classical phase, came the closest to Surrealism with his swollen bodies and deformed bathers, with his monsters and his metamorphoses, while still tending towards abstraction with his assemblages of soft forms. Léger and to a greater degree Miró simplified natural forms until they were transformed into abstract signs. The first approached Surrealism through his monumental enlargements of everyday objects; the second approached Abstract art through the proliferation of forms and the simplification of his vocabulary. In short, these artists had already made part of the journey that led towards combining opposing artistic tendencies. Robert Pincus-Witten noted that Mondrian's influence in the United States was also passed along through the versions of Neo-Plasticism that Léger, then Hélion and Calder[6] developed by aiming towards a greater formal flexibility and a freer utilization. This also applied to Surrealism and highlighted two major characteristics of the American context: the very lax and therefore more

Fig. 1
Charles Biederman,
Untitled (New York, June 1936), 1936.
Oil on canvas, 77 x 53"
(195.7 x 134.6 cm).
Frederick R. Weisman
Art Museum, University
of Minnesota, Biederman
Archive. Promised Gift
of Charles J. Biederman.

independent adhesion to the principles of the European movements and the acute awareness of the necessity for synthesis.

The biomorphic vocabulary dominated by the curve presented the advantage of corresponding very well to the ideas of energy and of vitality that were at the very heart of the myth of the American culture and soul and that were embodied by Romanticism as Holty defined it: "The American romanticism comes from a deep love of nature combined with a strong impulse towards self-searching and self-expression due to a deep-seated belief in the magic within a particular man, the magic and mystery of himself."[7] According once more to Holty, this also explained the American painters' preference for the organic, the recurrence of biological or plant metaphors in many of the artists' texts, especially in Biederman's, and the allusions to life forms and to their growth and natural processes as sources for the renewal of art. Beyond corresponding to the founding values of the American

culture, the primitive shapes of Biomorphism also enabled these artists to combine Abstraction with their interest in Eskimo art or in American Indian art (Morris, Bolotowsky) or in folk art (Charles Shaw). This perspective helped them to realize their ambition of adapting the contributions of international abstraction to a typically American content, and one can understand why the biomorphic craze swept New York during the 1930s.

The Hour of Reconciliation

The American context particularly favored the development of Biomorphism because, since it was located far from where the theoretical principles were formulated and was thus distanced from the violence of the ensuing intellectual schisms, it allowed for a far greater freedom in approaching the works. In this way exhibitions and publications abounded with reconciliations of artistic differences that would have been unthinkable in Paris. The sheer chance of

Fig. 3
Esphyr Slobodkina,
Biomorphic in Mustard,
1937.
Oil on cardboard,
21 x 31"
(53.3 x 78.7 cm).
The J. Donald Nichols
Collection.

alphabetical order brought Miró and Mondrian to-
gether, and it was enough simply not to reproduce
a Modigliani to find, in the Gallery of Living Art's
1933 catalogue, Miró's *Chien aboyant à la Lune* (*Dog
Barking at the Moon,* 1926) beside Mondrian's 1932
Composition—the ladder of the Miró offering an
amusing counterpoint to the grid of the Mondrian.
This chance result soon became a conclusive desire
when Mondrian's *Composition* with two reliefs and
one gouache by Arp[8] were hung on the same wall
of the gallery. Standing in front of these two kinds
of works, the visual effect was striking—organic on
the one hand, geometric on the other—and demon-
strated the same economy of forms and of colors as
well as the same search for flatness.

Following Calder, who founded his style in part on
the placing into motion of Neo-Plasticism, numer-
ous artists quickly jumped on the bandwagon and
tended to combine Mondrian's influence with
Miró's. Bolotowsky told of having discovered Neo-
Plasticism in Gallatin's collection and Miró's paint-

ings at the Pierre Matisse gallery in rapid succession
in 1933. "I felt the necessity of combining the
biomorphic and the geometric,"[9] he declared and
after Mondrian's death presented himself as one of
his disciples.[10] For the time being and up until
1939, he worked on this combination that was best
exemplified by the Williamsburg Mural (cf. p. 222)
made for the WPA (Works Progress Administration).
Slobodkina (fig. 3), his wife at the time, was head-
ing in the same artistic direction as were a good
number of artists, such as the sculptor Ibram Lassaw:
"Throughout the thirties, he mediated the poles of
Miró and Mondrian by evolving an inventive syn-
thesis of Surrealist Biomorphism and Cubist
Constructivism."[11] Other than these visual combi-
nations, there were also other kinds of more artificial
reconciliations—in her memoirs, Peggy Guggen-
heim wrote about Mondrian's interest in Surrealism,
in particular in Max Ernst's work.[12] On a different
note, Carl Holty asked Miró one day if he had ever
met Mondrian and wrote down his answer: "Miró

Fig. 4
Ilya Bolotowsky,
Abstraction # 3,
1936-37.
Oil on canvas, 28 x 36"
(71 x 91,4 cm).
Pittsburgh, The Carnegie
Museum of Art. Gift
of Kaufman's Department
Stores and the Women's
Committee of
the Museum of Art.

said that he had met him and that he had come away from the meeting conscious of Mondrian's great dignity, the supreme compliment coming from a Spaniard."[13]

This conciliatory willingness was reaffirmed countless times and justified the presence of artists such as Shaw who produced both biomorphic and geometric works at the same time, and even the increasing number of canvasses associating the grid with shapes inspired by Miró or by Arp. In *Abstraction No. 3* (fig. 4) of 1936-37, Bolotowsky constructed the space first through planes of pure colors and through an orthogonal network of black lines, before placing three amorphous shapes within a white rectangle, providing an organic counterpoint to the rigidity of the structure.[14] In his *Study for Williamsburg Mural* (1937), Albert Swinden created a similar play between colored planes and amoeba-like forms, without recourse to the grid. In the end, in addition to these insertions, the combination operated by superimposing curvilinear shapes and rectangles of color, and thus created a space made of transitions, some broken and others continuous. These various ways of combining the neo-plastic grid with shapes invented by Miró or Arp succeeded

so well because they fulfilled perfectly the painterly objectives of this generation of abstract American artists. It is obvious from the texts, in particular those published by the AAA, that if the major lesson of European abstraction was the importance of structure, these artists did not at all neglect the visual expression of dynamism.[15] In the same way, although they tended to concentrate the pictorial space within the surface plane, they were still clearly seeking to create a spatial sensation. Biomorphism fulfilled perfectly both these expectations by providing forms that were sharp and amorphous as well as structural methods that did not exclude a certain dynamic motion.

From Combination to Synthesis

The massive adoption of Biomorphism among the American abstract artists of the 1930s relied on a synthesis of styles, and occurred precisely because the visual vocabularies of Mondrian, Miró or Hélion were reexamined and taken up again as styles— gone were the overly constraining principles, the associations, the influence of the unconscious, the philosophical presuppositions. In this way, Slobodkina was inspired by Miró because his example enabled her to use "fluid colors and biomorphic shapes and crazy titles too," and because "he freed [her] from the obligation of being completely flat and completely geometric," formal motivations that she summed up by saying: "I'm not using the forms because they're biological. I'm using them because they make nice shapes."[16] This formalism largely characterized the understanding of European works. Linda Hyman said of Gertrude Greene and of her biomorphic vocabulary inspired by Arp, Miró or even by Masson that "it is interesting to note, however, that as much as she was influenced by the stylistic vocabulary, Greene decidedly rejected the illusionism of Surrealist theory."[17] P. Kaplan commented about one of Holty's paintings that "If Miró is strongly evoked, it is for his formal language not

his sense of fantasy or psychological content."[18] And Robert Pincus-Witten generalized: "The American Abstract Artists tended to synthesize movements rather than to adhere to sharp stylistic doctrine."[19]

An empty shell of arrested development, the visual vocabulary was reused and experimented with on a purely formal level, which explains one of the major characteristics of American Biomorphism—the evacuation of any tension in a synthesis intended to reconcile opposites. This was the fundamental difference between European Biomorphism—viewed as unstable and in-between[20]—and its American derivation. When Miró associated amorphous forms with triangles or right angles in the same work or when Giacometti imprisoned organic forms within his cages, a tension was created, a violence or a mystery that accounted for all the interest in these works and that disappeared from the American artists' vision that was too conciliatory and therefore pacified. Equilibrium was here restored in favor of a greater formal perfection leaning towards the sharpness and the clarity of the shapes and of the contours, in favor of more decorative compositions, and finally—and this is what is so striking at first glance—of more acidulous or more lively colors, due in part to the fact that the artists' knowledge of European works often came from black and white reproductions.

Ferren's evolution seems to have mirrored Hélion's, from the introduction of curves into the neo-plastic vocabulary up to the convex shapes that presaged, in Hélion's work, his return to the figure through vertical components and volume. At the end of the 1930s (in *Lutte As Ciel*, 1937, The J. Donald Nichols Collection), Ferren took these shapes up again, detached them onto the flatness of the backgrounds, but dispersed them over the space of the canvas in order to create simple visual rhythms (fig. 5); in that way, he eliminated the processes of structuring and of growth in Hélion's work, constituting his contribution to the abstraction of the 1930s. A similar analysis can be applied to Biederman, who reappropriated the bone structures used by Picasso after 1928 in crucifixion drawings and sculpture projects. Although the shapes do suggest bones, they fit well into harmonious compositions of fluid rhythms, but disposed of what accounts for the power of Picasso's images—their strangeness, violence and sexual associations. The menisca used by Miró to show the connections between the shapes and the way they were structured became simple motifs often represented in the same way throughout the painting; the same is also true of Arp's shapes that were isolated, superimposed or used with disregard for their true scale and no longer producing any impression of growth. From surface borrowings to their misinterpretations, such was the range of the relations maintained with the European inventions. And paradoxically, although they were seeking dynamism, in the end these artists froze, through repetition, the very forms originally conceived to describe energetic forces. This explains the impression of uniformity that emanates from their works.

For this fixedness and this formal sharpness, American Biomorphism appeared to be a system that had truly regained its balance and had man-

Fig. 5
John Ferren,
Untitled (JF7), 1937.
Oil on canvas,
44 3/4 x 57 1/2"
(113.7 x 146.1 cm).
New York,
The Solomon R.
Guggenheim Foundation.
Gift of the artist.

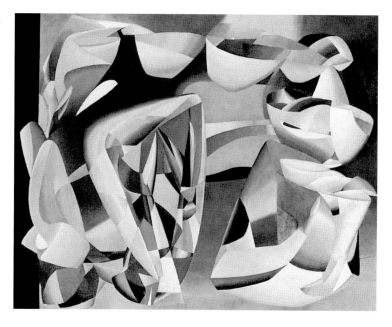

aged to synthesize opposing directions; a parallel with Synthetic Cubism—its wide expanses of color and its decipherable silhouettes opposed to the dissolution and to the instability of the forms of the analytical phase, the return to calm after the effervescence of experimentation—ended by justifying the use of the term synthesis and positioned American Biomorphism of the 1930s firmly in modern logic. Within this perspective, the question is one of conscious Biomorphism. Slobodkina employed the term in the title of one of his works, *Biomorphic in Mustard* (cf. fig. 3); Holty used it in his correspondence with Hilaire Hiler but deformed it very slightly—twice, he contrasted geometric paintings with others qualified as "bi-amorphic."[21] This accidental change in vowels may have arisen from the frequent use of the term "amorphous" as opposed to geometric;[22] above all, it dispensed with the allusion to the living world and shifted the accent onto the form, in a variation that was purely formal and free of either figurative or geometric references—in this sense, twice shapeless. In fact, the small vowel error speaks worlds about formalism and these re-utilizations of Biomorphism.

For some of the artists discussed here, Mondrian's arrival in New York in October 1940 marked a moment of abandoning the curve for the right angle, the ultimate sign of their superficial adherence to Biomorphism. It also proved that these American abstract artists transmitted artistic principles through assimilation—a surprising example of a group of artists shamelessly copying works in order to acculturate their style. The cluster of factors favoring this process was dense and the historical moment was not the least of them. This generation would be of little interest had it not participated decisively in implanting so-called Modern art, and especially Abstraction, in the United States. Even more, American Biomorphism would be worth little if it hadn't prepared the ground for the blossoming, during the 1940s and 1950s, of the two axes of the renewal of Abstract art, this time originally American: Abstract Expressionism and Hard-Edge, going beyond Surrealism on one hand and beyond Geometric Abstraction on the other. The goal had been reached.

Guitemie Maldonado

Notes

1. Letter from Jean Hélion to Raymond Queneau, 23 January 1937, in *Lettres d'Amerique*, Paris, Institut Mémoire de l'Edition Contemporaine, 1996, p. 31

2. Concerning the appearance and the definition of the term, see Guitemie Maldonado, "Biomorphisme: une Histoire de Temps et de Mots," *Cahiers du Musée National d'Art Moderne*, no. 70, winter 2000.

3. See Arnauld Pierre's study in this volume.

4. Charles Biederman, in a text published in *Trend* in 1942 and entitled "Chicago: A Future Art Center?" affirmed: "This very cultural deficiency and lack of a well-aged tradition is in these times our paramount advantage." (Quoted in *Charles Biederman*, Minneapolis, Dayton's Gallery 12, 1971).

5. One can compare an untitled gouache on paper of 1933 with *Intérieur Hollandais I* of 1928 (New York, Museum of Modern Art).

6. Robert Pincus-Witten, "Mondrian and Mondrianists," *Post-Mondrian Abstraction in America*, Chicago, Museum of Contemporary Art, 1973.

7. Carl Holty, "An Unpublished Manuscript," probably written during the 1960s and preserved in *Carl Holty Papers*, New York, Archives of American Art.

8. A photograph of this hanging was reproduced in the *Gallery of Living Art Bulletin*, February 1935.

9. Ilya Bolotowsky, interview with Mimi Poser, *Ilya Bolotowsky*, New York, The Solomon R. Guggenheim Museum, 1974, p. 20.

10. In "Reminiscences about the AAA," 20 June 1966 (text in the Archives of American Art in New York), he describes Mondrian's funeral and a talk given there that asserted that he had been unable to found a school of painting: "The undertaker's parlor was full of Mondrian's followers. We kept quiet, shocked by Mondrian's death, and our non-existence, and the non-existence of our style."

11. Lisa Phillips, introduction to *Ibram Lassaw Space Explorations, A Retrospective Survey*, East Hampton, Guild Hall Museum, 1988, p. 3.

12. In *Confessions of an Art Addict*, London, Andre Deutsch, 1960, p. 111, she quotes Mondrian, "I feel nearer in spirit to the Surrealists, except for the literary part, than to any other kind of painting."

13. Carl Holty, "Psychology of Art," *Carl Holty Papers, op. cit.*

14. At the source of such a system, one can evoke Giacometti's cages.

15. Alice Trumbull Mason recorded, on the back of a 1939 drawing, the equal importance for painting of "body rhythms" and of the intellectual complexity of structure" (quoted in *Three American Purists: Mason, Miles, Von Wiegand*, Springfield, Museum of Fine Arts, 1975.) In 1953, she told Dore Ashton that "These works spring from the need of a greater potential in governing the allotted space, and at the same time of creating a lyrical statement." (quoted by Robert Pincus-Witten in *Alice Trumbull Mason*, New York, Whitney Museum of American Art, 1975).

16. Esphyr Slobodkina quoted by Gail Stavisky in *The Life and Art of Esphyr Slobodkina*, Medford, Tufts University Art Gallery, 1992, p. 19.

17. Linda Hyman, in *Gertrude Greene, Constructions. Collages. Paintings*, New York, A.C.A. Galleries, 1981.

18. P. Kaplan, in *Carl Holty: Fifty Years. A Retrospective Exhibition*, New York, The City University of New York, 1972.

19. Robert Pincus-Witten, in *Alice Trumbull Mason, op. cit.*

20. On this subject see Guitemie Maldonado, *Le Biomorphisme dans l'Art Occidental des Années Trente. L'Analogie Créatrice*, doctoral thesis, Paris IV, 2000.

21. Letters from Carl Holty to Hilaire Hiler, 12 January 1941 and 25 May 1944, *Carl Holty Papers, op. cit.*

22. See how Balcomb Greene uses it in his text published in the AAA catalogue of 1938.

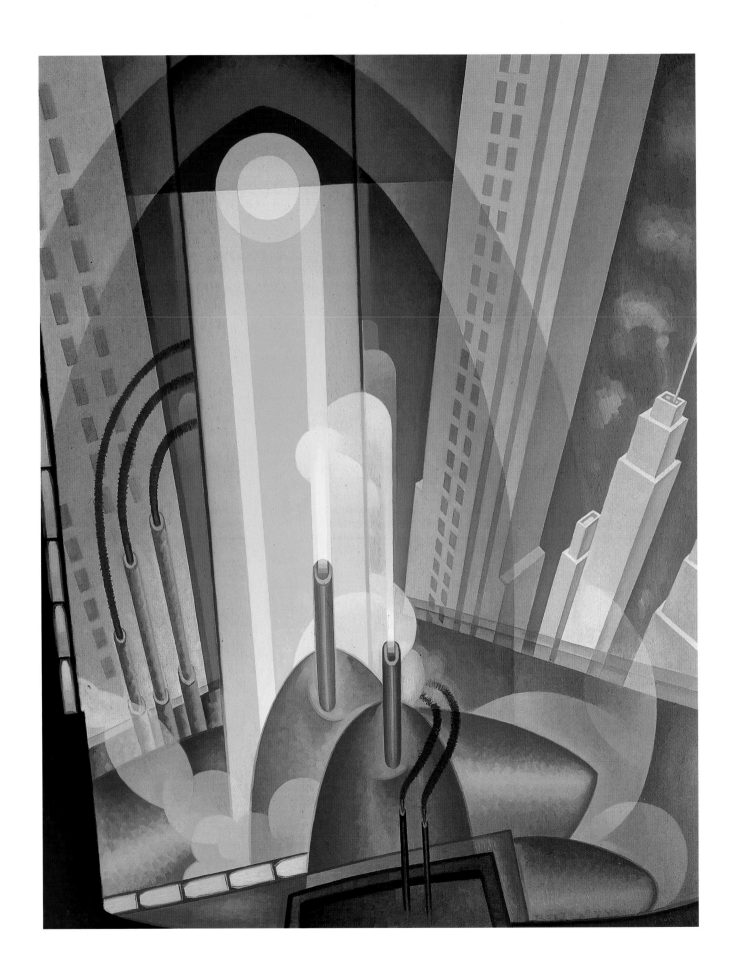

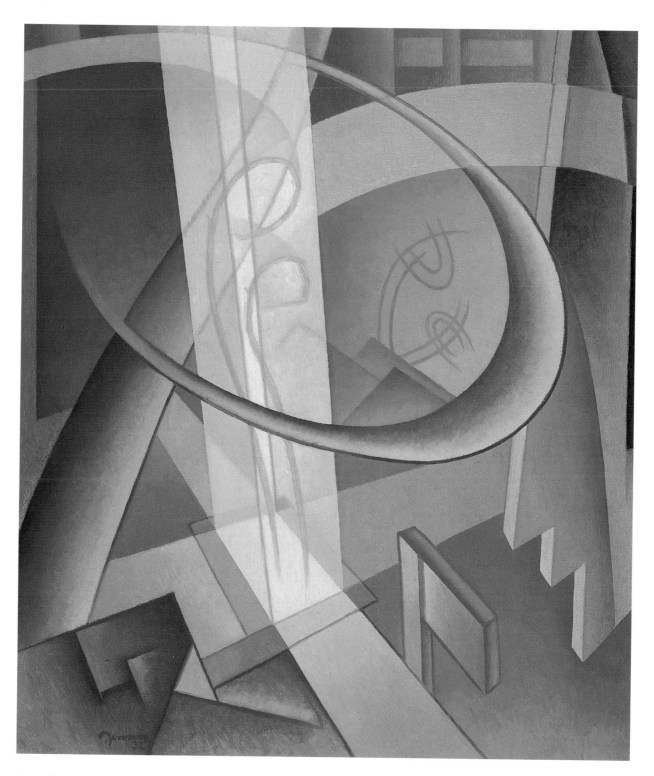

Raymond Jonson
City Perspectives, 1932
Oil on canvas, 47 ³/₄ x 37 ³/₄"
(121.3 x 95.9 cm)
The Portland Art Museum
Gift of Mr. Arthur H. Johnson

Raymond Jonson
Variations on Rhythm P, 1932
Oil on canvas, 33 x 29" (83.82 x 73.66 cm)
Dallas Museum of Art
Gift of Louise W., Edmund J. Kahn,
Fannie K. and Stephen S. Kahn

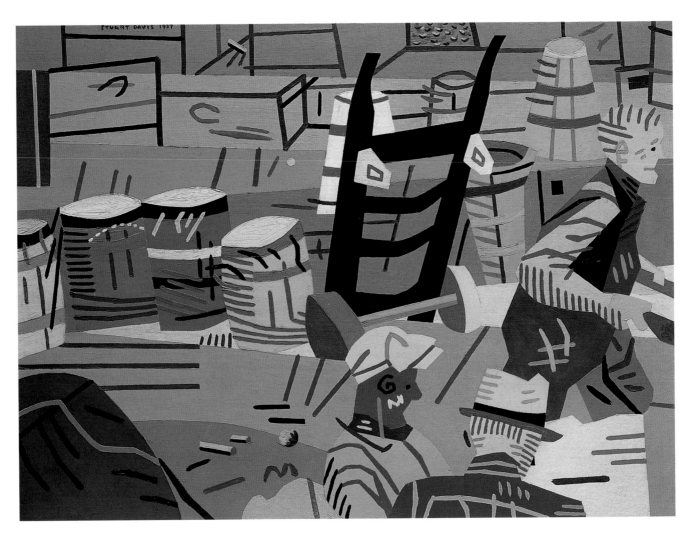

Stuart Davis
The Terminal, 1937
Oil on canvas, 30 ¹/₈ x 40 ¹/₈" (76.5 x 101.9 cm)
Washington D.C., Hirshhorn Museum and Sculpture Garden,
Smithsonian Institution
Gift of Joseph H. Hirshhorn, 1966

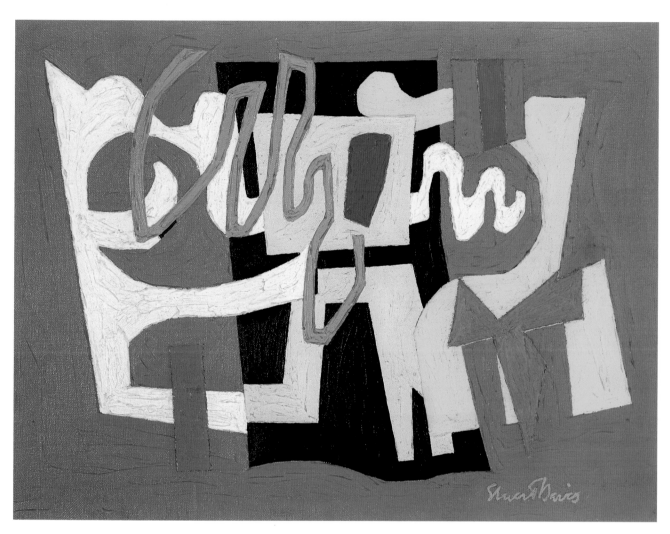

Stuart Davis
Still Life — Feasible N° 2, 1949-51
Oil on canvas, 11 ⁷/₈ x 16 ¹/₈" (30.2 x 41 cm)
The Saint Louis Art Museum
Gift of Morton D. May

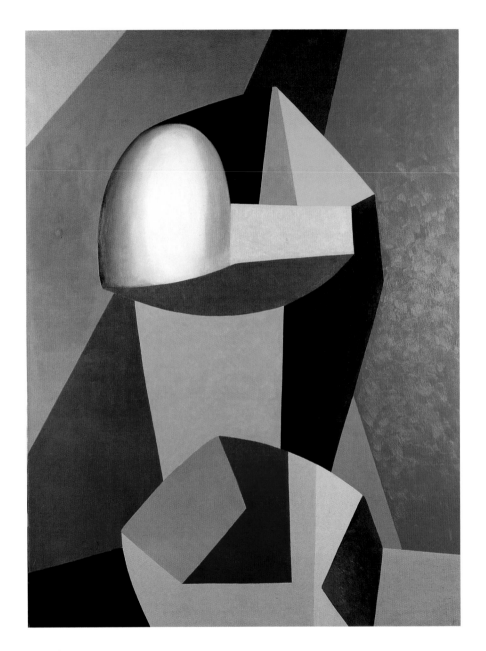

Jean Hélion
Figure de Rouille, 1936
Oil on canvas, 45 1/4 x 33 1/2" (115 x 85 cm)
Beauvais, Musée Départemental de l'Oise

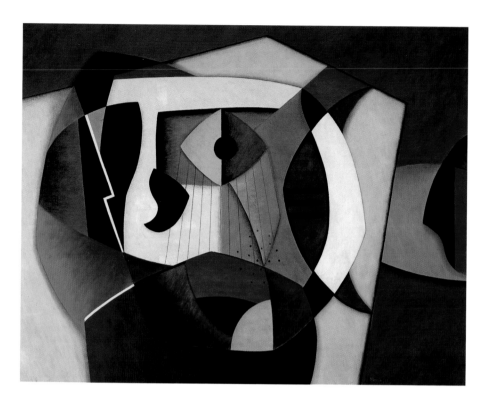

George L. K. Morris
Mural Composition, 1939
Oil on canvas, 49 x 63" (124.46 x 160 cm)
Dallas Museum of Art
General Acquisitions Fund

George L. K. Morris
Composition, 1938
Oil on canvas, 24 $\frac{1}{8}$ x 18 $\frac{1}{8}$"
(61.3 x 46 cm)
New Haven, Yale University Art Gallery
Gift of the artist

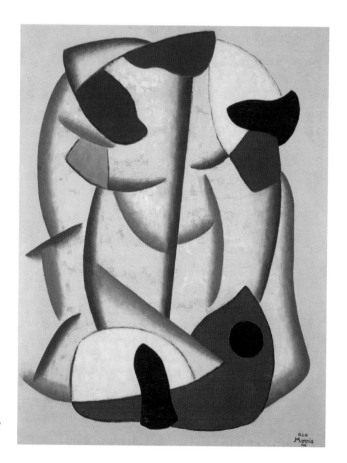

Ilya Bolotowsky
Abstraction (Yellow Background), 1939
Tempera on cardboard, 5 ⁵/₈ x 7 ¹/₂″ (14.3 x 19 cm)
New Haven, Yale University Art Gallery
Gift of Mary Dreier to the Collection Société Anonyme

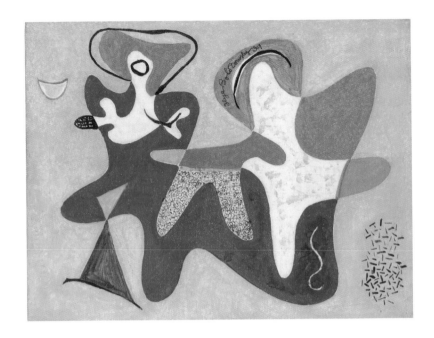

Ilya Bolotowsky
First Study for Williamsburg Mural, 1936
Oil on canvas, 19 ¹/₂ x 34 ¹/₂″ (49.5 x 87.6 cm)
New York, courtesy Joan T. Washburn Gallery

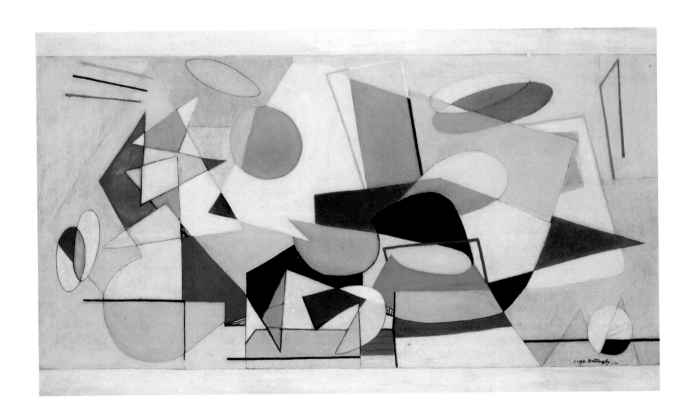

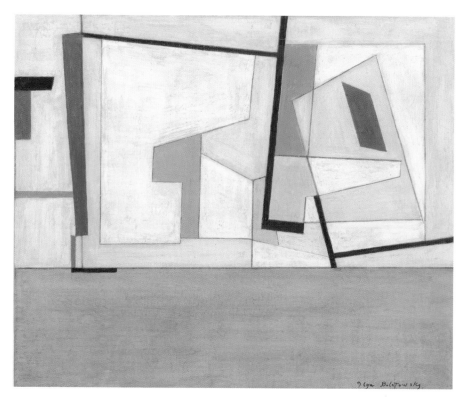

Ilya Bolotowsky
Autumn, study for Mural,
Men's Day Room, Chronic Disease
Hospital, Welfare Island, New York, 1940
Pencil and tempera on cardboard,
5 $^1/_4$ x 6 $^5/_{16}$" (13.3 x 16.7 cm)
New Haven, Yale University Art Gallery
Gift from the Estate of Katherine S. Dreier

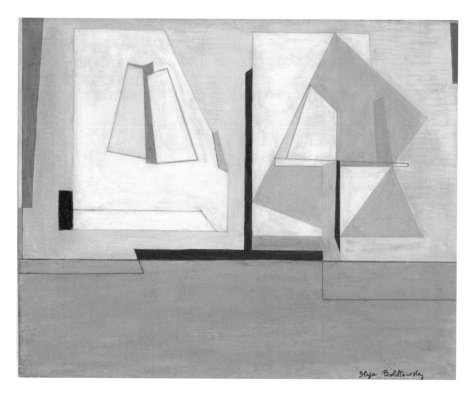

Ilya Bolotowsky
Sailing, study for Mural,
Men's Day Room, Chronic Disease
Hospital, Welfare Island, New York, 1940
Pencil and tempera on cardboard,
5 $^1/_{16}$ x 6 $^1/_4$" (12.9 x 15.9 cm)
New Haven, Yale University Art Gallery
Gift from the Estate of Katherine S. Dreier

Theodore Roszak
Untitled, c. 1932-39
Gelatin silver print, 5 $^1/_2$ x 4 $^1/_4$"
(13.9 x 10.9 cm)
The Cleveland Museum of Art
John L. Severance Fund

Charles Biederman
Relief, New York, 1936
Enamel on wood, 45 $^3/_4$ x 10"
(116.2 x 25.4 cm)
The Minneapolis Institute of Arts
Gift of Ruth and Bruce Dayton

Charles Biederman
2, New York, February, 1940, 1940
Painted wood and metal rods, 62 $^1/_2$ x 48 $^7/_8$ x 10"
(158.8 x 124.1 x 25.4 cm)
The Minneapolis Institute of Arts
Gift of Mr. and Mrs. John P. Anderson

225

Charles G. Shaw
Composition, 1942
Oil sur masonite, 32 x 39 ¹/₂"
(81.28 x 100.33 cm)
New York, courtesy Joan T. Washburn Gallery

Burgoyne Diller
Wall Construction, 1938
Relief, painted wood, 31 7/8 x 27 3/4 x 5 1/8"
(81 x 70.5 x 13 cm)
Musée de Grenoble

Arshile Gorky
Composition, 1936-39
Oil on canvas, 29 ³/₄ x 35 ³/₄"
(75.6 x 90.8 cm)
The Minneapolis Institute of Arts
The Francisca S. Winston Fund

Alexander Calder
Standing Mobile, 1943
Black wire and black plates on wire base, 45 x 34"
(114.3 x 86.4 cm)
New Haven, Yale University Art Gallery
The Katharine Ordway Collection

Alexander Calder
Cover of "View", Spring 1944
Heliogravure, 12 x 9" (30.5 x 23 cm)
Paris, courtesy Galerie 1900-2000
Marcel and David Fleiss

Marcel Duchamp
Cover of "View", March 1945
Heliogravure, 12 x 9" (30.5 x 23 cm)
Paris, courtesy Galerie 1900-2000
Marcel and David Fleiss

Gordon Onslow Ford
The Circuit of the Light Knight Through the Dark Queen, 1942
Oil on canvas, 36 ¹/₄ x 47 ³/₄" (92.08 x 121.29 cm)
Gordon Onslow Ford

Steve Wheeler
The Halogens, 1942
Oil on canvas, 25 x 27 3/4"
(63.5 x 70.5 cm)
Richmond, Virginia Museum of Fine Arts
The Arthur and Margaret Glasgow Fund

Charles Houghton Howard
The Progenitors, 1947
Oil on canvas, 24 3/8 x 34 1/2"
(61.9 x 87.6 cm)
M. H. de Young Memorial Museum,
Fine Arts Museums of San Francisco
Mildred Anna Williams Collection

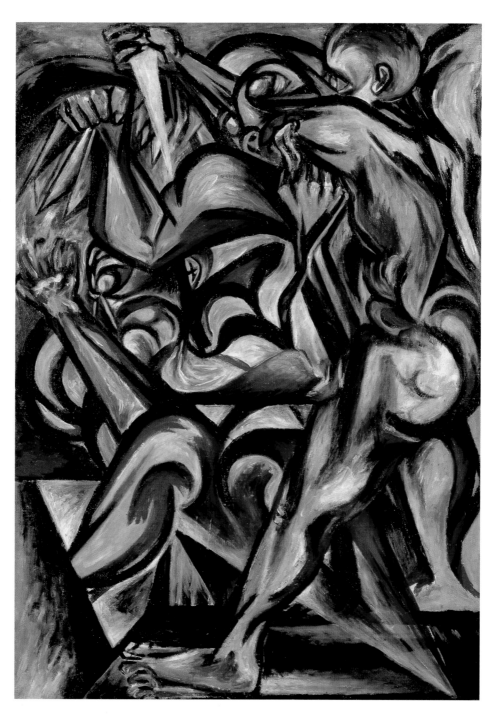

Jackson Pollock
Naked Man with Knife, 1938-40
Oil on canvas, 50 x 36" (127 x 91.4 cm)
London, Tate Gallery

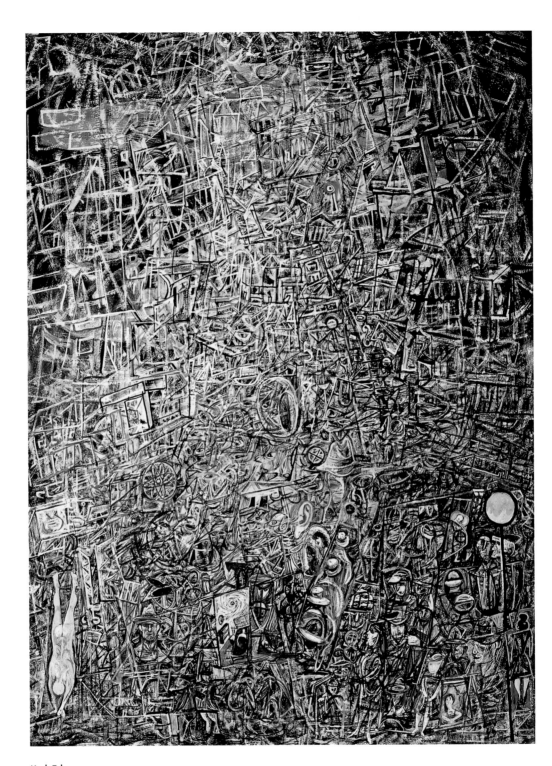

Mark Tobey
Flow of the Night, 1942
Tempera on panel, 23 $^1/_4$ x 17 $^3/_4$"
(59.1 x 45.1 cm)
Portland Art Museum
Helen Thurston Ayer Fund

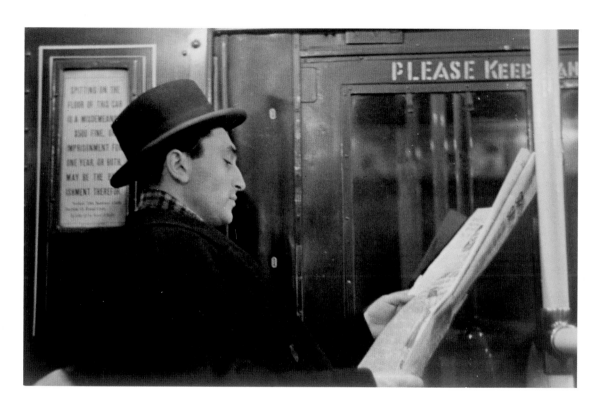

Walker Evans
Untitled (Subway Portrait), 1941
Gelatin silver print, 4 $^7/_8$ x 7 $^3/_4$"
(12.4 x 19.7 cm)
The Minneapolis Institute of Arts
The William Hood Dunwoody Fund

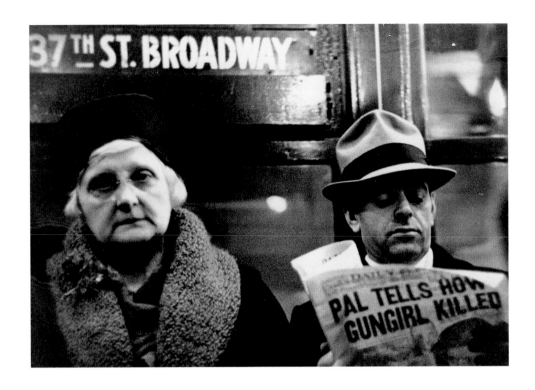

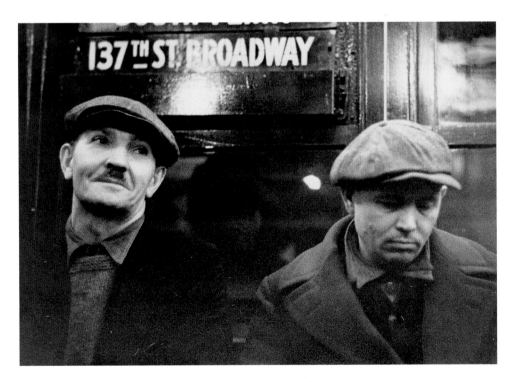

Walker Evans
Untitled (Subway Portrait), 1938-41
Gelatin silver print, 4 1/8 x 6 1/8" (10.5 x 15.5 cm)
Paris, Sandra Alvarez de Toledo

Walker Evans
Untitled (Subway Portrait), 1938-41
Gelatin silver print, 4 1/8 x 6 1/8" (10.5 x 15.5 cm)
Paris, Sandra Alvarez de Toledo

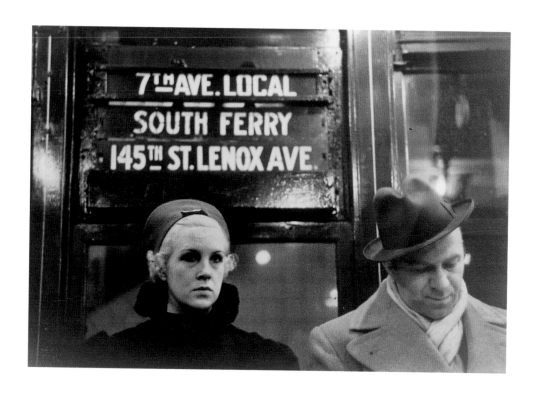

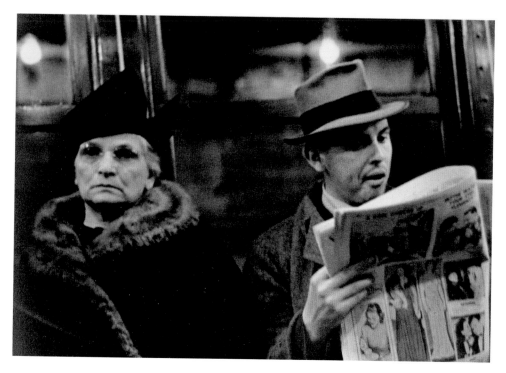

Walker Evans
Untitled (Subway Portrait), 1941
Gelatin silver print, 5 3/8 x 8 1/8" (13.7 x 20.6 cm)
The Minneapolis Institute of Arts
The William Hood Dunwoody Fund

Walker Evans
Untitled (Subway Portrait), 1938-41
Gelatin silver print, 4 1/8 x 6 1/8" (10.5 x 15.5 cm)
Paris, Sandra Alvarez de Toledo Collection

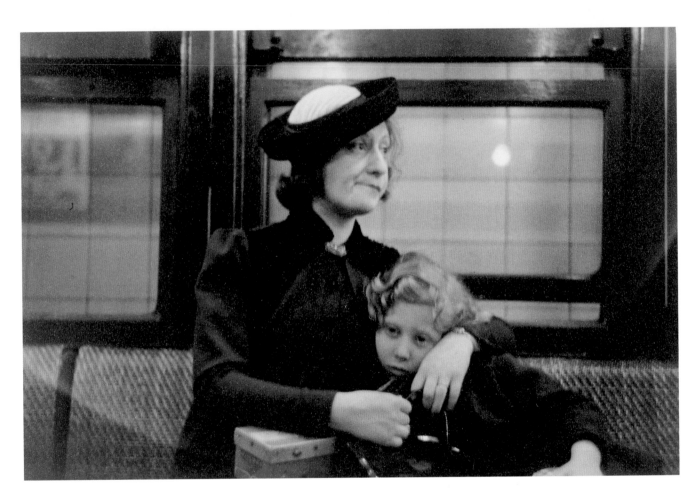

Walker Evans
Untitled (Subway Portrait), 1941
Gelatin silver print, 5 x 7 ½" (12.8 x 19.3 cm)
The Minneapolis Institute of Arts
The William Hood Dunwoody Fund

Jackson Pollock
Composition with Pouring II, 1943
Oil on canvas, 25 1/8 x 22 1/8" (63.8 x 56.2 cm)
Washington D.C., Hirshhorn Museum and Sculpture Garden,
Smithsonian Institution
Gift of Joseph H. Hirshhorn, 1966

David Smith
Steel Drawing I, 1945
Steel, 22 ¹/₄ x 26 x 6" (56.5 x 66 x 15.2 cm)
Washington D.C., Hirshhorn Museum and Sculpture Garden,
Smithsonian Institution
Gift of Joseph H. Hirshhorn, 1966

Barnett Newman
Untitled, 1946
India ink on rag paper, 36 x 24" (91.5 x 61 cm)
Paris, Musée National d'Art Moderne, Centre Georges Pompidou
Gift of Annalee Newman, 1986

Biographical Notes

The biographical notes were compiled by students preparing Master's and D.E.A. (*Diplôme d'Études Approfondies*) degrees in History of Contemporary Art, Université François Rabelais, Tours:

Élodie Antoine **(E.A.)**

Charline Attard **(C.A.)**

Anne Bariteaud **(A.B.)**

Pauline Bontemps **(P.B.)**

Yoan Brouté **(Y.B.)**

Alexandra Célant **(A.C.)**

Jérôme Cotinet **(J.C.)**

Marie Crozé **(M.C.)**

François Fiévre **(F.F.)**

Magali Flahault **(M.F.)**

Charlotte Grandbarbe **(Ch.G.)**

Estelle Grillon **(E.G.)**

Caroline Guillon **(C.G.)**

Billie Martineau **(B.M.)**

Caroline Mercuri **(C.M.)**

Charlotte Mus **(Ch.M.)**

Cyril Pineau **(C.P.)**

Manon Sellier **(M.S.)**

Dorothée Tramoni **(D.T.)**

Émilie Viau **(E.V.)**

under the supervision of Éric de Chassey **(E.C.)**

Berenice ABBOTT (1898-1991)

In 1918, Berenice Abbott left New York for Paris where she met Man Ray and became his assistant. Shortly thereafter, she started working as a professional portrait photographer and took portraits of Parisian intellectuals such as Cocteau or Joyce. Deeply struck by the work of Eugene Atget, who passed on to her his sense of bare aestheticism, she took it upon herself to preserve his work after his death. Upon her return to the United States, her project *Changing New York,* shot from 1935-39 for the WPA, was made into a book. The central theme of this detailed compilation of urban scenes was the documentation of the changing metropolis. She was fascinated by the city's multiplicity and illustrated its architectural monumentality in minute detail. Also interested in science and speed, her work reflected her knowledge of the American modernist visual vocabulary combined with a taste for documentary realism. **B.M.**
➤ p. 187

Ansel Adams (1902-84)

Adams's career began in 1930, following a decisive encounter with Paul Strand. Very quickly, he worked for the illustrated press and challenged the validity of pictorial photography, advocating instead purity and precision. In 1932, he was one of the founders of the group f/64. The use of this aperture, which resulted in an exceptional depth of field, endowed his photographs with an extreme sharpness, a wealth of detail and a wide range of values. His work was also characterized by his taste for flatness which emphasized formal plays. He depicted everyday objects—factories, houses, fences—and, above all, nature from its most minute manifestations—details of plants and flowers—to its grandest monuments, such as Yosemite Valley. In 1941, Adams developed his theory of the *zone system,* which enabled the photographer to pre-visualize a photograph and to correct its exposure before taking the shot. **M.C.**
➤ p. 138

John ATHERTON (1900-52)

After studying in San Francisco, Atherton practiced a painting style of restrained modernism which, in 1929, earned him a prize from the conservative Bohemian Club. His departure for New York that same year proved to be the opportunity for the blossoming of his career. His illustrations, published namely in *Fortune* and *The Saturday Evening Post,* reflected his interest in magical realism. From the mid-thirties, his work was shown at the Julien Levy Gallery, a stronghold of Surrealism in the United States. By 1939, his works often represented landscapes dotted with strange warlike or fantastic constructions, as well as incongruous objects. This Surrealistic inclination became more abstract towards the end of his life. However, Atherton never gave up representing more prosaic images—in both his commercial and his more personal production (if indeed this distinction applies in his case). For example, he painted a great number of still lifes of fishing equipment. **E.C.**
➤ p. 174

George Lee AULT (1891-1948)

From the early 1920s, Ault, who was born in Cleveland, made very flat drawings, watercolors and oil paintings of urban landscape and factory scenes in a Precisionist style. The use of a dark palette imbued his works with an austere atmosphere and enhanced the negative character of the position of the artist confronted with the city. To him, the industrial world was "hell without flames." Simplifying his forms, he accentuated the cold, abstract and geometrical aspect of workshops, buildings and skyscrapers, and the right-angle streets of New York where he lived between 1911 and 1937. In these urban and industrial landscapes, man was seldom present. In the last years of his life, Ault settled in Woodstock, where he underwent a radical change and developed a very personal approach to Surrealism in urban or rural fantasy settings, where figures appear in bizarre situations. **E.A.**
➤ p. 134, 135

Milton AVERY (1885-1965)

While working in a factory, Avery also studied at the Connecticut League of Art Students. His landscapes from the 1920s took on the light palettes and atmospheric perspectives of the American Impressionists. When he left for New York in 1925 and was confronted with the works of Matisse, Braque and Picasso, he started simplifying his forms into flat color. Although some of his compositions tended towards abstraction, he didn't give up representation. In the 1940s, his mature style was characterized by the reduction of elements to their basic forms, the elimination of detail, flatness, the choice of arbitrary colors in the manner of Matisse, but with a sardonic quality that was his own. First he was criticized for his use of a purely pictorial language, then for his use of representation. In spite of its contradictions, his work was essential to the young painters who visited his studio, including Gottlieb, Rothko and Newman. **D.T.**
➤ p. 154

Romare BEARDEN (1912-88)

At the beginning of his career, Bearden was an illustrator for the magazines *Medley* and *Baltimore Afro-American.* Following a gathering of the Harlem Artists Guild in 1935, he joined group 306, an informal group of African-American artists, and signed up with the Art Students League where his teacher was George Grosz. He started practicing a kind of monumental realism, that celebrated the virtues of the minority he belonged to: urban workmen, cotton field laborers, scenes of daily life observed in the South. After the war, he dedicated his first one-man show to the Passion of Christ. His style changed and his compositions became more abstract. Other thematic shows followed until 1950 when he left for France on the GI Bill. Upon his return, he took up a new technique and created Photo-Projections. He founded the Spiral group, which theorized about and promoted the history of African-American art. **D.T**
➤ p. 189

Georges BELLOWS (1882-1925)

For a long time, Bellows was considered the American artist *par excellence*, since he was among the rare ones who had not studied abroad. His works reflected the aesthetics of the Ashcan School. The genre painting for which he was known after 1908 was characterized by a palette dominated by cream and brown colors. This may explain why he was particularly noted for his lithographic work after 1916. After 1909, Bellows concentrated on painting and drawing boxing scenes in which he conveyed the rhythm and violence of the fights with great accuracy. However, as the years went by, though his themes remained unchanged, the outline of his characters became more fluid and his painting smoother; he showed greater interest in composition and his scenes became livelier through the intersection of implicit diagonals. Toward the end of his life, Bellows concentrated on more individual themes, nudes and especially portraits of his family and close friends. **E.A.**

➤ p. 47, 48

Thomas Hart BENTON (1889-1975)

Born in Missouri, Benton embarked on a career as a cartoonist which he gave up in 1905 to study art in Chicago. The following year he left for Paris where he met Macdonald-Wright. He returned to New York in 1913 and took an active part in Synchromism. Stieglitz included his works in the 1916 *Forum* exhibit. After the war, Benton turned his back on abstraction. Though his relentless opposition to contemporary trends isolated him from modern artistic developments, he was renowned throughout the country as a regional painter. In 1930 he painted frescoes for the New School of New York, followed by, among others, those for Jefferson City in 1936. After 1926, he taught at the Art Students League of New York. He left New York for Kansas City in 1934. Benton's moral and political beliefs led him to celebrate the daily life of small farmers and typically American laborers in an increasingly stylized form. **F.F.**

➤ p. 102, 176, 177

Charles BIEDERMAN (1906)

Born in Cleveland, Biederman studied at the Art Institute of Chicago. From 1934 to 1940 he lived in New York where he created his first relief compositions on canvas in a hybrid style of geometric and biomorphic forms floating in Cubist space. In 1936-37 he spent nine months in Paris where Pevsner introduced him to the members of Abstraction-Creation. He made his first totally «non-mimetic» relief shortly before his return to the United States and joined the AAA in 1938. He used «modern» materials (plastic and metal) and adopted a Constructivist approach resulting from his combination of Biomorphism and Geometrism. Biederman used Mondrian's visual language before the latter's arrival in New York, but he became rather free with the principles of Neo-Plasticism, particularly in his use of color. In 1941, he settled in Minnesota where he still lives, and continues to work as a painter and theoretician of abstraction. **D.T.**

➤ p. 224

Emil BISTTRAM (1895-1976)

A renowned graphic designer in New York since the early 1910s, Bisttram embarked on a teaching career early on. As a painter, he participated in the 1928 Venice Biennale. Although invited to Italy to study mural painting, he preferred to go to Mexico with the muralist Diego Rivera. He visited Taos for the first time in 1930, settled there in 1932, and started the Taos School of Art where teaching was based on «dynamic symmetry.» His discovery of Kandinsky at about the same time enabled Bisttram to give a shape—abstract—to his long-term enthusiasm for various esoteric doctrines which he complemented by reading Emerson, Nietzsche and Jung. In 1938, he created the Transcendental Painting Group with Raymond Johnson and drew into it two of his best students: Horace Pierce and Florence Miller. A practitioner of spiritualist geometric abstraction, Bisttram remained faithful to non-objective painting until his death and only closed his school in 1965. **M.S.**

➤ p. 179

Ilya BOLOTOWSKY (1907-81)

Born in Petrograd, Bolotowsky arrived in New York in 1923 where he studied at the National Academy of Design until 1930. In 1933, after discovering Malevich and Mondrian, Bolotowsky turned his back on his early figurative works that had linked him to the ideology of the group of Ten (alongside Gottlieb and Rothko, among others), and went on to produce purely geometric paintings. By 1934, his works revealed an interest in an abstract interpretation of Miró's work. He used a visual vocabulary associating rigorous geometry and Biomorphism that assumed a monumental aspect in his creations for the WPA and the 1939 World Fair. In 1937, Bolotowsky was among the first AAA members. In the early 1940s, he went back to Mondrian and produced works that would remain faithful for the most part to the principles of Neo-Plasticism, based on the rejection of any kind of spatial illusion and the rigor of straight lines. **P.B.**

➤ p. 222, 223

Margaret BOURKE-WHITE (1904-71)

In the 1920s, Margaret Bourke-White worked as a free-lance photographer in New York and Cleveland. She applied her art, which had already acquired an advertising slant through personal choice as much as through opportunity, to modernist subjects (factories and urban architecture). Her photographs celebrated industrial growth and relied on a pictorial approach that linked the strength of simple geometric forms with an decorative process owing much to the teachings of Clarence H. White. From 1929-36 Bourke-White collaborated on Henry Luce's magazine *Fortune*. When he created *Life* in 1936, she did the cover and the lead story for the first issue, in collaboration with the magazine's photographic staff. She contributed to the development of photojournalism and published numerous reportages until 1969, namely on the USSR and Germany in the 1930s, the Italian front, and the liberation of the concentration camps during the Second World War. **C.A.**

➤ p. 186

Patrick Henry BRUCE (1880-1937)

Born in Virginia, Bruce studied at the New York School of Art. Upon his arrival in Paris in 1907, he entered the circle of the Steins who initiated him into Impressionism and Cézanne's work. Through the Steins, he also met Matisse, and fell under his influence. At that time, he did a series of still lifes, landscapes and portraits in a Fauvist style inspired by Cézanne. In 1912, his encounter with Delaunay prompted him to concentrate on his theoretical research on color. Until 1916, Bruce was involved in Orphism and painted a brilliant series of six monumental *Compositions,* mostly abstract and geometric (though apparently based on images of a ball). His last series of still lifes, created before destroying his entire body of work in 1932 (except for 15 paintings he bequeathed to Henri-Pierre Roché, his sole collector with Catherine Dreier) showed his interest in a Geometrism akin to purism and revealed a very personal chromatic scale. He returned to the United States and committed suicide in 1937. **C.P.**

➤ p. 103

Charles BURCHFIELD (1893-1967)

After studying art in Cleveland, Burchfield returned to his hometown of Salem, Ohio. He created mostly watercolors of poetic landscapes with simplified forms and little regard for scale and actual colors. Reaching a visionary peak around 1917, his works of the time were inhabited by a fantasy world of butterflies and elves. In the 1920s he used his simplified forms to depict the American provincial scene. He painted the streets and houses, railway stations, industrial architecture and landscapes of Ohio. In the following decade, Burchfield used a realistic style to describe the country's mood during the Depression. From 1943 until the end of his life, he went back to his early poetic landscapes. He picked up the canvases that he had left unfinished around 1910 and developed the same themes in watercolors which often expressed his tormented feeling for nature. **E.A.**

➤ p. 164, 165

Alexander CALDER (1898-1976)

Calder was the son of a renowned sculptor, and studied painting in New York. Early on, he was interested in the entertainment scene and by 1923 had made drawings of the Barnum circus. Following his arrival in Paris in 1926, he created his first puppets and wire sculptures. In 1930, after a decisive encounter with Mondrian, he gave up Naturalistic representation and created abstract sculptures animated by man, nature or machine («Mondrians which move»). These works, called «mobiles» by Duchamp, used the properties of gravity to create dynamic harmony. He started showing them in 1933, the year he bought a studio in Connecticut, and thereafter shared his time between France and the United States. In 1936, he was one of the rare American artists to participate in the exhibition *Cubism and Abstract Art*. In 1943, he started creating «stabiles,» which would later assume monumental size, without losing their playful aspect. **C.M.**

➤ p. 228, 230

John COVERT (1882-1960)

Despite his stays in Munich (1908-12) and Paris (1912-14), Covert was not very interested in the avant-garde and continued painting portraits and academic nudes. However, upon his return to New York in 1915, through his association with his cousin, Walter Arensberg, and his circle, he had the opportunity to discover Cubist works and to mix with avant-garde artists such as Schamberg, Sheeler or Demuth, and particularly Picabia and Duchamp—in 1916, he was the first secretary of the Society of Independent Artists founded by Duchamp. After painting several Cubist-inspired works, in 1918 and 1919 he created his first assemblages and collages that were often abstract and drew on mathematical and musical themes. However, the Arensbergs' departure for California in 1923 isolated Covert, and left him alone to face the disinterest of the American audience. Financial difficulties led him to give up painting at a time when his work had just developed into a very original cryptographic figuration. **C.P.**

➤ p. 120, 121

Ralston CRAWFORD (1906-78)

A stint at the Walt Disney studios encouraged Crawford to study art in several American and Parisian institutions and to try his hand at painting, photography, and lithography. Having been struck by Cézanne's and Stuart Davis's work, in 1935 he became interested in the geometrical perfection of Pennsylvania's industrial architecture. The sharpness of his works, that embodied the American technological ideal, positioned him among the Precisionists. However, his age and the discipline of his abstraction designated him as one of the last representatives of this movement. In 1937, he stopped considering his photographs as visual supports in order to observe graphic contrasts in greater depth. Later, he diversified his visual language and subjects, as is shown by his series of photographs of black American jazzmen of the 1950s, and his subsequent highly abstract paintings influenced by Cubism, in which the criticism of nuclear armament supersedes any apology for industry. **A.B.**

➤ p. 135

Imogen CUNNINGHAM (1883-1976)

After working with Edward S. Curtis, around 1910, Imogen Cunningham opened her own studio in Seattle and then in San Francisco. At first, she was mainly interested in the treatment of faces and bodies in a pictorial, romantic and allegorical vein. She was among the first artists to exhibit photographs of nudes, such as the outdoor nudes of her husband which caused a scandal. From 1922-29, she photographed her house and shot an interesting series of plants and flowers in which the monumentality of the forms and the erotic dimension took over the ornamental nature of the subject, through playing on the purity of lines and contrasts. In 1932, along with photographers Willard Van Dyke, Ansel Adams and Edward Weston, she founded group f/64, a name which refers to a small lens aperture producing sharpness and precision, thus heralding a specific alternative to Pictorialism. **C.A.**

➤ p. 139

Edward S. CURTIS (1868-1954)

Curtis began his career as a studio photographer in Seattle. However, his interest in the American Indians was stronger. In 1889, he was the official photographer for the Harriman ethnographic mission in Alaska. In 1901 he started building up a photographic documentation on the lives, customs and folklore of the American Indian tribes. This project was made into 20 volumes—*The North American Indians*—published between 1907 and 1930, and comprised of hundreds of photographs taken throughout the country. Curtis staged his photographs adding props, scalps and costumes suggesting the bellicose nature of his models, always shown as proud and noble characters in individual portraits or group scenes. His photographs, in a largely pictorialist vein, represent a truly artistic work that described a vanishing cultur **E.A.**

➤ p. 59

Stuart DAVIS (1894-1964)

A student of Robert Henri, Stuart Davis participated in the *Armory Show*. After discovering the European avant-garde, he gave up Realism to develop a personal approach to synthetic Cubism that was associated with an artistic vocabulary derived from common objects. After 1924, this approach led him to abstraction as can be seen in the series "Eggbeaters" (1927-28). Although on the occasion of a stay in Paris in 1928, Davis went back to picturesque urban scenes, he never stopped fighting against the distinctions between figurative and abstract painting. In the 1930s, he created several murals, most of which were for the WPA. Their themes (new trends in American society, jazz), as well as his approach to pictorial space, in which he blended large blocks of bright colors with real-life elements and abstract forms, made Davis the inventor of vernacular modernism. **Y.B**

➤ p. 218, 219

Manierre DAWSON (1887-1969)

Dawson spent most of his painting career in Chicago. An industrial graphic designer by profession, by 1910 he had painted a fully abstract work, *Prognostic,* a lyrical abstraction of colored rhythms. Encouraged by the Armory Show where he discovered Duchamp's work, for several years Dawson painted mostly geometric variations of the great masters he had discovered during a trip to Europe, under the increasingly strong influence of Cubism. At times, these variations, that emphasized solely linear structure, were difficult to decipher. Dawson's originality was undeniable but his isolation was almost complete and these works and their reception greatly confused him. After 1914 he devoted most of his time to farming, gradually giving up his artistic activities which slowed down further after 1921. **E.C.**

➤ p. 89

Charles DEMUTH (1883-1935)

After his studies in Philadelphia, Demuth made several trips to Europe, mostly to Paris. Even though he appreciated European modernism, his work bore the stamp of an American identity, namely of industrial aestheticism. He was close to Hartley, Duchamp and Sheeler, whom he had encountered during his many visits to New York, and after 1917 he applied analytical Cubism to a geometrical simplification highlighting the structure of the object. His increasingly monumental prismatic technique reduced representation to a play on two-dimensional intersecting colored planes springing to the surface of the canvas, whether in his urban scenes (particularly of the small town of Lancaster where he lived), his compositions of flowers and vegetables, or his enigmatic oil paintings (1923-29). In 1926, without changing his style or subjects, he joined Stieglitz's circle. **J.C.**

➤ p. 125, 127, 128

Burgoyne DILLER (1906-65)

Diller studied art in New York from 1928-33, namely with Hans Hofmann. He moved rapidly from Cubism to Abstraction, which he developed according to the principles of Neo-Plasticism after he discovered Mondrian's work in 1934. However, he did introduce some originality into his geometrical compositions—the lines came in different planes and densities, the primary colors were enriched with gray, and after 1938, reliefs and constructions increased in number. Throughout his career, his work revolved around three categories of highly structured compositions, which he called "Themes," often prepared with collages. He tried to promote abstraction in the United States and was, in 1937, a co-founder of the AAA. From 1934 he directed the AAA's mural program for the New York area and commissioned several abstract frescoes for public places. **P.B.**

➤ p. 227

Arthur DOVE (1880-1946)

From 1903-07, Dove worked as an illustrator, and then spent two years in France where he discovered Cézanne and Matisse. His paintings remained figurative and his palette inspired by the Fauves. When he returned to New York, he was among the first American artists to move toward colorist Expressionism, that was occasionally abstract. He met Stieglitz, who organized, in 1912, his first one-man show consisting of works the critics considered to be abstract. From 1917-20, Dove produced mainly pastels and tried his hand at collages. His work, carried out in the isolation of rural semi-retirement, was largely inspired by nature, whose forces and movements he wanted to express. To the end, stars, animals and landscapes remained the main themes of his repertory, stressing the expressive power of color, and thus highlighting the abstract nature of his work. **E.G.**

➤ p. 93, 153

Marcel DUCHAMP (1887-1968)

Duchamp became famous in the United States through the scandal caused by his *Nu Descendant l'Escalier* (1911) exhibited at the *Armory Show* in 1913. Thereafter, he gave up painting and devoted himself to the choice of ready-mades—common manufactured objects shown as they were or with minor transformations, such as the urinal signed R. Mutt, which he created for the exhibition of the Indépendents in 1917. He lived in New York from 1915-23 (with short stays in Paris and Buenos Aires). A central figure of the Arensbergs' circle and co-founder, with Catherine Dreier and Man Ray, of the Société Anonyme in 1920, he became one of the main actors in transatlantic relations. From 1913-23, Duchamp worked on *The Bride Stripped Bare by Her Bachelors, Even*, also known as *The Large Glass*. Living between Paris and New York, though he claimed to be almost entirely devoted to chess-playing, he found the time, from the 1930s, to write notes, to have replicas made of his previous works and to create various objects. **J.C.**
➤ p. 118, 230

Walker EVANS (1903-75)

After discovering the work of Strand and Atget around 1929, Evans decided to devote himself to photography. From the outset, he favored describing American reality, particularly that of vernacular architecture, and rapidly abandoned Constructivism for a more descriptive approach. From 1935 to 1938, in the framework of the FSA, he developed a special interest in the poor rural South which became the subject of his book *Let Us Now Praise Famous Men*, published in 1941 with a text by James Agee. From 1938-42, he did a series of "anonymous faces" in the New York subway. Though intent on preserving his independence, Evans was a member of *Fortune*'s editing staff from 1945-65. According to him, photography was a "documentary style," as was powerfully demonstrated by his one-man show at MoMA in 1938, *American Photographs*. Although a photographer, his art always drew its main references, both modern and disillusioned, from Flaubert and Baudelaire. **C.G**
➤ p. 160-63, 182, 185, 235-38

William James GLACKENS (1870-1938)

Born in Philadelphia, Glackens started working as an illustrator for the local press. In 1891, he met there the painters Luks, Sloan, Shinn and Robert Henri. A stay in Paris in 1895 acquainted him with the painting of Manet and Renoir, who had a determining influence on him (he was to be called the "American Renoir"). Back in the United States, he settled in New York where he saw again his Philadelphia friends with whom he founded the Group of Eight. Their exhibition at the Macbeth Gallery in 1908 earned them the name of Ashcan School, because they stressed the gloomy side of the contemporary landscape and urban scenes. Glackens was the most eager among his companions to introduce Impressionist values to America. Sharing his time between Europe and the United States, he was one of the organizers of the Armory Show in 1913, and evolved thereafter towards an increasingly light palette. **E.F.**
➤ p. 44

Raphaël GLEITSMANN (1903-75)

Gleitsmann led a rather quiet career as a self-taught painter in Akron, Ohio, where he had no in-depth contact with modernism. His paintings and watercolors of the 1930s were generally close to Grant Wood's style, without his sarcastic quality—they represented the artist's environment in great detail in daily scenes of a small Midwest town and its immediate surroundings. The artist's straight and simple style of *The White Dam* (1939) brought him close to the magical realism, or mechanist trend, of the previous decade, due to its precise structure and rendering. But this work remained an exception within a production governed by a concern for legibility, which would become more expressionistic after the war. In 1948, Gleitsmann was awarded the prestigious Carnegie Prize, only a few years before he decided to give up painting to become a framer and restorer. **E.C.**
➤ p. 175

Arshile GORKY (1904-48)

Born in Armenia, from where he was driven away by the genocide, Gorky (whose original name was Vosdanik Adoian) immigrated to the United States in 1920. For a long time his work was marked by successive experimentation in an eclectic combination of styles borrowed from Cézanne, Matisse and particularly from Cubism, and from Picasso's various periods. From the late 1930s, Gorky developed a passion for Miró's work and produced abstract versions of it. His encounters with Matta and Breton during their New York exile were determining. Having already embraced certain principles of Surrealism (such as Biomorphism and relationship with the unconscious through automatic drawing), he gave himself a free rein and created paintings in which personal myths emerged from revived childhood memories. His intuitive approach and his friendship with Graham, De Kooning and Pollock placed him at the turning point between Surrealism and Abstract-Expressionism. **A.C.**
➤ p. 229

Philip GUSTON (1913-80)

Under the aegis of the Mexican muralists admired during his youth in California, his early works were stamped by the longing for political and social commitment; his paintings of the 1930s stigmatized in particular his country's racist violence and the massacres taking place in Europe. At that time, his artistic references were Piero della Francesca, Michelangelo, De Chirico and Picasso's neoclassicist period. In 1939, he discovered Beckmann and Picasso's *Guernica*, that showed him allegory could be more effective than allegiance to the principles of social realism. He then painted what he considered his most "accomplished" work to date, a fight between children, *Martial Memory* (1941). By 1945, his paintings expressed his estrangement from an art linked to current events. In 1945 he was awarded the prestigious Carnegie Prize for both his "abstract and symbolist" works and he moved progressively into the sphere of Abstract Expressionism. **D.T.**
➤ p. 188

Robert GWATHMEY (1903-88)

Gwathmey was one of the first white American painters to represent African-Americans in a realistic way. His work highlighted their aspirations, contributions, and identity and the failure of society to acknowledge these. His paintings from the early 1940s were devoid of sentimentalism, and depicted the lives of African-Americans in the South, that was still governed by segregation. The scenes were generally of great simplicity, making the most of symbols to spread a broader message. According to Gwathmey, both the use of a significant composition and symbolical abstraction gave his message a wider dimension. In order to overcome a literal reading of the painting, the symbols had to be simple, powerful and inventive. The emphasis on a two-dimensional composition, the use of deep iridescent colors and a thick outline call to mind stained-glass windows. In this way, Socialist realism was renewed for some time to come. **D.T.**
➤ p. 194

Marsden HARTLEY (1877-1943)

Born in Maine, Hartley arrived in New York in 1899 to study at the New York School of Art, and the National Academy of Design. By 1905, back in Maine, he painted Post-Impressionist landscapes. In 1909, in New York, he discovered modern European art and joined the circle of Stieglitz who helped him make his first trip to Europe. In 1912, he was in Paris where his interest in Cubism made up for his lack of theoretical knowledge; in 1913 he was in Berlin where he met Kandinsky and moved toward a very personal abstraction, as can be seen in his most famous Symbolist portraits, the most significant series of which express grief over the death of a Prussian officer (1914-15). In 1926, Hartley lived in Provence where he made numerous studies of Montagne Sainte-Victoire. This return to Naturalist Expressionism took him to Maine where he spent the last six years of his life. There, he painted many sentimental Primitivist portraits. **C.P.**
➤ p. 90, 91, 155, 157

Jean HELION (1904-87)

Influenced by Cézanne and Derain, Hélion moved progressively towards Abstraction that he had discovered in Paris in 1924. Following his encounters with Van Doesburg and Torrès-Garcia, he developed a sign system embracing the principles of Constructivism. In 1929, he was a co-founder of the Concrete Art Group (he would later belong to the Abstraction-Creation group along with several American and European artists). In 1933, he took a first trip to the United States and lived in Virginia from 1936-38. His formats acquired a broader scale, becoming actual "organisms," leading to the motif of the *Figure,* a geometric and biomorphic construction set against a plain background. His numerous journeys between France and the United States led him to play a significant role on the New York artistic scene, in particular in the context of his relationships with Gallatin and AAA members. In 1939, upon his return to France, he gave up abstraction and focused on the human body and the still life. **J.C.**
➤ p. 220

Lewis HINE (1874-1940)

In his youth, Hine studied drawing and sculpture before turning to sociological and pedagogical studies. He discovered photography in 1903 and immediately understood the power of the medium he would use as a propaganda tool. Through his special interest in the living conditions of poor immigrants (which became the subject of his first reporting in 1905) and workers, in particular of children, he inaugurated the genre of photo-reportage as social statement. He maintained a close relationship with reformist circles, fighting relentlessly against the exploitation of children in factories, especially in the framework of an investigation he carried out from 1908-18 for the National Labor Committee. His photographic work was used in information campaigns. Through the practice of individual or group portraits, Hine brutally confronted the viewer with raw reality, trying to elicit from him a strong reaction. **M.C.**
➤ p. 55-59

Alexander HOGUE (1898-1994)

Hogue grew up in Texas. After earning his living as a calligrapher in New York in the 1920s, he settled in Dallas. After 1932, he became one of the leading members of the local artists' guild, generally linked to regionalist trends. Hogue painted numerous Texan landscapes noted for their serenity and solitude, however, he distinguished himself mostly through his depictions of the darkest aspects of the Depression in rural areas, in particular in a series of six paintings called *Erosion*, painted between 1934 and 1938. Although his descriptions of the desertification brought about by the overexploitation of farmland placed him apart from the irenicism and nostalgia of the American Scene artists, he nevertheless continued being associated with them. His works are rigorously composed, isolating significant elements against well defined backgrounds, and through their persistent verism and precision, are like a kind of socially committed magical realism. **E.C.**
➤ p. 180, 181

Winslow HOMER (1836-1910)

Homer became famous through his 1866 historical genre painting showing the confrontation between the North and the South, *Prisoner on the Front*. His oil paintings remained in the popular American style. In spite of a ten-month stay in France during the 1867 World Fair, where he exhibited his work in the «American art» section, he claimed to be uninterested in European art. Self-taught, focusing on native subjects and motifs, he was rapidly considered as the «most American in American art.» Following a stay in England in 1881, his main motifs became the sea and the power of the natural elements. Upon his return, he settled in Prout's Neck (Maine) on the Atlantic coast, where he spent the rest of his days painting nature, gradually abandoning the human figure. The constant confrontations between the natural elements, the strong contrasts and colors, and the asymmetrical arrangements testify to a definite dialogue with Japanese art and Impressionism. **J.C.**
➤ p. 42

Edward HOPPER (1882-1967)

Until 1924, Hopper led a dual career as an illustrator and a painter. He also practiced engraving, a technique that lent power to his compositions. Before developing his own style, he was influenced by Matisse, Degas and the Impressionists whom he discovered during his several stays in Paris between 1906 and 1910. Thereafter, under Sloan's influence, his work took a new turn, without falling, however, into the sensationalism of the Ashcan School. He reached maturity as a painter around 1925 and created paintings such as *Early Sunday Morning* (1930) or *Gas Station* (1940) where loneliness became the dominant theme. Love, usually unrequited, was also one of his main subjects. Hopper's treatment of light that rendered it intense and sharp, his solid compositions and his emphasis on chiaroscuro gave his works a distinctive character which earned them long-lasting popularity. His works also had a considerable influence on the cinema. **E.G.**
➤ p. 166-69

Charles HOWARD (1899-1978)

Howard was born into a family of architects and artists from Berkeley. It was during a trip to Italy in 1924 that he decided to dedicate himself to painting. Upon his return, he settled in New York where he first created works of fantasy populated with isolated figures. Linked early on with Surrealism, he went to London in 1933. There, he became friendly with Edward Wadsworth who prompted him to join the Unit One group. Combining abstraction and Surrealism, Howard attempted to express his inner feelings in biomorphic works in which he introduced geometric figures. He adhered totally to Surrealism from 1936 - 38. In 1940, he returned to San Francisco and worked in the dockyards. The forms he discovered there strongly influenced his pictorial language that was considered as a sort of «biomorphic expressionism» marked by symmetry as well as by a highly symbolic and dark iconography. In 1947, Howard returned to London to stay. **M.S.**
➤ p. 232

Raymond JONSON (1891-1982)

After studying art in Portland, Jonson started working in Chicago in 1910 as art director of the Small Theater. He also taught at the Academy of Fine Arts in a fully traditional style. Having discovered both Kandinsky and Theosophy, he settled in Santa Fe in 1924 and began the series of «Earth Rhythms» inspired by the desert landscapes of New Mexico. He wanted to express a new spirituality by changing naturalistic elements into increasingly non-representative rhythmic and geometric harmonies. In 1931 he started a series of abstract works based on the alphabet, «Variations on a Rhythm,» that combined architectonic forms with illusionist space. He painted cosmic abstractions until his death, creating several mural paintings for the WPA. From 1938-42, he brought artists from Taos and Santa Fe who shared his concerns into the Transcendental Painting Group. **D.T.**
➤ p. 216, 217

Clark KINSEY (1877-1956)

In 1889, Kinsey followed his family to the West Coast of the United Sates. In 1895, he started a career as a professional photographer with his brother Darius. They both focussed on the camps and activities of the local lumbermen and opened a portrait studio. Attracted to the Yukon by the gold-rush, Clark Kinsey ended the association with his brother around 1897 and opened a new studio at Grand Forks, along the Klondike. Upon his return to the coast, from 1914-45, he concentrated on documenting the evolution of the gigantic forest lining the Pacific in Oregon and southern Washington. He seems to have worked for a long time with the heavy equipment of his early days, and used, at least until the 1920s, glass-negative plates that produced images of great sharpness and depth of field. **E.C.**
➤ p. 173

Gaston LACHAISE (1882-1935)

A French sculptor with academic training, Lachaise immigrated to the United States in 1906 and settled in New York in 1912. His work was linked, and mostly dedicated, to his wife, Isabelle Nagel. *Standing Woman* shown in 1927 in Stieglitz's Intimate Gallery, made him a name as one of the most prominent artists of his generation. His monumental sculpture, isolated in space, broke with the prevalent aestheticism and resolved the form-matter equation through size. A member of the Society of Independent Artists, Lachaise received numerous commissions. He made half-length portrait sculptures of members of Stieglitz's circle. In his sculpture of Marin, he strongly emphasized the material. The works created in the context of his public career were in conflict with his studio sculptures that brought him to full maturity as an artist. In his studio, he gave free rein to his inspiration, valorizing an aggressive female sexuality focusing the viewer's attention on expressive parts of the anatomy. **D.T.**
➤ p. 158, 159

Dorothea LANGE (1895-1965)

After studying with Clarence H. White, Lange opened a studio in San Francisco at a young age. The work of her mature years was done in the context of the American crisis of the 1930s, which she started shooting as a personal project. On assignment for the FSA from 1935, she devoted herself to showing the farmers who were driven away from their land and stranded in California. The book *An American Exodus* gave lyrical form to this documentation. In 1942, Lange started a project of her own about the internment camps for immigrants of Japanese origin. While her photographs documented social changes, they also conferred dignity onto the people she photographed. They brought the viewer in communion with the subject through timeless images devoid of superfluous effects. Forcing America to face the gap between its ideals and its reality, her work, which she continued until she died, made her the first humanist woman photographer. **B.M.**
➤ p. 183, 192, 193

Jacob LAWRENCE (1917-2000)

From 1932, shortly after his arrival in Harlem, Lawrence studied with the muralist Charles Alston and discovered the writers of the Harlem Renaissance. In 1937, he undertook several series of paintings depicting emblematic figures and events in the history of American blacks. In 1940-41, his series on "The Black Migration" from the South to the North earned him recognition. In the 1940s, Lawrence produced still more series dedicated to the lives of blacks in the country's urban centers—in particular, he conveyed the movement and energy of Harlem. His painting, usually tempera on cardboard or canvas, was characterized by its two-dimensionality, its angles and flat forms as well as its vivid colors. He called his deliberate Primitivism "dynamic Cubism." He taught at the Black Mountain College from 1946-86 and painted black themes until his death.

➤ p. 195 **E.V.**

Louis LOZOWICK (1892-1973)

Lozowick was born in a Russian village. At twelve, he entered the Kiev school of Fine Arts, one of the rare establishments unaffected by the persecution of Jews. At fourteen, he immigrated on his own to the United States where he was struck by the powerful structures of the skyscrapers. A student at the National Academy of Design and an assiduous visitor to the *Armory Show*, he made the most of his tour of the United States with the army. In Europe from 1920-24, he met the Cubists, Dadaists and Futurists, and particularly the Constructivists whose work fascinated him. He settled in New York in 1924, and saw in the diversity of the city's architectural forms the rational energy of the machine. With the onset of the Depression, he introduced the human figure and desolation into his work. An advocate of industry through his lithographs, murals, and writings on art and social justice, he later devoted himself to poetic representations of his travels and gave up abstract light effects. **A.B.**

➤ p. 129

Luigi LUCIONI (1900-88)

Born in Italy, Lucioni arrived in New York in 1911 and quickly began studying art. A trip to Europe in 1924 reinforced his conviction of the need to return to tradition, rejected by many of his contemporaries. Inspired by Italian Renaissance and Flemish painting and influenced by the intensive practice of etched engraving, little evolution can be seen in Lucioni's painting after the 1920s. They were characterized by a meticulous realism, a strong tendency to spread the motifs over the entire canvas, and a serene mood. After 1929, Lucioni spent part of the year in Vermont, in the small village of Stowe. The landscapes and still-lifes he painted there were acclaimed by the public and reflected his desire to depict a world little affected by the Depression, where man and nature lived in harmony, and pleasant fields and hills were dotted with small buildings and bustling human activity. **E.C.**

➤ p. 172

Stanton MACDONALD-WRIGHT (1890-1973)

After frequenting the Art Students League in Los Angeles, Macdonald-Wright settled in Paris in 1907. In 1910, his first participation in the Salon d'Automne revealed the influence of Cézanne, his interest in Pointillism, and his discovery of the works of Matisse, Picasso and Braque. In 1911, his encounter with Russell, with whom he shared an inquiring interest in the autonomous role of color, led to the development of the principles of Synchromism (expression through color). The results were exhibited in Paris and Berlin in 1913 and in New York in 1916. At first emphasizing the figurative nature of his colored compositions, Macdonald-Wright went on to produce increasingly abstract works. After 1918, back in California, he returned to a more narrative painting while carrying out chromatic research that led to projects of color films and the construction of a Kinoscope Projector. His activities as a teacher had a strong local influence. **C.P.**

➤ p. 100

MAN RAY (1890-1976)

Born as Emanuel Rudnitsky, Man Ray visited Stieglitz's gallery as early as 1911. In 1913, he discovered the works of Duchamp, who was to become his friend. Under his influence, he gave up painting in the Cubist vein for witty plays on images, using the most unorthodox means—assemblages, airbrush painting, and photography. In 1919, he reproduced the works of the Société Anonyme that he had co-founded with Duchamp and Katherine Dreier. In 1921, he traveled to Paris where he participated in Dadaist, and then in Surrealist activities. From the outset, his ignorance of the laws of photography enabled him to flout conventional formulae. Through his manipulations, he discovered rayography in 1922 and solarization in 1929. His portraits and fashion photography earned him instant recognition. From 1927, Man Ray returned several times to the United States to exhibit his work. In 1944, he decided to give up photography to devote himself to his own version of magic Surrealism **E.A.**

➤ p. 119, 122

John MARIN (1870-1953)

Throughout his life, Marin dedicated himself to landscapes, mostly painted in watercolor. Upon his return from Europe in 1911, he painted brightly colored semi-abstract scenes of South Manhattan, fragmented by angular oblique lines of construction which seem borrowed from the Futurists, but which actually revealed his personal reading of Cézanne's work. The urban landscape appears to erupt, streets and buildings burst with the frantic energy of the city's heart. Marin settled part-time in Maine in 1914-15 and produced views of the sea, islands, villages and surrounding landscape. The views of New York, which he continued to paint, are like those of Maine, watery and swathed in light. Progressively, through the use of powerful strokes, he introduced dynamism in increasingly structured and simplified compositions, lending a rare vigor to watercolor and oil. **E.A.**

➤ p. 82-84, 88, 156

Reginald MARSH (1898-1954)

Born in France, the son of an American artist, Marsh distinguished himself early on with cartoons in the Yale University journal. In 1920, he started developing this genre in New York dailies and magazines through satires of the vaudeville and burlesque theater audience. He alternated this work with stays in Europe and studies at the Art Students League where he met the Social Realist painters Sloan, Lucks and Miller. Thereafter, he specialized in painting a flashy urban reality populated with likeable beggars, buxom ladies and other low-class characters strolling before posters, in the subway and on the beaches of Coney Island. With the Depression, he reinforced his gloomy tonalities while his tempera drawings became more luminous, expressing his compassion in the face of misery. He also created mural paintings and taught at the Art Students League (namely Roy Lichtenstein). **A.B.**

➤ p. 186

Adolf de MEYER (1886-1949)

After spending his childhood in Paris and Germany, De Meyer settled in London where he was made baron in 1901 thanks to a very busy social life. He also started there his career as photographer, working in the pictorialist style, which brought him close to Stieglitz who published his photographs in *Camera Work*. In 1914, he settled in New York and was hired to work for *Vogue* and *Vanity Fair* by the publisher Condé Nast who appreciated both his style and his high society connections. Living between the United States and France, where he often returned after the war, De Meyer defined with Steichen a true aesthetic of fashion photography—the heir to Pictorialism. When this aesthetic lost the public's favor, he stopped his activities in this field—in 1934, he quit *Harper's Bazaar*, which had been his exclusive employer since 1921, and settled in Hollywood where he spent the rest of his life in semi-oblivion. **E.C.**

➤ p. 54

George L. K. MORRIS (1905-75)

Morris studied in New York, and then in France, in 1929-30, where he became a fervent disciple of Léger. Upon his return, he adopted the Cubist style and applied it to subjects drawn from the American past, particularly American Indian themes that recurred throughout his work. In 1937, he was a founder of the AAA. His paintings took a non-figurative turn, though their origin can often be traced to naturalistic observations. The articles he published regularly (until 1943) in *The Partisan Review* testified to his strictly formalist understanding of geometric abstraction in the development of Modern Art, based on Cubism. His close relationship with the collector Gallatin, as well as his personal wealth, enabled him to build up collections that recounted the history of this conception of abstraction. Between 1942 and 1945, the war led Morris to return briefly to figuration. **D.T.**

➤ p. 221

Barnett NEWMAN (1905-70)

Everything undertaken by this New York Jew—politician, writer, theoretician, businessman, painter and sculptor—was linked to art in one way or another. Close to Avery in the 1930s, he produced little and destroyed much (only six studies, drawn rapidly from life in 1936, have survived). He stayed away from the WPA, and around 1940 felt the need to wipe the aesthetic slate clean. He devoted himself almost exclusively to analyzing history and to writing theoretical essays. His works on paper from 1944-45, and the paintings he did after 1946, treated the theme of creation and growth in an abstract way using a vocabulary close to Surrealism. After turning progressively to geometrical forms and doing away with any kind of iconography, it was only in 1948, with *Onement I* that Newman found in the *zip*, a vertical component defining the painting, the means of a true "ideography," that made him a prominent Abstract Expressionist. **D.T.**
➤ p. 241

Georgia O'KEEFFE (1887-1986)

In 1915, when she met Stieglitz, O'Keeffe was teaching in Texas. The works she showed at Gallery 291 after 1916 were instantly interpreted as the direct expression of a certain intimate feminine perspective. However, the oriental method of distributing gradations, that she had learned during her studies, was the foundation of her work and she maintained, even in her most abstract paintings of the 1920s and 1930s, a strong and sensuous relationship with nature. In New York as well as in Taos, which she visited regularly and where she ultimately settled, flowers were one of her favorite motifs, and often spread over the entire composition. No fundamental difference should be seen, however, between the unidentifiable colored forms of certain paintings and the representations of flowers, landscapes or architecture. According to O'Keefe, "a representation cannot be a good painting if it isn't also good in abstract terms." **J.C.**
➤ p. 133, 152

Gordon ONSLOW FORD (born 1912)

Onslow Ford settled in Paris in 1937. His interest in non-Euclidean geometry, in ties between art and science, as well as his admiration for Tanguy and his friendship with Matta, prompted him to become a member of the Surrealist group. He rapidly engaged in a form of "absolute automatism" which led him to experiment with new techniques, creating, for instance, paintings through "drippings" of shellac on a canvas stretched on the ground. In 1940, the New School for Social Research in New York invited him to organize a series of lectures on Surrealist painting. His eagerness to explain and help others discover the significance of Surrealism and automatism had a great impact on young New York artists. At the end of that year, he left for Mexico where his compositions departed from orthodox Surrealism in favor of a meditative landscape dimension that he would carry on in California. He collaborated on the journal *Dyn* and published *Towards a New Subject in Painting* in 1947. **D.T.**
➤ p. 231

Paul OUTERBRIDGE (1896-1958)

After studying anatomy, drawing and aesthetics at the Art Students League, Outerbridge discovered photography when serving in the army. In 1920, influenced by Strand's modernism, he challenged the Pictorialist trend, that was forced on him by his professors at the Clarence H. White School of Photography in New York, and began to create abstract still lifes of daily objects. By 1922, his quest for a perfect aesthetic and his bourgeois dandy charm brought him the favor of the trendy magazines. With *Ide Colar*, which Duchamp displayed in his studio, he created one of the first examples of reconciliation between avant-garde aims and advertising. When he settled in Paris in 1925, he associated with the European avant-garde and worked for *Vogue*. Back in New York in 1929, he experimented with the Carbo-color process and used it from then on for female nudes and still-lifes. He was thus among the first to consider color photography a full-fledged art, a status denied it by most of his contemporaries. **A.B.**
➤ p. 140, 141

Gordon PARKS (born 1912)

Self-taught, in 1941 Parks decided to work with Roy Stryker at the FSA where his work rapidly took a photo-documentary turn. In this context, he made *American Gothic* (1942), a political parody of Grant Wood's painting in which Parks replaced the figures symbolizing American rural values with a black cleaning-lady. For thirty years, he covered the most significant social themes, illustrating for *Life* stories on poverty, Harlem gang violence, or segregation in the South. By concentrating on individuals, he wanted to transcend stereotyped images. Among his numerous experiments, he worked for *Vogue*, joined the Office of War Information and became a war correspondent in Europe. He later distinguished himself in fields as diverse as music, writing, and movie making, namely with *Shaft* (1971). **B.M.**
➤ p. 190

Maxfield PARRISH (1870-1966)

At the age of twenty-five, after finishing his studies at the Philadelphia Academy of Fine Arts, Parrish took a trip to Europe that had a great influence on his work. Indignant about the avant-gardes, he had developed a passion for the masters of the Quattrocento, 18th century Flemish art and especially the Romantics. In 1906, he published his first color illustrations of Italian villas in which these influences are evident. He later produced many advertising posters, magazine covers and other commercial illustrations. He stopped working in advertising in 1930 to devote himself entirely to painting. With the help of models and photographic manipulations, he created artificial idyllic landscapes, swathed in shiny light that was obtained through glazes, stencils and dispersion. The wide distribution of his posters and illustrations earned him great popularity. **Ch.M.**
➤ p. 43

Francis PICABIA (1879-1953)

Picabia owed his early reputation in the United States to the fact that he was the only Parisian to have come for the Armory Show in January 1913. His popularity was due as much to gift for creating scandals and the abstract nature of the gouaches he showed at Stieglitz's in March ("Impressions" of New York) as to the publication of numerous interviews in which he said repeatedly that America was the country of the future. Upon his return to France in April 1913, Picabia took up again his American subjects in large compositions on canvas (*Udnie*, subtitled *Young American Girl*). The declaration of war in spring 1915 gave him the opportunity to go back to New York. Together with Duchamp he became one of the major figures of the Arensbergs' salon where the spirit of American Dada developed. By summer, his first drawings of the "mechanic" period were published in *291*, followed by paintings. Expressing the idea that "the machine" is the "very soul of human life," his works had a strong impact on many American artists, long after his return to Europe in September 1916. **E.C.**
➤ p. 116-117

Jackson POLLOCK (1912-56)

After spending his youth in the West, in 1930, Pollock started studying in New York with Benton. Beyond their distinctive themes of the American Scene, his works of that time reveal the artist's own anxiety. At the end of the 1930s, influenced by the Mexican muralists and by John Graham, Pollock took Picasso as his main reference. He broke up the forms before restructuring them, using a harsh chromatic gradation, in the manner of Miró and Masson. His first show, in 1943, held at the Art of This Century gallery, firmly established his position on the New York art scene. With the monumental 1943 *Mural* and a few smaller paintings along with it, Pollock's Surrealism turned abstract, with linear networks and splashes of color covering the whole canvas (*all-over*). Pollock then pushed the automatism of movement to its pictorial extreme, systematically using the technique of *pouring* from 1947 to 1950. **M.F.**
➤ p. 233, 239

Maurice PRENDERGAST (1859-1924)

Prendergast started with seaside watercolors that remained his favorite theme, and only began studying art in Europe when he was around thirty. In 1908, he exhibited his work in the United States with the group of The Eight and stood out for associating vernacular themes with vivid colors, making him one of the first Americans to adopt the Impressionist style. He also assimilated the lessons of Cézanne, distributing colors into areas with no focal point. His most labored works, sometimes based on photographs, always appeared to be unfinished and earned him disparaging criticism. His "*fin de siècle*" quest for beauty, in conflict with early industrialization, led him to a somewhat repetitive idyllic painting. **A.B.**
➤ p. 46

Theodore ROSZAK (1907-81)

After studying art in Chicago, Roszak spent 1929-30 in Europe where he discovered modernism. Upon his return to the United Stated, he started using industrial materials and created his first abstract sculptures. From 1932-45, he made many photograms, applying Moholy-Nagy's and Man Ray's methods. He also devised plastic and metal constructions, appropriating the streamlined design forms that were developed after the 1929 Stock Market crash and that emphasized progress and modernity. Although inspired by European Constructivism, Roszak's constructions were worlds apart from the abstract urban sculptures of the 1920s and instead resembled the spacecrafts of *Buck Rogers* or *Flash Gordon* comic strips. After the war, his work developed into irregular and explosive organic forms bringing him closer, though in a superficial way, to Abstract Expressionism. **D.T.**

➤ p. 225

Morgan RUSSELL (1886-1953)

After studying with Henri in New York, Russell settled in Paris in 1908, associating with, and rapidly imitating, the major figures of modernism, particularly Matisse. In 1913, he exhibited his "Synchromies" with Macdonald-Wright, in Paris and Berlin; in these paintings, he used color for color's sake to create a three-dimensional effect. His interest in a chromatic organization of the canvas led him to study the theories of Chevreul and Rood, which in turn, led him to abstraction from 1913-15. His Synchromist paintings were shown in 1916 at the *Forum* exhibition in New York (where he returned for a month). While pursuing his attempts to build a kinetic light machine, Russell returned to figuration, first in the style of Cézanne, and after the war in a neoclassicist style. He spent most of his life in France, in a semi-isolation broken by his exchanges with Macdonald-Wright and returned to the United States to stay in 1946. **J.C.**

➤ p. 100, 101

Viktor SCHREKENGOST (1906)

Born into a family of potters, Schrekengost turned to ceramics after studying art in Cleveland, where he started teaching in 1930. After several journeys to Europe in the 1930s, he rapidly acquired a solid reputation for his creations in which he adapted the geometric style of European decorators to the American taste. Commissioned by Eleanor Roosevelt, *Jazz Bowl*, a blue glazed clay bowl with motifs inspired by jazz and Art deco, was, in 1930, his first success. Dedicating most of his time to his designing activity (creating, among other things, bicycles which were widely distributed after 1940), Schrekengost also tried his hand at painting and watercolor in works marked by his interest in adapting modernist structures to narrative and decorative ends that allowed him to express rhythmically the spectacular themes he favored. **E.C.**

➤ p. 178

George SEELEY (1880-1955)

A solitary artist, Seeley spent his entire life in his home town of Stockbridge, Massachusetts. He studied drawing and painting at Massachusetts Normal Art School of Boston. His encounter with Frederick Holland Day, who introduced him to the pictorial potential of photography was decisive. Following a show at the First American Photographic Salon of New York in 1904, he was invited by Stieglitz to join the Photo Secession group and remained a member for six years, both exhibiting and publishing his photographs. His highly intimist work revealed his preference for images showing the daily life of small provincial towns and his rejection of the changing policies of organized photography. The declining interest in pictorialist aesthetics brought an end to his career and caused him to break with Stieglitz's group. Although he stopped working almost entirely, he continued to exhibit his works through the 1930s and turned to painting towards the end of his life. **B.M.**

➤ p. 50

Ben SHAHN (1898-1969)

Born in Lithuania, Shahn first earned a living as an illustrator. His taste for European modernism prompted him to settle in Paris from 1917-22, but he didn't find the artistic solutions he was seeking there. It was only in 1931-32, with a series of paintings dedicated to the trial of the anarchists Sacco and Vanzetti, ten years earlier, that he found his own style, characterized by quick drawings and gouache on canvas, with particular care paid to the singularities of contemporary features. Shahn used his art to advance his political and social beliefs, positioning him at the peak of the Socialist realism that triumphed in New York in the 1930s. He also used these qualities in his photographic work for the FSA from 1935-38, as well as in posters (those commissioned during the war were masterly). At the end of his life he was known as one of the most influential illustrators and graphic artists in the United States. **E.C.**

➤ p. 190, 191

Charles SHAW (1892-1974)

An architect and journalist by training, Shaw became interested in the fine arts rather late. He did his first paintings during a stay in Paris in 1929, that were inspired by the city's architectural lines, and were influenced by both Arp and second-hand Cubism. His personal wealth earned him the nickname (shared with Morris among others) of "Park-Avenue Cubist." In 1933, he undertook the monumental series of *Plastic Polygons*, pioneering a technique of painting on irregular stretchers. This enabled him to better express his affinities with urbanism and industrial landscapes which he considered to be the pride of the United States. In 1936, along with Morris, Biederman, John Ferren and Calder, he participated in a show in New York entitled *5 Contemporary American Concretionists,* one of the first prefigurations of the AAA, of which he would be one of the first members. In the 1940s and 1950s, Shaw's style became purer and simpler, while maintaining its geometric character. **M.S.**

➤ p. 226

Charles SHEELER (1883-1965)

A student in Philadelphia from 1900-03, Sheeler turned rapidly to photography. He arrived in New York in 1916 where he associated with the Arensbergs' circle and also met Steichen. His photographs and paintings of urban and industrial scenes revealed his interest in the formal vocabulary of Cubism. He worked for advertising agencies (particularly for Ford) and collaborated with fashion magazines, while his painting developed into an increasingly "immaculate" rendering. After 1932, he gave up photography, using it solely as a model thereafter. His paintings and drawings are characterized by a formal simplification, an impersonal style, and a precision of the brushstroke, somewhat close to Demuth. Sheeler described the heartland of America, without falling victim to regionalist isolation. His paintings of factories, Pennsylvania farms, and Shaker furniture reflected his desire to glorify a kind of progress specific to America, where mechanical progress followed tradition. **B.M.**

➤ p. 126, 134

John SLOAN (1871-1951)

When he was twenty and living in Philadelphia, Sloan started a career as a press illustrator, an activity that would provide his main source of income until the end of his life. At the same time he studied at the Philadelphia School of Fine Arts, where he met Henri and other future participants in the group of The Eight. After 1908, both Henri and Sloan had settled in New York, where they were protagonists of the Ashcan School. Sloan specialized thereafter in picturesque scenes of the city's working-class districts, testifying to his political commitment, which also led him to collaborate regularly with Socialist publications. His realistic style was marked by the statement that "a literary motif often inspires the best art." Often narrative, hardly touched by modernism, his works rely, however, on a stable geometric composition which he also taught to his students at the Art Students League. Towards the end of his life, Sloan turned mainly to nude and landscape painting. **E.C.**

➤ p. 44

David SMITH (1906-65)

In the early 1930s, Smith started a dual career in New York as a painter and a sculptor, expressing himself in a vein close to synthetic Cubism, which led him to become a member of the AAA as soon as it was founded. His subsequent work called on his mastery of metal (he had worked on an automobile assembly line) and his knowledge of the history of sculpture (in particular Gonzales's and Picasso's metal works). In 1939, he began his series "Medals for Dishonor" (1939-40), figurative bronze reliefs inspired by the rise of Fascism in Europe, as well as by Sumerian seals. The metamorphic and narrative Figuration in his sculptures of the early 1940s was often close to Surrealism. Smith also reconciled pictorial and sculptural differences by introducing the space of the frame into the sculpture. He practiced a visual vocabulary that he radicalized in the 1950s, through his association with Abstract Expressionism. **D.T.**

➤ p. 240

Joseph STELLA (1877-1946)

An Italian immigrant, Stella settled in New York in 1896, but continued to visit Europe regularly. His early realistic drawings of immigrants and youths were published in dailies and magazines. His discovery of Futurism and Cubism had a strong influence on his style which became progressively more modernist. Stella captured the pulse and energy of urban life by linking the details in his paintings with angular and oblique "lines of construction," *Coney Island*, painted in 1913, is an example of this whirling dynamic energy. During the 1920s, Stella worked concurrently on two significant series. The first one was dedicated to bridges and urban buildings, mainly in New York and Brooklyn, in a style close to Demuth's and Sheeler's. The second is a collection of realistic studies of often outsized flowers and birds. His later work became increasingly mystical and Symbolist. **E.A.**
➤ p. 87, 128, 131

Florine STETTHEIMER (1871-1944)

Of Jewish-German origin, Stettheimer studied art in New York, and then in Europe, accompanied by her mother and sisters. The family was back in New York in 1915, and for the next twenty-five years they held an open salon for artists, critics and writers, competing for some time with the Arensbergs. Stettheimer wanted to complement her modern life-style with painting. She staged her entourage in entertaining scenes where the characters stood out through caricatured traits. Sophisticated attitudes, artificial tones, and a heavy style reflect the influence of the American garment industry. However, her private circle was her only audience, and despite a posthumous show initiated by Duchamp, the artist was marginalized for a long time. Unknown to the general public, her work gradually acquired a highly subversive reputation in gay and feminist circles, particularly for its provocative irony and deceptively simple imagination. **A.B.**
➤ p. 123

Alfred STIEGLITZ (1864-1946)

An American photographer, critic and gallery owner, Stieglitz played a significant role in the development of photography and its acceptance as a fine art, as well as that of modernism in American painting. An engineer by training, he dedicated himself early on to photography and collaborated with specialized journals. In 1902, he founded the Photo Secession group, whose journal *Camera Work* was published from 1903 to 1917. He managed gallery 291, where he exhibited the pictorialist photographers, whose aesthetic he then shared, as well as French and American modernist painters. After the war, he adopted the principles of *straight photography* and created the masterly series "Equivalents"—views of the sky and clouds, and "Portrait of a Woman"—views of Georgia O'Keefe's body. In 1925, he opened the Intimate Gallery and, in 1929, An American Place. He put an end to his photographic work in 1937. **C.G.**
➤ p. 49-51, 124

John STORRS (1885-1956)

After studying architecture, Storrs settled in Paris in 1910 and discovered sculpture through Rodin. He started working in pottery and developed an interest for inlaid stone and marble, creating massive sculptures that were influenced by Cubism and abstract trends. His hieratic style became increasingly adapted to architecture and took a definite Art Deco turn. After the 1920s, while continuing to visit France for long periods, he returned regularly to the United States, and the urban transformations there led him to create large assemblages of simple forms evocative of skyscrapers. He carried out several monumental commissions for buildings, namely in Chicago. From 1930-50, his sculptures became almost streamlined. A great admirer of poetry and a writer himself, he illustrated Edgar Allan Poe's poems with wooden sculptures. In 1939, Storrs returned to France to stay, and lived near Orléans until his death. **M.S**
➤ p. 94, 130

Paul STRAND (1890-1976)

Paul Strand's photographic career began in 1907 at the Ethical Culture High School of New York under the influence of his teacher Lewis Hine. Through Hine, he met Stieglitz and discovered the European pictorial avant-garde exhibited at gallery 291. This dual influence led him to progressively abandon Pictorialism and to produce, from 1915-17, semi-abstract images of common objects. At the same time, his interest in the human condition was revealed in portraits of anonymous individuals. From 1920, he worked as an independent filmmaker (collaborating with Sheeler on *Manhatta*), while continuing his activity as a photographer. In Mexico, he continued to explore the close-up and developed a sharper interest in nature while adhering to the principles of straight photography. His taste for documentary films as well as his social commitment reached a peak in 1937 with the foundation of Frontier Films in New York, of which he was the chairman until 1942. In 1943, he returned to full-time photography and settled in France in 1950.➤ p. 95-99, 132 **Ch.G**

Mark TOBEY (1890-1976)

Born in Wisconsin, Tobey was on the move throughout his life, traveling from coast to coast in the United States, and then from one continent to another. In 1923 in Seattle, he met a Chinese student who initiated him into oriental calligraphy. In 1925 he was in Paris, but was unsatisfied with the artistic scene there and later divided his time between New York, Seattle and the Far East. Following a retreat in a Japanese Zen monastery in 1934, he created his first "white writings." His works became the reflection of his inner life, sometimes abstract, sometimes figurative. Before Pollock, he created images entirely covered with a tight network of lines, but always in small formats. From 1944, Tobey isolated himself in Seattle while his first solo exhibition was held in New York. His art became increasingly spare, even though he associated the *all-over* technique with European aesthetic principles, which accounted for his early success on the old continent. **M.F.**
➤ p. 234

Abraham WALKOWITZ (1878-1965)

Of Russian origin, Walkowitz arrived in New York in 1889. In 1906, he journeyed to Paris. There, he met Max Weber who introduced him to the art of Cézanne, Matisse, Picasso and Rousseau. Walkowitz defined his own production at the time as being in a post-Cézanne vein. During the same period, a visit to Rodin's studio enabled him to see a dance performance by Isadora Duncan. Subsequently, he attempted to translate the sensations he had experienced during the performance into a series of abstract drawings and watercolors about choreographic creation. From 1911-17, through his association with Stieglitz, Walkowitz became interested in New York and produced more or less abstract works, mainly on paper, highlighting the linear and dynamic aspects of the city. He was also one of the first American artists to show an interest in Kandinsky. His chairmanship of the Society of Independent Artists in 1918 and of the Galleries of the Société Anonyme in 1934 testified to his unwavering commitment to modernism. **C.P.**
➤ p. 85, 86, 88

Max WEBER (1881-1961)

Of Russian origin, Weber immigrated to the United States in 1891. He spent some time in France but his career only took off in 1909, after his return to the United States where he painted primitivist pictures strongly influenced by Rousseau. He was close to Stieglitz's circle, and wrote several articles on art and color theory for *Camera Work*, that were increasingly marked by his artistic inquiry into a fourth dimension. He actually discovered Cubism in New York, and from 1910-19, it influenced his works in which he explored the signs, sounds, rhythms and intensity of the urban environment. He distorted his figures and sometimes created purely abstract forms, applying both Abstraction and the principles of Cubism to sculpture. After publishing an essay paying tribute to the mystic interpretation of abstract art proposed by Kandinsky, he came back to a more figurative expressionism in largely Judaic themes. **E.A.**
➤ p. 92

Edward WESTON (1886-1958)

Weston became a professional photographer in 1906 and started working on a series of portraits. After 1915, he gave up Pictorialism for increasingly simple subjects, that tended toward the abstract from about 1919-22. After meeting Stieglitz in New York, he settled in Mexico and lived there until 1926. His photographic experiments in still lifes, portraits, nudes and Mexican landscapes led to images of great sharpness where the object, taken out of its context, clearly stands out from the background to achieve what Weston called "a significant representation," distinctive of the shell or vegetable series undertaken in 1927. The same year, he returned to California and went back to a larger format to photograph nudes; then, thanks to the Guggenheim Fellowships he received in 1937 and 1938, awarded for the first time to a photographer, he traveled extensively to photograph American landscapes. In 1932, he was one of the founders of group f/64. **Y.B.**
➤ p. 136, 137

Steve WHEELER (1912-92)

Wheeler settled in New York in 1932 and towards the end of the decade started painting abstract pictures characterized by a blend of European avant-garde influences and an interest in American Primitive art. His works made in the very late 1930s and early 1940s were colored geometric *all over* compositions mixing Constructivism and Amerindian patterns. Wheeler was one of the first artists to introduce pre-Columbian and Indian motifs into his vocabulary, creating works he considered to be "iconographies." After 1946, although he refused to formally enlist in the group, he became associated with the events and publications of the Indian Space Painters run by Howard Daum which claimed the legacy of the Northwest Coast tribes. He rapidly played down the debt owed to these influences, attempting to create works that would be "active objects" of biological complexity that communicated the essence of nature in abstract terms.

➤ p. 232 **D.T.**

Clarence H. WHITE (1871-1925)

White met Stieglitz at the turn of the century and became one of the founding members of the Photo Secession group, showing his work at the New York Camera Club and publishing it in *Camera Work*. He started working at a decisive moment in the history of photography, when the legitimacy of the medium as a fine art was once again being questioned by mechanical reproduction. After breaking away from Stieglitz's group around 1916, White emerged as the leading proponent of Pictorialism. His balanced compositions enhanced the subtle effects of natural light. A professor at Columbia University, he opened in New York, in 1914, the Clarence H. White School of Photography. He supported aesthetic principles highlighting the significance of composition, in a clearly more Modernist vein, helping to build the careers of some of the leading photographers of the following generation, such as Dorothea Lange and Paul Outerbridge. **B.M.**

➤ p. 51

Lily WHITE
(active in the early 20th century)

Hardly anything is known about Lily White, except for the fact that she was one of the six members of the Photo Secession group on the West Coast of the United States. Her photographs of the Portland surroundings, mainly of the Willamette Valley and the canyons of the Columbia River that were often processed in her houseboat studio, demonstrated her desire to show the sublime aspect of a still largely wild landscape, by adapting the East Coast aesthetic then made fashionable by Stieglitz and his associates. **E.C.**

➤ p. 52

Beatrice WOOD (1893-1998)

Before the First World War, Wood started a career as an actress in Paris where she had studied drama. In 1916, she returned to New York where she first met Varèse and Duchamp, and then Louise and Walter Arensberg. In 1917, she founded *The Blind Man* with Varèse and Roché, and *Rongwong,* with Roché and Duchamp. Both journals gave her the opportunity to publish provocative drawings. She also participated with Duchamp in organizing the Society of Independent Artists. Though she didn't show her work often, she caused a scandal at the 1917 Salon des Indépendants by exhibiting a collage made of a piece of soap placed on a rough nude. She later published in the journal *Rogue* several sketches in a "non-objective vein." In 1933, she started a career as a ceramist. Her glazed crockery carved her an international reputation. One remembers her more as a ceramist than a Dadaist. **Ch.M.**

➤ p. 117

Grant WOOD (1891-1942)

In his early days, Wood created thickly painted scenes in the Impressionist style. After 1925 however, he composed highly realistic images of the American scene, particularly of the rural Middle West; in these, he was influenced by the Flemish Primitives he had discovered during his travels to Europe. He used glazes to paint extremely detailed portraits in which the characters were often shown squarely facing the viewer. *American Gothic* (1942), undeniably his most famous work, perfectly illustrated the atmosphere of the most under-privileged regions of the United States, at the opposite pole from New York cosmopolitanism. This series of portraits satirized the puritanical and rigid rural qualities of American life. At the same period, Wood produced a series of simplified panoramic views of country landscapes in which the excessively round hills of his paintings and prints seem to be made of modeling clay.

➤ p. 170, 171 **E.A.**

Samuel J. WOOLF (1880-1948)

After his studies at the Art Students League of New York, Woolf at first remained close to the Ashcan School style taught by his professors. He retained its urban subjects and dark realistic manner. However, he rapidly specialized in the portrait genre, becoming one of the favorite portrait illustrators of the *New York Times* and *Time* magazine (which he joined in 1924). Until the end of his life, the greater part of his artistic production consisted of several hundreds of charcoal portraits intended for mass reproduction and distribution, sometimes complemented with reportages painted from life. **E.C.**

➤ p. 44

List of exhibited works not reproduced:

Milton Avery
Gaspe Fisherman, c. 1938
Oil on canvas, 19 $^1/_2$ x 24 $^1/_2$" (75 x 62.5 cm)
Portland, Reed College, Douglas F. Cooley Memorial Art
Gallery

Thomas Hart Benton
Down the River, 1939
Lithograph, 12 $^1/_2$ x 10" (31.7 x 25.4 cm)
Dallas Museum of Art
Juanita K. Bromberg Memorial Fund and gift of an
anonymous donor

Thomas Hart Benton
Edge of Town, 1938
Lithograph, 8 $^7/_8$ x 10 $^7/_8$" (22.7 x 27.5 cm)
Dallas Museum of Art
Gift of Leon A. Harris, Jr.

Georges Bellows
The Murder of Edith Cavell, 1918
Lithograph, 10 $^7/_8$ x 24 $^7/_8$" (47.9 x 63.2 cm)
Dallas Museum of Art
Gift of John L. Hauer in memory of Mrs. Roger Sullivan

Edward S. Curtis
Tablita Dancers and Singers, San Ildelfonso, c. 1905
Photogravure, 17 $^7/_8$ x 21 $^3/_4$" (45.5 x 55.3 cm)
Estate of Harry Lunn
Paris, courtesy Galerie Baudoin Lebon

Maya Deren
Meshes of the Afternooon, 1943
Silent film, black and white, 18 min.

Marcel Duchamp
Boxing Match, 1916
Photomontage
Paris, courtesy Galerie Marion Meyer

Walker Evans
Untitled (Industrial Elevators), c. 1929
Gelatin silver print, 8 $^5/_8$ x 6 $^1/_2$" (22 x 16.5 cm)
Paris, Sandra Alvarez de Toledo collection

Walker Evans
Millworkers' Houses in Willimantic, Connecticut
Gelatin silver print, 5 $^5/_8$ x 5 $^1/_4$" (14.5 x 13.2 cm)
Paris, Sandra Alvarez de Toledo collection

Gaston Lachaise
Classic Torso, 1928
Bronze, 10 $^1/_2$ x 6 $^1/_2$ x 3" (26.7 x 16.5 x 7.6 cm)
New York, courtesy Salander-O'Reilly Galleries

Dorothea Lange
*Grandfather and Grandson, Japanese Relocation Camp,
Manzanar, California,* 1942
Gelatin silver print, 9 $^1/_2$ x 7 $^5/_8$" (24.4 x 19.5 cm)
Dixon Family Collection

Dorothea Lange
Filipino Shipyard Worker, 1942
Gelatin silver print, 8 $^1/_4$ x 9 $^1/_2$" (21 x 24.1 cm)
Dixon Family Collection

Dorothea Lange
Head of an Illiterate, no date
Gelatin silver print, 7 $^1/_2$ x 8 $^3/_4$" (19 x 22.2 cm)
Dixon Family Collection

Dorothea Lange
Richmond, California, 1942
Gelatin silver print, 7 $^3/_4$ x 8 $^3/_4$" (19.7 x 22.2 cm)
Dixon Family Collection

Dorothea Lange
End of an Era, 1938
Gelatin silver print, 7 $^1/_2$ x 8 $^1/_2$" (19 x 21.6 cm)
Dixon Family Collection

Helen Levitt and James Agee
In the Street, 1946
Silent film, black and white, 16 min.

Allan Lock
The New Negro, 1926
Paris, American Library

John Marin
Landscape, 1915
Watercolor on paper, 15 $^1/_4$ x 18 $^1/_4$" (39.9 x 46.3 cm)
Paris, Musée National d'Art Moderne,
Centre Georges Pompidou

Adolf de Meyer
Lenome Hughes, 1919
Gelatin silver print, 9 $^1/_2$ x 7 $^1/_4$" (24.2 x 18.5 cm)
Paris, courtesy Galerie Baudoin Lebon

Dale Nichols
The Twins, 1946
Oil on canvas, 29 $^1/_2$ x 39 $^5/_8$" (75.25 x 100.8 cm)
The Minneapolis Institute of Arts
Gift of Richard Lewis Hillstrom in memory of Marion
Gustafson Lindquist

Paul Strand
Jug and Fruit, Connecticut, 1915
Gelatin silver print, 11 $^1/_4$ x 7 $^3/_8$" (28.6 x 18.7 cm)
Dallas Museum of Art
Gift of Joseph W. Gray, M.D.

Paul Strand and Charles Sheeler
Manhatta, 1921
Silent film, black and white, 9 min.

James Weldon Johnson
God's Trombone
Illustrations by Aaron Douglas
Paris, American Library

Review 291
March, April, May, June and December 1915,
January 1916
Heliogravure and half-tone engraving on paper,
17 $^3/_8$ x 22 $^5/_8$" (44 x 57.5 cm)
Paris, Musée d'Orsay

Review *Camera Work*
N° 21, 1908, and n° 36, 1911
Paris, Bibliothèque Nationale de France

Reviews
Rongwrong, The Blind Man, n° 2, 1917
Art Front, November 1934, January 1935
Paris, Documentation, Musée National d'Art Moderne,
Centre Georges Pompidou

Review *View,* January 1943 and May 1945
Printed magazines
6 $^1/_2$ x 7 $^1/_4$" and 12 x 9"
(16.5 x 18.5 and 30.5 x 23 cm)
Paris, courtesy Galerie 1900-2000
collection Marcel and David Fleiss.

Photography Credits